JOSEPH PAUL VORST

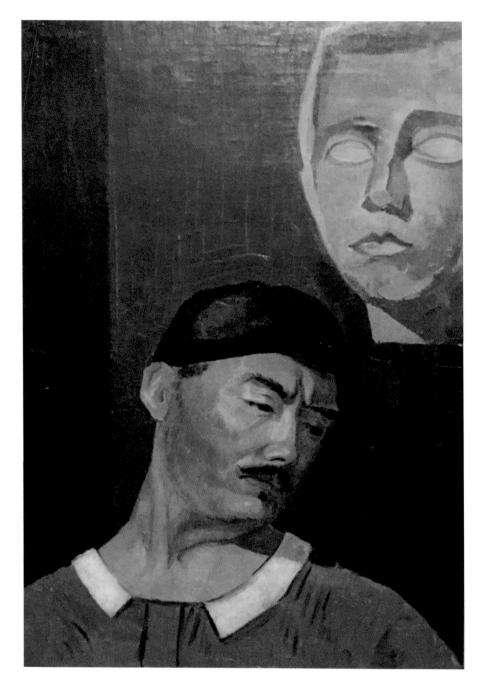

Fig. 1 Joseph Paul Vorst, *Self Portrait*, ca. 1935, oil on canvas,
28 x 20.5 in., Carl and Carole Vorst, St. Louis, Missouri.

JOSEPH PAUL VORST

GLEN NELSON

MORMON ARTISTS GROUP
NEW YORK

Mormon Artists Group
457 West 57th Street
New York, New York 10019
mormonartistsgroup.com

Designed by Cameron King

ISBN: 978-0-692-95022-7

Printed in U.S.A.

TABLE OF CONTENTS

INTRODUCTION

JOSEPH PAUL VORST

The short and tumultuous life of Joseph Paul Vorst reads like a proxy for the 20th century. Raised in poverty, Vorst lived through two world wars (he fought and was injured as a German solider in World War I). After his immigration, he struggled through the Great Depression, witnessed the rise of the Nazis in Europe, and experienced prejudice against German immigrants in America. He met and drew heads of state including Prince Ferdinand of Germany, President Paul von Hindenberg, and before they seized power, a young Adolf Hitler and his lieutenants. Fleeing Germany alone as his renowned teachers were censored and labeled degenerate one by one, he decried fascism and was embraced by artists in America such as Thomas Hart Benton and Joe Jones—unfairly, perhaps, laboring in their shadow.

Yet he created a body of art that was exhibited often and admired widely, in his day. The following is a partial listing of his American museum exhibitions during his lifetime: the Metropolitan Museum of Art, the Whitney Museum of American Art, the Art Institute of Chicago, the Library of Congress, the San Francisco Museum of Art, the Corcoran Gallery of Art, the New York World's Fair, the Kansas City Art Institute/Nelson-Atkins Museum, the Pennsylvania Academy of Fine Arts, the Carnegie Institute, the St. Louis City Art Museum, the Dayton Art Institute, the Toledo Museum of Art, the Golden Gate International Exhibition, the Virginia Museum of Fine Arts, and even the White House. These are Vorst's museum credits that occurred within a span of ten years in the United States. He also showed in commercial fine art galleries of distinction and historical importance in St. Louis and New York City.

After his death, although his reputation receded, his art entered into additional public collections of significance including the National Gallery of Art, the Smithsonian American Art Museum, Crystal Bridges Museum of American Art, the Saint Louis Art Museum, and others.

Still, today few outside of the St. Louis, Missouri area, where Vorst made his home, know of his work. Like many artists before mid-century, Vorst's paintings, watercolors, murals, prints, artist's books, photographs, sculpture, and drawings spoke powerfully of his specific place and time. Now, removed from the immediacy of the politics of his day—particularly his concern for the disadvantaged and those affected by natural disasters, the Great Depression, and war—perhaps the artist's images and life can be seen afresh. This monograph, the artist's first, may serve as the opportunity for rediscovery and reappraisal.

Glen Nelson
New York City, September 2017

ACKNOWLEDGMENTS

IN APPRECIATION

Joseph Paul Vorst left no diary and very little correspondence. To the extent his life can be pieced together and shown alongside his artwork is thanks to his wife Lina (now deceased), his son and daughter-in-law Carl and Carole Vorst, his three grandchildren Matt, Jennifer, and Eric, and their spouses and children. The Vorst family has carefully safeguarded photographic albums, newspaper clippings and other ephemera, and of course, artwork. This book could not have been possible without their unending support and encouragement, and I consider this book a gift between us.

In 1988, Grant Kniffen, a young artist and student in St. Louis, met the Vorst family, and he compiled and organized their records for a graduate degree thesis on Joseph Paul Vorst. His 20-page narrative introduction was the first attempt to summarize the artist's full life story in print. Since that time, much additional information has come to light, enough to suggest to me that a full history might be possible.

I acknowledge with gratitude the assistance with German public records of Jutta Vonrüden-Ferner of the Haus der Essener Geschichte/Stadtarchiv, Mario von Luettichau of the Museum Folkwang, and Daniel Schütz who shared with me his insights as an archivist of German art. I was also assisted by Dwight Blazin with translation of correspondence and poetry, by Curtis Bajak with translation of the notation of sketches, and by Thomas Plummer with translation of the published work, *Der Vulkan*.

I was alerted to Joseph Paul Vorst's story in June 2013 by a friend Randy Astle, who referred to me a blog post on *The Keepapitchinin*, by Mormon historian Ardis E. Parshall. She had come across a brief article about Vorst in a June 1940 magazine, *The Improvement Era*, and wondered whether there was more to the story.

After I conducted a little research of my own and wrote a short article about Vorst online, I was contacted by Carl and Carole in St. Louis who invited me to explore their collection. Given the connection between Joseph Paul Vorst and his religion, The Church of Jesus Christ of Latter-day Saints, I contacted the LDS Church History Museum in Salt Lake City and invited its global curator, Laura Allred Hurtado, to accompany me to St. Louis. Warren Winegar provided wise counsel regarding the unique needs of artists' estates.

The resulting trip to St. Louis in November 2014 was the real beginning of the adventure, and at every step, Laura has been grace, tenacity, and advocacy personified. The team at the museum, and Alan Johnson, its director, in particular, have been the best colleagues one could wish for. The preservation staff at the Church History Library scanned early photograph albums and sketchbooks that the Vorst family generously provided for the purpose of research. Charles Baird took beautiful photographs of the exhibition artworks, many of which had never been professionally photographed before. Staff at the museum, James Ito, Mark Ware, and Wayne Pullman, came to the works with fresh eyes and pointed out multiple connections between Vorst and Mormonism that I had missed.

The museum partially subsidized my research and the publication of this volume, which appears in conjunction with their full retrospective of Vorst's work at the museum, co-curated by Laura and myself.

I have received patient encouragement and assistance from museum libraries at the Metropolitan Museum, the Museum of Modern Art, the New York Public Library, the Frick Collection, and a number of other institutions that maintained

catalogs and clippings of Vorst's American progress in the 1930s and 40s, and by the U.S. Federal Government and its collection of WPA-era correspondence with American artists at work on public murals before World War II. I wish to thank Gene Morris of the National Archives, who copied and sent letters from the 1940s between Vorst and government officials. The Church History Department in Salt Lake City provided extensive and valuable records of Vorst's participation in his German congregation, as well.

I must add that a large number of individuals in the U.S. and Germany—gallery owners, auction house management, scholars, museum directors and staff, art school administrators, and art collectors—were kind in responding to my queries about Vorst, even (and often) when they had no further leads for me to follow.

Aside from the Vorst family, private collectors have been key in the preservation of the Vorst story. After his death, the paintings scattered, and the majority of them, aside from those residing with the Vorst family, went into the homes of private collectors or to commercial galleries. Tracking them down would have been impossible without the generosity and openness of these collectors and their art advisors. The most knowledgeable resources on the artist's work aside from the Vorst family have been these collectors, art dealers, and gallerists—in particular, Thom Pegg and the staff at Tyler Fine Art in St. Louis. These individuals had maintained files of press clippings and ephemera that illuminated frequently my storytelling, and they very kindly introduced me to institutional and private collectors who, in turn, invited me into their homes and workplaces. Some of these people wish to remain anonymous, but I express my gratitude to them for their stewardship of Vorst's work and their willingness to share it.

The book exists because of the images it describes, and I am especially indebted to those who gave permission to reprint images and for access to photographs of the artworks. Museum and magazine staffs quickly responded to my inquiries and requests. Occasionally, the museums were unable to lend works to the exhibition, and so their generosity in sharing their images for this publication is richly appreciated. (A full listing of photography permissions and credits appears at the end of this volume, on page 234.)

German and American newspapers played an important role during Vorst's life in disseminating his images, providing critical responses to exhibitions, and charting biographical events. Additionally, the *St. Louis Post-Dispatch* discovered recently that a number of unattributed mural studies long displayed in their offices were by Vorst, and they were generous in allowing me to view the works and study them. I wish to single out Matthew Franck for those introductions and access.

The LDS community in St. Louis was a vital presence during Vorst's life, and its local members then and since eagerly shared with me photographs and memories of Vorst, notably Tom Farmer and Dick Oscarson. I contacted the children and grandchildren of the LDS missionaries who knew Vorst in Germany, and they were delightful assets who told me the stories of the lives of their ancestors.

Before I began serious research on the artist, I found and acquired a few of Vorst's artworks in the U.S. and in Germany and placed them in the collections of friends in January, 2014. This initial positive feedback that Vorst's story was compelling to Contemporary Art aficionados gave me the confidence to expand my thinking about the potential for a book and a retrospective exhibition of the artist. For that initial support, thanks go to Cris Baird, Stanley Hainsworth, Mark Butler, Ardis E. Parshall, and Brad Kramer.

In my research, I found books and articles written about art of the period in which Vorst lived to be immensely helpful to me, in particular the books: *Joe Jones: Radical Painter of the American Scene* (Andrew Walker, general editor, Saint Louis Art Museum); *Thomas Hart Benton: An American Original* (Henry Adams, Knopf); *New Objectivity: Modern German Art in the Weimar Republic, 1919-1933* (Stephanie Barron and Sabine Eckmann, Los Angeles County Museum of Art); and *Artists on the Left: American Artists and the Communist Movement, 1926-195*6 (Andrew Hemingway, Yale University Press).

In preparing the final manuscript for publication, I asked the help of readers. At every turn, they improved the book. These extra eyes include those of Cris Baird, Katherine Nelson, Marcia Nelson, Luisa Perkins, and Kimball Smith.

I have worked with book designer Cameron King on a number of projects. I approached him about Vorst at the worst possible moment, when he was overwhelmed with family,

career, and new charity volunteer duties. Somehow, he was open to the idea, nonetheless, and the result is this design which is, to my eyes, more elegant than the text it shapes.

We are a family of four: my wife Marcia, and my college-age children, Katherine and Dashiell. I have tried not to force upon them every discovery of Vorst's art and history and my new contacts and friendships made over the last four years, but at a certain point I gave up filtering and included them in each development. They are now enthusiasts, too. I love them and thank them, especially Marcia, who has made everything possible for me.

Every book's acknowledgments seems to have a disclaimer that the errors great and small therein are entirely the author's fault. Although I have written some twenty books before this one (I am a ghostwriter by profession), I have never read those words without rolling my eyes . . . until now. I feel embarrassed about the errors that almost certainly litter this volume. I've tried to weed them out, but I can guarantee that I have come up short as a researcher, writer, linguist, proofreader, critic, and historian. I have tried not to claim guesses as facts, but without a doubt, in coming years, new information and previously unknown Vorst works will point out the error of my version of things, and I welcome it all.

Finally, many times throughout the process of research and writing about Vorst, strange coincidences occurred—previously unknown artworks saved from a basement flood surfaced, paintings literally stuffed into attic crevices came to light, portfolios and rare examples of Vorst's print work were discovered in bookshops and auction house catalogs, records were recovered after decades having been presumed lost, works that the family thought only existed in aged newspaper reproductions were revealed to be hiding in plain sight, to say nothing of the "discovery" of Vorst himself—and all with such regularity, that it often seemed to me like the entire project were guided by some unseen force.

In a listing of acknowledgments, perhaps that unattributable thanks is best saved for last.

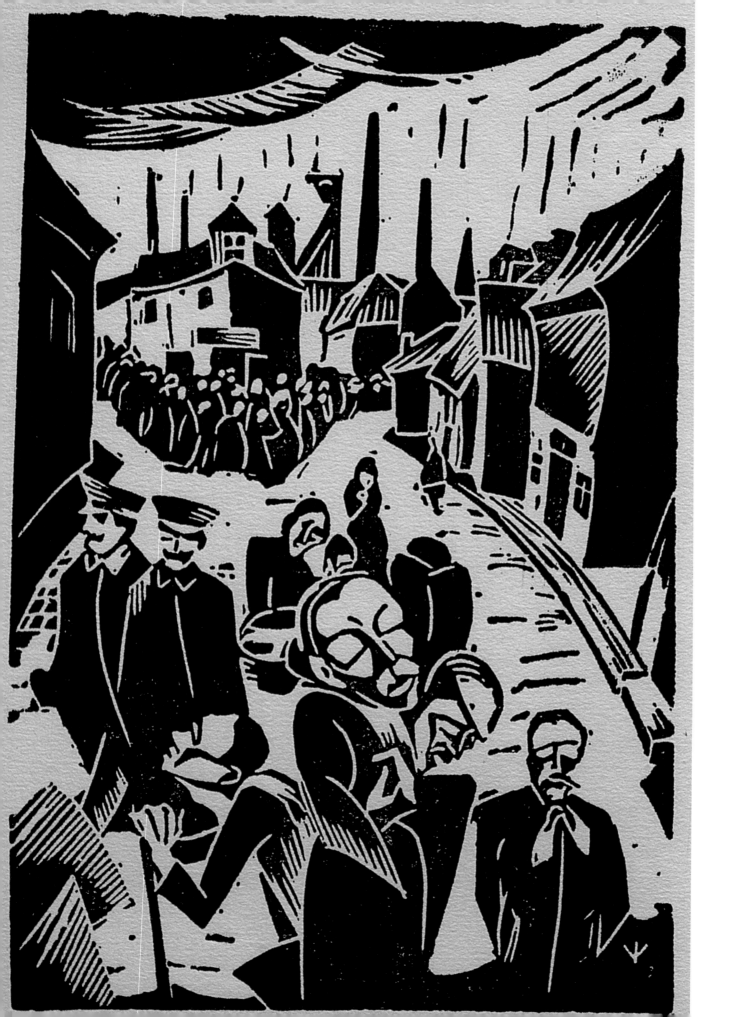

PART 1: 1897-1930
CATACLYSM AND TRANSFORMATION IN GERMANY

For us lads of eighteen they ought to have been mediators and guides to the world of maturity, the world of work, of duty, of culture, of progress—to the future. We often made fun of them and played jokes on them, but in our hearts we trusted them. The idea of authority, which they represented, was associated in our minds with a greater insight and a more humane wisdom. But the first death we saw shattered this belief. We had to recognize that our generation was more to be trusted than theirs. They surpassed us only in phrases and in cleverness. The first bombardment showed us our mistake, and under it the world as they had taught it to us broke in pieces.

Erich Maria Remarque, *All Quiet on the Western Front*

Fig. 2 Joseph Paul Vorst, *Der Tragödie aus der Strasse*, 1929, linoleum cut, 9 x 6 in., Carl and Carole Vorst, St. Louis, Missouri.

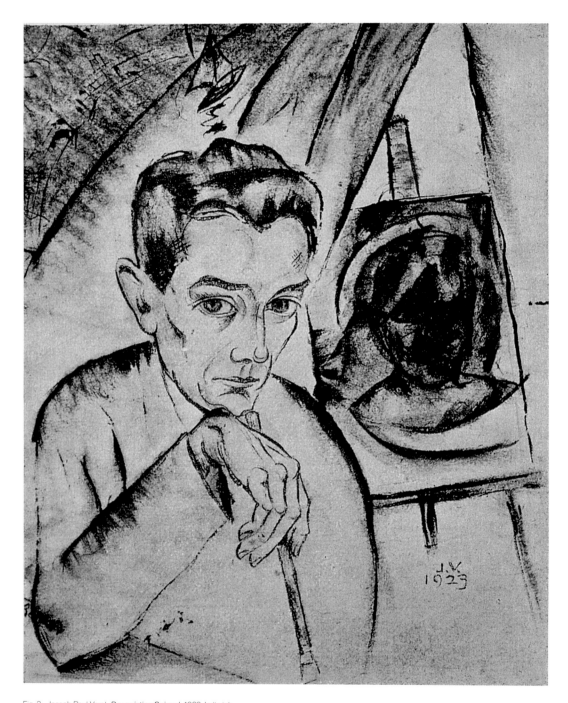

Fig. 3 Joseph Paul Vorst, *Der geistige Spiegel*, 1929, India ink, whereabouts unknown, reproduced in *Der Vulkan*, 1929, 9 x 6 in., Carl and Carole Vorst, St. Louis, Missouri.

CHAPTER 1
ESSEN

THE CITY AND ITS HISTORY

Joseph Paul Vorst was born on Saturday, June 19, 1897, the seventh in a family that would eventually grow to include ten children. His parents, Paul Johan Josef Vorst and Christine Wißkirchen, lived in Essen, a city of 100,000 inhabitants approximately 20 miles northeast of Düsseldorf, 35 miles north of Cologne, and 280 miles southwest of Berlin. His father had been born in Halle, 70 miles away, but the couple relocated after he married Christine, a native of Essen, in 1888. At the time of Joseph Paul Vorst's birth, Essen was part of the German confederation within the Prussian empire, as it had been for much of the 19th century.

Essen is in the Ruhr valley, where the River Ruhr meets the mighty Rhine. In the year AD 852, Saxon nobility built a convent for their daughters in Essen. Mathilde, a granddaughter of Emperor Otto I, became a prioress of the convent in 971, and for centuries the convent, and later the Essen cathedral, were tightly connected to royal and imperial families. Prioresses were also princesses; Emperors Otto II, Friedrich II, and King Rudolph each granted sovereignty to the prioresses over Essen, its people, and its resources. These included art objects and relics. From its earliest days, the convent collected precious objects. The cathedral treasury became one of the most important in Europe. Further, these women developed the economy of the area by beginning to extract coal in 1369. Coal mining made possible by the development of the steam engine led to iron and steel production. By 1470, gun making had begun in the town, followed by a forge that in 1620 was capable of producing 14,000 rifles and pistols, annually.

Essen's post-industrial revolution economy is inextricably bound to the Krupp family, who began manufacturing operations there in 1782. In 1820, the family began a steel found-ry in Essen, later headed by Friedrich Krupp. The business moved steadily toward the manufacture of armaments and munitions—particularly, cannons and weapons—and quickly grew to be among the world's largest industrial companies aided by rich natural resources and convenient transportation: waterways, railroad, and highway systems. The Ruhr valley became one of the most important industrial districts in the world.

In 1802, Prussian soldiers occupied Essen, its westernmost province, after treaties held Napoleonic forces to the left bank of the Rhine. This action supplanted Essen's historical sovereignty. The annexation by Prussia changed the region, and after Napoleon was defeated at Waterloo in 1815, Prussia's territory expanded greatly.

The empire of Prussia enacted reforms including the elimination of serfdom, which paved the way for land ownership of the peasantry. It also wrote into its constitution freedoms of religious independence. Catholicism had a long history in Essen because of the convent and cathedral that formed its historical foundation even as Protestant reformation cascaded across the empire. The right to determine one's own religion and gain instruction based on choice was a significant development for the area.

In 1816, Essen was transferred within the province of Westphalia to the Rhine Province. Within the Prussian empire, a confederation of German states and kingdoms emerged. Throughout the 19th century, Austria, Denmark, France, and other nations battled Prussia. William I was persuaded by Otto von Bismarck, his prime minister, to encourage German unification, and after the Franco-Prussian War of 1870, King William I led a unified Germany (still under the Prussian empire) as its first emperor.

This cursory survey of regional history serves to illustrate that at the time of Vorst's birth, the town of Essen was a bustling center of activity with a rich but volatile history of politics and blurred national identity. It was also a crucible of disparate impulses regarding social reform and cultural development—religious rights, land ownership, military might, political turmoil, the collection of fine art and precious objects, and the entrepreneurship and culture-building of wealthy individuals. Each of these foreshadowed direct and lasting influences on Vorst.

THE VORST FAMILY

Perhaps the most salient point to the telling of the Vorst story is the acknowledgment that biographical narrative documents about his early life are limited. Essen, a primary center for German munitions during World War II was a nearly constant target of Allied bombing from 1939 to 1945. All told, 272 air raids destroyed 90 percent of the center of Essen, the remaining city was 60 percent destroyed, as was said of the relentless bombing of war, making ruins of ruins. The result being, that many family documents as well as public and military records were destroyed. Still, German public and private life was documented routinely. The national character of Germans as exacting record-keepers, even the caricature of it, has basis in fact. German officials of the period were precise, and they were extensive documentarians. It is frustrating, therefore, to acknowledge that much has been irretrievably lost. And yet, although much of its historical evidence was compromised and destroyed, there remains hope that additional information will someday emerge. That is the caveat when writing about 20th-century Germany.

In middle age, Vorst wrote a brief history of his childhood for an art exhibition catalog, and it is the sole surviving autobiographical text of his early home life and education:

> My own family was a large one, twelve members to be exact. My father, a cabinet maker, could not always find sufficient work and it was necessary for my mother to find ways of adding to the family income.

> We lived in the country and raised goats, pigs and chickens, but more important was a big potato patch and vegetable garden. My mother, older sister, and

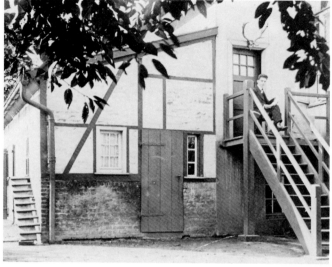

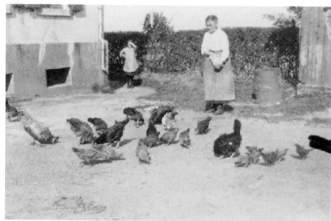

Fig. 4, this page, top unidentified photographer, Vorst at his home, ca. 1915, Carl and Carole Vorst, St. Louis, Missouri.

Fig. 5, this page, bottom unidentified photographer, Christine Vorst feeding chickens, n.d., Carl and Carole Vorst, St. Louis, Missouri.

Fig. 6, opposite page, top unidentified photographer, the village near Essen, n.d., Carl and Carole Vorst, St. Louis, Missouri.

Fig. 7, opposite page, middle unidentified photographer, the Vorst family orchard and garden, n.d., Carl and Carole Vorst, St. Louis, Missouri.

Fig. 8, opposite page, bottom unidentified photographer, the village near Essen, n.d., Carl and Carole Vorst, St. Louis, Missouri.

later myself pulled the garden produce in a primitive hand-wagon three times a week to the city market where it was sold. It was not always sunshiny weather and often in the snow and sleet the vegetables froze and our hands and feet were frostbitten.[1]

After their marriage in 1888, the Vorsts had ten children in quick succession: Christine Klara Berta (January 13, 1889), Berta Maria Amalia (May 16, 1890), Paul Johann Josef Anton (February 10, 1891), Otto Josef Paul (October 12, 1893), Hermann Paul Josef (July 2, 1895), Joseph Paul (June 19, 1897), Alfred Paul Friedrich (May 29, 1899), Karl Paul Peter (February 20, 1901), and Agnes Hedwig (May 20, 1903), and Maria Christina (November 1, 1908). Two of the children died before adulthood: Paul Johann Josef Anton died in 1906 at the age of 13; and Otto Josef Paul died in 1897 at the age of 4.[2]

Although his official birth record lists his name as Paul Joseph Vorst and later documents drawn directly from the record repeat that name, it is a peculiarity of German recordkeeping that traditionally transposed the order of given names. The artist's name was Joseph Paul Vorst. Regarding the spelling of Joseph, he also toyed with his name as he began signing artworks, changing the "ph" of Joseph to a truncation that almost looks like "Josef," but not quite (there is no horizontal line of the "f"). In correspondence, he is known as "Josef" and some of the family's genealogical records listed him as "Josef" rather than "Joseph." Further, he anglicized the writing of the 19th century German letter ess—the signature is almost a glyph. Early published artworks were labeled "Josef Vorst." He signed his artwork in numerous ways as he began his career, perhaps indicating experimentation with his name: Vorst; J. Vorst; Jo. Vorst; Jos. Vorst; Josef Vorst; Joe Vorst; and later Joseph Vorst, Joseph P. Vorst; and finally Joseph Paul Vorst. There are no known artworks signed Paul Joseph Vorst.

The Vorst and Wißkirchen relatives lived in and near Essen in districts named Holsterhausen and Rüttenschied. Joseph's paternal grandfather, Johan Josef Vorst, died six years earlier, on May 2, 1891, but his grandmother, Amalie Karoline Voigt, remained in Essen until her death in 1912. Records show a number of Vorsts in Essen during Joseph's childhood. According to records from the Stadtarchiv (state archive) in Essen, Joseph's parents were married in Altendorf, a western district in the city of Essen. Their first three

children were born in Altendorf. The Vorsts then moved their home to another nearby district. Birth records show that Joseph's younger brothers and sisters were born in two additional districts just south of the city of Essen, namely Rüttenscheid and Bredeney. These districts are very close together; fewer than three miles separate them.[3]

Vorst kept an album of photographs. Unfortunately, these images are undated and without captions. Still, it is possible to piece together a few of the elements of his life with some certainty. Later, in adulthood, he also spoke about his upbringing and artistic journey.

Vorst showed an early interest in drawing. His father had artistic inclinations himself and was supportive of his son's efforts, under the age of five, to draw from nature. An early memory was his habit of following his older siblings to school, then waiting outside the school, and peering in the windows to observe the young schoolchildren drawing from colorful models at small easels. With the encouragement of his father, he began drawing in earnest before he reached school age.[4]

Again from Vorst's recollections published later:

I was not very old, however, before my father found that I showed talent in drawing with pastel and managed to send me to an art school aided by several scholarships which I was fortunate enough to have awarded me. Although I did not have to pay any tuition, I nevertheless had to supply my own art materials. Of course, most of the time it was impossible for me to buy these materials and so I picked up from the floor of the schoolroom pieces of charcoal and thumb tacks which the more fortunate students had thrown away. For drawing paper I used the back side of wallpaper. My teacher, Carl Hepke, soon noticed these things because he himself had gone through similar experiences in his early training. Occasionally he would give me a piece of good drawing paper or the drawings done by previous students the backs of which I used.

My work was of such quality that the school has kept it for exhibition purposes.[5]

The name of his teacher was Karl Hapke, not Carl Hepke,

Fig. 9, right unidentified photographer, near the Vorst home, n.d., Carl and Carole Vorst, St. Louis, Missouri.

Fig. 10, below unidentified photographer, Christine Vorst ferrying sheep across the river, n.d., Carl and Carole Vorst, St. Louis, Missouri.

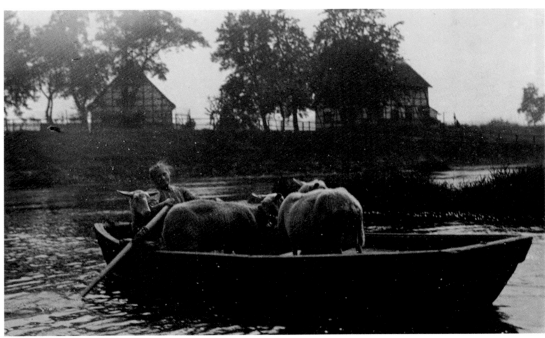

as the catalog cited above stated. Hapke became a well-known figure as an educator and artist, and he taught for decades in Essen. In adulthood, Vorst repeatedly singled out this teacher as a kind and important influence. Vorst's mention of "Hepke" occurred during transcribed interviews rather than direct autobiographical writing. Vorst spoke with an accent that some found difficult to decipher, and he was not particularly careful with spellings and grammar, even pertaining to people close to him. The transliteration is a simple mistake. (He is not to be confused with another teacher, Karl Kriete, who taught Vorst in the 1920s.) Unlike Vorst's early watercolors that are somewhat gestural and loosely painted, Hapke's work is tight and exact. Eventually, Vorst owned three small watercolors by Hapke.

FOLKWANG AND EHKGS

In 1901, a trade school opened in Essen that offered courses in mechanical engineering and decorative painting. One year later in Hagen, 21 miles east of Essen but only a few miles away from the district of Rüttenscheid, where Vorst lived, Karl Ernst Osthaus opened the first museum in the world that would be dedicated to Contemporary Fine Art, called the Museum Folkwang. The name Folkwang comes from Norse mythology. In Valhalla, the goddess Freyja dwells in a vast meadow of the people (Folkwang, or in Old Norse, "Folkvangar"). Freya, the daughter of Njörðr, is the goddess of beauty, love, and art.

Osthaus was the grandson of a wealthy industrialist and heir to a considerable fortune. He turned away from the family business and dedicated his life to building his community through art, architecture, social reform, and education. He had begun the construction of a museum in the 1890s. Initially, he sought a museum dedicated to Islamic art; then he determined to build a natural history museum. But in 1900, after reading about the work of Henry van de Velde in *Dekorative Kunst* (Decorative Art), Osthaus contacted van de Velde, a leading figure in the Art Nouveau movement in Belgium, to finish the interiors of the Museum Folkwang.[6]

When Osthaus visited the Arts and Crafts Exhibition in Dresden in 1906, however, he transformed the intent of his institution entirely; he was convinced by van de Velde that instead of a museum aimed to lift the spirits of an industrial area by showing the beauty of the natural landscape, he should instead use the structure to house the artworks that he had begun acquiring.

In some regards, this was an aesthetic swap—a museum about nature replaced by a museum about artworks drawn from nature. Art Nouveau embraced natural forms, particularly curvilinear imagery of flowers, vines, and trees, as a way to bring viewers in contact with their landscape. The movement, which was known as Secession in Vienna, Jugendstil in Germany, Art Nouveau in France and England, and Modernisme in Spain, was strongly connected to the decorative arts. At its heart was an elevation of nature in art and design.

Paradoxically, Hagen—and by extension, the manufacturing region near Essen—was an industrial wasteland at the time. Henry van de Velde described the city this way:

> Hagen was then a provincial city the old core of which had been virtually consumed by its numerous industrial concerns; a hideous sight. No less hideous was the effect of the ostentatious villas of the industrialists built in the *Grunderzeit* and crammed into small gardens where one could hardly breathe. The lawns were wretched, the shrubs sickly, and everything lay under a thick cloud of coal smoke.[7]

Under van de Velde's tutelage, Osthaus began to amass a visionary collection of art. At first, his collecting efforts focused on art and textiles of Asia and the Pacific. Then he moved toward Impressionist and Post-Impressionist paintings including works by Renoir, van Gogh, Cézanne, Gauguin, and Matisse. To acquire their works, Osthaus sought out the artists personally. Next, Osthaus collected African sculpture and early Modern Art of the 20th century. The Folkwang was the first museum to display European works together with African masks, figures, and fetishes. He mounted exhibitions at the Folkwang that juxtaposed objects from around the world. For example, a painting by Gauguin was hung next to a Balinese temple painting, and fabrics from local German mills were exhibited next to Asian textiles. Galleries were hung ahistorically, inspired by a theosophist impulse to probe the mysteries of divinity by connecting far-flung objects and ideas in order to come to shared enlightenment.

Given his concerns for community and art and the role that each plays in the development of the other, it was a logical progression when Osthaus turned his sights to the support

of German artists as a way to elevate and transform the Ruhr valley. He had long been interested in social reform and considered engagement through living artists a key priority. Osthaus wrote, "The most important question in life cannot be solved without the involvement of art." Another oft-quoted maxim was this: "Transformation through culture—culture through transformation."[8]

Around 1910, he began in earnest his patronage of Jugendstil, Die Brücke, and Der Blauer Reiter groups of artists. The museum started to show German, Austrian, Swiss, and Scandinavian progressive artists regularly and in depth. Osthaus collected tens of thousands of contemporary works by Max Beckmann, Otto Dix, George Gross, Erich Heckel, Ernst Ludwig Kirschner, Paul Klee, Oskar Kokoschka, Wilhelm Lehmbruck, Otto Müller, Edvard Munch, Emil Nolde, Max Pechstein, Christian Rohlfs, Egon Schiele, Karl Schmidt-Rottluff, and Kurt Wolff, to name a few. To give an example of the depth of the Folkwang collection, by 1941, when the Nazis labeled "Entartete Kunst" (Degenerate Art) works from the museum and cataloged them for sale or destruction, the Folkwang owned 518 "degenerate" works by Emil Nolde alone.[9] For some of these avant-garde artists, the Folkwang was the first museum to show their work. This is the remarkable institutional environment—a whole-hearted and revolutionary embracing of the new in visual art—in which Vorst found himself as a student. These artworks were his educational backdrop.

When discussing the styles of painting in early-20th century Germany, it is common to lump art movements together as "German Expressionism," but that is inaccurate. As Vorst studied art in Essen and was exposed to the country's most progressive artists' works, he witnessed shifting and divergent philosophies to making art, each of which came to influence him. The Jugendstil (Young Style) artists had responded to an emotional, romantic view of nature and human interaction, and the next generation of progressive artists built upon Jugendstil ideas, particularly its graphic arts, and they flattened their imagery further.

Two artists' groups are especially important: Die Brücke and Der Blaue Reiter. Both of these were officially organized public entities. In Dresden, Die Brücke (The Bridge) artists voiced an eagerness to embrace the future. They had two goals: to produce bodies of work they considered authentic expression; and to serve as a connection for international artists working with similar aims. They worked together as a community between 1905 and 1913. Leading members included Erich Heckel, Ernst Ludwig Kirchner, Max Pechstein, and Karl Schmidt-Rottluff. This was rough, unpolished, emotional, raw imagery based on reduction and distortion. The rawness of color and depiction was something of a slap to its viewers, a wake-up call to provoke emotional and visceral responses.

Munich's Der Blaue Reiter (Blue Rider) was led by Vasily Kandinsky and Franz Marc. The name of the group was taken from imagery by Kandinsky. These artists that included Kandinsky, Marc, Alexei Jawlensky, August Macke, Paul Klee, and Heinrich Campendonk shared elements with Die Brücke, but their focus on abstraction and prismatic colors distinguished their work, as well as an impulse toward spiritualism. Organized in 1911, the group disbanded with the outbreak of World War I in 1914.

Other artists such as Emil Nolde, Käthe Kollwitz, Ernst Barlach, Lovis Corinth, Wilhelm Lehmbruck, and Christian Rohlfs—the latter lived near Osthaus in Hagen—labored independently in similar styles. Osthaus collected works from all of the above groups of artists, and therefore, Vorst had access to them as well.

Osthaus also commissioned a large number of new buildings. In a 1912 catalog of the Folkwang, thirty-three buildings could be attributed to Osthaus' sponsorship, including architecture by Peter Behrens, Walter Gropius, Henry van de Velde, and J. L. M. Lauweriks.

TRAINING AND MENTORSHIP

The trade school in Essen that had opened in 1901 continued to grow, and in 1911 the government granted it permission to be organized formally as Essener Handwerker und Kunstgewerbeschule (Essen School of Trades and Applied Arts). It had strong support from the Krupp family. The architect Alfred Fischer was the director of the EHKGS and also served as an instructor. The school offered a robust curriculum in architecture, sculpture, metalworking, decorative painting, printing, posters, book design, photography, graphic design, weaving, embroidery, and nature studies. The faculty included acknowledged leaders in their fields, a number of whom later taught at the Bauhaus school in Weimar.

The precise chronology of Vorst's attendance at EHKGS is unknown. He noted later that he spent eight years at the Folkwang—EHKGS changed its name to the Folkwang School of Design in 1928, after Osthaus died and his collection was purchased by the city of Essen and moved across the river from Hagen to Essen. Vorst also said that he taught at the Folkwang following the completion of his days as a student. Osthaus had created a school in Hagen, too, called the Folkwang School, but from the list of teachers that Vorst noted as influences, all of whom taught at Essen's EHKGS, it is reasonably certain that his studies were in Essen rather than Hagen.

During World War II, museum artworks were whisked away to safety, but their archives were not. The Museum Folkwang archives, for example, were almost entirely destroyed when the museum was bombed. At the outbreak of the Second World War, such documents were considered supplementary, and to some extent, expendable. Furthermore, teachers at the school received little instruction about maintaining notes and records of their students during Vorst's student days. Almost certainly, then, Vorst's academic records are gone.[10]

His student records and examples of his art made there have not surfaced and are presumed lost except for a certificate of completion, dated July 21, 1923, from an evening and Sunday course of study of the Essener Handwerker und Kunstgewerbeschule.

Still, Vorst kept a photo album of his family, friends, and school days. In the back of it, he pasted newspaper images of some of his teachers. These included professors at EHKGS: Alfred Fischer (architecture), Wilhelm Poetter (printing and posters), Josef Urbach (nature studies), and Karl Kriete (decorative painting). He also wrote about the influence of some of these men.

Vorst studied for a time under Johan Thorn Prikker.[11] Thorn Prikker was born in The Hague, Netherlands and gained attention for his symbolist paintings and furniture and textile designs. As Jugendstil gained popularity, Thorn Prikker sat at its forefront, particularly because of his work in the applied arts. The artist became one of the first Dutch modern artists to win international acclaim. He produced controversy, therefore, when he left the Netherlands in 1904 to seek greater success in Germany, and he requested German cit-

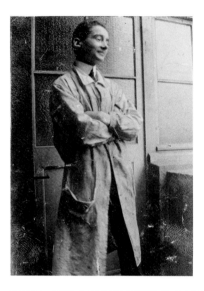

Fig. 11, top unidentified photographer, Vorst, ca. 1915, Carl and Carole Vorst, St. Louis, Missouri.

Fig. 12, bottom unidentified photographer, Vorst, ca. 1916, Carl and Carole Vorst, St. Louis, Missouri.

izenship in 1914. He taught first in Krefeld, Germany, and then moved to Hagen, where he lived from 1910 to 1919.

Living in Germany altered Thorn Prikker's work and expanded his ambitions. He responded to the manufacturing resources of the country and developed an interest in mosaics, textiles, and glass. The wealthy classes in Germany provided new avenues for expression as well, and he took commissions for large glassworks and massive wall paintings. An interest in wall art blossomed in Germany at the time. Monumental art and particularly art dedicated to religious subjects occupied him increasingly. Thorn Prikker was a deeply religious man, with numerous works in German churches, including the Alt-Katholischen Friedenskirche (Old Catholic Church of Peace) in Essen, an important monument of Art Nouveau. He taught at Folkwang from 1913 to 1918.

During this period, Vorst came under Thorn Prikker's influence. After finishing his initial artistic training, Vorst realized that he was unable to continue his studies. It was simply an issue of insufficient family resources. Instead, he found a job designing and painting church windows. During the day, he worked, and then he continued his studies at night. Following classes, he returned home and drew until the early morning hours. In addition to the influence of his teachers, he also met visiting figures who inspired him, including Richard Strauss and Pierre-Auguste Renoir. Renoir, in particular, made a lasting impression.

Vorst's exposure to the techniques of glass painting, however, included activities that became more about destruction than creativity:

> Following my early training in the art school I put in quite some time learning the skill and craft of the glass painter. I took a special course in glass painting under that famous Dutch master Torn Pricker [Johan Thorn Prikker].

> At that time commissions were very rare and there was not much work. We boys often were forced to smash some art glasses in private homes to stimulate the demand for our product. My father soon heard of our escapades and took me away, securing a position for me in a big printing company. There I learned the various techniques of rotogravure, offset, and letterpress printing, and finally was transferred to the art

department where I became a commercial artist. [12]

Vorst was a teenager at the time, and the growing fields of the commercial arts swayed him toward a career as a printmaker and illustrator. He also felt confined artistically by local religious leaders who commissioned painted glass. Although inexact, the timing of the episode above can be estimated with some confidence because Vorst's father died in 1918 and Thorn Prikker was only in the vicinity between 1910 and 1919.

When Thorn Prikker arrived in Hagen, Vorst would have been about 13 years old. Photographs exist of young Vorst wearing a white smock smeared with printer's ink. The period can be isolated further because of the impending war.

ENDNOTES

1. Joseph Paul Vorst, "Foreword," exhibition catalog *Vorst*, ACA Galleries, New York, NY: 1941.

2. All records come from the Stadtarchiv (state archive) in Essen, Germany.

3. The Stadtarchiv in Essen is the repository of marriage and birth records including those of the Vorst family. There is supposition to the precise location of the family's home within the linked districts of the city of Essen because the provided addresses on official documents are minimal. It is possible that over time, redistricting altered the names of their residences; or perhaps the Vorst family moved within the city of Essen from district to district.

4. William Edward Hoffman, *Joseph Paul Vorst: Missouri Artist*, n.d., ca. 1938, self-published, unpaginated.

5. Ibid.

6. See Robert Jensen, *Marketing Modernism in fin-de-siècle Europe*, Princeton University Press, 1994, 211.

7. Henry van de Velde, *Geschichte Meines Lebens*, Munich, 1962, 176, cited and translated into English by Susan R. Henderson, author of "J.L.M. Lauweriks and K.P.C. de Bazel: Architecture and Theosophy," Syracuse University, 1998, 7.

8. "The History of the Folkwang," Folkwang University of the Arts, folkwang-uni.de, accessed November 5, 2015.

9. See *"Entartete" Kunst: digital reproduction of a typescript inventory prepared by the Reichsministerium für Volksaufklärung und Propaganda,* ca. 1941/1942, London: Victoria and Albert Museum, January 2014.

10. Author's correspondence with Mario-Andreas von Lüttichau, curator of Painting, Sculpture, Media Art, 19th and 20th Century, Museum Folkwang, December 7, 2015.

11. In German publications, his name is printed in various ways, often as Johan Thorn Prikker and sometimes hyphenated, Thorn-Prikker.

12. op cit., Joseph Paul Vorst "Foreword," exhibition catalog *Vorst*, ACA Galleries, New York, NY: 1941.

Fig. 13 unidentified photographer, Vorst in uniform, n.d., Carl and
Carole Vorst, St. Louis, Missouri.

CHAPTER 2
THE WORLD AT WAR

THE MILITARY

After the 1871 constitution, all German men served in the military. From age 17, men had obligatory service. Typically, active duty began during the year of their 20th birthday, and after their initial duty of two years (three years for the cavalry or mounted artillery), they served up to five more years as reservists, another eleven years as Landwher (home guard) until their 39th birthday; then a second Landsturm period (militia) for additional years. They were expected to remain battle-ready into middle age, and they could be recalled at any time until age 45.

Archduke Franz Ferdinand and his wife were assassinated at the hands of Serbian nationalists on June 28, 1914, and afterwards, countries around the world fell into war quickly. A tangle of treaty alliances and rulers connected by blood and marriage hastened their entry, by obligation—Russia was bound to Serbia; Germany to Austria-Hungary; France to Russia; Britain to France; Australia, Canada, India, and South Africa to Britain; Japan to Britain; and eventually, the United States to Britain and France.

When World War I broke out in 1914, the German military muster accelerated. During World War I, approximately half a million German men were eligible annually for active duty. At the onset, many men volunteered in advance of being obligated. A soldier opting to volunteer before turning 20 could choose his service unit. As a result, a large influx of soldiers volunteered in 1914. The new soldiers were given medical exams and assigned to duty. After 3-4 months of training, they went to various fronts. Only a very small number of potential soldiers were labeled "unfit," approximately 5%, but even those men were typically assigned some other military duty. Smaller numbers of recruits arrived in 1915 and 1916, and they had longer training periods before taking the plac-

es of their fallen comrades. In 1914, the German army had approximately 30,000 officers, 100,000 non-commissioned officers, and 650,000 enlisted men.

Soldiers in the army were paid comparably to other European soldiers, the equivalent of about $5 per month, broken into three payments. Furthermore, they relied upon packages from home for basic sustenance. They were served a large lunch, but breakfast and dinner consisted of bread and tea or coffee, with a little chocolate at dinner. War was a family affair. Rations were deliberately meager; to compensate, families sent food to supplement rations and provided continuous care and comfort.[1]

Any history is dependent upon records, and unfortunately, many of Germany's World War I records of its soldiers were destroyed in World War II. All Stammrollen und Karteimittel (personnel and card listings) of the army, the Übergangsheeres (transition army), Reichswehr (regular army), and Kaiserlichen Marine (navy) were destroyed by fire during an air raid in Berlin, February 1945. Adding to the relative paucity of documents, numerous military records were scattered by district, and many of them are still uncatalogued. Officers' names and ranks were published in other books, some of which remain. Paradoxically, among the soldiers' records most likely to survive are for those for men injured in combat.

Vorst fought in World War I. At the time of Germany's entrance into the global conflict, he was 17—old enough to join in advance of compelled service and part of the first wave of volunteers. He spoke later of being injured with shrapnel in his leg that caused him lingering physical impairment for the rest of his life. He used the phrase, "permanently lame in one leg." An official listing of war casualties, *Verlustlisten 1. Weltkrieg* (Casualty List of World War I), has two ref-

erences to an injured soldier named Vorst (the first name is not provided) from the small district of Rüttenschied, in Essen. Vorst had two older brothers who would have been 19 and 22 years old in December 1914. Their father was 50 and therefore beyond the age of military service. There were also cousins in Essen, including Rüttenscheid. The listing's specificity that the injured soldier lived in the district of Rüttenscheid limits the possibility somewhat that the injured soldier was outside the immediate family. It is possible then, that the casualty citations are for Vorst.[2]

The first entry in the casualty listing for the soldier named Vorst is dated December 17, 1914, during an early winter campaign. It says, simply "vermißt" (missing). The second reads: "Wehrm. Vorst (11.komp.)—Rüttenscheid—bisher vermißt, verw" (Armed forces. Vorst. 11th company—Rüttenscheid—missing until now, wounded).[3] It is dated February 24, 1915.[4]

One can imagine a young soldier with little training and scant experience on the battlefield. It is winter. He is fighting from trenches, attacked, shot, and then goes missing. His company loses contact with him. Only two months later does he resurface—wounded, but alive.

To date, more specific information about Vorst's military activities is unknown, and the casualty list does not indicate locations of the battles. The listing contains information to identify soldiers in the Prussian or Bavarian forces, but Vorst's entry mentions neither. It is unclear where he was fighting.

There is no evidence to suggest that Vorst had ever traveled outside of his country before. The meager economic circumstances of his family most certainly points to a somewhat limited experience of the world. The horrors of war must have been disorienting, even unimaginable to him. At least the Vorst family was accustomed to guns. They hunted. There were mounted antlers inside their home, and there are photographs of men in the family, including Vorst, hunting and shooting local deer. War, of course, was entirely different.

Many soldiers entered the war with patriotic enthusiasm only to discover a world of bayonets, poison gas, machine guns, column formations, tanks, airplanes, cavalry, and their attendant casualties. The emotional betrayal and psycholog-

ical debilitation from the war can hardly be overstated. The term "shell shock" was coined in World War I to describe symptoms of disorders caused by the panic and intensity of war bombardment. The war claimed nine million soldiers' lives plus another five million who died of starvation and illness.

THE WAR AND ITS AFTERMATH

However and wherever Vorst fought, by 1918 it was over. An armistice was signed on November 11, 1918, effective at 11:00 a.m. It marked the utter and complete defeat of German forces. Kaiser Wilhelm II abdicated the throne after having fled to exile in the Netherlands with a decree signed November 28, 1918. Conditions of the armistice required immediate withdrawal of German troops from Allied territories; evacuation of forces west of the Rhine; and surrender of trains, trucks, naval fleet, cannons, machine guns, trench mortars, and planes. Furthermore, some German territories were to be occupied by Allied forces. The armistice fell short of a military definition of total surrender, but for all intents and purposes, it was precisely that.

For the following six months, Allied powers negotiated a peace treaty, mostly without the participation of Germany. On June 28, 1919, the Treaty of Versailles was signed. The date was the fifth anniversary of the assassination of Archduke Franz Ferdinand. The terms were brutal. Germany was stripped of its colonies, gave back lands it had taken (including Alsace to France), accepted occupation of some of its territories, was given full responsibility for the war, created a demilitarized zone, dismantled its military (and was forbidden to own certain kinds of weapons), and accepted financial responsibility for losses and damages suffered by the Allies during the war. The monetary reparations, in particular, had lasting consequences, particularly on German inflation rates. The terms of the treaty were so onerous that the U.S. Senate refused to ratify it, even though President Woodrow Wilson had largely initiated the armistice with his Fourteen Points of January 1918. The U.S. Government distanced itself from the majority of the treaty's provisions.[5]

As dispiriting as this must have been for the Vorst family, an even larger sadness hung over them. On March 17, 1918, eight months before the war's fighting ended, Vorst's father, Paul Johan Josef Vorst, died. He was 53 years old—strange-

Fig. 14, left unidentified photographer, Vorst, right, in uniform, n.d., Carl and Carole Vorst, St. Louis, Missouri.

Fig. 15, bottom unidentified photographer, Vorst, far left, n.d., Carl and Carole Vorst, St. Louis, Missouri.

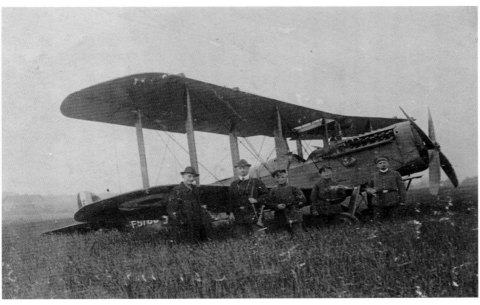

ly, his father Johan Josef Vorst had also died at the age of 53, in 1891. Vorst's father left eight children, ages 12-28, and his wife Christine. A death record dated March 18 gives no cause of death. According to the state archive in Essen, he did not die in a local hospital, which would have generated a different kind of record. Vorst later wrote an ambiguous and undated note, "Father died while sick in France," which could mean that his father was in France and died, or that he died while Vorst was there and ill. Whatever the particulars, never a household with abundant financial resources, this loss certainly worsened their position.

And yet, how happy Vorst looks in family photographs. There he is accompanying his sisters at the piano, playing the guitar, swimming and bathing in the river, attending costume parties, celebrating Christmas in the family's large house, hunting, frolicking with various family dogs, holding his infant nieces and nephews, cycling, picnicking, working in the garden, hiking, playing, exploring, and smiling.

Vorst described his childhood in terms that included hardship, but one would not know it from looking at photographs of him. The family home is large, decorated smartly with wallpaper, photographs, artworks, and mementos. It sits on a large parcel of land that includes orchards and gardens of flowers and vegetables. In the home, musical instruments abound. The family appears well-fed and well-dressed. He was a dapper young man, almost always photographed in suit, shirt, pocket square, bow tie, slacks, and boots. In the dozens of photographs of Vorst, he is wearing what today would be described as professional attire, even in scenes working or playing outside. Vorst sported a mustache after the war, although it was not nearly as prodigious as some of his relatives, whose enormous, billowing mustaches overwhelm their faces. He was slender and tall, with wavy hair, and he had long, delicate, and expressive fingers.

There are limits to what can be reasonably extrapolated psychologically from photographs, but in Vorst's case, there are so many of them, and of those, so many appear to be candid snapshots, that some generalizations can be made. Essentially, he looks happy. He is surrounded by a large group of extended family, friends, and colleagues. He is comfortable with himself and involved in a wide range of activities—performing music, boxing, painting, hiking, swimming, and working. There is joy on display in many of the photographs as well as humor, even zaniness. These are the impressions that arise from looking at Vorst's photo album.[6]

EARLY WORKS

The earliest known artworks by Joseph Paul Vorst are dated 1919. Given that the war ended in 1918, it is likely that Vorst began his art studies in Essen before the war and completed his education in the early 1920s. The watercolor, *Braunschweig* (Brunswick) [Fig. 16] is a detailed street scene of the city nearly 200 miles east of Essen. The quaint buildings are depicted carefully, although the townspeople are reduced to little more than stick figures. The work is signed "Jos. Vorst" and is dated 1919. Also surviving is a pen and ink study of a woman, 1919, [Fig. 18] completed during his time in school. Additional watercolor scenes from 1920 show that Vorst was traveling enough to capture the cityscapes of regions close to him. These are brightly colored, attractive works, *Görlitz* (1929) [Fig. 17] and *Paderborn* (1920). An untitled watercolor from 1920 is mostly unremarkable. It is a gauzy image of a forest, not particularly well articulated, but in the foreground a tall, dead tree leans away from the others, its empty and brittle branches in sharp contrast to the surrounding greenery. The notable thing about the image is that it heralded the artist's interest in decay in nature as a psychological symbol.

Vorst explored different styles in the 1920s. It was a dynamic period of art history, with a confluence of philosophies and artists exploring a broad range of expression. It is a misnomer to suggest that Essen was a location of principal influence in German art. While the Folkwang offered local residents and students unprecedented exposure to the new though extraordinary examples of contemporary art, it remained a distant city to Berlin and Munich, for example, where the most adventurous artists lived and worked and where emerging groups of artists organized into colonies.

No thorough discussion of 20th-century Western art is possible without examining the connections between art and wars and their aftermath. This is nowhere more evident than in Germany. With the end of World War I, German artists faced a political landscape of great confusion. The war had taken millions of German soldiers' lives and more than 500,000 civilians' lives. Four million more were disabled and injured—including Vorst. The sight of amputees on the streets of Germany became so common that artists used it as a symbol for their disfigured and beaten country.

Still, the Weimar Republic, the nation's first democratical-ly-elected government, gave the citizens a sense of hope that together they could reframe their destiny. Artists determined that they would be a part of shaping the country's future rather than merely depicting it passively. In December 1918, radical writers, artists, and designers formed the No-vembergruppe (November Group) in Berlin. Their aim was to establish a relationship of advocacy between politicians and artists in support of the new republic through the creation of propaganda.

The Expressionist artists who had seemed revolutionary only a few years earlier were now perceived as outdated. Wilhelm Housenstein, an early champion of the movement, proclaimed in 1919, "Expressionism is dead. The individuals who distinguished themselves from each other and from the movement…are alive. Their arts are absolute. The category no longer expresses anything. It has fulfilled its purpose. It can go."[7]

How can an artist respond to viciousness and horrors like those of World War I? This was not a theoretical question. Consider this overview of notable German artists' experiences who served in the war: Otto Dix was a decorated soldier, wounded multiple times; Ernst Barlach was discharged after three months; Heinrich Campendonk was discharged due to poor health; Erich Heckel was stationed in Belgium; Ernst Ludwig Kirchner volunteered then suffered a mental breakdown and was discharged; Oskar Kokoschka was wounded in 1915; Kathe Kollwitz was devastated by the death of her son in the war in 1914; August Macke went into battle during the first week of the war and was killed seven weeks later; Franz Marc was killed in action in 1916; Karl Schmidt-Rottluff served three years on the Eastern front and suffered from shattered nerves that left him unable to paint afterwards; Max Beckmann was discharged after a nervous breakdown in 1915; George Grosz was discharged in 1915, then recalled, and suffered a nervous breakdown in 1917; Wilhelm Lehmbruck was discharged for hearing impairment in 1916; and Max Pechstein had a nervous breakdown after the Battle of the Somme, where 1,000,000 men were killed or wounded.[8]

What were they to do with their experiences of betrayal, rage, shock, and injury? The hellishness continued upon their return. Political assassinations, foreign occupation, unemployment, and inflation assaulted the country. At the

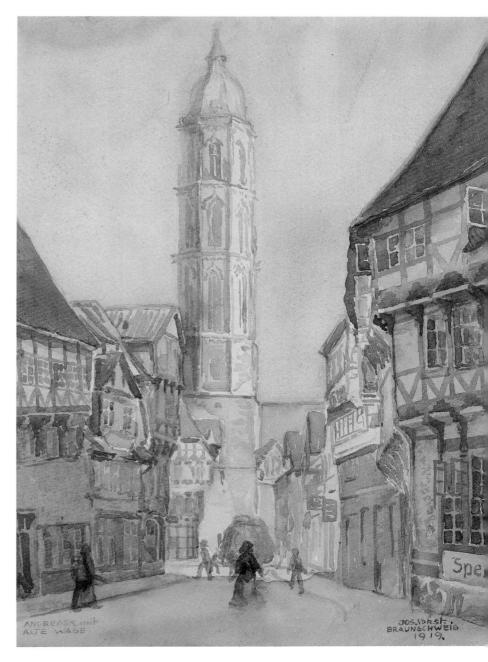

Fig. 16 Joseph Paul Vorst, *Braunschweig*, 1919, watercolor, 16 x 12 in., Cris and Janae Baird, Arlington, Texas.

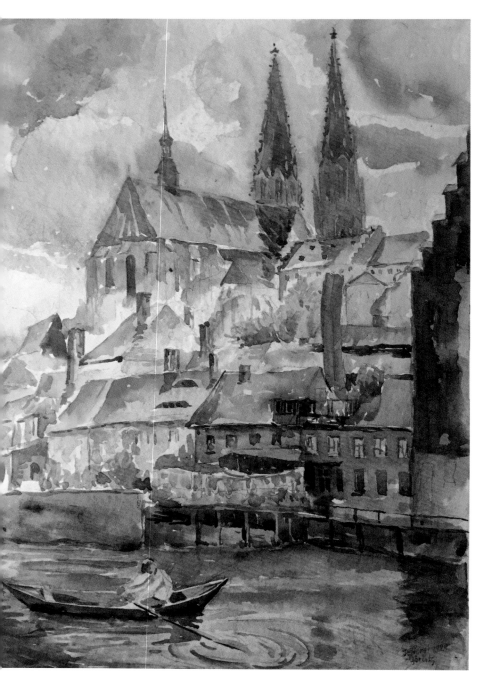

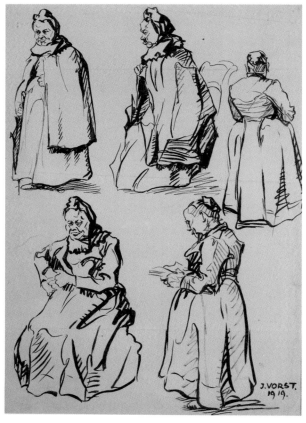

Fig. 17, left Joseph Paul Vorst, *Görlitz*, 1929, watercolor, 16 x 11.75 in., Carl and Carole Vorst, St. Louis, Missouri.

Fig. 18, above Joseph Paul Vorst, *Study of a Woman*, 1919, ink., 24 x 18 in., Carl and Carole Vorst, St. Louis, Missouri.

war's end, German reparations were set at 269 billion gold marks (the equivalent of $31.4 billion at the time), due to be paid over four decades. French and Belgian forces occupied the Ruhr valley to enforce reparation payments beginning in 1923. The monetary exchange rate escalated violently. For example, in 1921, the rate was 76.7 marks to the dollar; in early 1923, it had risen to 18,000 marks to the dollar; eight months later, 4.6 million marks to the dollar; and three months after that, 4.2 billion marks to the dollar. Currency printed one day was worthless the next. Strikes broke out across the country. Briefly, a single egg cost 100 billion marks.[9]

Artists readjusting to life after the war sought abrupt changes in visual representation, in some ways as violent as the whipsawing of their currency. What were they to make of their recent experience and how could they effect change in a new political order? Many were determined that there never be another war of this magnitude. The absurdity of war and the sheer madness of it pushed some toward creations that were absurdist (Dada, for example). Others attempted to process what they had witnessed firsthand by pushing Expressionism further than it had been, in order to capture the wildness of its artists' world view. But younger artists in Germany rejected the emotionality of Expressionism altogether. This seems almost counter-intuitive. One could imagine a war veteran/artist creating visceral work in the Expressionist style, an emotional, creative scream. A few did, but a large group turned away from it entirely. They felt betrayed by Expressionism because some of those respected artists who founded the movement had been enthusiastic supporters of the war at its outset.

WEIMAR ART

The Weimar Republic (1919-1933) presented to the country the hope of a society remade. Gradually, interest in technology and machines blossomed. Once the country regained its financial footing, German households rebounded. The reparation payments were renegotiated, foreign investments poured in, and foreign troops withdrew. New machinery in factories led to increased productivity, which led to household wealth improvements—even to a booming age of consumerism. In Germany, the six-year period of 1924-1929 became known as the Golden Twenties. In contrast to the years immediately after the war, the later interwar era

brought out the excesses of society.

In 1925, Gustav Friedrich Hartlaub, the new director of the Kunsthalle Mannheim (Mannheim Museum) organized an exhibition of 124 paintings, drawings, photographs, and prints in an epoch-marking show, *Neue Sachlichkeit: Deutsche Malerei seit dem Expressionismus* (New Objectivity: German Painting since Expressionism). Artists included Max Beckmann, Heinrich Maria Davringhausen, Otto Dix, Hans Finsler, George Grosz, Albert Renger-Patzsch, August Sander, Christian Schaud, Georg Scholz, among others. The exhibition traveled throughout Germany, and subsequent scholarship and exhibitions canonized the emerging movement.

Throughout the 1920s, younger German artists replaced the subjectivity and emotionality of Expressionism with a new, dispassionate approach based on objectivity, realism, satire, order, sardonic humor, exaggeration, and classicism.[10]

New Objectivity was not a single style of art but a heterogeneous gathering of connected ideas. This mirrored the disparate opinions of the larger society. There was little consensus after the war regarding the past—why did this happen to us?—or the future—where do we go from here? Still, the pluralism of aesthetic approaches of New Objectivity shared a newfound interest in realism. The movement developed in two branches. The first was composed of artists who were mostly conservative, who looked to Old Masters to point the way forward—Michelangelo, Ingres, and so forth—regarding formality and style, including study to resurrect fresco and tempera techniques and materials. Their landscapes, for example, omitted signs of modern technology and industry.

Artists on the other side of the movement had less faith in art history. They were decidedly contemporary, frank to the point of self-flagellation, and intent upon laying truth bare, however ugly it might be. Their work consistently explored modern machines, conveniences, and lifestyles. Those two disparate approaches may appear irreconcilable, but an important feature of New Objectivity was the very fact that society had no single unifying ideal. In this, new art mirrored the fractured and traumatized German state of mind. Who could say anything definitively about anything? Their shared goal was simply to be real.[11]

The fact was that life in Germany had changed radically. Af-

ter the severe losses of men's lives in the war, for example, women entered the workforce in great numbers. They took jobs that historically had been unavailable to them. It was an era of emancipation. Gender roles shifted, and combined with widespread prostitution in the largest cities, explorations of sexuality, and violence toward women increased. The New Objectivity artists portrayed women in ways that shocked the public.

Two important aspects of New Objectivity were the embrace of technology, specifically photography, and an emphasis on portraiture. A significant group of artists took to the camera. Pioneering photographers who elevated images to fine art levels reflected a view that the camera was more accurate, dispassionate, and truthful than the eye. They explored the landscape ravaged by war, as well as cities and people undergoing titanic social change. Similarly, a large number of painters gravitated to the portrait. These were not the self-flattering commissions of the upper-classes; rather, they were clinical, raw explorations of humanity.

To some degree, Vorst was influenced by all of the above. He had not reached a mature style by the time New Objectivity was codified in 1925. Until then, he was in school, and staying in Essen afterward to teach, he remained somewhat distant from the more radical action of the new. Still, each of the aspects of New Objectivity can be seen in Vorst—bluntness, awareness of politics, portraits of common people, interest in classical painting processes, allegorical warnings about negative changes in society—but in some cases, it would take years for him to process and incorporate these concepts into his work.

Vorst sprang from paradox. He was born and worked in a city, but he lived in the countryside. He loved nature, but he was surrounded by coal country and polluted manufacturing. Vorst's earliest artworks were almost exclusively landscapes. In the 1920s, he came under additional influences, and his work—at least the work that has surfaced—hints at his attempts to take up the paintbrushes of the New Objectivity artists, so to speak, and see what they were seeing. At the same time, he produced works securely in the stylistic camp of the Expressionists.

It is interesting to examine what is absent in Vorst's work relative to his more progressive contemporaries. He appears to have been uninterested in shock, generally speaking, and

the politics of gender. Further, his work is free of mockery, exhibitionism, and horror. His works delved into psychology and a small number of portraits echo work by Otto Dix and Max Beckmann, but a large percentage of his works are religious subjects. This is not especially unusual. A great number of artworks on Christian themes appeared in Germany during the Weimar era in the area of the country in which Vorst lived. Perhaps a belief in God shielded him from the excesses of the anything goes attitude of urban Germany at the end of the decade.

One of Vorst's teachers at the Folkwang was Josef Urbach. He had been a member of the Junges Rheinland group and then the Rhenish Secession. He joined the faculty of the EHKGS in Essen in 1914 and stayed with the school as it became the Folkwang School in Essen. Urbach taught classes in drawing, portrait, and the nude. Vorst was one of his students, and at least for a brief period, was highly influenced by him. Side-by-side comparisons of Urbach's painting, *Landschaft mit Bahndamm* (Landscape with Railway Embankment) of 1916, for example, and Vorst's untitled pastels of landscapes and *Abendstimmung an der Ruhr* (Evening on the Ruhr) 1924 (Fig. 22), show the younger artist reacting to his teacher's abstracted depiction of trees and sky, and almost identical choices of coloration. It is rough-hewn art, with an emphasis on graphic mark-making fully in keeping with Expressionism.

Vorst abandoned the elements of the style, but emotional fundamentals of it remained with him. The same could be said of Urbach, who explored a variety of approaches over a period of decades. Originally from Neuss, approximately 25 miles from Essen, Urbach remained at the Folkwang his entire career. As Hitler came to power, two of Urbach's paintings were labeled "degenerate" and taken from the Museum Folkwang. Then in 1943, during a bombing raid, Urbach's entire studio and all his artwork were destroyed. He began again, working mostly in the medium of watercolors until his death in 1973.

IN PRINT

On April 19, 1920, a newspaper, *Die Wochenschau* (The Newsreel), distributed in Essen, Düsseldorf, and Berlin, reprinted *Eine Kohlenzeche mit Förderturm* (Coal Mine with Headframe Tower), "Aquarell von Josef Vorst" (watercolor by

Joseph Vorst) [Fig. 20]. The image depicts the industrial output of coal manufacturing. Train tracks and laborers are shown in the foreground amid a depot-like structure behind them. The sky is nearly obliterated by smoke. Both forests and factories are Vorst's local landscape. It appears to be Vorst's first published work.

Over the following eight years, numerous artworks by Vorst materialized in local newspapers. The artist maintained a documentation of them in a 50-page scrapbook. Each image is pasted on a sheet with the newspaper's masthead, number, and publication date above it. The majority are cityscapes and portraits of people in cities. They document Vorst's evolving style. It is impossible to know if they were commissioned illustrations or whether they were submissions by Vorst chosen by the newspapers to accompany articles. Likely, they are a combination of the two. Some of these works extend beyond illustration and represent his exploration of fine art. A small number of them were published as stand-alone imagery without connection to a news story; they are mini-portfolios of artwork. Nevertheless, one assumes that for Vorst this distinction between commercial and fine art was relatively unimportant in the 1920s. He gradually moved toward fine art and did so proudly, but the works for newspapers mirror the development of other works in his surviving body of art.

As a whole, the newspaper images cover a broad stylistic range. There are fifteen separate appearances of Vorst's work in newspapers—*Westdeutsche Illustrierte Zeitung* (West German Illustrated Newspaper), *Die Wochenschau* (The Newsreel), and *Die Illustrierte* (The Illustrated)—between April 10, 1920 and September 18, 1928. Other than the 1920 illustration, all the others are from 1924 through 1928. Because they appear chronologically in the scrapbook and seem to have been annotated by Vorst with different pens over time, it appears that the artist maintained the scrapbook carefully over a period of years and that it represents a complete portfolio of Vorst's newspaper work.

As for the images themselves, they include reproductions of a charcoal drawing, *Abendstimmung an der Ruhr* (Sunset on the Ruhr) [Fig. 22] and village scenes around Essen, September 20, 1924; a linoleum cut, *Atrium des Münsters in Essen* (Atrium of the Cathedral in Essen), June 6, 1925; a suite of woodcuts, *Ein Totentanz* (Dance of Death), August 21, 1926 [Fig. 37]; *Die Prodigt* (The Preacher), October

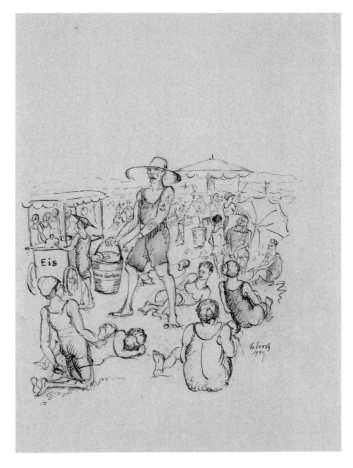

Fig. 19 Joseph Paul Vorst, untitled, 1919, ink., 12 x 8.75 in., Carl and Carole Vorst, St. Louis, Missouri.

31, 1926; a drawing, *Invaliden* (Invalids), August 21, 1927; a woodcut (holzschnitt), *Klatschweiber* (Gossips); and drawings *Blid aus die Synagoge in Essen* (Picture of the Synagogue in Essen), April 1, 1928 (Fig. 23), and *Am alten Burgplatz in Essen* (At Old Castle Square in Essen), April 1, 1928; a woodcut *Frühling im Ruhrtal* (Springtime in Ruhr Valley), April 17, 1927 (Fig. 21); a woodcut, *Der Meistersinger Bedmesser* (The Mastersinger Bedmesser), July 17, 1928; and a drawing *Großstadtbild, Säuleneingang der Börse in Essen* (Large cityscape, Pillared Entrance of the Stock Exchange in Essen), September 18, 1928.

After he returned from the war and finished his studies, Vorst set up his own printing business around 1923.[12] His early training in commercial art and printmaking led Vorst to produce a series of lithographs in both black and white and color. Two color lithographs are landscapes dated 1922, *Ruhrland* (Fig. 25) and *Dorf in d. Ruhr* (Village in the Ruhr). Both are pleasant works, picturesque. Again, Vorst chooses to insert trees into the foreground with sawed-off limbs; these works undercut the panorama with a faint psychological distress. They also show a familiarity with the land and a control of basic printmaking techniques without being especially probative or innovative. He also produced *Hyazinthen* (Hyacinths) in 1922. Vorst made black and white lithographs that appear to have been created during the same period; they are undated: *Ruhrweigen* [illegible], and *Ander Ruhr* (At the Ruhr), as well as a lithograph *Wald* (Forest) (Fig. 24) in 1922.

In style, the above are conservative works, but they show the artist exploring modes of expression. The watercolors are somewhat carefully rendered studies, and the lithographs are clear depictions of nature; but the linoleum cuts show more daring. An untitled work and *Homo Sapiens* (Fig. 28), both from 1922, reflect anguish, confusion, and danger.

FINDING A MATURE STYLE

In 1923, Vorst drew a self-portrait in India ink, *Der geistige Spiegel* (The Mirror of the Mind) (Fig. 3). It is an image of heightened artistry. The work is evidence of Vorst's philosophical engagement with the modern art movements around him and a distinct leap forward as an artist. It is clearly influenced by the modern artists whose work was championed at the Museum Folkwang, particularly Egon Schiele, Oskar Kokoschka, and Gustav Klimt.

In the picture, Vorst (without his mustache) stares forward, an attenuated right hand holds a paintbrush, his chin rests on the back of his bent wrist. Behind him, a portrait sits on an easel, its face almost entirely obscured in blackness. The background of the interior image suggests a loose drapery, perhaps. Vorst has chosen to carefully depict the face and hands and leave much of the rest to mere suggestion. This work pushes the viewer toward interrogation. It is an image within an image: which is the self-portrait? The figure of the painting on the easel is in roughly the same posture as the man holding a paintbrush. If they are of the same man, does one represent what he sees versus what others see when they look at him?

Another significant work of 1923 is *Ausklang* (Finale) (Fig. 27)—sometimes listed as *Anlitz Christi* (Face of Christ). The large print—the plate size is 16" x 12"—shows Jesus crucified. Thorns encircle his head, which tilts to the left in defeat. The eyes are thin slits, and his gaunt, tormented face is roughly drawn to heighten the painful scene. He is bearded, as are many German images of Christ from the period. Behind him however is a radiant circle that amplifies the jagged lines of the thorns and transforms them into an exuberant halo. For all of its masculine power and rugged surface, the image is remarkably intimate and almost serene. Vorst certainly would not have equated his injuries in the war to Christ's crucifixion, but the image feels personal, somehow. At the bottom right corner, Vorst inserted a mark of overlapping initials, J and V, that form a shape not unlike a jagged tree or cross. This monogram appears in many of his prints in the 1920s.

Perhaps Christian imagery is not the first subject that comes to mind when considering the legacy of German artists of the era, but one must remember that the country had a strong religious base. In the Rhine and Ruhr areas, a large number of artists created works with Jesus at its center.[13] These included artists of the avant-garde as well as more traditional artists. The figure of Jesus was employed in a number of ways to contemporize him as a symbol. Although a few did so ironically, artists with reputations built on innovation such as Campendonk, Davringhausen, Kollwitz, Lehmbruck, Rohlfs, Peckstein, and Thorn Prikker found powerful contemporary resonances in Christian suffering, particularly the cross. Some updated the action of the New

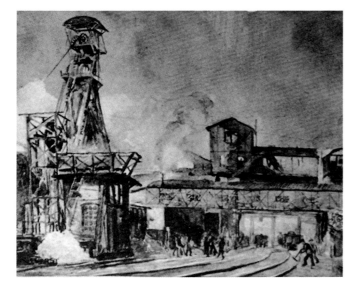

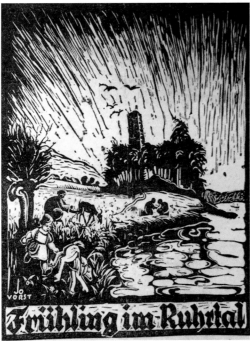

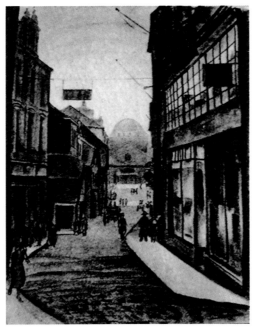

Fig. 20, top Joseph Paul Vorst, *Eine Kohlenzeche mit Förder-turm,* ca. 1920, watercolor, whereabouts unknown, reproduced in *Die Wochenschau,* April 10, 1920, Carl and Carole Vorst, St. Louis, Missouri.

Fig. 21, bottom Joseph Paul Vorst, *Frühling im Ruhrtal,* ca. 1927, woodcut, whereabouts unknown, reproduced in an un-identified German newspaper, April 17, 1927, Carl and Carole Vorst, St. Louis, Missouri.

Fig. 22, top Joseph Paul Vorst, *Abendstimmung an der Ruhr,* ca. 1924, charcoal, whereabouts unknown, reproduced in *West-deutsche Illustrierte Zeitung,* September 20, 1924, Carl and Carole Vorst, St. Louis, Missouri.

Fig. 23, bottom Joseph Paul Vorst, *Blid aus die Synagoge in Essen,* ca. 1928, drawing, whereabouts unknown, reproduced in *Die Wochenschau,* April 1, 1928, Carl and Carole Vorst, St. Louis, Missouri.

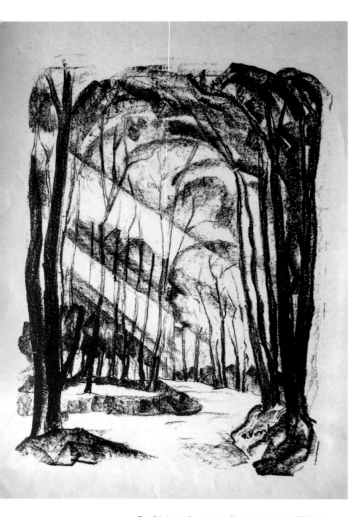

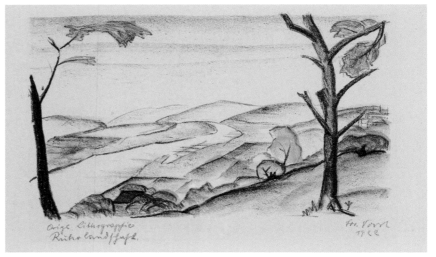

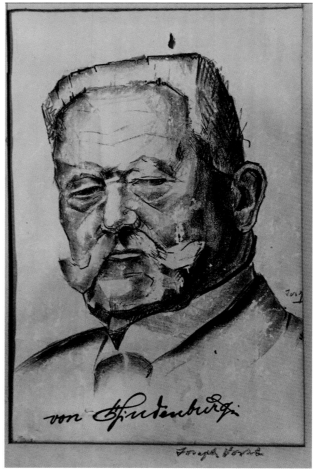

Fig. 24, top, left Joseph Paul Vorst, *Wald*, 1922, lithograph, 19.25 x 12.75 in., Church History Museum, Salt Lake City, Utah.

Fig. 25, top, right Joseph Paul Vorst, *Ruhrland*, 1922, color lithograph, 6.5 x 11 in., Church History Museum, Salt Lake City, Utah.

Fig. 26, right Joseph Paul Vorst, *von Hindenberg*, n.d., lithograph, 16 x 12 in., inscribed by Paul von Hindenberg in ink, Carl and Carole Vorst, St. Louis, Missouri.

Testament tragedy and placed it alongside contemporary war atrocities.

After World War I and the demise of the German Empire, the country established the Weimar Republic, named after the city where the new constitution was written during a national assembly in 1919. It was an era as embattled in its way as the great war had been, with hyperinflation, extremists factions and paramilitary groups, and continued agitation between the state (Deutsches Reich, or German Reich) and Allied nations.

Shaken, humiliated, and desperate, the country gradually but steadily became susceptible to a rise in the politics of hate, led by the German Workers' Party whose name was changed to the National Socialist German Workers' Party—the word "Nazi" is derived from the popular German truncation of "Nationalsozialist"—and by its standardbearer, Adolf Hitler. In 1923, Hitler made an attempt to overthrow the Weimar government, and this failed coup, known as the Beer Hall Putsch, landed Hitler in prison for treason. His sentence was only five years. He was released after less than nine months' incarceration, during which time he began writing a manifesto/rant that would become *Mein Kampf* (My Struggle).

Many of the German Workers' Party members were young former soldiers, and these men formed paramilitary groups aimed at intimidating enemies, opposing divergent ideologies, and providing protection for party officials during public rallies. They were known as Sturmabteilung (Storm Detachment), SA, or Braunhemden (brownshirts)—named for the color of their uniforms, a surplus holdover from World War I.

In the winter of 1924, Vorst was walking in the city when a group of marauding brownshirts approached him and pushed him off the sidewalk and into a snowdrift. He later cited this event as the beginning of his opposition to the Nazis.[14]

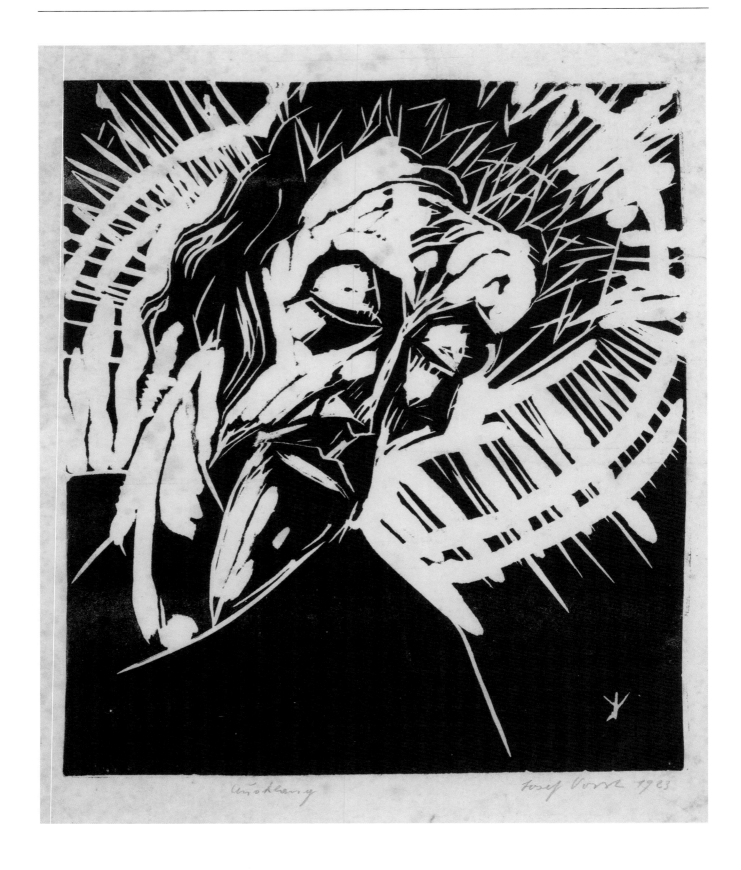

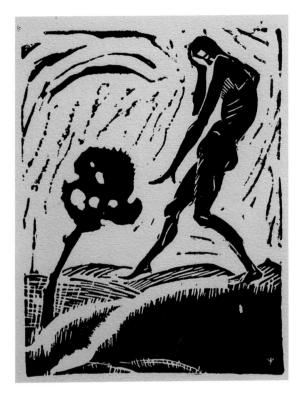

Fig. 27, opposite page Joseph Paul Vorst, *Ausklang*, 1923, lino-
leum cut, 16.25 x 12 in., private collection, Germany.

Fig. 28, above Joseph Paul Vorst, *Homo Sapiens*, 1922, lino-
leum cut, 9.65 x 6.89 in., private collection, Germany.

ENDNOTES

1. R. H. Keller, *Great War Militaria*, "The German Soldier in World War I," 2009, greatwar.com, accessed November 17, 2015.

2. Address books were published annually in Essen, but sporadically for nearby suburbs, including Rüttenscheid. The address books name only fathers, their occupations, and home addresses. According to the state archive in Essen, fuller listings, comparable to U.S. census records, were not kept in Germany at the time.

3. Abbreviations decoded using *German Military Abbreviations*, April 12, 1943, Military Intelligence Service War Department, Washington, D.C., 1943 (unclassifed on May 23, 2003).

4. *Verlustlisten 1. Weltkrieg*, pages 3689 and 4982, Vorst (Rüttenscheid), Verein für Computergenealogie, accessed November 17, 2015.

5. See *The Reader's Companion to Military History*, edited by Robert Cowley and Geoffrey Parker, 1996, Houghton Mifflin Harcourt.

6. Vorst left an 80-page photograph album of Germany with approximately 6-10 photographs on each page. Unfortunately, none of the images is dated nor captioned. He identified none of people or locations in the photographs. A small number—approximately ten— have a signature or inscription to Vorst that identifies them. Unfortunately, the photographs are pasted into the album in no chronological order. It is likely that they were collected over a period of years and then mounted to the album however they would fit, without a continuous timeline implied. A few groups of photographs appear to have been taken on the same occasion. With close scrutiny, one can place Vorst, his family, and friends in a rough chronology, based on his gradual maturation, although it is not definitive. Although frustrating from a historian's point of view, images of Vorst in his studio provide priceless information because he was in the habit of tacking his artworks onto the walls behind him. In numerous examples, these works (which can be attributed to him by zooming in on the works' signatures as well as recognition of his coalescing style) are the only known images of these paintings and prints.

7. Wilhelm Hausenstein, "Die Kunst in diesem Augenblick," *Der neue Merker 3* (1919-20), excerpt translated as "Art at This Moment," in *The Weimar Republic Sourcebook* (Berkeley: University of California Press, 1994), ed. Anton Kaes, Martin Jay, and Edward Dimendberg, 481.

8. See German Expressionism, Works from the Collection, Museum of Modern Art, New York, NY, moma.org, accessed December 3, 2015.

9. Bernd Widdig, *Culture and Inflation in Weimar Germany* (Berkeley: University of California Press, 2001) 9.

10. See Stephanie Barron and Sabine Eckmann, *New Objectivity: Modern German Art in the Weimar Republic 1919-1933*, Los Angeles County Museum of Art exhibition catalog, Museum Associates/Los Angeles County Museum of Art and Prestel Verlag, Munich, London, New York, 2015.

11. Neue Sachlichkeit has become the accepted term for the movement, although scholarship also notes satellite movements such as Post-Expressionism, New Naturalism, Verism, Magic Realism, and New Classicism.

12. William Edward Hoffman, op. cit.

13. See *Christus an Rhein und Ruhr: zur Wiederentdeckung des Sakralen in der Moderne 1910-1930*, (Christ in the Rhine and Ruhr: the Rediscovery of the Sacred in the Modern 1910-1930), Nr. 55 Schriftenreihe Verein August Macke Haus, Bonn (exhibition at the August Macke House museum, Bonn), May 29 through September 13, 2009.

14. "Joseph Vorst Named Art Supervisor at Jefferson College: Artist Who Painted Hitler Chosen for New Course at 'Y' Institution," (unidentified newspaper article), August 9, 1936.

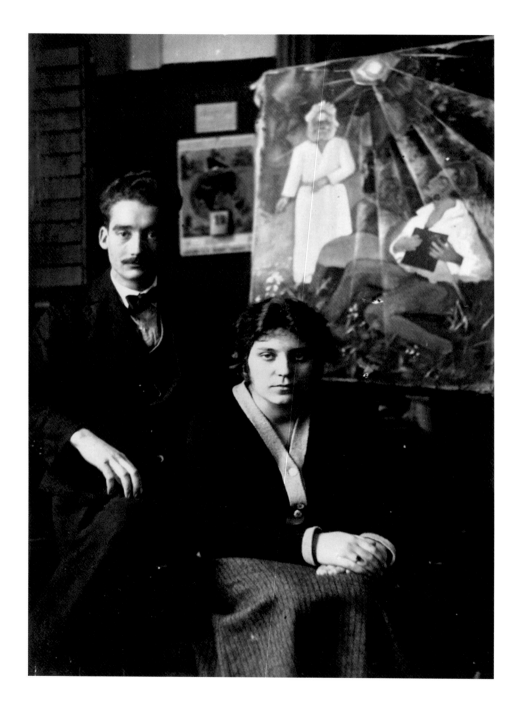

CHAPTER 3
NEW RELIGION

MORMONISM

On May 13, 1924, Vorst's brother, Karl Paul Peter Vorst, died. He was only 23 years old. Judging from the frequency in which he appears in Vorst's German photographs—and the many photos of him that were pinned visibly to Vorst's office walls and throughout his home, even decades later—the brothers appear to have been especially close.

Four weeks later, on June 10, 1924, Vorst was baptized and became a member of The Church of Jesus Christ of Latter-day Saints, in Essen. LDS Church members (commonly called Mormons) were not unknown in Germany, but the presence of the Church at the time was small. It was seen as a predominantly American religion. The branch of the Church in Essen was established on March 19, 1919. At first it met in the homes of members, but after two years, it began to hold services in a school building run by the Krupp Corporation. By the time Vorst encountered the congregation, weekly meetings were attended by 50-100 people. Records noted at the time that approximately half of those present were non-Mormon visitors. He was baptized by E. Neil Burton from Utah and confirmed a member of the Church by Joseph S. Gasser from Idaho. There is no other record of Mormon membership in Vorst's family history, and it is unknown how he came in contact with the religion.

For a number of reasons, Vorst's documented interactions with Mormonism in Germany are plentiful. His name appears 134 times in local records from the period. Mormons are record-keepers. In the 1920s, the small LDS congregation in Essen maintained detailed accounts of every meeting and its participants: citations for every hymn sung, every prayer offered, and every sermon uttered by its member volunteers. Vorst's name appears regularly in the records—sometimes weekly—the first mention shortly after his conversion, on

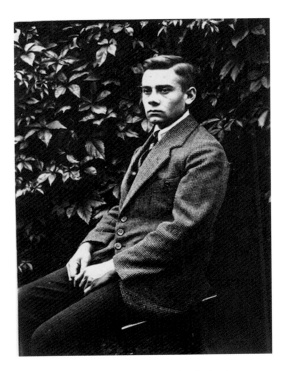

Fig. 29, opposite page unidentified photographer, Vorst and an unidentified woman in his studio, whereabouts of painting of Joseph Smith and the angel Moroni unknown, ca. 1925, Carl and Carole Vorst, St. Louis, Missouri.

Fig. 30, above unidentified photographer, Karl Paul Peter Vorst, ca. 1924, Carl and Carole Vorst, St. Louis, Missouri.

July 2, 1924 and continuing nearly uninterrupted until July 9, 1930. He is listed as serving as a teacher to youth groups, offering prayers in meetings, passing the sacrament, and giving sermons. His largest contribution appears to have been as a musician, however. Vorst was the congregation's organist. He accompanied numerous worship services, which would have meant playing prelude music before the meeting, accompanying congregational singing of three or more hymns each meeting, and playing postlude music. He also performed solos in the services—the records are explicit that they were harmonium solos, such as the Pilgrim's Chorus from *Tannhäuser* performed on May 3, 1925—and he also sang in small ensembles and taught hymns to the members.[1] These documents have survived when so many historical records in Germany did not because they were sent periodically to the United States and unlike some German records, safeguarded during World War II.

The Mormon missionaries who worked in Essen were almost exclusively American. These young men, who were approximately the same age as Vorst, took many photographs during their three years of volunteer service. Frequently, Vorst received copies of their snapshots. As they left Germany, they gave Vorst gifts of small postcard portraits, too, inscribed with their home addresses to encourage his future correspondence. Vorst kept missionaries' photographs, like one from Arthur L. Liddle of Salt Lake City, Utah, which he inscribed and translated:

> Zur freundlichen erinnerung an Ihren Freund und Bruder im Evangelium (The friendly reminder of your friend and brother in the gospel). Hopeing [sic] to continue our pleasant association on the "other side."[2]

Mormonism provided a new social outlet for Vorst. The cache of photographs and the narrative history records clearly show that these local German members and their missionary guests embraced this new convert and included him in a wide number of parties, gatherings, and outings in addition to worship services and religious activities. They are easy to identify separately from other groups in Vorst's photo album because the same faces appear over and over, and they often include the missionaries, whose names are known because of their inscribed photographs to Vorst. Furthermore, none of the people in the "Mormon" photographs ever appear in the family photographs; they seem to be entirely distinct social groups.

Fig. 31, top unidentified photographer, Vorst and E. Neil Burton, 1924, inscribed in ink, Carl and Carole Vorst, St. Louis, Missouri.

Fig. 32, bottom unidentified photographer, Arthur L. Liddle, ca. 1925, inscribed postcard, Carl and Carole Vorst, St. Louis, Missouri.

Fig. 33, left unidentified photographer, Joseph S. Gasser, 1924, inscribed in ink, Carl and Carole Vorst, St. Louis, Missouri.

Fig. 34, bottom unidentified photographer, members of the Essen, Germany branch with Vorst at far left, ca. 1925, Carl and Carole Vorst, St. Louis, Missouri.

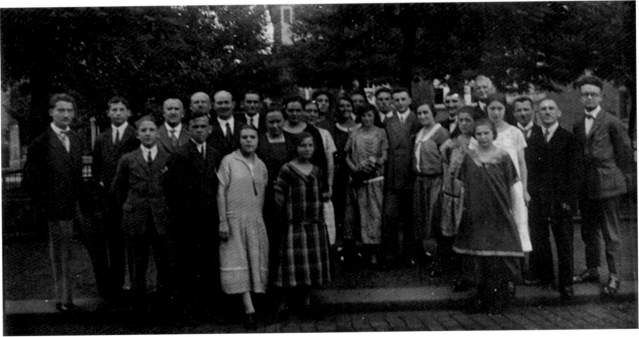

Vorst gathered photographs from twelve of these missionaries: Arthur Leroy Liddle, Elden H. Dye, Elbert Neil Burton, Joseph Samuel Gasser, Sr., Eldred Vickery Robison, Clyde Fisher Squires, Rudger Solomon, F. W. Rieper, Francil J. Pohlmann, G. Raymond Ross, and Walter Louis August Stoll. All but Stoll, who was born in Muehlhausen, Germany, were American.

In Germany, permission to admit Mormon missionaries into the country was granted by local police. In an article written in 1925 by Clyde H. Wilcox and published in a Utah magazine that was the official monthly publication of the faith, *The Improvement Era*, a missionary (elder) describes his efforts in occupied Germany:

> In parts of our conference one has a hard time to make sure whether he is in Germany, France or Belgium. The map says, Germany, but from the looks of the many soldiers with blue or yellow uniforms who appear to have complete control of everything, one must admit that it is pretty much French and Belgian. The occupation has hindered us considerably in that we could not always obtain proper places to hold our meetings, and due to the ruling that, "no one must be on the street after 7 on pain of being shot at sight."
>
> A number of elders have been released from this conference because of lack of money, just at the time when they were a real asset to the mission. We are able to work only in twelve different cities, due to lack of elders. Many people have been humbled and prepared by our heavenly Father to accept the gospel. These people lay nothing in our way, and from the officers we receive every consideration and privilege

Fig. 35 unidentified photographer, Vorst in his studio, ca. 1925,
Carl and Carole Vorst, St. Louis, Missouri.

granted to other denominations. The policemen who formerly arrested and banished the elders are now our best friends. They help us to make our programs interesting and to assemble money for the building up of our branches…. The largest of them [the police officers in an accompanying photograph] who stands in the center on the front row is an inspector of police who, with his family, is a Latter-day Saint. The police president in Essen has extended permission for elders to remain in Germany.[3]

The demonstration of Vorst's ongoing interaction with and belief in Mormonism is most apparent in two additional ways: his ordination to its priesthood and the influence of the faith in his artwork. Unlike his Catholic upbringing, many lay male members of Vorst's Mormon congregation became officers in its priesthood. In one year increments after his baptism, Vorst became a deacon (ordained by Aaron C. Taylor, December 1, 1925) and then a teacher (ordained by W. Kieth Wilson, September 14, 1926).

RELIGIOUS SUBJECT MATTER

Some of Vorst's imagery included religious subjects. This began shortly before his Mormon conversion, most notably with *Ausklang* (Fig. 27). Other examples are the works printed in newspapers of local cathedrals in and around Essen and its synagogue. In 1926, however, Vorst enlarged the scope of his artwork to include more direct quotations regarding belief. *Die Prodigt* (The Preacher) is one example, but a panel of six allegorical works is more direct still. It appears that Vorst created the images and issued them as a portfolio, with an oversized folder imprinted with one of the images and the title, *Du sollst nicht* (Thou shalt not) (Figs. 36, 37). It was published by Druck und Verlag Kunstanstalt Ruhrland, Essen, and it is unlike any of his earlier work.

The six woodcut panels present cautionary scenes of vice: *Der Spieler* (The Gambler), *Der Geldmann* (The Money Man), *Der Raucher* (The Smoker), *Der Trinker* (The Drinker), *Die Verlorene* (The Lost), and *Der Verbrecher* (The Criminal). Together, they form a warning narrative, something akin to the Seven Deadly Sins. Done in the stark, primitive style of Expressionism, each panel portrays someone captured in a vice—gambling, covetousness, smoking, drinking, lasciviousness—and finally, a man imprisoned. The characters are

accompanied by a skeleton that urges them on toward sinful self-destruction, sometimes alongside a devil or a grim reaper. *Du sollst nicht* is a morality play.

The set of images was printed in the newspaper under a different title, *Ein Totentanz* (A Dance of Death) (Fig. 37), in the August 21, 1926 issue of *Westdeutsche Illustrierte Zeitung*. The paper presented the works on a single page, not as an illustration to any article, but as an exhibition of original artwork by a local artist. The subject matter is not entirely original; there are other instances of such warnings of vice, but the artist's choice to vilify smoking, money, and sex—and drinking, in particular, given Germany's historical love of beer—hints to Vorst's new morals. For the artist, the dramatics and power of the images is something of a creative breakthrough, too. The series was important enough to him that he posted it on the wall of his studio, as can be seen in photographs.

Entirely unambiguous regarding Mormonism are two works that also appear in Vorst's studio photographs: a portrait of the president of the LDS Church, Heber J. Grant (Fig. 35) and

Fig. 36 Joseph Paul Vorst, *Du sollst nicht*, ca. 1926, linoleum cut portfolio cover, 17.25 x 13.5 in., Church History Museum, Salt Lake City, Utah.

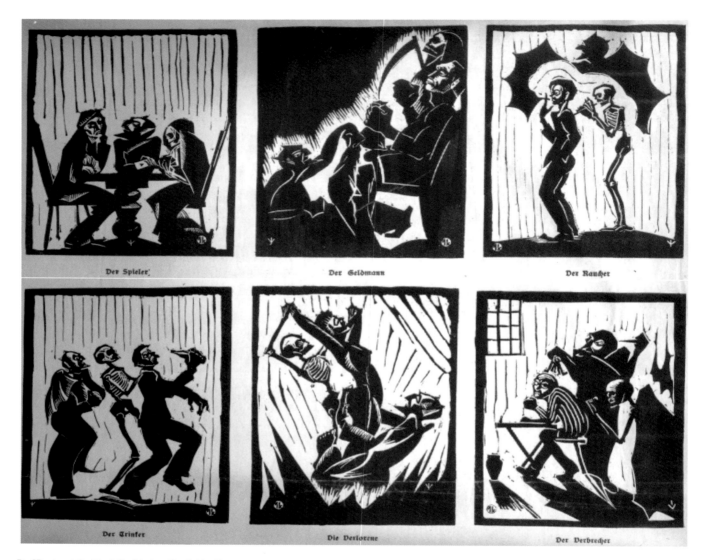

Fig. 37 Joseph Paul Vorst, *Ein Totentanz (Der Spieler, Der Geldmann , Der Raucher, Der Trinker, Die Verlorene, and Der Verbrecher)* ca. 1926, linoleum cuts, whereabouts unknown, reproduced in *Westdeutsche Illustrierte Zeitung,* 1926, 9 x 10.25 in., private collection, New York, New York.

a painting depicting the dawn of Mormonism, represented by the visitation of the angel Moroni to Joseph Smith, Jr. (Fig. 29). The former portrait appears to be charcoal on paper. It is based on a well-circulated photograph, and is approximately two feet high. The image of the bespectacled, bearded leader is loosely worked other than his face, which demonstrates more careful attention.

The painting of Joseph Smith, on the other hand, is larger and attempts something considerably more artistic. It depicts the story of the rural American prophet, Joseph Smith, who holds a book in his arms. To his side is a heavenly messenger in a long white robe. Although the narrative of the painting might not be apparent to others, any Mormon would recognize it immediately as a pivotal moment in which ancient golden plates were given to the young boy to translate as the Book of Mormon.

Elements of the painting echo stylistic imagery consistent with Vorst's other paintings of the period—although sadly, they only survive through photographs of the artist's studio. In the foreground, a young Joseph sits on a tree stump. At his feet are various flowers. Many of Vorst's paintings in the 1920s demonstrate an interest and study of botany, and the artist almost always had cut flowers in a vase on his studio desk. He completed multiple paintings of floral motifs. The most striking feature of the work, however, is light. The sun shines upon the figures in fractured streams of glory. They are columns that descend and wash over Joseph, each separated and shaded into solidity. This effect of the sun reinvented as a cubist magnetic form is something of an obsession for Vorst between 1924 and 1930. Any number of prints, watercolors, and paintings explore the modernity of sunlight in this way; it is what elevates Vorst's early landscapes and makes them new.

GERMAN PAINTINGS AND PRINTS

It is likely that Vorst made his living as a printmaker and teacher during Weimar's Golden Twenties. To date, the only proof that he exhibited his prints is a label on the back of a 1923 color lithograph in a German private collection noting the work was shown (no date is given) at the Kunsthallen Hansa Haus Essen Ruhr. He worked in various print media: lithography (both color and black and white lithographs), linoleum cuts, woodcuts, and etchings. One of the few known etchings by Vorst is a small portrait of an infant, *Schlafendes Kind* (Sleeping Child) (Fig. 174) from 1925.[4]

Vorst had long been interested in photography. He documented his activities, family, and friends with a camera, but he seems to have experimented with fine art photography as well. Some of these works can be seen tacked up to Vorst's studio walls. They are reminiscent of the images of Albert Renger-Patzsch, a New Objectivity photographer who trained his lens on the changing landscape in an era of industrialization. Renger-Patzsch moved to Essen in 1929, where he was briefly the professor and head of the photography department at the Folkwang School of Design.

One of Vorst's innovative photographs is a portrait of a man and a woman on a chaise. The man sits with a camera pointed at the viewer, his thumb on the shutter. She is reclining behind him, her body propped up by her left elbow on a pillow. But it is a self-portrait, too. Vorst is visible in the mirror door of the cabinet to their right. The door is opened just enough to create a continuous flat surface and to reveal Vorst behind a camera on a tripod signaling to the couple (see Fig. 39).

It is a shame that the paintings by Vorst in the 1920s have not surfaced to date. Unlike his prints that are relative-

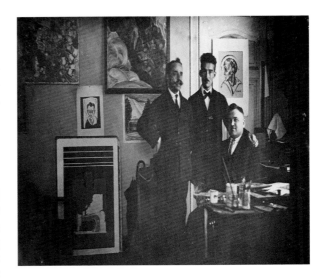

Fig. 38 unidentified photographer, Vorst, center, with his prints and paintings in the background, ca. 1925, whereabouts of the artworks unknown, Carl and Carole Vorst, St. Louis, Missouri.

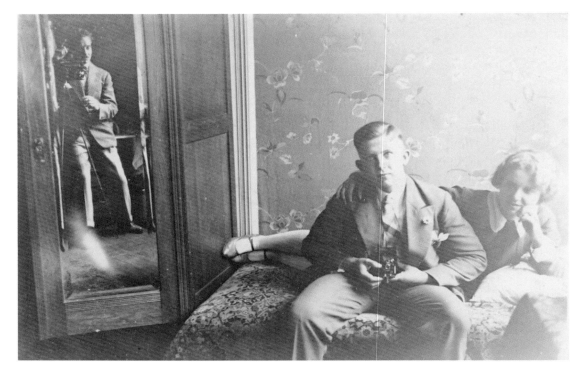

Fig. 39 Joseph Paul Vorst, untitled photograph, ca. 1926, Carl
and Carole Vorst, St. Louis, Missouri.

ly modest in their adoption of modernity and are likely to have been created to sell to a wider public, the documentary photographs that contain his paintings in the background provide a fleeting glimpse of his more ambitious goals as a painter. He created a number of still life images of flowers, some of them in elaborate compositions.

He also explored imagery that probed the human condition. One large painting is of a dark room with two men sitting. On the table before them rests a mask. It is not entirely possible to read the meaning of the work, and not only because the grainy, black and white photograph can only represent it partially. But the image itself is ambiguous. It is a mysterious, moody painting, like a film noir movie still. At the same time, it feels German. The disembodied mask is echoed in the smear of white paint on the face of one of the men. What little light there is in this painting of shadows comes from below, casting an eerie haze over the scene.

Another painting, one that Vorst hung in his print shop, captures people in some sort of watery crisis (see Fig. 38). It appears that they are about to be consumed by waves that attack them from every angle, as if they are to be swallowed up. Desperate hands reach up into the sky. Eyes search upward as well. This work by Vorst is a departure from other paintings because it suggests motion in ways that are not evident in other early Vorst works. The brushstrokes, too, are dynamic, sometimes unblended and striated swirls of movement. More than any of his painted works, this Vorst painting is firmly positioned among his peers of Expressionism and New Objectivity.

It is as if Vorst were trying on different painting styles like suits of clothes. He wore them for a while, lived in them, and they gradually became part of his appearance or were discarded. All of the works, when viewed together, contain faint similarities that come to be seen as Vorst signatures. As a style, they gradually coalesce, but it requires extended looking to see their commonalities.

Vorst was thirty years old in 1927, and he had been drawing from a very young age. In some respects, it took him longer to arrive at a mature style than the famous artists all around him. Perhaps the circuitous route is a consequence of his financial circumstances and environment. He began art studies as a way to make a living in a commercial landscape, fueled by Ruhr industrialists. The war disrupted that

trajectory, and it appears that Vorst moved slowly away from commercial art and design and toward an entirely riskier career, that of the fine artist.

Although all of his family was in Essen, Vorst left them to move to Berlin sometime near 1930. There is a seven-month gap in his participation in LDS Church records in Essen, from January to July, 1930. Possibly, this is the time he left Essen to study in Berlin. He later said that he studied at the well-known Akademie der Künste (Academy of Arts) under Max Slevogt and Max Liebermann, the director of the Academy. Again, these dates are more guesses than fact, and some of the information is disputed.[5]

The Academy of Arts was founded in 1696 as the Prussian Academy of Arts. Its name changed somewhat over the centuries until 1945. In modern times, it is known as the Academy of Arts, Berlin. At the very least, Slevogt taught master classes connected to the Academy of Arts in Berlin, and Liebermann was president of the Prussian Academy of Arts until his resignation under pressure of the Nazis, in 1933. Vorst corresponded with Slevogt as early as 1928, when he received a postcard that Slevogt sent from his home in Neukastel. These short, somewhat impersonal cards continued throughout 1929. Gradually, both the letters from Slevogt and Liebermann grew to be more intimate and came to include shared sketches (Fig. 76).

The decision to study with these German Impressionist masters merits examination. Here was Vorst, in his thirties, already the owner of a commercial print shop, with a growing body of work. He packed up and moved nearly 300 miles away. The opportunity to work with Slevogt and Liebermann must have been enticing. Both were highly-regarded artists, educators, and artists' group leaders. But that too is strange. Did Vorst want to paint like them? It is doubtful; none of his works to that point in his life showed an Impressionist impulse. Further, Vorst stated that he was little influenced by Matisse, Braque, Picasso, Nolde, and Laurencin, either.

Max Liebermann had a fine reputation nonetheless. He was widely admired by the general public—certainly more than the brash, young painters who would eventually eclipse him as rebels in art history. His paintings read as French in many ways: canvases filled with dappled sunlight, romantic landscapes, portraits of fashionable society, equestrian paintings, and flowery gardens created with relaxed brush-

strokes and gently adventurous color combinations. But by the late 1920s, they were no longer revolutionary. If Liebermann's paintings are like those of the French Impressionists, they recall the earliest days of the movement, even fifty years earlier. At the turn of the century, Liebermann led the Berlin Secession and was seen as an innovator and owner of an important collection of French Impressionist works. The Berlin Secession was a member organization that included a large group of notable painters who would develop Expressionist styles (Beckmann, Heckel, Kirchner, Kollwitz, Munch, Nolde, and Schmidt-Rottluff, among them).

However, as anti-Semitism grew in Germany, Liebermann, the son of a Jewish banker, became a political target. Shortly after Vorst began to study with him, Liebermann was prohibited from exhibiting works. His painting of Jesus in the midst of scholars at the temple sparked angry protest that the work looked too Semitic—a preposterous accusation. He resigned his post in 1933 and died two years later. Despite his prominence, his death went entirely unreported in the press, which was, by 1933, in the firm control of the Nazis. He had attracted the ire of the Nazis for his Jewishness, his liberalism, and his pro-French politics. He also painted the official portrait of the country's president, von Hindenberg, and that was more than they could stand.

Lieberman was already in his 80s by the time Vorst met him, but the younger artist took pride in their association. Like Liebermann, Max Slevogt studied in Paris. He was also a member of the Berlin Secession. One of the controversies of the group regarded Expressionism. Lieberman wrote against it, infuriating some of the younger members of the group. Slevogt's artwork was not quite a bridge between the two camps—he worked firmly in the Impressionist style—but his darker, moodier works foreshadowed the painterly ruggedness that was to follow.

Slevogt was an accomplished printmaker as well as painter. A considerable number of his prints and artist's books rail against political forces. With nearly Goya-like ferocity, the artist's illustrations for texts on political subjects form arguments against injustice, notably *Schwarze Szenen* (Black Scenes), *Penthesilea, Die Mörderin* (The Murderess), *Benvenuto Cellini, Kitcheners Schlachtopfer* (Kitchener's Sacrifice), *Die Eroberung Mexicos von Ferdinand Cortes* (The Conquest of Mexico by Fernando Cortez), and a number of highly-charged works for the periodical *Der*

Bildermann (The Picture Man). The latter, circa 1916, was a daring venture to communicate fine art and political issues with the public, but after heightened problems with censorship, it was shut down after only 18 issues. The visual style of Slevogt's images stops short of revolution, but this was a fearless artist.[6]

Vorst took to Slevogt, in particular, and they became close friends. The only work by Vorst that owes a strong stylistic debt to Impressionism is *Irdische Herrlichkeit* (Earthly Glory), a watercolor drawing executed in 1929 of nude, exotic figures in a lush tropical landscape. But the younger artist drew less from his mentor's style than from his boldness.

LANDSCAPES

An interest in political art developed slowly, however. The genesis can be found in Slevogt and in Vorst's own difficult experiences, but in the mid-1920s, as other artists sped into risky philosophies to challenge viewers, Vorst hesitated. His desire to study with German Impressionist masters is indicative of the artist's sensibility regarding provocation, namely a reluctance to offend, if not an aversion to the avant-garde itself, notwithstanding his fearless sensitivity to social issues. Three kinds of work were developing simultaneously. Paintings, at least those captured through photographs of Vorst in his studio and print shop, embraced turbulent forces of nature and society. These are the most modern of his German works. Although only a few of these are known, they indicate likely the direction he intended to pursue as a fine artist. They are complex, dynamic, and dark.

A second body of work are prints and artists books of religious subjects or social commentary and warning—with a helping of Christian morality—in contrast to a society on the edge of destruction. More on them, momentarily.

The third stylistic group of Vorst's mid-1920s works are landscapes: color lithographs, pastels, and watercolors, in particular. In the calm before the coming storm, as Germany enjoyed an economic reprieve, it is as if Vorst reconnected with the landscape of his youth and allowed himself to relax and immerse himself in nature. He traveled. A by-product of these excursions is a suite of lyrical scenes of rivers, forests, sunsets, cityscapes, and agriculture.

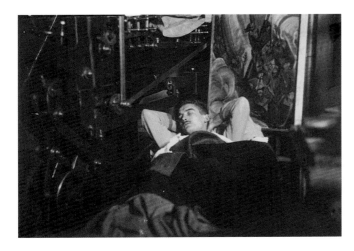

Fig. 40, above unidentified photographer, Vorst in a printshop with his painting in the background, ca. 1926, whereabouts of painting unknown, Carl and Carole Vorst, St. Louis, Missouri.

Fig. 41, right Joseph Paul Vorst, *Die Industrie*, ca. 1929, etching, whereabouts unknown, reproduced in *Der Vulkan*, 1929, 9 x 6 in., Carl and Carole Vorst, St. Louis, Missouri.

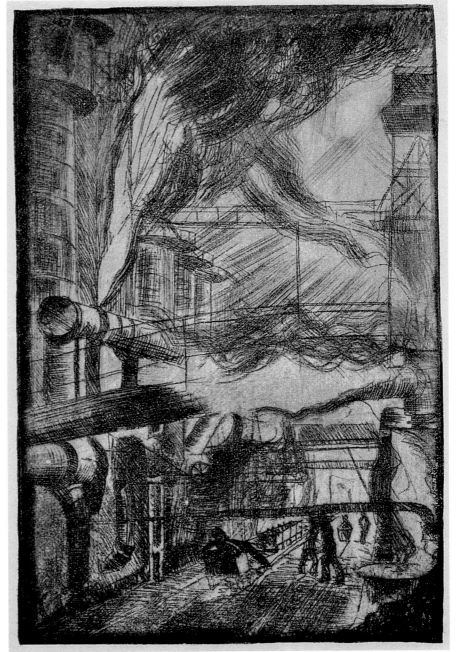

It would be easy to dismiss these images as less probing and consequential than the works that would bring him lasting recognition, but the elements of his later successes begin here. Vorst commenced employing symbols from nature as emotional markers. A broken branch, a fallow field, an emerging sun, a coming storm: each of these for Vorst became more than a simple snapshot of natural beauty. Often, they were shown in contrast to the expected.

DER VULKAN

In 1929, Vorst published a 24-page artist's book, *Der Vulkan* (The Volcano) (Fig. 51) with text by Mathias Pflanzl and images by Vorst. Its publisher was Druck und Verlag: F. W. Rohden, Essen. It is Vorst's only artist's book, and it acts as a summation of his visual thinking in Germany.

The same year, Vorst collaborated on a children's book. The author was Ingeborg Binge and the title of the book is *Fietermann, Der Kleine Held, Macht eine Riese um die Welt* (Fietermann, the Little Hero Who Makes a Trip Around the World) (Fig. 50). Binge was a poet and author who had published a book in 1925 with woodcuts by Toni Ascheri. For

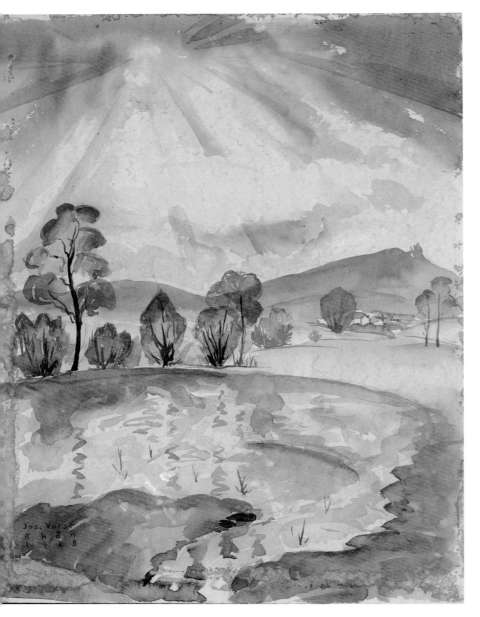

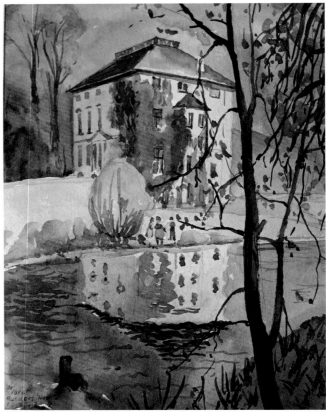

Fig. 42, left Joseph Paul Vorst, *Rhön*, 1928, watercolor, 13.75 x 10 in., Church History Museum, Salt Lake City, Utah.

Fig. 43, above Joseph Paul Vorst, *Rasdorf Host.,* 1929, watercolor, 10.75 x 8.5, Carl and Carole Vorst, St. Louis, Missouri.

Fig. 44, right, top Joseph Paul Vorst, untitled landscape, 1927, watercolor, 10.5 x 13.75 in., Church History Museum, Salt Lake City, Utah.

Fig. 45, right, bottom Joseph Paul Vorst, *Furrowed Fields*, 1922, color lithograph, 17.5 x 22 in., Cris and Janae Baird, Arlington, Texas.

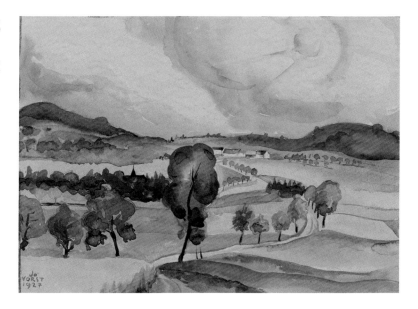

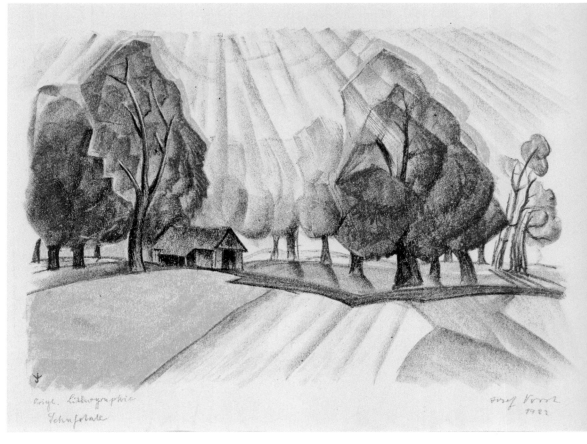

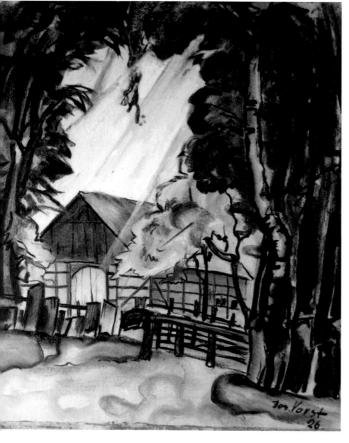

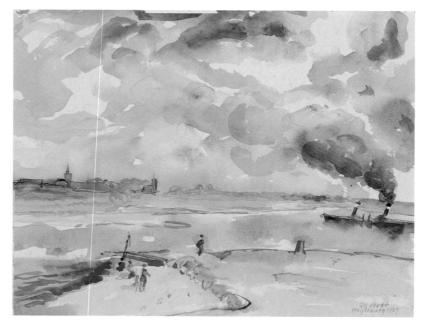

Fig. 46, top, left Joseph Paul Vorst, untitled, 1920, pastel, 13.5 x 10 in., Carl and Carole Vorst, St. Louis, Missouri.

Fig. 47, top, right Joseph Paul Vorst, *Berlin*, 1929, watercolor, 9.5 x 12 in., Carl and Carole Vorst, St. Louis, Missouri.

Fig. 48, bottom, right Joseph Paul Vorst, *Magdeburg*, 1929, watercolor, 9 x 11.75 in., Carl and Carole Vorst, St. Louis, Missouri.

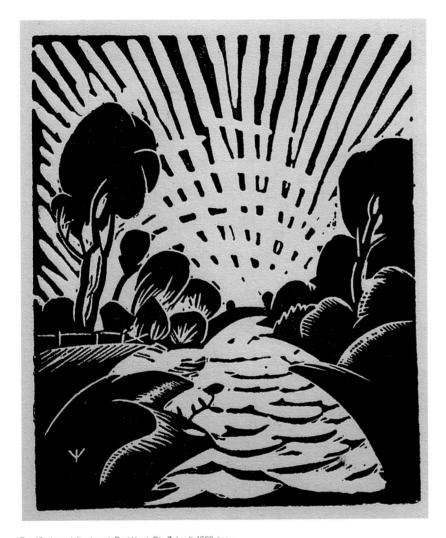

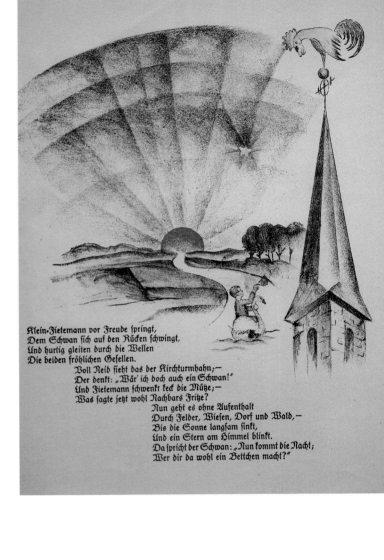

Fig. 49, above, left Joseph Paul Vorst, *Die Zukunft*, 1929, lino-
leum cut, printed in *Der Vulkan.*, 9 x 6 in., Carl and Carole Vorst,
St. Louis, Missouri.

Fig. 50, above, right Joseph Paul Vorst, untitled image from
Fietermann, Der Kleine Held, Macht eine Riese um die Welt,
1929, text by Ingeborg Binge, print media reproduction of color
lithograph, 11 x 8 in., Carl and Carole Vorst, St. Louis, Missouri.

their collaboration, Vorst drew quaint illustrations that hint at his fine art interests. The 22-page volume was published by Kunstanstalt Ruhrland. Vorst and Binge became friends who maintained correspondence for years. But *Der Vulkan* is an entirely different kind of work.

The book is 9" high by 6" wide. Vorst printed a cover that refers to imagery created in prints he made in 1922. The cover reads "Der Vulkan von Josef Vorst." It was printed in an edition of approximately 100. The first eight pages contain text by Pflanzl—a writer about whom almost nothing is known, at present; he published another book in Essen, *Die Sippe der Pflanzl: Pflänzel Eine vorläufige Skizze* (The Pflanzl Family: A Preliminary Sketch) in 1935.[7]

Throughout the text of *Der Vulkan*, paragraphs are divided by titles of Vorst's artworks that are woven into the text. Pflanzl is writing in response to Vorst's work rather than Vorst illustrating a pre-existing written text. It begins:

Contemporary art strives to internalize and dematerialize [its subject matter]. It is not concerned with reproducing the external world. Rather it seeks to show things as they appear to the mind's eye. Therefore all rules and points of view [applied previously to art] vanish. The work of art becomes the external expression of an internal experience, in which feeling and sensitivity, have the greater part. The artist becomes a

MIRROR OF THE MIND,

which gives everything that it reflects a personal quality. That J. Vorst has called his work a self-portrait is an acknowledgment to all those who do not have the mindset or capacity to judge from the picture his own relationship to the art…[8]

It is an art treatise of sorts, but it appears to have been written to explore the meanings of the artworks; the visuals sets the agenda of the book. In the initial pages, the author invites the viewer to think like an artist, using Vorst's images as reference points: "All subjective characteristics, which are expressed by the head and the hand, are reflected in these hieroglyphics. Expressionism is a volcanic force, which at least in part has already worked itself out."[9] The aesthetic debates of New Objectivity are referenced, particularly the balance between what is real, what is external vs. internal:

"But true art knows how to find a synthesis between the inner and outer worlds by allowing each to penetrate the other."[10]

After that lengthy preamble, the text turns to an extended commentary about social ills and their idealized solutions. This is the heart of the book: human suffering, the tortured worker, unemployment, industrialization, and death:

The victor is Death. His black robe already flutters around those, who are selected for him. Just as where large masses of people are rolled together, which occurs so frequently, the man is physically and mentally wasted, and his son has inherited from him the traces of disfiguration. The wife crumples like a worm at his side and cannot free herself from him. That is the fate of countless families, who have fallen victim to the demon Industry and the metropolis.

For Vorst, as described by Pflanzl, the solution to this dark struggle is man's quest to be free of these forces, particularly to leave the city and rediscover the land.

The great problems refuse to release their hold on the artist. They plague him even in nature and there he finds everything again that moves his innermost self. For him, everything is filled with spirit. That is what the landscape, filled with emotions, teaches us, the inscription of which is

THE FUTURE."[11]

But that journey is not enough. *Der Vulkan* points away from crowds, into nature, and then…to God.

Thus nature stands as a bright witness of the future, which stands in the sign of the storm. Prophetic as this sunset on the meadow is the

FINALE,

a picture of Christ. Like a new sun, the head of the man wracked with pain emerges from the chaos. What gives mankind value is the unbounded goodness, which speaks from his emaciated expression. This Christ is the highest expression of love for mankind, which embraces the entire world and forms the

religion of impoverished humanity. Visionary reflections of light flicker up from His head and disclose beside the aureole the deep adoration, which the plagued mankind will bring to the Savior. Religious faith is an elemental force, which slumbers deep in mankind and awaits only times of greatest excitation to break forth in irresistible fashion. Likewise the creator of our picture must bear within himself a large portion of this energy. Otherwise this glorification of God's love could not have succeeded. The Finale shows that religious art can only be expressionist, if it is contained in the nature of the thing.[12]

Der Vulkan consists of the text and eight images (excluding the cover). The first three pictures are reproductions of Vorst works tipped into the volume, *Der geistige Spiegel* (The Mirror of the Mind) [(Fig. 3)]; *Die Industrie* (Industry) [(Fig. 41)], a complex etching of manufacturing; and *Vulkanische Gewalten* (Volcanic Forces), an ink drawing of an exhausted worker. The remaining five images are linoleum cuts printed directly into pages of the staple-bound book: *Der Tragödie aus der Strasse* (The Tragedy on the Street) [(Fig. 2)]; *Der Sieger* (The Victor) [(Fig. 56)]; *Homo sapiens* [(Fig. 28)]; *Die Zukunft* (The Future) [(Fig. 49)]; and finally, the slight reworking of the image of Christ, *Ausklang*. All are Expressionist images, presumably created circa 1923. Of these, only two are known as separate, signed works: *Homo sapiens* (1922) and *Ausklang* (1923). It is likely that all five were editioned previously, but that is only an educated guess.

As a volume, *Der Vulkan* is something of a summary of Vorst's artistic progress and thought. It is not an up-to-date representation of his style, however. By the time of its publication in 1929, he had begun to move away from Expressionism, though not from printmaking.

THE PASSION

Years earlier, Vorst had started an extended project of linoleum cuts on the topic of the Christian Passion. Telling the story of the last days of Christ, the artist began the suite in 1927, or possibly slightly earlier. In 1927, he created *Beweinung Christi* (Lamentation of Christ) [(Fig. 55)] and *Christus betet am Ölberg* (Christ Praying on the Mount of Olives) [(Fig. 54)]. Another similar print that appears to tell the story of Jesus and the Samaritan woman at the well is tacked to

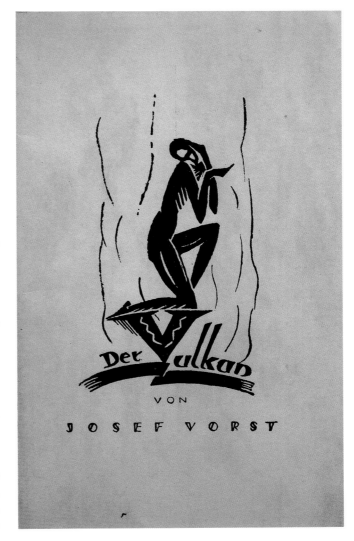

Fig. 51 Joseph Paul Vorst, *Der Vulkan*, 1929, linoleum cut book cover, 9 x 6 in., Carl and Carole Vorst, St. Louis, Missouri.

Vorst's artist studio wall in an undated photograph from the same period. It is unknown whether the project was designed as a large suite from the beginning nor whether it was limited to traditional images of the Passion. Perhaps he envisioned it as a complete narrative from the outset. It appears, however, that he put the project aside for an extended period, only to return to it in full vigor in 1929 and 1930.

In the meantime, he executed a lithograph of the second president of Germany, Paul von Hindenberg; Vorst kept a copy of the print signed by himself and Hindenberg [Fig. 26]. From that fact, one extracts that Vorst was known well enough to either receive the commission or at the very least to gain audience with the president. Either way, it became currency for Vorst that he used to gain future commissions with political figures and members of society.

Given his studies in Berlin, it is inconceivable that Vorst would not have created numerous other works in the last years of the 1920s. We simply do not have them as evidence of his industry.

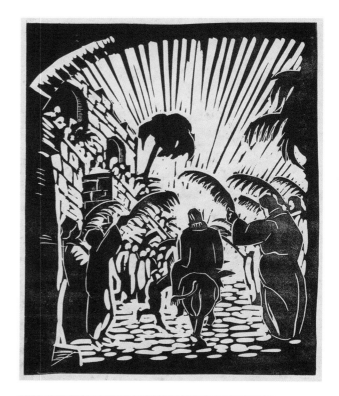

Yet, in 1929 and continuing in 1930, he returned to the Passion linoleum cuts and completed *Christus am See Genesareth* (Christ on the Sea of Galilee), *Einzug Christi in Jerusalem* (Christ's Entry into Jerusalem) [Fig. 52], *Letzte Abendmahl* (Last Supper) [Fig. 53], *Kreuztragung* (Cross), and *Kreuzabnahme* (Descent from the Cross).[13] The size of the edition of each print is unknown; the surviving prints have no such markings. The dimensions of the prints vary, but it is easy to see that they were created as a set, stylistically.

The way that Vorst depicted the figures had evolved from the 1923 images in *Der Vulkan*. In these new works, the lines of faces and body shapes resemble the painting on Greek vases. They are incised into the image rather than delineated as outlines in blocks of negative and positive space. The backgrounds are thoroughly in keeping with Expressionist woodcuts, but the figures, in particular, draw heavily from classicism.

From the view of composition, Vorst creates some novel ideas of structure. His *Beweinung Christi* features the slightest hint of Jesus on the cross on the far left, with the shadow of the cross falling into the picture and orga-

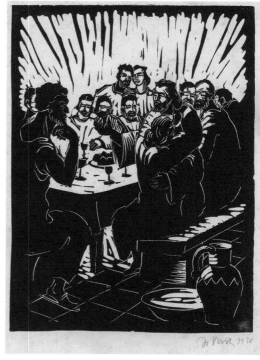

Fig. 52, opposite page, top Joseph Paul Vorst, *Einzug Christi in Jerusalem*, 1930, linoleum cut, 17.64 x 14.69 in., private collection, Germany.

Fig. 53, opposite page, bottom Joseph Paul Vorst, *Letzte Abendmahl*, 1930, linoleum cut, 13.9 x 11.61 in., private collection, Germany.

Fig. 54, above, left Joseph Paul Vorst, *Christus betet am Öl-berg*, 1927, linoleum cut, 13.39 x 10.63 in., private collection, Germany.

Fig. 55, above, right Joseph Paul Vorst, *Beweinung Christi*, 1927, linoleum cut, 13.58 x 10.63 in., private collection, Germany.

nizing the mourners into groups. Vorst's use of marks in the background of the images is clever. In his *Einzug Christi in Jerusalem*, *Letzte Abendmahl*, *Kreuztragung*, and *Kreuzabnahme*, Vorst imbues similar hatchmarks with diverse emotional power. The same gouges into linoleum appear, alternately, like paving stones, bricks, rays of sunlight, as well as weeping shadows that look as if the world is dissolving behind the slain Jesus.

EMIGRATION

At the time these final works were pulled from his press, Vorst knew that they would be among his last made in Germany. He was making plans to emigrate to the United States. He would leave his family, business, studies, and country. He would travel alone. Vorst had planned to take the voyage that would place his arrival on March 25, 1930, but instead booked a later boat in July. The records of his church congregation briefly describe his departure. In 1929 and 1930, numerous LDS members left Germany for America, which they referred to frequently as Zion:

> July 9, 1930. In the mutual the farewell Program for Bro. Joseph Vorst was held. He had a wonderful farewell.[14]

> July 13, 1930. Brother Vorst left today for America. Quite a number of saints didn't come to the preaching meeting as they had to see Brother Vorst off.[15]

In April, Vorst was given a hand-written poem by Irene Ruhrmann titled "Kindersingen" (Children Singing). It reads as a valediction. It said, in part:

> A child's song shows me the soul of mankind deep within the heart...

> They lead thee into holy spheres,
> where happiness and peace are given,
> where eternally you come to hear angels sing,
> O soul of man, let us become a child![16]

Vorst had slyly embedded an image of the Salt Lake City temple into his 1929 children's book *Fietemann*. Clearly, he had been thinking of leaving. Why did Vorst leave Germany? He later wrote about artistic freedom and political op-

pressions as his motivations. This presupposes that Vorst suffered from artistic censorship, and there is no evidence of it. But it was on the horizon, certainly. If Vorst's career continued to grow, he would have encountered problems, given his willingness to criticize the politics of society. Without a doubt, nearly all of his art professors and mentors were falling victim, even those like Liebermann whose styles seemed perfectly safe. Others were soon to receive the official tag of "degenerate." From that standpoint, the writing was on the wall. His fears included a personal concern that he would begin to be as closed-off artistically and militarily-focused as the German population was quickly becoming.

In 1938, he gave an interview in which he put the 1930s in context with his emotional state before emigration. The author described Vorst's motivation, presumably quoting the artist, for leaving Germany:

Fig. 56 Joseph Paul Vorst, *Der Sieger*, 1929, linoleum cut, printed in *Der Vulkan.*, 9 x 6 in., Carl and Carole Vorst, St. Louis, Missouri.

Fig. 57 Joseph Paul Vorst, *Dance Marathon*, n.d., oil on canvas, 34.5 x 27.5 in., Carl and Carole Vorst, St. Louis, Missouri.

Although by this time his paintings were beginning to receive notable recognition, the spirit of unrest, which pervaded the nation, made him uneasy and dissatisfied; so he decided to leave German shores before his perspective was forced into the shallowness inevitable with "mailed-fist" restriction.[17]

Aside from the emotional insights of the statement, this is the only extant reference that Vorst exhibited his paintings in Germany. From the sole source of candid photos in Vorst's studio and workplace, with paintings on easels and leaning against or hanging on walls, there are perhaps a dozen paintings that can be documented. Further, there is no reason to believe that Vorst did not produce many more paintings. It is a tantalizing, if frustrating, possibility that a sizable body of his art was well received and then lost.

A pressing motivation for Vorst at the time must have been financial uncertainty, as well. In 1928, German unemployment stood at 650,000. After a series of Wall Street crashes in 1929, leading up to Black Tuesday on October 29, 1929, financial markets around the world seized up. The inflows of foreign capital to Germany reversed immediately. American banks called back all German loans. A worldwide depression ensued. In Germany, the most visible consequence was unemployment. By the Spring of 1930, when Vorst prepared to leave the country, unemployment stood at 3 million, and that number was rising. By 1933, the number would crest at 6.1 million German people without work, 10% of the population.

Since 1926, Vorst had been working, at least part time, in the office of architect Hans Hammann, a man who would serve the government more than a decade later by building many surface bunkers to protect the population from World War II bombing raids. Essen would become, after Berlin, the most-bombed city in Europe, and its 670,500 inhabitants shared 12,000 cellar shelters, 184 large shelters, and 36 surface shelters that were advertised as "bombproof."[18]

In preparation for Vorst leaving the country, Hammann wrote a letter of recommendation for Vorst on firm letterhead that could be used in America:

Mr. Josef Vorst (artist/painter) from Essen worked in my office on artistic renderings from 1926 to 1930. His principal activities extended from the presenta-

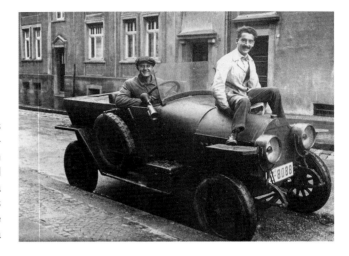

Fig. 58 unidentified photographer, ca. 1926, Vorst riding on the hood of a car with an unidentified driver, Carl and Carole Vorst, St. Louis, Missouri.

tion of improvements to single-family dwellings to larger multi-family housing projects. Also, the design and presentation of floorplans. In addition, he was most engaged in the architectural color shading of the presentation and collaborated on the details of color tones as well as furnishing improvements to the living and social rooms.

Mr. Vorst exhibits a very fine sense for shading and colors. His performance shows a great artistic maturity. I was very satisfied with his work, and I can firmly recommend Mr. Vorst.

Essen, March 31, 1930

Hans Hammann, architect
[signed][19]

In his homeland, Vorst had worked as a teacher, a printer, newspaper illustrator, printmaker, commercial artist, architect's assistant, and fine artist. That is, in challenging times, he had cobbled together a living by using his artistic talent and training in a wide spectrum of pursuits.

Vorst had extended family in America. If he left Germany and moved to where they lived, in and around St. Louis, Mis-

souri, he could be near the support of relatives as he rebuilt his life and career. His photographs in Germany include images of American cousins. Vorst spoke little or no English. His art work had never been exhibited in America. He had no job lined up and no connections to American galleries and museums. He took with him very few of his artworks from Germany, mostly unframed works on paper, a small number of paintings, albums of photographs and newspaper clippings, and a few books. He set sail and never lived in Germany again.

ENDNOTES

1. See the following records compiled in Essen at the time: Essen Branch records, Swiss German Mission, Historical Record, A 3908, No. 420/1, CR 2700 11, v. 7, 1919-1930; Essen Branch records, Swiss German Mission, Historical Record, A 3900, No. 1752, CR 2700 11, v. 8, 1922-1926; Essen Branch Sunday School records, Swiss German Mission, Sunday School Minute Book, A 3919, CR 2700 15, v. 4, 1923-1925; Essen Branch records, Swiss German Mission, Historical Record, A 3910, CR 2700 11, v. 9, 1926-1931; and Essen Branch records, Swiss German Mission, Sunday School Minute Book, A 3920, CR 2700 15, v. 5, 1927-1929; Essen Branch records, Swiss German Mission, Historical Record, A 3910, CR 2700 11, v. 9, 1926-1931. Note: Of the above, only the Sunday School Minute Books were forms. The rest are narrative accounts kept in ledgers. As such, they did not typically list organists. Therefore, if Vorst was the congregation's organist (as the Sunday School records indicates), he likely performed similar duties in many, many other meetings as well. The records are written in German and in calligraphic script that is difficult to decipher. As a result, it is likely that there are even more references to Vorst than this author was able to identify.

2. Postcard from Arthur L. Liddle to Vorst, February, 1925.

3. Clyde H. Wilcox, "Ninety-one Baptized in the 'Ruhr District,' Germany, *The Improvement Era*, March, 1925, Salt Lake City, Utah, 465-466.

4. It should be noted that Vorst created lithographs using traditional lithographic stones as well as zinc plates. He acknowledged both media but in his labeling of the works, he used the catch-all term "lithograph."

5. In a March 10, 2016 letter to Carl Vorst, Dieter Schenk of Leiter des Universaitätarchivs stated that Slevogt and Liebermann were not teachers at the Berlin Academy of Arts.

6. See Museum of Modern Art, German Expressionism, moma.org, accessed December 7, 2015.

7. An author by the same name wrote a small number of books: 1957, 1960, 1966, and 1981.

8. *Der Vulkan*, text by Mathias Pflanzl, p. 3, English translation by Thomas Plummer, 2014.

9. Ibid, 3.

10. Ibid, 5.

11. Ibid, 7.

12. Ibid, 8.

13. The works are untitled and have been given presumed titles by a German collector who found and acquired a portfolio of prints and watercolors owned by Ingeborg Binge. To date, they are the only known copies.

14. Essen Branch records, Swiss German Mission, Historical Record, A 3908, No. 420/1, CR 2700 11, v. 7, 1919-1930, 61.

15. Ibid, 62.

16. Irene Ruhrmann, "Kindersingen," hand-written poem, April, 1930, English translation by Dwight Blazin, April 6, 2017.

17. William Edward Hoffman, *Joseph Paul Vorst Missouri Artist*, 1938, self-published, unpaginated.

18. See Raif Blank, *Germany and the Second World War: Volume IX/I: German Wartime Society 1939-1945: Politicization, Disintegration, and the Struggle for Survival*, Oxford University Press, 208, multiple authors, 424.

19. Letter by Hans Hammann on behalf of Vorst, March 31, 1930, English translation by Dwight Blazin, August 8, 2017.

PART 2: 1930-1939
THE REGIONAL AND THE REAL IN DEPRESSION-ERA AMERICA

I ain't got no home, I'm just a-roamin' 'round
Just a wandrin' worker, I go from town to town
And the police make it hard where I may go
And I ain't got no home in this world anymore

My brothers and my sisters are stranded on this road
A hot and dusty road that a million feet have trod
Rich man took my home and drove me from my door
And I ain't got no home in this world anymore

Was a-farmin' on the shares, and always I was poor
My crops I lay into the banker's store
My wife took down and died upon the cabin floor
And I ain't got no home in this world anymore

I mined in your mines and I gathered in your corn
I been working, mister, since the day I was born
Now I worry all the time like I never did before
Cause I ain't got no home in this world anymore

Now as I look around, it's mighty plain to see
This world is such a great and a funny place to be
Oh, the gamblin' man is rich an' the workin' man is poor
And I ain't got no home in this world anymore

Woody Guthrie, "I Ain't Got No Home in This World Anymore,"
Dust Bowl Ballads

Fig. 59, left Joseph Paul Vorst, untitled, n.d., oil on masonite,
37 x 24.5 in., courtesy McCormick Gallery, Chicago, Illinois and
Vallarino Fine Art, New York, New York.

Fig. 60 Joseph Paul Vorst, *Marble Quarry*, ca. 1935, oil on canvas, 21 × 16.5 in., Collections of the St. Louis Mercantile Library at the University of Missouri-St. Louis; the Bruce and Barbara Feldacker Labor Art Collection.

CHAPTER 4
ARRIVAL IN AMERICA

ST. LOUIS, MISSOURI

On July 21, 1930, Joseph Vorst arrived in the United States aboard the S. S. Europa, a German vessel with modern steam turbine engines that allowed Atlantic passage in less than a week. If his goal was to speed away from the unsettled political landscape of Germany, however—the waning years of the troubled Hindenburg presidency leading up to the seizure of power by Hitler in 1934—he traded it for something almost as perilous: the Great Depression in America.

He arrived in New York City to witness a country both expanding and beginning to crack. From his pier in New York, Vorst could see the rising Empire State Building, the world's tallest, in mid-construction. On the day of his arrival, the front pages of the New York papers contrasted the dynamism of the Empire State worksite with foreign reports of a venerated but ailing Hindenburg back in Germany.

Economically, Wall Street was recovering from the Black Tuesday stock market crash ten months earlier, although the reverberations of high unemployment, bank failures, and devastating economic consequences for U.S. corporations and households were just around the corner. Less than a month before Vorst's arrival, the Smoot-Hawley Tariff Act raised trade tariffs to historic levels. Retaliatory trade wars ensued, and U.S. imports and exports were cut in half. Banks began to fail by the fall of 1930, and the spiral of suffering gathered speed at the same time that devastating droughts ravaged the farmlands of the Midwest.

Vorst traveled directly from New York City to Ste. Genevieve, Missouri, by train. The oldest town in Missouri, Ste. Genevieve was founded by French colonists around 1750, when a large part of the vast territory was French—it included land from 15 present U.S. states. The picturesque village of Ste.

Genevieve, approximately 63 miles south of St. Louis and located on the Mississippi River, is home to the largest collection of French Creole buildings in North America. These were constructed from logs that were hewn by hand and set vertically into trusses with mortise and tenon joints. Long after the Louisiana Purchase in 1803, Ste. Genevieve retained its authentic flavor as it gradually embraced new residents and structures along its rolling hills. It is a historic district that is remarkably well preserved. 5,269 residents of the township were listed in the 1930 U.S. census. It was primarily an agricultural village, but local mining interests were an important resource for the community, too. For a European immigrant like Vorst arriving in 1930, Ste. Genevieve was the closest approximation to Old Country life in the New World. Specifically for Vorst, the area's landscape echoed his home of Essen, Germany—set where two rivers meet: in Germany, Rhine and Ruhr, and in America, the Missouri and Mississippi.

He relocated near relatives. His uncle, Leon Charles Vorst, died one year before his immigration, but Vorst knew his aunt, Louise Anna Francina Andre, and two cousins, Joseph Leon Vorst and Myrtle Leona Vorst, who lived in Ste. Genevieve. A photograph taken in Germany shows Vorst posing in his art studio with photographs of his cousins [Fig. 115], Joseph Leon and Myrtle Leona, indicating familiarity and that the Vorst families in Germany and the United States were well acquainted.[1]

The Vorst family had lived in Missouri for years. Joseph Johannes Vorst emigrated in 1855 at the age of 24. He came from a town near Essen—Rellinghausen, Prussia. After his arrival in the U.S., Joseph Johannes worked in the coal mines of Pennsylvania, then moved to New Orleans, and finally to the St. Louis area. He enlisted in the Union Army at the outbreak of the Civil War and rose from private in

the infantry regiment to the rank of first lieutenant. After he married Anna Scherer in 1864, he moved to Ste. Genevieve, where she had been raised. There, he opened a saloon, later an inn named the Jefferson House. This he sold to purchase the Kerns Hotel, renaming it the Southern Hotel, in 1874— even now, it is a landmark destination.

Other Vorsts had come from Essen, as well. Joseph Langhardt, the cousin of Joseph Henry Vorst, who ran a livery stable, emigrated in 1884, and a small number of distant relatives populated the area. A final relative worth mentioning, particularly in the context of Vorst's acclimation as an artist in America, is Matthew Emile Ziegler. He was the grandson of Joseph Johannes Vorst, and Ziegler would be an important link to a community of painters closely tied in Ste. Genevieve.

That is all to say that upon entering the United States in 1930, Joseph Paul Vorst was among family. They understood his background, and they were established, industrious residents of a small and quaint community that served as a gentle transition for him into a new culture and a respite from the turmoil on the horizon in Germany. In Missouri, Vorst began to put down his own roots. Shortly after his arrival, he became a naturalized citizen.

According to later newspaper accounts, he moved from Ste. Genevieve to a small and dingy apartment in St. Louis shortly after his arrival in 1930. In those days, traveling between the two communities required several hours by car or train, and it is likely that Vorst wanted to be closer to a large city for professional reasons. However, eventually he would begin the construction of a home and studio in Ste. Genevieve on Sugar Bottom Road called Maple Grove. The building remained unfinished, although its stone foundation is still visible.

In late October, Vorst sought treatment at St. John's Hospital in St. Louis. A self-portrait sketch that he sent to Max Slevogt in Germany shows Vorst in his hospital bed with large bouquet of roses and a basket of fruit on a nearby table. In another sketch for Slevogt, the young, mustachioed artist with his left leg in a cast is trying awkwardly to maneuver on crutches, which are slipping out from under his arm, his hand flailing. The drawings are dated: October 22, 1930 and signed, "Josef Vorst" (Fig. 61). They are captioned in German and also in a lighthearted attempt at English, quot-

ing the medical staff at the hospital urging him to practice walking with crutches. The artist replied, "Yes, sir!" But under another image of himself in bed with his leg propped up in a cast, he wrote in German, "This way's better. I won't stand up until I know I can walk again." He made a possible reference to his leg as being broken, "Darn it, here I'm falling over my own bones and there's nearly a second break."[2] It is unclear whether his condition was a consequence of the shrapnel that remained in his leg after World War I or a more recent accident. He wrote to Slevogt that he was drawing himself in the hospital "after 8 days of bed rest." One of the drawings was inscribed to Slevogt, "To my dear Professor Max Slevogt, as a greeting from the land of unlimited opportunities, passed on by the German consul, Dr. Ahrens."[3]

America may have been the land of unlimited opportunities theoretically, but in the fall of 1930, Vorst quickly realized the challenges of his professional prospects. Artists could join an art club and enter works into juried shows from clubs and museums with prizes, but finding patrons who would acquire works from a gallery setting was much more difficult. At that time, Missouri artists had limited outlets for local sales; there were scattered galleries in St. Louis although there were numerous artists in the vicinity.[4]

Nevertheless, St. Louis citizens had ample exposure to art, including modern art from Europe. Duchamp's *Nude Descending a Staircase* and other modernist works were exhibited in one of the city's leading department stores in 1913. And throughout the following decade and a half, the city's stores, libraries, galleries, and museums placed modern art on display regularly. Critical acceptance followed gradually, if grudgingly. Local newspapers published critics and commentators who described American artists at a crossroads—painting works that startled or pleased the public (abstraction or realism). For its part, the majority of St. Louisans preferred the latter.

One of Vorst's first American paintings was a conservative modernist work, *St. Louis Factories* (Fig. 62), executed circa. 1930. The oil painting shows a row of modest homes in bleak winter on the waterfront with a factory's billowing smokestacks in the distance. In many ways, it echoed the landscape of industrial Essen that Vorst had captured in Germany years before and published in newspapers. At the time in St. Louis, a number of American artists sought to blend traditional scene painting with the vibrancy of mod-

Fig. 61 Joseph Paul Vorst, two untitled sketches of Vorst in the hospital sent to Max Slevogt, 1930, pencil, 10 x 8 in., Cris and Janae Baird, Arlington, Texas.

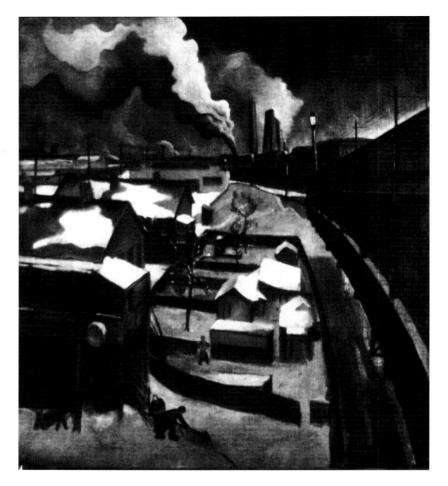

Fig. 62 Joseph Paul Vorst, *St. Louis Factories*, ca. 1930, oil on
canvas, 36 x 36 in., courtesy Treadway Gallery, Cincinnati, Ohio.

ernism, particularly in the formal approaches to urban landscape. St. Louis artists such as Joe Jones and Miriam McKinnie developed local variations on a stylized approach to landscape championed by Eastern artists Charles Sheeler and Louis Lozowick, whose precisionist paintings formed a bridge between the traditional and the new. Vorst admired Sheeler and eventually kept an autographed copy of his 1938 book, *Artist in the American Tradition*.

Vorst set about to introduce himself to the local arts scene. He quickly joined societies of local artists in Missouri, and his linoleum cuts exhibited at the St. Louis Art Club in 1930 took a Guild prize. In fact, the annual exhibitions at the City Art Museum of St. Louis and the Saint Louis Art Museum became very important for him. He showed new work at these annuals every year but one for the rest of his life. Despite the signs that he was adjusting to his new surroundings socially, there is no doubt that he suffered financially as a recent immigrant artist. Vorst spoke later of these lean days, of trying to sell little paintings at Sears and on crowded St. Louis street corners for as little as fifty cents, and even that without success.

The religious conviction that Vorst discovered in Germany accompanied him across the Atlantic. Mormonism has a long history in Missouri, and he found a small congregation of the LDS Church in St. Louis with approximately 100 members. He was ordained in the priesthood to the office of Elder, the same office held by the missionaries who had baptized him in Germany. This ordination took place March 21, 1931, under the hands of Lloyd Victor Frandsen, a missionary from Idaho serving in Missouri.[5] None of Vorst's relatives followed him into the faith, including those in Missouri.

For believing adult Mormons, an important rite of passage is a trip to a temple. Unlike houses of worship that are located in communities around the world, a temple provides the membership with ordinances and instruction only to be found therein. Further, the only people allowed into the buildings are those who are fully committed and found worthy to enter after an ecclesiastical interview. At the time of his conversion in 1924, there were no temples in Europe—the first, in Switzerland, was dedicated in 1952. By 1930, there were four LDS temples in Utah (St. George, Logan, Manti, and Salt Lake City), and just three others: Laie, Hawaii; Cardston, Alberta; and Mesa, Arizona. He apparently made it a priority to go to an LDS temple as soon as he

could upon reaching the United States.

Vorst's first trip after settling in St. Louis was to Salt Lake City, in April 1931. While there, he entered into the Salt Lake Temple and performed ordinances for himself that he would have considered sacred. The faith believes in performing the same saving ordinances by proxy (including baptism) for deceased family members, essentially providing an opportunity for them, after death, to choose or reject the faith. Vorst did this temple work for a number of members of his family who had died: his father, Paul Johann Joseph Vorst; his uncle, Otto Vorst; and the artist's younger brother, Karl Paul Peter Vorst. His interest in genealogy was a life-long pursuit, and he completed reams of charts of his family tree. For Mormons, genealogy is more than a discovery of family history; it is a process of linking families together through temple ordinances.

The trip coincided with the semi-annual General Conference of the Church, which Vorst attended. Never a diarist, he did maintain photographic documents of travels, and in Salt Lake City, he took pictures of local points of interest. A photo album of the trip documents his tour of the area's recreational sites, guided by friends. The missionaries who taught him in Essen and those with whom he associated there had finished their volunteer service, and some of them lived in Utah. One assumes that Vorst contacted Utahns he had met in Germany, told them of his impending trip west, and arranged to rendezvous with them.

A few photos show Vorst standing next to the future President of the Church, George Albert Smith, and his family at their Salt Lake City home (Fig. 66). It is unlikely that the two men had met previously, although Smith was the president of the European Mission from 1919 to 1923 and spent time guiding the missionaries there. But an analysis of Smith's detailed diaries reveal no more direct connection.

For the first time, Vorst experienced a large body of members from his adopted religion. The domed Tabernacle on Temple Square has a capacity of 8,000, for example, and Vorst snapped a photograph of himself in the building, listening to a session of a semi-annual religious conference surrounded by more believers in his faith than he had ever seen before (Fig. 65).

He returned to St. Louis—his address was 4538 Parkview

Fig. 63, opposite page, left unidentified photographer, Vorst walking in front of the Salt Lake City Temple, ca. 1931, Church History Museum, Salt Lake City, Utah.

Fig. 64, opposite page, right unidentified photographer, Vorst (far right) in Utah, ca. 1931, Church History Museum, Salt Lake City, Utah.

Fig. 65, right, top Joseph Paul Vorst, inside the Tabernacle on Temple Square, Salt Lake City, ca. 1931, Church History Museum, Salt Lake City, Utah.

Fig. 66, right, center unidentified photographer, Vorst (far right) with future LDS President George Albert Smith (center), ca. 1931, Church History Museum, Salt Lake City, Utah.

Fig. 67, right, bottom Joseph Paul Vorst, photograph of bus to Denver, ca. 1931, Church History Museum, Salt Lake City, Utah.

Place, near Forest Park. He received documents from Joseph Christenson of the Salt Lake Temple dated July 6, 1931. A cover letter on Temple letterhead explains that the Church was providing Vorst with blank sheets called Family Group Records that he was to complete and return, presumably for additional proxy ordinances.

Any Mormon living in Missouri in 1930 would be well acquainted with the state's dark history regarding the religion. Events in the northwestern counties of Missouri 100 years earlier culminated in an executive order by Governor Lilburn Boggs to drive the Mormons from the state. The order, in part, stated, "The Mormons must be treated as enemies and must be exterminated or driven from the state, if necessary for the public good."[6] Some historians suggest that the usage of the term "exterminate" in the 1830s would have interpreted as forced out rather than murdered, but the Haun's Mill Massacre of October 30, 1838 indicates that at least some Missourians, including a militia, took the term literally. In the attack in eastern Caldwell County (approximately 50 miles northeast of Kansas City and 180 miles west of St. Louis) a militia of some 240 men killed at least 17 Mormons and a non-Mormon sympathizer, according to an eyewitness. Additionally, 13 were injured, including a woman and child. Victims were shot; some of them were mutilated and dismembered; the dead were stripped of their clothing, and many women were assaulted. Further, the victims saw their homes ransacked, wagons and clothing stolen, and their horses scattered. The lingering consequences of the massacre being that survivors were left destitute.[7] Missourians refer to this era as "The Mormon War."

It is commonly thought that the brutal event precipitated the withdrawal of all Mormons from the state of Missouri, but that is not entirely correct. Many fled to Illinois, but St. Louis proved to be a hospitable place—even a sanctuary—from persecution in the western side of the state.[8] More than that, the city became a crucial waystation for thousands of Mormon converts over the next decade as they traveled west, and it was a source of supplies for the nascent communities in the Rocky Mountains in the 1840s and 50s.

Over time, however, the number of LDS members in St. Louis dwindled. At the turn of the 20th century, the city was the fourth-largest in the nation by population, but it wasn't until 1916 that the congregation of Mormons in the city had enough members to purchase a building of their own. It was

in that space, at 5195 Maple Avenue, that Vorst attended church services upon his arrival.

A COMMERCIAL ARTIST

The commercial art that Vorst had created as a printmaker in Germany portended similar success in America, and in the spring of 1931, he found employment at the Gray-Adams Printing and Engraving Company, a well-established business in the city. He was engaged as an artist, and according to a woman who was a 17-year old at the time and

Fig. 68 Joseph Paul Vorst, *A Night in Venice*, 1930, linoleum cut poster, inscribed to Ingeborg Binge, 10 x 7.68 in., private collection, Germany.

the daughter of management, he was viewed as a "very fine artist."[9]

The Great Depression hit St. Louis hard. In 1932, 20,000 businesses fell into bankruptcy in the United States, and wages fell 40%. In St. Louis, 30% of the population was unemployed. But for African Americans in the city, the rate of unemployment or underemployment was dramatically higher; it breached 80%. Furthermore, for a city of its size, St. Louis spent far less on relief than others: 38% less, per capita.

The St. Louis poet Orrick Glenday Johns noted that the homeless in St. Louis camped in a Hooverville shantytown one mile long:

> ...I had never seen such stark destitution as that on the river front of South St. Louis. The people were practically imprisoned there, discouraged by police and watchmen from going into the city.[10]

In 1932, Vorst sailed back to Germany for a visit. He also traveled to Pfetterhouse, France, and the Vosges mountains, as evidenced by watercolors of the journey. His return to Germany led to a meeting with Adolph Hitler and senior party officials and the drawing of their commissioned portraits. On the surface, this decision makes little sense. The artist repeatedly spoke of leaving Germany—he sometimes used the word "flee"—at the very least as an act of declaring artistic and personal independence. Why return? And why take the job of drawing Hitler?

The economic landscape of Germany in 1932 was similar to that of the United States. It shared a worldwide economic depression that began on Wall Street in 1929. High rates of unemployment prevailed—some 6 million Germans were without jobs—small businesses were closing their doors, and people took to violent demonstrations in the streets of Berlin. The National Socialist German Worker's Party included more than 100 elected officials in the Reichstag (German parliament), and they were determined to subvert Hindenberg's ineffectual government, the Weimar Republic.

For the presidential election of 1932, political moderates urged the 84-year old President Paul von Hindenberg to seek a second, seven-year term in order to thwart Adolf Hitler, who had only become a German citizen in February

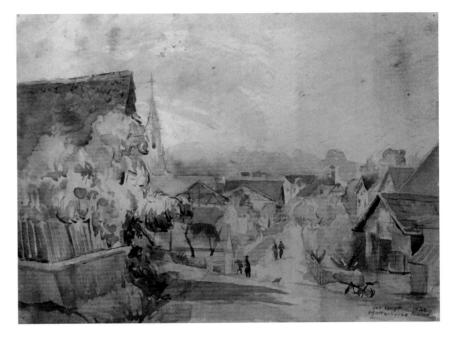

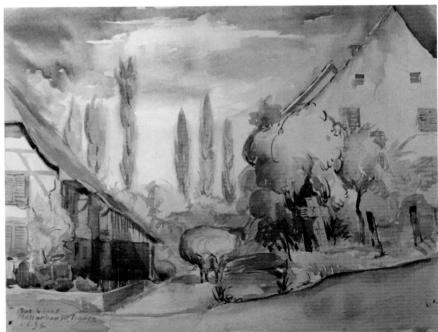

Fig. 69, top Joseph Paul Vorst, *Pfetterhouse, France*, 1932, watercolor, 10.5 x 14 in., Carl and Carole Vorst, St. Louis, Missouri.

Fig. 70, bottom Joseph Paul Vorst, *Pfetterhouse, France*, 1932, watercolor, 10.5 x 13.5 in., Carl and Carole Vorst, St. Louis, Missouri.

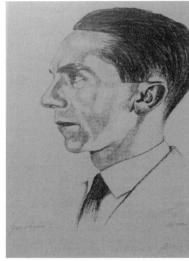

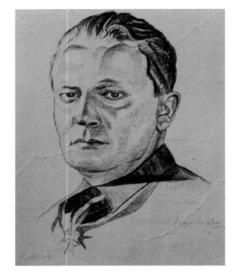

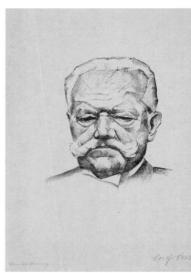

Fig. 71, top, left Joseph Paul Vorst, *Adolf Hitler*, 1932, lithograph, whereabouts unknown, previously published in *Esquire* magazine, February 1934.

Fig. 72, top, center Joseph Paul Vorst, *Goehring*, 1932, lithograph, whereabouts unknown, previously published in *Esquire* magazine, February 1934.

Fig. 73, top, right Joseph Paul Vorst, *Goebbels*, 1932, lithograph, whereabouts unknown, previously published in *Esquire* magazine, February 1934..

Fig. 74, bottom, left, *Strasser*, 1932, lithograph, whereabouts unknown, reproduced in *St. Louis Post-Dispatch*, 1932, Carl and Carole Vorst, St. Louis, Missouri.

Fig. 75, bottom, right, *von Hindenberg*, ca. 1932, lithograph, previously published in *Esquire* magazine, February 1934, Carl and Carole Vorst, St. Louis, Missouri.

1932. (Max Liebermann, one of Vorst's teachers in Berlin, was one of the signatories calling on the ailing leader to run again.) Realistically, no one expected the infirm Hindenberg to survive seven more years—he would be 92 at the end of the term—but the prevailing belief held that the incumbent was the only person capable of defeating the ascendant Hitler.

Vorst created two distinct portraits of Hindenburg. One in 1928, and another, undated, that Hindenburg signed for the artist (Fig. 26). They were made into lithographs. Even years later, Vorst kept the autographed image his home.

In the election of 1932, Hindenberg won in the first round of voting, 49.6% to Hitler's 30.1% on March 13. Falling shy of a 50% majority, a run-off election took place on April 10, with Hindenberg prevailing with 53% of the vote to Hitler's 36.8% for a second term. As the country—indeed, many countries—slipped deeper in the Great Depression, Hitler was named chancellor on January 30, 1933. Meanwhile, Hindenberg restricted civil liberties and gave increased legislative powers to others in a bid to restore order. When Hindenberg died on August 2, 1934, Hitler vacated the office of president altogether and named himself Führer und Reichskanzler (Leader and Reich Chancellor), a new position as head of state that he created for himself.

There is no contemporary record from 1932 of Vorst answering the questions of how and why he came to draw Hitler. The first documentation of the portraits appeared in an article in the *St. Louis Post-Dispatch*, published almost three months after Vorst's return to the U.S. The article appeared on December 11, 1932 titled, "A St. Louis Artist Looks at the Hitlerites." It contained the reproductions of four drawings with the following caption, "Joseph Vorst has recently returned from Germany with these pencil interpretations of the head of the National Socialists and three of his lieutenants." There was no additional commentary. The images are portraits of Herman Wilhelm Goehring, Adolf Hitler, Dr. Georg Strasser, and Dr. Joseph Goebbels (Figs. 71-74). In 1934, *Esquire* magazine published Vorst's portraits (with the artist uncredited and with Hindenberg replacing Strasser) in its article, "Two Opposing Views of Germany as a Factor in Europe's Future."[11] It was only the magazine's second issue.

A few years later, a fuller story of the portraits emerged in

a profile of Vorst published in the *St. Louis Post-Dispatch,* August 9, 1936. The article describes Vorst as being "of anti-Nazi mind" and gives an extended quotation from the artist about the events:

That was just before Hitler's rise to power. You see, I came to America in 1930 and got my first naturalization papers right away, going back in 1932 on a re-entry permit. It was then that one of my friends, a newspaperman, asked me if I would do some portraits of the Nazi leaders. Said there would be 250 marks a picture in it for me.

I needed some money, so I accepted. Hitler posed for me for about a half-hour, as did Herman Goehring. The work was for lithographs. My portraits of Dr. Georg Strasser and Dr. Joseph Goebbels were made from other pictures.

The work seemed acceptable to the Nazis at first, for they accepted them and the lithographs were widely distributed in Germany. Yet when I called to collect, it was another matter. They said the back of Mr. Hitler's neck wasn't just right, and that certain corrections had been found necessary.

As my re-entry permit was about to expire, I left Germany and placed the bill with my mother for collection. She filed suit and collected the full amount, the case being heard before a jury of art critics.[12]

There are slightly conflicting accounts of these incidents, even from Vorst, and it is logical to assume that German Americans, even in a German-friendly city like St. Louis, distanced themselves from affiliation with the Nazis throughout the 1930s and 40s as World War II neared. As time passed and as the Nazis committed acts beyond understanding, Vorst's associates said he had been "forced to leave Germany because of trouble with the Nazi officials involving Hitler and Goering."[13] Another story had Vorst being taken with a sack over his head and forced to create the portraits in a clandestine location. The truth, likely, is much more pedestrian: that the artist needed the money and because of his established reputation in Germany as an artist of heads of state and his personal connections with newspapermen, Vorst was given access to the ambitious politician more than two years before he took power. There is no indication that

Vorst sympathized in any way with the Nazi party, and he proved this repeatedly as his career took root in the United States.

And what of the images themselves? Stylistically, the drawings of Goehring, Goebbels, and Strasser are very similar to Vorst's earlier portrait of Hindenberg. They retain a sketched quality, like a black and white illustration for a magazine. Before a blank backdrop, the figures are shown in ¾ length—their shoulders giving hint to uniforms that are only partially depicted. Only Goehring (Fig. 72) has any visible military insignia—the Pour le Mérite medal that he won in World War I hangs around his neck. Faces are realistically rendered, but there is no particular attempt to show anything psychological from the subjects. Their faces are stern and yet blank. In each, the last name appears at the bottom left corner of the portrait, which simply announces, in script: "Goebbels," "Goehring." The artist signs his name on the right, "Joseph Vorst" and dates the works: 1932. Their shading echoes Vorst's lithographs before he left Germany (particularly the landscapes) which contrast light and dark in planes that are broken up in patches that provide contours of skin, hair, and cloth.

The exception to these works is Hitler himself (Fig. 71), who is given a fuller artistic treatment by the artist. He sits in profile, his head turned to his right, in an unadorned uniform of a dark shirt and tie. He stares into the distance with his brows furrowed. Behind him, and partially obscured, is the large and dark swastika of the Nazi flag. The figure is lighted somewhat dramatically, and the textured shadows are accomplished with Modernist fractured planes of broad pencil marks, particularly behind his head. In this picture and the portrait of Goebbels (Fig. 73), Vorst signed his name differently than on any picture in his life: the wholly American "JOE VORST."

Some aspects of Vorst's involvement in German politics can be established and some discredited. It was later said that the images were used in Hitler's national campaign. Vorst himself said so directly. That appears to be incorrect; the election of 1932 was over by the time Vorst created the works. And the St. Louis newspaper was quite specific in saying that the St. Louis artist returned with pencil sketches (now lost), rather than lithographs—although the existing drawings might have been made into lithographs and used in propaganda either shortly before or after Vorst left the country. The artist maintained a comprehensive file of newspaper clippings of his work, particularly in Germany. These images are entirely absent.

There is another possible reason for Vorst's trip, although this went undisclosed in the press and has heretofore been overlooked: his beloved teacher and friend Max Slevogt was ailing and died on September 21, 1932, during Vorst's visit to Germany. In Essen, Vorst received a thank you and bereavement card on behalf of the Slevogts dated October 6, 1932. Vorst set sail for his return to America three weeks later, on October 27, 1932 aboard the ship Berlin from Bremen to New York. He took with him a lithograph of Slevogt dated 1932, signed by Vorst and Slevogt (Fig. 77).

Upon arrival, he was briefly detained for special inquiry at port, and on his immigration paperwork, American authorities wrote the designation "P.D.L.P.C." "P.D." referred to aliens with mental, physical, economic, or educational disqualifications. "L.P.C." stood for Likely Public Charge. That is, if immigrants did not possess much money, they were considered financial risks, being unable to support themselves. They were held at port until it could be established that they would not be burdens on the state. This supports the interpretation of the artist's motivation for the Nazi portraits and indicates that Vorst was financially strapped. The returning artist was held for a few hours and then sent home to St. Louis.

He left Germany, but he maintained relationships there. Vorst sent back to Germany news of his tentative artistic successes. Vorst's local newspaper in Essen published a photo of Vorst in St. Louis, reading the daily German newspaper, *Die Wochenschau*, in front of a skyscraper in downtown St. Louis. To some extent, Germany was also keeping tabs on him, too. He also tried to help his Berlin teachers. Apparently, Vorst worked behind the scenes to line up an exhibition of his former teachers graphic prints in America. Both German artists corresponded with Vorst in 1932 and 1933. Slevogt, in particular, before his death, revealed his exasperation about the atmosphere in German politics, which provides some insight into their relationship.

My Dear Mr. Vorst,

It was a great joy to have received news from you.

With some concern I often thought of your fateful

step and how it would affect your artistic nature as well as your mind and sense of well-being.

Now that you've obtained a measure of contentment and your viewpoint has been expanded by this remarkable and very important country, it seems to me of some importance that a certain inner sight might become withdrawn.

It's good that you've found patrons for your art and person, and wonderful that you have a solid job: Let's hear it again for this.

There's not much new to report from here.

It's quite poor here for artists and art.

Few young people have anything to do with the certain fiction on display in the press, though one easily forgets that unfortunately even the good forget.

Europe is old and knows little more than to protect its irreplaceable cultural relics, and everyone is asking themselves where best to endure this Winter.

I myself, remain here in this country keeping myself occupied with a few motifs until the sunshine emerges out of these endless weeks of rain.

As for graphics, I do not have any more.

Incidentally the Dresden Art dealer Gubier [Gubler?] with support from the US and American artists is currently trying to cultivate interest in the German graphic market.

He is very well informed in this area and probably the right man, but I'm skeptical.

America only knows France and has not really formed its own opinion yet.

Again, best wishes,

Yours,

Max Slevogt[14]

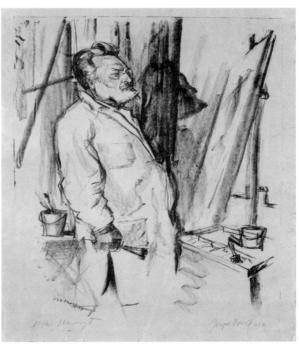

Fig. 76, top Max Slevogt, untitled correspondence with Vorst, 1932, Carl and Carole Vorst, St. Louis, Missouri.

Fig. 77, bottom Joseph Paul Vorst, *Slevogt*, 1932, lithograph, 22 x 18.5 in., Carl and Carole Vorst, St. Louis, Missouri.

The 21st century concept of the global citizen was far removed from the mindset of Americans and Europeans before World War II. For Vorst, leaving Germany and becoming an American in 1930 was a decision about reshaping identity. When circumstances forced one's immigration, those affected wrestled, nevertheless, with remaking themselves in a new land. This process was more than merely choosing to live in one country or another. It was a retooling of one's psyche.

Vorst received this letter, dated April 2, 1933, from Max Liebermann,

> Berlin Paris Place
> 2 April 1933
>
> Dear Mr. Vorst,
>
> I thank you especially for your letter of 2.3. [March 2nd] and for the interest your expressed in me and my art.
>
> Mr. Handke, a friend of mine here for over 40 years and a very skilled painter in his own right—in business for a long time and has done exhibitions for me and sold some of my works—just told me to maintain purchasing prospects in America especially at this time when true art is very correct.
>
> Of course it was entirely due to you and Mr. Handke that your idea to show my graphics in America was realized.
>
> Slevogt's death was an irreplaceable loss for art.
>
> Also certainly for me, although much younger, he was the only one with whom I harmonized internally.
>
> You may know that I was recognized by him at the founding of the old Berlin "Secession" [illegible] of Munich, where he was not known at the time, and grateful that we spoke of this prior to his unfortunately premature death.
>
> I am happy to see in the newspaper sent to me that you have found some recognition in St. Louis and wish you even more success there, as the opportu-

nities for emerging talents have deteriorated significantly in Germany.

> With pleasure I will fulfill their wish for an original work of mine for the planned exhibition.
>
> Awaiting further communications from you,
>
> Faithfully yours,
>
> Max Liebermann[15]

With Vorst's German teachers and artists, Vorst was more likely to discuss incremental strides in his career rather than ideological progress and newfound artistic freedoms. Liebermann's congratulations about success were relative. Still, however conflicted, it is likely a mistake to infer that Vorst saw himself as utterly penniless in America. The economy drove his desire to be American on some level, but his thinking was broader than that, and it surely included a yearning for artistic freedoms every bit as strong as fears about losing them in Europe.

Regarding his financial situation, however, compared to the deprivation of his childhood, the Great Depression presented stiff challenges, but they were not debilitating ones. He had some income. Vorst's experience as a fine artist, teacher, and commercial artist in Germany were helpful preparations for his relocation to the United States. In his early years in America, Vorst took work wherever he could find it. In addition to Gray-Adams Printing and Engraving Company, he did industrial work for Cooks Champagne, Lewis Medicine Company, Wagner Electric, Beach-Birch Stove Company, and Huttig Sash and Door.

Found after Vorst's death, among his papers on the back of a ledger, the artist wrote the following about his motivation for becoming an American. Was it an economic decision? What is a career choice? Without clearly defining either, he focused on his own identity, instead, "Several people pleaded with me to stay a German. As an answer so no one would have their feelings hurt, I answered, 'No, I will not forget Germany, how could I, I asked myself, didn't I have enough of it?'"[16]

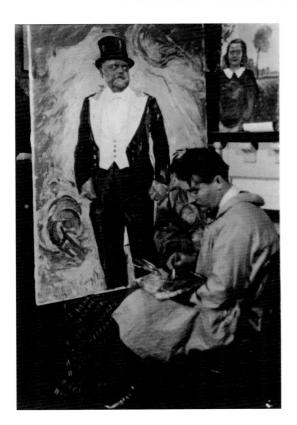

Fig. 78, top "German Artist's Block Prints on Display," 1934, *Salt Lake Tribune*, Salt Lake City, Utah.

Fig. 79, bottom unknown photographer, Vorst painting portrait of August A. Busch, Sr., ca. 1933, photograph, Carl and Carole Vorst, St. Louis, Missouri.

FIRST COMMISSIONS AND EXHIBITIONS

Although Slevogt and Liebermann commended him for his American early success, the truth is that Vorst was as impoverished as many artists and residents of St. Louis. It was a windfall, then, when Vorst was approached by August A. Busch, Sr. to paint his portrait. He was an influential man of society, the president of Anheuser-Busch. During the Depression and throughout Prohibition (which ended in 1933), Busch helmed the brewery as it attempted to diversify.

Vorst told the story of the commission. The anecdote provides some insight into the painter's level of confidence, even in the depths of the Depression:

> Realizing in advance I probably wouldn't get it, I asked Mr. Busch $2000 for the commission. He laughed and handed me $700…. To tell the truth, I was tickled to death for $700 was a pretty handsome sum as payment for a portrait by an artist without a reputation in this country.[17]

Vorst painted Busch, a patron of horse shows and outdoor sports, in a formal costume of top hat, scarlet tailcoat, white gloves, and dark trousers (Fig. 79). It was published in the *St. Louis Globe-Democrat* with the caption, "Mr. Vorst came to St. Louis from Essen, Germany, to make the portrait of Mr. Busch. The painting will shortly be placed on exhibition at the Newhouse Galleries."[18]

He said he was a man without a reputation in America, but Vorst's status as a portraitist of German leaders opened doors for him. He painted portraits of St. Louisan members of society: Alfred Lee Shapleigh, Clairie Hazel Von Gontard, and Mrs. William O. Schock. In 1933, Prince Louis Ferdinand of Germany visited St. Louis. While staying at the Jefferson Hotel in downtown St. Louis, he sat for a quick portrait by Vorst to be used by a local publisher. The sketch was signed and inscribed to Vorst by Prince Louis Ferdinand and dated June 10, 1933.

The St. Louis Art Club appears to have been Vorst's only venue for fine art exhibition during the first two years in Missouri. He became a member of the Club, and he won prizes from the Club in 1930 and 1933, the latter for drawing. Gradually, he expanded his reach with the public. In 1933, he exhibited *Wandelnde* (Changing) at the St. Louis Artist's

Guild. Presumably, given its German title, this work may have come with the artist across the Atlantic. Vorst also received an honorable mention at the Exhibition of American Artists. With these contributions, as well as the Busch portrait at Newhouse Galleries, he was becoming a familiar local artist.[19]

He aspired to an identity as a fine artist—something aside from a career as a commercial artist of commissioned portraits. Artistic freedom was a principal motivation for leaving his homeland. He left Germany to become a fine artist. Immigration was a prescient decision. German art was changing rapidly. Under government pressure, the Bauhaus school closed its doors at the beginning of the summer semester, 1933. The Nazis claimed that the Berlin school was a hotbed of Communism; its esteemed faculty scattered.

The same year, the Nazis created the Reichskulturkammer (Reich Culture Chamber). Only members of the Chamber were allowed to create works for the broader culture—literature, music, film, architecture, and visual art. These artists were required to be "racially pure" and to support the Party. Hitler's ideal for art was Greek and Roman classicism, which he saw through his racist lens as being untainted by Jewish influence. Vorst's work, had he stayed in Germany, would have been no more or less offensive to the government than that of his teachers and perhaps the well-known Expressionists, Emil Nolde, Erich Heckel, Max Beckmann, and Ernst Ludwig Kirchner. By 1937 all of these artists' work—and Vorst's imagery, had he continued with the political messaging of *Der Vulkan* and *Ein Totentanz*, certainly, would have been seen in lockstep with their group—received the designation "degenerate," and the artists were severely crippled professionally.

Back in the United States, Vorst again traveled to Salt Lake City, Utah the following year. He performed vicarious religious ordinances for additional deceased relatives in the Salt Lake Temple. These included work for Vorsts from St. Louis who were deceased: Joseph Johannes Vorst, his son Leon Charles Vorst, and Leon's brother Joseph Henry Vorst. Especially notable is the work performed for Max Slevogt, who had died less than two years earlier. This is the only time that Vorst performed temple ordinances for anyone other than a direct family member.

It was also a business trip. Vorst met the influential Utah

legislator and art champion, Alice Merrill Horne. It was she who introduced Vorst to the Utah public with an exhibition of more than 40 prints in the Deseret Gymnasium Art Room. Perhaps an unlikely place for an art exhibition space, the Art Room displayed works by local and visiting artists for a number of years in a landmark pioneer building.

On the occasion of the Vorst exhibition, the *Salt Lake Tribune* ran a profile of the artist. His German history was recounted, as well as recent successes at the Chicago Art Institute, St. Louis Artists' Guild, and even his Nazi portraits—the paper went out of its way to note Vorst's recently published condemnation of the Nazi movement. An oil landscape by Vorst, *In the Vogges Mountains*, appeared in Utah at the same time as part of an exhibition at the Springville Museum, 50 miles south of Salt Lake City. (One suspects that the title is a typographical error and the painting depicts the Vosges Mountains, which compose the border between eastern France and Germany, a site he visited in 1932.) The article mentioned that Vorst was visiting Utah for a short time and planned to "do some sketching in the vicinity." To date, only a handful of the prints exhibited have come to light. Our knowledge of them comes from the article and the reproduction in the paper of two of the works from "more than 40 prints in the exhibit here, among them a striking series depicting the Passion of Christ, with other New Testament themes, Christ walking on the water, with the woman at the well, the wedding at Cana, and with the fishermen."[20]

Presumably, these 40 prints included the series of linoleum cut prints on the Passion that Vorst made between 1927 and 1929. Whether all of the works were created in Germany or a combination of prints made in Germany and St. Louis is unknown. Stylistically, a few of the known works represent a departure for Vorst and point toward his American approach to art making.

Christ Walking on the Water (see Fig. 78, center) depicts men in a sailboat who are struggling to gain control of their vessel, while in the distance Christ stands atop the waves placidly. Compared to his German prints, this image shows Vorst experimenting with a new way of storytelling; they read less as symbols and more as living beings. The figures are in motion. Color contrasts remain starkly black and white, but it is difficult to read positive and negative space in the new prints. The effects are more atmospheric than ever before. It requires more contemplation to determine what the artist

is trying to say. He is inviting the viewer into a conversation. The marks themselves are softer, and less graphically incisive.

The second illustrated linoleum cut is *At Work* (see Fig. 78, right). It is tempting to call this a pivotal composition, a harbinger of the themes of labor and the American worker that will consume Vorst's imagination for the rest of his life. And yet there is nothing else quite like this image in Vorst's output. In this horizontal print, a group of men are gathered around a loaded wagon. Perhaps they are Mormon pioneers who crossed the plains in the 1840s from Illinois to what would become Utah. None of the men stands upright; they all lean forward to push the company along. The workers are shown in silhouette. They are faceless, with heads bowed to their task. The one exception is a man shown in profile, at the center of the picture, whose facial features are more readily discernible. It is a rugged image, with vertical lines in the background bumping into horizontal marks that represent the road on which they travel.

Earlier newspaper articles about Vorst in America were mostly announcements of exhibitions. None crossed the boundaries of journalism into criticism. Here, again, the Salt Lake paper offered the first published, if brief, description of the artist's work, "A number show the artist's interest in the workers, and still others are of symbolical nature. In sharp blacks and whites, with no intermediate tones, the artist obtains startling effects."[21]

Vorst returned to St. Louis, and on the way home—the record is unclear whether in 1934 or on his earlier trip from Utah in 1931—the artist was robbed.

STE. GENEVIEVE ART COLONY

Travel was an important influence for American artists in several ways. Enclaves called art colonies developed at the turn of the century that served as magnets for recognized artists and students as well. These developed predominantly in small towns away from urban centers—Provincetown, Taos, Old Lyme, Bucks County, the MacDowell Colony, Monhegan Island, and Woodstock, among many others. By the 1930s, art colonies served as sites for artists to work together, socialize, advance philosophies that would inform their work, gain additional instruction, and earn much-need-

Fig. 80, above Joseph Paul Vorst, *Binding the Wheat*, 1940, oil, whereabouts unknown, photograph, Carl and Carole Vorst, St. Louis, Missouri.

Fig. 81, right Joseph Paul Vorst, *The Benton Family*, 1940, lithograph, 17 x 14.75 in., Carl and Carole Vorst, St. Louis, Missouri.

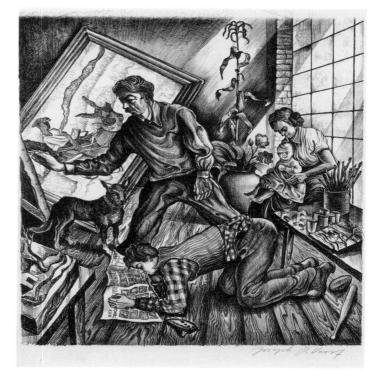

ed money by training younger artists in summer schools and providing lodging for seasonal artists/residents. These colonies were situated in striking natural settings, and an important consequence of the colonies was a new emphasis on *plein-aire* painting by American artists who captured the contemporary landscape. During the summers, in particular, as city dwellers escaped the heat and vacationed near the shore, in the woods, or in the high desert, art colonists mirrored their exodus.

The Great Depression changed that pattern. In the early 1930s, it was still relatively inexpensive for an artist to spend the summer at a colony, but the Depression brought restrictions of travel that became financially prohibitive. A few artists from Missouri who had previously spent their summers at the Cape Cod Colony in Provincetown looked for new opportunities within the state. St. Louis artists Aimee Schweig and Jessie Beard Rickly had been frequent guests in Provincetown. Both of these women studied under Charles Hawthorne. His death in 1930, along with the growing infeasibility of travel, caused them to look closer to home. Schweig and her daughter Martyl had been to Ste. Genevieve to paint recreationally. In the summer of 1932, Rickly and Bernard Peters and their families—at the urging of Frank Nuderscher, director of the Ozark School of Art in Arcadia, Missouri—moved to Ste. Genevieve for the season and established the Ste. Genevieve Art Colony. They rode a rising swell of interest in American Scene Painting called "The New Wave" in exhibitions in Chicago and elsewhere, circa 1932.

After establishing the colony, they founded a school two years later, in 1934. The combined vision of all of the above artists was to bring the experience of a major art colony to the Midwest. At the time of its founding, new all-weather roads between St. Louis and Ste. Genevieve made expedited travel much more attractive than it had hitherto been.

None of these artists lived in Ste. Genevieve. Of the eventual dozens of artists who were part of the art colony, only two were natives of the village: Matthew Ziegler, who raised goats, chickens, and bees on his farm; and his aunt, Sister Cassiana Marie, a Roman Catholic nun, who participated in the colony during visits to her family.[22] Ziegler and his family owned the Mammy Shaw House, where several of the artists boarded and created studios.

St. Louis has a long and troubled history of racism, and Ste. Genevieve, too, on the eve of the establishment of the art colony, became embroiled in violence and controversy. On October 12, 1930, two black men and a woman fought and killed two local white male quarry and kiln workers. They said they were defending the woman against rape, but angry citizens of Ste. Genevieve retaliated by driving the 200 African American residents out of the small town, threatening lynchings. Vigilantes were intent on mob violence, and they conducted kidnappings and intimidation. This event, which became a national press story, crushed the racial harmony that had prevailed in Ste. Genevieve for decades.[23] The art colony responded; it came to include, philosophically, a newfound civic importance as a way to redeem the reputation of Ste. Genevieve and bring back tourism to its quaint village.

The Ste. Genevieve Summer School of Art was organized by the colony in 1934. Students were recruited from local high schools, the majority of whom were upperclassmen. There were also adult students. It was advertised as providing instruction in "outdoor and studio painting from the Model, Landscape and Still Life…with class and individual instruction…by teachers of wide reputation and recognized ability."[24] Tuition for the full term of six weeks was $30; food and lodging started at $7 per week.

Every day but Saturday, classes began at 7:00 a.m. Students painted outdoors until 10:00 a.m. Studio classes continued from 2:00-6:00 p.m., three times a week, and time was given each afternoon for a "free creative period." Sundays were unscheduled. Instructors provided lessons and demonstrations, and the demonstration painting that resulted was raffled off to students of the school at the end of the season. At the end of each week, the students' work was criticized, and the instructors gave directions for new work to be completed during the coming week. By the mid-1930s, the colony's instructors included a few of the most important artists in America.

It was more than a school, however. The professional artists found in the colony a place to work and engage with each other. They benefited financially as they became the instructors of the School. Significantly, it provided a gathering of works to display before the public. At the end of each summer, a large exhibition was announced, and hundreds of visitors attended from Ste. Genevieve, St. Louis, and increasingly farther abroad. The exhibitions were important,

particularly for the female artists. At the time, they had fewer opportunities than their male colleagues to show their work. The Ste. Genevieve Art Colony, founded by women, was especially nurturing of female artists.

The colony also brought tourism and attention to the town. Students set up easels in town squares as well as in the countryside. Local shopkeepers and citizens were transformed into artists' models. It revitalized the area. At a time when other historic communities were in decline, the colony provided Ste. Genevieve recognition, protection, and an infusion of resources.

Vorst was closely aligned to the Ste. Genevieve Art Colony, and it became a highly important entity for him, professionally, socially, and intellectually. He was traveling in Germany when it was founded, and the second summer of its existence, he was in Utah. But in 1934, he exhibited with colony artists at their third annual show. Almost surely, he was intimately aware of its progress from the beginning, given that Matt Ziegler was a relative and friend, and the Ziegler's Mammy Shaw House was its epicenter. When Vorst visited, he stayed on the Ziegler farm. Among the other artists at Ste. Genevieve, Vorst was known as "the philosopher."[25]

A new class was added to the summer curriculum in 1936. The public's interest in painting for public spaces—and the artists' interest in government commissions of it—led to the creation of a mural class. Five student members of the class went on win commissions for post offices. Other members of the colony, including Vorst, were to become muralists for numerous government programs as well. In fact, Ste. Genevieve grew to become a crossroads of these commissions.

More than anything Vorst learned or taught in Ste. Genevieve, however, lasting changes in his life came about through the artists with whom he taught at the colony, particularly Thomas Hart Benton and Joe Jones.

"THERE'S JUST BENTON"

One day in Kansas City, Missouri, a stranger knocked on Benton's door. "Are you Tom Benton, the artist?" he asked. After Benton answered, Joseph Paul Vorst said, with a considerable German accent, "I want to meet us."

Fig. 82 unidentified phogorapher, Vorst (left) and Benton (right), ca. 1936, inscribed, 11 x 8.5 in., Carl and Carole Vorst, St. Louis, Missouri.

Benton later wrote about the experience of meeting Vorst for the first time,

> After I became used to [his] accent, however, I saw the man was even more interesting than his words. This was extraordinary. Accent or not, very few people apart from farmers or workmen are more interesting than their words, which means generally that they're not interesting at all. As my visitor talked I caught the idea I was up against the rare case of a professional person who had his eye on things rather than on phrases. I saw he was not trying to concoct meanings and values but was trying to find out what was. Having lived for a long time among professional people, artists, writers and politicians, I said to myself, "Here's something."[26]

The two men—who could hardly be more different in background, in reputation, wealth, or temperament—became friends. For one thing, Benton loved Vorst's sense of humor. Vorst knew Benton's work, was influenced by it, and considered Benton the high water mark for American art at the time. Asked to make a list of the best "American Scene" artists of the day, Vorst replied that there was no list, "there's just Benton."[27]

The quality that most endeared Vorst to Benton was the former's adaptability:

> Joe was willing, even determined to remake himself and the art he had learned in the new experience of a new land. He was not out to reform, recultivate or to bring his new environment up to any set of cultural notions hanging over from his European past. He was out to be an American and see America and he wanted to paint under the pressure of that being and seeing.[28]

Among Vorst's papers are found photographs of Benton and of his wife and family. They became friends and remained friends. Appropriately, the handiest visual documents of their connection are artworks. Benton sketched Vorst and inscribed the drawing, "To Joe, Yours, Tom H. Benton" [(Fig. 150)]. Vorst made a lithograph of the entire Benton family in his Kansas City studio. It belies an effortless ease and storied acquaintance. Benton had married Rita Piacenza in 1922. She emigrated as a teenager from a small village in Northern Italy where her family subsisted in a two-room home on the earnings of her father's copperworking shop. Emigration was something else that Vorst and the Bentons had in common.

Vorst's 1940 lithograph, *The Benton Family* [(Fig. 81)], (variously known as *A Family Picture* and *Studio, Benton*) shows Benton, approximately 50 years old, at the easel painting. His son, Thomas Piacenza Benton, is on the floor reading a Dick Tracy comic in the newspaper; Rita sits on a bench in front of a wall of windows with their toddler daughter, Jessie, on her lap; and the family dog, Jake, stands under Benton's upraised arm. The domestic scene includes children's toys, artist's tools, and finished paintings leaning against the wall (of a farmer and a Missouri mule). A lone stalk of corn is growing in a pot with some flowers. This is not Benton, the garrulous, American art star; it is a man at work with his family surrounding him—an intimate, if ordinary, moment.

It is also a staged moment. All of these are symbols rather than realistic depictions of a single event. In fact, Benton hated interruptions while working; to say nothing of having a dog and wife and children underfoot as he painted. The Benton household had to be quiet; the studio, which was outside the main residence, was a place of focused solitude.

A few months after Vorst returned from Utah in 1934, Benton became the most famous painter in America. The moment can be pinpointed to a single event: the publication of a cover story, "The U.S. Scene," in *Time* magazine, December 24, 1934 with Benton's self portrait of 1925 on the cover. It was the first time an artist had ever appeared on the magazine's cover, a space previously reserved for politicians and business leaders. Inside the publication, which reached an audience of half a million weekly, editors had reproduced paintings in color—again, for the first time in its history—and profiled artists around the country who were working with similar themes. The article codified a group of painters as representatives of a new and important school of American painting: Regionalism.

The main three painters of this Midwestern movement were Benton (Missouri), Grant Wood (Iowa), and John Steuart Curry (Kansas). In part, it was a calculated reaction against modern art ideas imported from Europe. The scandal of the 1913 Armory Show continued to reverberate in the U.S.—with its shocking works by Pablo Picasso, Henri Matisse, Wassily Kandinsky, Marcel Duchamp, and others. The article began: "Few years ago many a good U.S. artist was content to borrow from France, turn out tricky, intellectual canvases which usually irritated or mystified the public. Today most top-notch U.S. artists get their inspiration from their native land, find beauty and interest in subjects like Kansas farmers, Iowa fields, Manhattan burlesques." It added, "In the U.S. opposition to such outlandish art first took root in the Midwest…. Of these earthy Midwesterners, none represents the objectivity and purpose of their school more clearly than Missouri's Thomas Hart Benton."[29]

As Henry Adams, the author of Benton's biography, *Thomas Hart Benton, An American Original,* points out, the *Time* article is a bit of a concoction. To suggest that these artists represented a unified school of painting ignores the fact that when the artists were first associated together in 1933

in a 35-painting museum exhibition at the Kansas City Art Institute, organized by Maynard Walker of the Ferargil Galleries in New York, Benton had never even met Wood. Nor were these artists all residents of the Midwest. Curry lived in Connecticut and Benton in New York, although Benton fled New York City famously in a huff in 1935 and moved to Kansas City.[30] Only Wood lived in his home state. Their painting styles were entirely different, to say nothing of their politics. It was a pairing of convenience. They shared only subject matter: images of America. But that reading, too, is suspect.

Before the *Time* story, these artists' works, such as Wood's *American Gothic*, Curry's *Baptism in Kansas*, and nearly all of Benton's works, particularly his murals such as *America Today and The Arts of Life in America, A Social History of Indiana*, were widely viewed as satire. Afterwards, the same images and those that followed them were transformed in the public mind into Americana—patriotic, indigenous, even virtuous art.

The fashion for paintings of gleaming, rising cities of New York, Philadelphia, and Boston, made popular by the Realism movement, temporarily evaporated. Americans were suspicious of abstraction, but also of urban settings—certainly idealized ones. Distrust extended beyond nationalism or isolationism, however. The East Coast establishment and its artists came to be associated by many in America with the stock market crash itself. The antidote to the country's problems, it seemed, would come not from the same communities that brought the economy to its knees but from the heartland and its perceived simpler way of life. These were the images that the country rallied around, to the exclusion of others.

The return of Benton to Missouri, the establishment of the Ste. Genevieve Art Colony, and the new national popularity and admiration for Regional art crystallized in Vorst's mind into a newfound, artistic purpose and a way to shed his German identity and replace it with Americanism. Benton was a guest lecturer at the Ste. Genevieve Art Colony in 1936 and 1937, and he likely shared a studio with Vorst. (The latter noted that they were once studio-mates; this appears to be the sole instance of overlapping residency. In fact, some records suggest that Benton's so-called residency was actually a single day of teaching.) Photographs of a summer class in Ste. Genevieve show Benton expounding on artistic ideas in front of students outdoors, with Vorst acting as his assistant.

A number of works by Benton and Vorst have shared interests and subject matter. Visual themes that became Vorst hallmarks—including scenes of natural disasters, Missouri farmers and their work animals, and the plight of African American sharecroppers—appear in paintings by Benton, too. Even an image that must have felt personal to Vorst, a scene of Mormons being driven from Haun's Mill, was part of Benton's mural at the Missouri State Capital, *A Social History of Missouri,* completed in 1936. Vorst created mural sketches of the same scene sometime around 1939.

If one were to line up the paintings of the best-known Ste. Genevieve Colony artists—Joe Jones, Martyl, Miriam McKinnie, Joseph John Paul Meert, Jessie Beard Rickly, Aimee Goldstone Schweig, E. Oscar Thalinger, Matthew Ziegler, and Vorst—and place them alongside Benton and any number of Regionalists, many of the paintings would be marginally indistinguishable. These dozens of artists were exploring a new subject for painting, and given that they were working alongside each other and shared some of the same teachers, it is unsurprising that they have recurring imagery and overlapping philosophical approaches.

Many of the Ste. Genevieve artists had a common point of view, but Benton and Vorst were quite distinct stylistically. Vorst was only eight years younger than Benton. If anything, it is surprising that Vorst's work does not borrow more from Benton, who became a towering figure in the mid-1930s, especially in the Midwest. But Vorst's background in Germany and his work and study among European figures of importance in art immunized him, somewhat, from being overwhelmed by Benton's influence.

Their process of developing paintings was markedly different as well. This is especially visible in the way the human images were constructed. For each painting Benton made, he created clay figures of his subjects before he ever took up his paintbrush. In a very literal way, his paintings are visualizations of physical, three-dimensional models. Vorst worked quite differently. He took voluminous photographs of his subjects, the real people, places, and animals of Missouri, and these he used to compose and arrange figures in paintings. His works are considerably flatter and darker in tone and effect than Benton's, which frequently have a

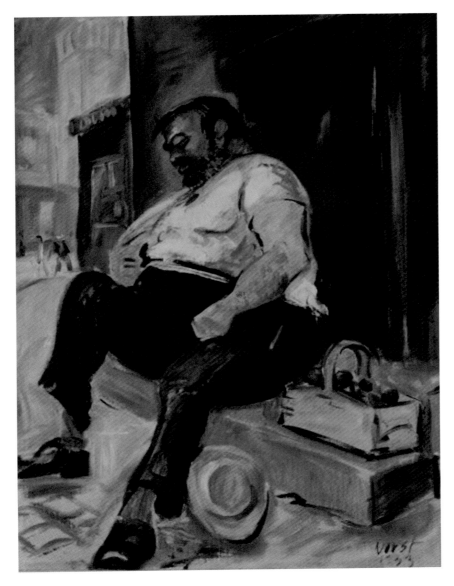

Fig. 83 Joseph Paul Vorst, untitled, 1933, oil on board, 26 x 20 in., private collection.

tabloid gloss of accessibility.

Vorst's photographs themselves do not aspire to fine art; they were candid shots, for the most part. They are like quickly-scribbled notes to himself. Rarely are the photographs carefully composed. Objects of interest are askew, sometimes unfocused, and often slightly out of frame. The dimensions of the photographs vary widely. But they likely served to ignite his imagination and assist memory. One can envision the artist outside, suddenly seeing a streaked pattern of clouds in the sky, for example, and pulling out his camera to capture the vista for future use.

The majority of Vorst's photographs show animals and people at work, but occasionally he selected people and posed them for specific paintings he was planning to execute. It was the exception to his painting process, but he was known to pose and costume models, as well. In the example of *Thine Is the Kingdom* (Fig. 181), a photograph exists of a model on his knees with hands clasped in urgent prayer. Notably, Vorst did not try to elicit emotions from these models. They are more like anatomical stand-ins and reference points.

Photography had a role in Vorst's creative process, but it is slightly surprising that there are not more photos of his American domestic life. In Germany, he had an abundant collection of photographs, preserved carefully in albums. In the United States, other than his trips to Utah in the early 1930s, Vorst let his paintings do the talking, as it were. Photography came to be a creative tool for him. And these were kept in a box, without much regard for preservation. While he captured some significant moments in his life and career in America—or other people took photos of him on special occasions—it appears that he came to view photography as less important socially.

REGIONALISM AND SOCIAL REALISM

There were implicit political agendas in Regionalism, but another branch of American painting took artists further ideologically, toward affecting public opinion and enacting change. These artists were the Social Realists, and for Vorst, their aims were personified by a young painter at the Ste. Genevieve Art Colony named Joe Jones.

Joseph James Jones was a local firebrand. The troubled son of a one-armed housepainter from St. Louis, Jones left school at age 15, ran away from home, got himself into constant financial and legal difficulty, and taught himself to paint. By his mid-20s, he had become the leader of the St. Louis John Reed Club, an organization with clubs scattered around the country whose purpose was to organize intellectuals and artists on behalf of the American Communist Party. (The American Communist movement began functioning as a single party in 1923.)[31]

The 1930s was an era of political and social agitation, one of the most politicized periods in the history of American art. To understand the art of the decade one must look at the politics with which the art was intertwined.

Across the political spectrum, art was seen as a political tool, with artists as powerful tastemakers. The overwhelming conditions of poverty and public anger in America were certainly components of its power, but the U.S.S.R., which was still viewed in the 1930s by many American intellectuals and workers as an idealized society and a paradise in the making, had profound influence on artists' visual output, as well.

The relationship between Regionalists and Social Realists is a delicate one. Both used local imagery as a way to promote Americanism. On the surface, they shared an interest in capturing the environments close at hand. Their views of Europe and history were also distinguishing characteristics. Regionalists craved an all-American vocabulary of painting, and they sought aesthetic liberation by turning their backs on European subject matter and styles, particularly Modernist ideas coming from France. Social Realists, in their way, were also determined to establish their American-ness, but they looked to the Soviet Union as a model to bring about revolutionary transformation to build a new America.

In each, artists were seen as powerful agents of change. Regionalists were confident that they could recast the look and feel of the nation's visual identity as they represented (and ennobled) the underrepresented lands and populations of its geographical center. The art of Social Realists was tandemized by political movements in order to stir up the passions of viewers to rise up against oppression—painters were workers, like any other workers in the new order. Although they sprang from similar impulses in some

ways, many referred to Social Realists as anti-Regionalists. Social Realism vented the rage that many Americans felt. One might say that these paintings were constructed of oil, canvas, and anger. The apt slogan of the era, "Art is a weapon," was common in the American Communist Party after 1930. The two groups were the most prominent new forces in 1930s American art. Both were propelled by the bleak circumstances of the time and a distrust and disdain for Europe and the aesthetic of art for art's sake.

Even these distinctions were fluid, however. Although the American Communist Party frequently gathered names of members as a way to show strength (even inflated strength), the truth is that many workers, intellectuals and artists among them, participated in or observed these activities on the fringes—and over time, they moved in and out of involvement with the Party. This was especially the case in the late 1930s and early 1940s, as the leaders of Russia, Germany, Italy, and Spain came under additional scrutiny, and the idealism of the movement faltered against the emerging press accounts of foreign totalitarianism.

Anti-immigration sentiment in the U.S. after World War I also drove foreign-born residents toward sympathy with Communism—whose U.S. membership was as high as 70% foreign-born. But that, too, was temporary. As immigrants became acculturated—and Vorst is a perfect example of this sentiment—they longed to shed the disparaging hyphen in their identity: their German-American, Irish-American, Italian- American selves. They wanted to simply be American.

The notion that artists labeled themselves permanently in one ideological camp or another is erroneous and is an anachronism of later U.S. history, particularly the hearings of the McCarthy era. Of course, some artists did identify as Communists permanently, but it is a mistake to label a generation of painters that way. Benton, the great-nephew and namesake of a legendary U.S. senator, had many leftist friends in the 1920s and exhibited with the John Reed Club until 1933, and his work was a frequent topic of discussion in the Communist Press. He said to a reporter in 1935, "I used to vote the Communist ticket more as a protest vote than anything else."[32] After Stuart Davis, a prominent artist and leftist, jealously attacked Benton in print after the *Time* magazine cover story, Benton responded and criticized Stalinism. This created an uproar inside the Party, and Benton became *persona non grata* and a target.

These debates became public because artists were creating public artworks viewed by large segments of the population that had rarely, if ever, entered fine art museums. Public mural projects highlighted the dangers of this volatile mixture. Artists who rallied for the upheaval of the traditional order of governments found courage in the powerful and combative work of Mexican muralists like Diego Rivera, José Clemente Orozco, and David Alfaro Siqueiros (although some Social Realists thought even they were too timid). Rivera's mural, *Man at the Crossroads* at Rockefeller Center in New York was destroyed in 1934 because the artist had depicted Lenin holding hands with the working class. It became a national debate, and among artists who were discovering political awareness, a call to arms.

Joe Jones experienced a similar episode in St. Louis. He taught a class for unemployed artists in a vacant wing in the old courthouse. The 30 students—approximately half of them were African American—created a 37' x 16' mural in chalk pastel that depicted "the life and revolutionary struggles of Mississippi River workers."[33] Police and conservative political groups tried to evict the class and destroy the temporary mural. Instead, Jones led a group of 400 workers who barricaded themselves in the classroom to protect the art.

Jones's work of the period was vibrantly radical and new, notably, *American Justice* (1933), *Roustabouts* (1934), and *We Demand* (1934). He once said, "I am not interested in painting pretty pictures to match pink and blue walls, I want to paint things that will knock holes in walls."[34] By the time he joined the Ste. Genevieve Art Colony as its director in 1936, Jones's works had already been exhibited at the Whitney Museum and the Museum of Modern Art in New York. Despite his youth, he was among the first Social Realists to gain entrance to the elite corridors of museums and galleries. His first one-person exhibition in New York at American Contemporary Art Galleries (ACA) in 1935 set off a landslide of recognition. His work was called brash, boisterous, and irrepressible. The annual exhibitions of Jones's work in New York galleries were widely covered in the local and national press. *Time* wrote a story about him, "Housepainter," June 3, 1935, as did *Fortune* and numerous others. By that time, he had become a Communist, and his arrival in New York was celebrated by *New Masses*, the Party periodical, with a symposium on February 2, 1936. The Metropolitan Museum purchased his painting, *Threshing No. 1,*

in 1937, making him, at age 28, one of the youngest artists ever to enter its permanent collection.

Jones altered the imagery and purpose of the Party's art to some degree. Previously, its publications had been full of political satire, propaganda, cartoons, images of hammers and sickles, and the like. Jones depicted the struggle of the working class irrespective of dogmatic fealty to a specific political movement by documenting abuses as they happened. It was art designed to agitate, but first and foremost, it was art. It was also informed and authentic. To create a series of paintings on agricultural harvests, for example, he went to work as a field worker himself. For Jones, artists from the Midwest represented authentic and unimpeachable points of view on society. In part, his credibility came from direct contact with and intimate knowledge of his subjects.

Political art bumped up against, complemented, and sometimes fought against governmental support of artists. Regarding the economic policies at the time, very briefly: President Hoover thought that the Great Depression was a temporary situation. As a free-market believer, his confidence led him to withhold federal money from state unemployment relief. President Roosevelt's election and his taking office in 1933 reversed those policies immediately with a flurry of legislation aimed at revitalizing the workforce through government intervention. One of these programs was the Federal Emergency Relief Administration, enacted and established in May 1933. This was a grant-in aid program. Rather than receiving money on the dole, which Roosevelt believed would sap the morale of the people over time, citizens applied and were granted state and federal funds in exchange for work.

Any student of American Art is well acquainted with the art programs and sponsorships of the New Deal. It had a transformative and instant effect on artists, communities, and the national character of art. It was not a single program, but a series of them spread over years: the Public Works of Art Project (1933-1934); the Treasury Section of Fine Arts (1934-1943); the Treasury Relief Art Project (1935-1938); and the Works Progress Administration Federal Art Project (1935-1943). It is common now to lump these together as WPA initiatives, but for Vorst and artists at the time, each program had specific parameters, personnel, sources, and goals. In some of the programs for artists, for example, qual-

ity mattered; in others, the objective was to put as many people to work as possible, regardless of their skill level.

The following are specific programs under the auspices of the four broad initiatives listed above: Civil Works Administration (CWA) and its program, the Public Works of Art Project; Section of Painting and Sculpture (renamed the Section of Fine Arts) under the Treasury Procurement Division; Treasury Relief Art Project (TRAP); Works Progress Administration (WPA), established by Executive Order in 1935 and funded by the Emergency Relief Appropriation Act; Federal Art Project (FAP); and a number of subsets of these programs administered by federal and state governments.

These were massive projects that touched nearly every community in the country in some way. By 1943, the year the program ended (as the nation's level of prosperity rose in advance of World War II), over 8 million Americans had worked for the WPA. At its peak, 3.3 million citizens worked for the program each month. This included projects beyond art. In some states, officials chose to use funding for entirely different purposes than art, such as the construction of community centers, buildings for national parks, bridges, highways, monuments, etc. But consider: the "WPA program produced 2,500 murals, 108,000 paintings, 18,000 sculptures, and 200,000 prints from 11,000 designs, as well as 2 millions posters and the 23,000 historic records of the Index of American Design."[35] It is almost unfathomable to imagine its effects on the public and the artists themselves. Vorst was a direct beneficiary of these programs.

There were numerous instances when federal art programs clashed with politically-minded artists and resulted in censorship and controversy. Artists could illustrate a nation in need of change, but at the same time, they were the recipients of the nation's largesse. Further, the system that the American Communist Party (CPUSA) decried was shown to serve the workers by providing them opportunity and funds to support themselves. In a way, WPA programs undercut the goals of revolutionary uprising of leftist politics and tilted the dialogue of the Social Realists away from propaganda to a role as truth-telling documentarians of the nation's suffering citizens.

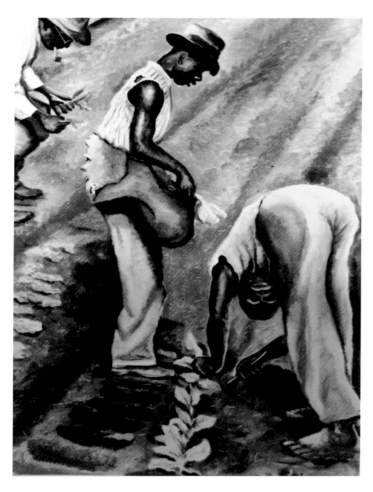

Fig. 84 Joseph Paul Vorst, *Plantin' Cabbage,* n.d., oil, where-
abouts unknown, photograph, Carl and Carole Vorst, St. Louis,
Missouri.

ENDNOTES

1. An extended family history of the Vorsts has been created by Louise Vorst Shepperd Wade whose mother, Myrtle, was Vorst's cousin. See http://myrtlevorstsheppard.com/odds-ends.php#JoeMatt created by Louise Vorst Sheppard Wade, 2009.

2. English translation of the German by Curtis Bajak.

3. Ibid.

4. James G. Rogers, Jr., *The Ste Genevieve Artists' Colony and Summer School of Art, 1932-1941*, Foundation for Restoration of Sainte Genevieve, Missouri, 1998, 40.

5. Membership record 202, March 21, 1931.

6. Joseph Smith, Jr., *History of the Church of Jesus Christ of Latter-day Saints,* ed. B. H. Roberts (Salt Lake City: Deseret Book, 1964), 3:175.

7. Ibid, 3:184-186.

8. See Fred E. Woods and Thomas L. Farmer, *When the Saints Came Marching in: A History of the Latter-day Saints in St. Louis,* (Millennial Press, 2009).

9. Mrs. L. Shelton, letter to Carl Vorst, January 16, 1989, cited by Grant Kniffen, *Joseph Paul Vorst,* 1989.

10. Orrick Glenday Johns, *Time of Our Lives: The Story of My Father and Myself* (Stackpole Sons, 1937; reprint: Octagon Books, 1973), 338.

11. Richard von Kuhlman and Lion Feuchtwanger, "Two Opposing Views of Germany as a Factor in Europe's Future," *Esquire*, February 1934.

12. *St. Louis Post-Dispatch*, August 9, 1936.

13. Letter to François Douglas (*St. Louis Globe Democrat*) from Paul Williams, director of Jefferson College, July 28, 1936.

14. This letter is undated, but it can be placed rather easily, given Slevogt's sudden death in 1932. English translation by Dwight Blazin, June 1, 2016.

15. English translation by Dwight Blazin, June 1, 2016.

16. "Joseph Vorst Named Art Supervisor at Jefferson College," *St. Louis Globe-Democrat,* August 9, 1936.

17. *St. Louis Globe-Democrat,* March 26, 1933.

18. Ibid.

19. Deedee Wigmore, *1930s-1940s Regionalism: Evolution of a Style*, exhibition catalog, D. Wigmore Fine Art, New York, NY, 47.

20. "German Artist's Block Prints on Display," *Salt Lake Tribune*, June 10, 1934, 117.

21. Ibid.

22. See Rogers, op. cit.

23. Kevin Sharp, "Joe Jones in Ste. Genevieve," *Joe Jones: Radical Painter of the American Scene,* Saint Louis Art Museum, University of Washington Press, 2010, 81.

24. Jessie Rickly and Aimee Schweig, "Ste. Genevieve Summer School of Art, 1935," a pamphlet advertising the 1934 session of the school, 3; cited in *The Ste. Genevieve Artists' Colony and Summer School of Art, 1934-1941* by James G. Rogers, Jr.

25. Rogers, op. cit, 92.

26. Thomas Hart Benton, "A Missouri Artist," essay for exhibition catalog, *Joseph Paul Vorst,* November 22-December 10, 1938, Charles L. Morgan Galleries, New York, NY.

27. William Edward Hoffmann, *op. cit.*

28. Ibid.

29. "The U.S. Scene," *Time* magazine, December 24, 1934.

30. Henry Adams, *Thomas Hart Benton, An American Original*, 1989, Knopf, NY, 216-221.

31. A comprehensive scholarly study of the topic is Andrew Hemingway's *Artists on the Left: American Artists and the Communist Movement, 1926-1956*, Yale University Press, 2002.

32. Henry Adams, op. cit., 225.

33. James G. Rodgers, Jr., op. cit., 30.

34. Scott Kerr and R. H. Dick, *An American Art Colony, The Art and Artists of Ste. Genevieve, Missouri 1930-1940*, 67.

35. Andrew Hemingway, op. cit., 79.

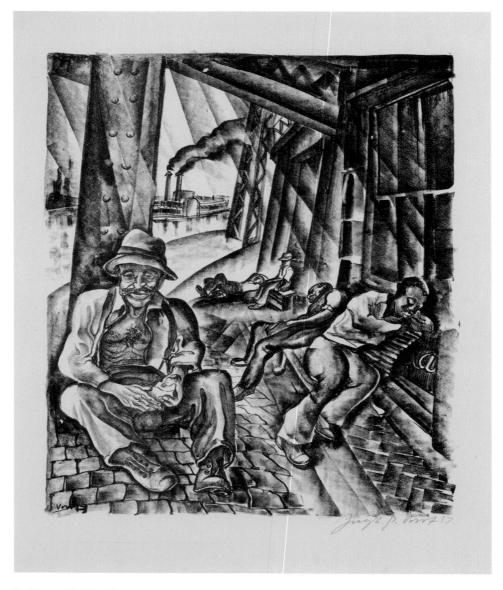

Fig. 85 Joseph Paul Vorst, *Under the Bridge, St. Louis*, 1937, lithograph, sheet size: 17 x 14 in., Saint Louis Art Museum, Gift of Rosellen McKenzie Weider 6:2011.

CHAPTER 5
"PICTURES CAN FIGHT!"

MOB LYNCHING

It may be informative to take a single political cause as an example of artists' advocacy and examine it using the artworks generated by American artists, Regionalists and Social Realists, Vorst, and his colleagues.

Mob lynching had been on the decline in the 20th century, but it re-emerged forcefully in the 1930s. Scholars have pointed to numerous causes for mob violence aimed at African Americans. Yet lynching included the murder of women, children, Native Americans, and Chinese, Italian, and Mexican immigrants, too. Leo Frank, a Jewish New Yorker living in Atlanta, was lynched in 1915 after a judge commuted his sentence to life imprisonment for the rape and murder of a young girl at his factory (he was posthumously pardoned). Nevertheless, most often, lynching involved black men murdered in public at the hands of white men. Lynching was more common than many have supposed. A recent multi-year investigation by the Equal Justice Initiative uncovered documented cases of "3,959 racial lynchings of African Americans in Alabama, Arkansas, Florida, Georgia, Kentucky, Louisiana, Mississippi, North Carolina, South Carolina, Tennessee, Texas, and Virginia between 1877 and 1950."[1]

Numerous race riots sparked throughout the country after World War I as well. One of the worst riots in American history took place in East St. Louis in 1917. It was the scene of the killing of many African Americans who had settled there to replace union workers. The NAACP estimated the death toll between 100 and 200 people (which included lynchings). In 1919, there were seven large race riots in the U.S. The Scottsboro Boys trial was yet another case that captured the attention of the wider public and highlighted the tensions of the legal system and mob justice. Nine young African Americans were framed for crimes in Alabama. This

was an especially divisive trial and highlighted the challenges that organizations faced combating social inequality.

Even a crime such as lynching divided organizations. The NAACP and the American Communist Party (CPUSA) were at odds philosophically (the NAACP viewed racism as a class issue; the Party saw it as orchestrated terrorism to force submission). Yet, the groups also overlapped. For example, the Communist Party organized the League for Struggle for Negro Rights in 1930. But in 1935, the two organizations were opponents because of the aftermath of the Scottsboro Boys trial (in 1931), for which the NAACP provided legal support of the victims rather than the accused men.

In 1935, two different anti-lynching legislative bills moved through Congress. The NAACP and the CPUSA each supported a separate bill. (Neither bill passed in the Senate, and indeed, no legislation on lynching has ever been passed in the U.S.) With the aim of garnering public support by exhibitions of artworks to bolster their causes, two anti-lynching art exhibitions were held in New York in 1935. The first was organized by NAACP director Walter White, with works by 38 artists titled *An Art Commentary on Lynching*. The two-week exhibition was held at the Arthur U. Newton Galleries at 11 E. 57th St., February 15 through March 2, 1935. Another gallery had initially agreed to host the show, but it pulled out at the last minute. This hasty reshuffling generated additional public interest and press, and this translated to a gallery packed with curious and sympathetic visitors. Some were physically overcome by the violence on display.

Immediately after the NAAPC's *An Art Commentary on Lynching*, another exhibition on the same topic took place downtown at the American Contemporary Art Gallery on 8th Street in Greenwich Village, from March 3-16, 1935. This second exhibition, *Struggle for Negro Rights,* was organized

by the John Reed Club, the Artists' Union, and four other organizations affiliated with the Communist Party. Forty-four artists loaned works for the show; five artists exhibited in both shows. The exhibition catalog featured an introductory essay written by Angelo Herndon titled, appropriately, "Pictures Can Fight!" An undercurrent tone of *Negro Rights* was the Communist Party's impatience with the NAACP and an indictment that its middle-class-oriented agenda was not radical enough to be transformative.

Throughout the Harlem Renaissance (which began after World War I and continued into the 1930s), poets like Langston Hughes and other writers employed lynching and its imagery as one of several recurring themes in powerful works of poetry, fiction, and essay. (Hughes served as president of the CPUSA's League for Negro Rights.) Painters came to the subject of depicting lynching somewhat later than the writers; they also created works that hinted at the crime without directly showing victimization. But *Struggle for Negro Rights* and *An Art Commentary on Lynching* proved that artists could harness their outrage and engage the public with an aim to affect change.[2]

The artists who participated in these two exhibitions included some of the most prominent in the country. The largest painting in *Art Commentary* was Thomas Hart Benton's *A Lynching*. Joe Jones showed his work, *Lynching* (now lost) not with the NAACP, but at ACA Galleries. These were not fringe exhibitions. In addition to Benton and Jones, participating artists included John Steuart Curry, George Bellows, Reginald Marsh, Isamu Noguchi, José Clemente Orozco, Paul Cadmus, Louis Lozowick, Harry Sternberg, Julius Bloch, and many others. It is also worth noting that a number of the artists were Jewish, and their immediate experience with anti-Semitism informed their sympathies with racism of all kinds. Further, many of the artists commonly used the imagery of the crucifixion in their works related to lynching and thereby imparted a Christian zeal into their documentation of violence.

Vorst as yet had not shown his work in New York City, but he created an image, *Gallows* (Fig. 86), that easily fits into the group of Social Realists and anti-lynching, likely painted around this time. In this undated work, Vorst paints the aftermath of a hanging. A makeshift scaffold is partially surrounded by a loose timber structure. High above is an empty noose, and the smoke from a fire directly below the rope wends its way up into the sky and converges with white clouds against a darkened night and full moon. The site is on a hill alongside a river, and in the painting the men and women descend down a path in single file, away from the gallows. A woman has collapsed into the arms of an old man, and a Missouri farmer (noted by the large-brimmed hat that Vorst frequently used as a symbol of his adopted state) sits on a log fence, his head bowed. At the far right, a Missouri mule sips innocently from a trough of water.

A number of symbols appear in the image. These include the mule, the farmer, the river, and a dead tree whose leafless branches reach upwards to the sky. Perhaps the most central symbol of all is the telephone or power line pole that stands atilt, between the figures and the gallows itself. It is a long, thin pole, with a crossbeam at the very top that echoes the cross of the crucifixion. Benton used this device, too, in his painting *A Lynching*, shown in the *Art Commentary* exhibition of 1935. In that work, a man tied to a cross writhes as men stoke a fire below him. In the Benton painting, a distant telephone or power pole is starkly lit in contrast to the darkness around it. There are two crossbeams, however. Vorst's single beam reads unmistakably as a cross.

ACA Galleries, the site of *Struggle for Negro Rights*, had become home base for the Social Realists. It was highly important to them professionally. Founded in 1932 by Herman Baron (co-founded by Stuart Davis, Adolf Dehn, and Yasuo Kuniyoshi), it was closely identified with leftist politics. The John Reed Club became involved with ACA very early. The gallery's first exhibit on November 7, 1932 was organized by the JRC. At the time, there were few galleries showing American artworks in New York: Alfred Stieglitz's An American Place and Edith Halpert's Downtown Gallery are notable examples.

In April 1935, shortly after the anti-lynching exhibitions, Baron and a faction of the John Reed Club discussed the idea of bringing far more artists together for a larger gathering than had participated in the earlier NAACP and ACA exhibitions. Their purpose was to discuss art and culture and the world economic crisis. Clearly, this would involve artists whose politics lay broadly across the spectrum. The following month, on May 18, 1935, the first meeting took place at the American Artists' Congress. Twenty artists participated. Stuart Davis was initially the executive secretary but later became the chairman. During the summer, the group met

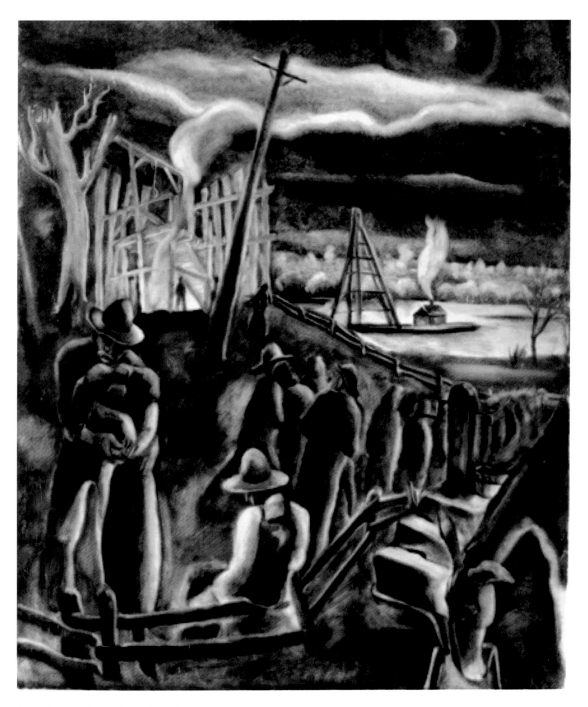

Fig. 86 Joseph Paul Vorst, *Gallows*, ca. 1935, oil on panel, 30 x
25 in., courtesy Treadway Gallery, Cincinnati, Ohio.

each Friday night at ACA Galleries. Among their first tasks was to draft a manifesto.[3]

By August, a Call had been drafted and was published in the October 1 issue of *New Masses*. The organization was growing. In August, it listed 56 artist members, but by October, that number had grown to 114. When the organization held its first official meeting, it boasted 401 members.

The organization prepared its Call to be signed. It was titled "American Artists' Congress against War and Fascism." In February 1936, the three-day Congress was held in New York City in two locations, Town Hall and at the New School of Social Research, and the document was presented to artists. This was a milestone event that included hundreds of leading American artists as well as a delegation of Mexican muralists. The American Artists' Congress presented the Call to the artists, and more than 400 of them signed it, including Vorst.

The signatories are a who's who of American painters; many of them had not previously shown an inclination toward the political. The impetus referenced in its title aimed to combat war and Fascism. It has been categorized as an anti-Fascism document—and indeed it refers to contemporary events in Italy and Germany—but it had a purpose from which the artists in America would benefit much more directly.

The manifesto began by describing the perilous state of the professional artist whose "income has dwindled dangerously close to zero." It noted their predicament given a loss of support by "dealers, museum, and private patrons." And it stated that even the government projects benefitted only a small number of artists—even that help was temporary.

The central paragraphs of the document cited specific and general injustices, censure, civil liberties, and discrimination that were constant reminders of the erosion to "living standards, to civil liberties, to workers' organizations, to science and art" as well as global peace and security. Finally, it called upon artists, directly:

> We artists must act. Individually we are powerless. Through collective action we can defend our interests. We must ally ourselves with all groups engaged in the common struggle against war and fascism.

There is a need for an artists' organization on a nation-wide scale, which will deal with our cultural problems. The creation of such a permanent organization, which will be affiliated with kindred organizations throughout the world, is our task.[4]

It was a utopian proposal formed in dark times, but it never truly became a nationwide artists' organization. For a few years, it served to rally artists to various causes, to protest, urge, and inspire action. The American Artists' Congress continued through 1941, although realistically, its accomplishments and influence were largely symbolic. By 1939, the organization had more than 900 members, but in 1940, it backed the Russian invasion of Finland—it was always closely affiliated with the CPUSA—and its members began to leave. It merged with other artists' societies, then dissolved in 1941, as the U.S. prepared to join Allied forces in World War II.

Vorst's signature on the "American Artists' Congress against War and Fascism" document marked his formal introduction to the art world of New York City. It is unclear whether he was in attendance at the Congress meetings, but the assumption is that he was present. Four hundred members attended from 28 states; 2,000 were at the opening meeting and hundreds more were turned away when the building exceeded its capacity.[5] At roughly the same time, from November 1, 1935 to January 6, 1936, Vorst exhibited a lithograph, *The Picnic* [Fig. 91] at the Fifth International Exhibition of Lithography and Wood Engraving at the Art Institute of Chicago.[6] But something even more significant to him took place in the summer of 1935: Vorst got married.

LINA WELLER VORST

Lina Weller was born October 31, 1900, in Böckingen, Germany. The city is near Stuttgart and approximately 230 miles southeast of Essen. Her parents were Karl Weller and Caroline Ernestine Frank. Weller was born slightly to the north, in the town of Neckargartach, and Frank was from nearby Heilbronn. Both of their families had resided in the surrounding area for generations. Lina met Vorst in St. Louis. She had emigrated from Hamburg to the U.S. in 1927. Her emigration form lists her occupation as housekeeper and emigrant. From New York, she went to St. Louis. According to the stories she later told her descendants, Lina and Jo-

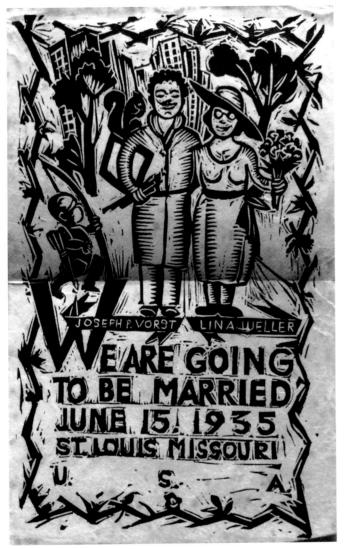

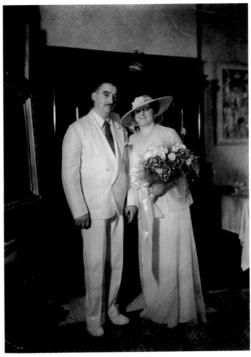

Fig. 87, above, left Joseph Paul Vorst, *We Are Going to Be Married*, 1935, linoleum cut, 12 x 10 in., Carl and Carole Vorst, St. Louis, Missouri.

Fig. 88, above, right unidentified photographer, Joseph and Lina Vorst in wedding clothes, 1935, Carl and Carole Vorst, St. Louis, Missouri.

seph Vorst met after Lina fell and injured her hip. Vorst was told about her, and he visited her in the hospital. Lina was a devout Lutheran, as were her parents. It appears that Vorst attempted to introduce her to Mormonism, but she was not interested. They were married civilly on June 15, 1935, by Elder C. L. Russell, a member of Vorst's LDS congregation.[7]

Before the wedding, Vorst created a large linoleum cut print that served as their wedding announcement [Fig. 87]. The image is of the couple standing with the city behind them. A blindfolded Cupid and his bow are to Vorst's right. The artist has a picture frame under his arm (with a squirrel perched atop it) and holds paintbrushes in his hand. His left arm is around Lina, who stands smiling with a broad-brimmed hat and eyeglasses and holds a bouquet of flowers. Below the couple, their names appear: "Joseph P. Vorst" and "Lina Weller." The announcement's hand-cut text is simple: "We are going to be married June 15, 1935 St. Louis, Missouri U.S.A."

This is not a picture of adolescent matrimony. Vorst was four days shy of turning 38 years old and Lina was 34. She is depicted in the announcement as semi-matronly. But even though there is a cartoonishness to the image, it manages to capture and foresee what Lina will be for his life and career: a steadying, constant presence.

The theme of family came to be important for Vorst. His interest in the study of his own German family through genealogy continued. He compiled charts with the names, dates, and locations of ancestors annotated with symbols to which he provided decoding keys. After the wedding, this study expanded to include the Wellers and their relatives. Perhaps this was a way for him to feel connected to people who were no longer a part of his day-to-day life. That is one interpretation. Another is a religious response, namely that Mormons have a great interest in family histories and the concept that all people are connected to each other through lineage. A third reading of Vorst's interest in family is that he grew up in a large household, and at a somewhat advanced age, he was finally starting his own.

ACA GALLERIES

After the anti-lynching exhibitions, the virtual anointing of Thomas Hart Benton and artists from the Midwest (Region-

alists) in *Time* magazine as leading American artists, and the attention that both Regionalists and Social Realists received from the broader public, Joe Jones brought together a group of St. Louis artists—all of them affiliated with the Ste. Genevieve Colony—with the idea of creating a group exhibition in New York made up exclusively of Midwestern artists. Joe Jones had enjoyed great success in a one-man exhibition at ACA Galleries in 1935, and he used this as a springboard for other St. Louis artists, including Vorst, to make their debuts in New York, as well.[8] Jones was selfless in his desire to share the spotlight with Missouri colleagues. He wrote to his New York gallerist, Waynard Walker, "I don't think I shall ever be completely happy about my own success untill [sic] my fellow artists have a decent chance to prove their usefullness [sic] to society."[9]

Jones, Vorst, Fred Conway, E. Oscar Thalinger, and James Turnbull organized a search committee for artists. They produced an open call to uncover "a representative and alert group of Middle-western artists who are vitally responsive to the socio-economic, environmental, and natural forces of life about them, and who are making use of this material for the subject matter of their art." They sent out a letter to artists on January 15, 1936, which continued:

> Because of the vitality, the significance, the fertility, of this subject material of the interior, the East is now looking toward this part of the country for the nucleus of an American art—a genuinely native and typical art, which not only interprets the region or locale, in its part or its present evolution, but reflects as well the dynamic transition in the social organization and the individual life. Not only has the socio-economic catastrophe affected our art, but the impetus of Post-Impressionism has vitalized creativity, giving to the intuitive and sensitive craftsman a fresh realization of the possibilities for creative work today in all section of the country, but more particularly in the large and neglected area of the Middle West.[10]

The organizing committee's announcement had immediately tilted the theme of the exhibition away from being a strictly geographical survey (Regionalism) and toward political commentary (Social Realism) by explicitly calling for artists' work that responded to "socio-economic" subject matter. They were not hunting for Missouri painting exclusively, however, as the exhibition catalog's introduction stat-

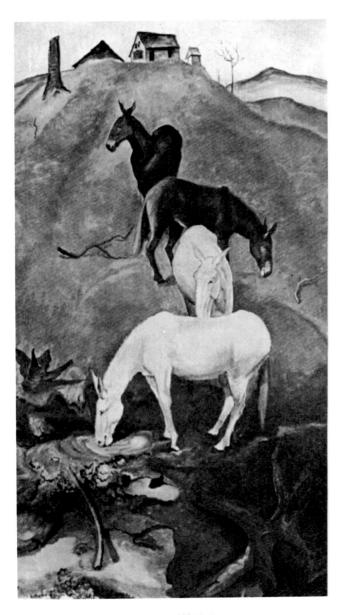

Fig. 89 Joseph Paul Vorst, *Missouri Mules*, ca. 1936, oil, where-abouts unknown, reproduced in *Joseph Paul Vorst Missouri Artist*, ca. 1938, Carl and Carole Vorst, St. Louis, Missouri.

ed, "For the first time in the brief cultural history of the Middle West, a group of artists banded together to assemble and to select a representative exhibition of paintings which might be agreed upon as works indigenous to their environments expressive of the life and the people about them. The work, which is offered here reflects and records the native life of Missouri, Southern Illinois, Arkansas, Kansas, Oklahoma and, in part, Tennessee and Texas."[11] Although artists from multiple states were included, the viewpoint of the Ste. Genevieve Colony artists became a proxy definition for Midwestern art for the East Coast establishment.

The exhibition came together quickly. *Paintings by Midwestern Artists* opened at ACA Galleries at 52 West 8th Street on May 4, 1936 and ran until May 16. The exhibition catalog accompanying the show provided the following justification for bringing these paintings to New York: "It is a natural and logical progression in our art life, this transition from the folk handicrafts and folk art of intrepid pioneers to a sophisticated and self-conscious art of local content that combines an inherent and deep-rooted understanding of the environment with a critical detachment and analysis."[12] Twenty-two artists were represented by forty-three works. Vorst showed three paintings in the exhibition, *Missouri Mules* [Fig. 89], *Hill Farmers*, and *Cotton Pickers*.

The timing was right. The public was curious about this new American art, and they embraced the exhibition and its artists. For those artists unfamiliar to the viewing public, like Vorst, the *Midwestern* show proved to be the gateway to wider recognition. The newspapers responded strongly to the ACA exhibition, as well. Vorst was singled out by the *New York Sun* and the *New York Post*. The latter wrote, "Joseph P. Vorst grows lyric over 'Missouri Mules' in a remarkably effective way. Altogether, there is a heap of talent burgeoning forth in the Mississippi Valley. This show gives a very good idea of its gathering power and direction."[13]

Of Vorst's three paintings in the exhibition, *Missouri Mules,* in particular, resonated with viewers. By August, it was hanging in the White House.[14] The vertical painting depicts four mules grazing and drinking from a stream at the base of a tall hill. Each of the mules—two white and two dark—are facing different directions. The first impression of the work is that the artist is presenting a bucolic and peaceful landscape, but there are clues scattered about of darker symbolic intent. The trees are all either bare of leaves or have

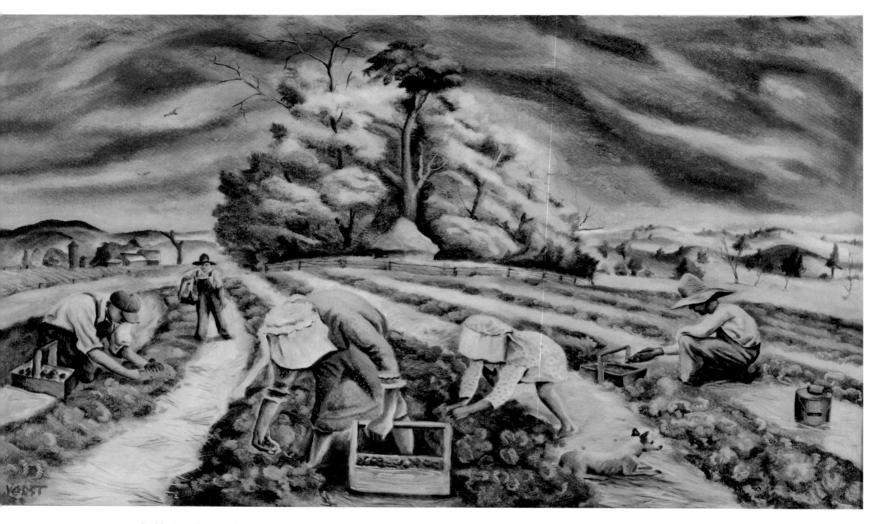

Fig. 90 Joseph Paul Vorst, *Strawberry Pickers*, ca. 1936, oil on
maonite, 27 x 37.5 in., Carl and Carole Vorst, St. Louis, Missouri.

Fig. 91, above, left Joseph Paul Vorst, *The Picnic*, ca. 1936, lithograph, whereabouts unknown, reproduced in *Allied ARTS in Greater St. Louis*, 1936, photograph, Carl and Carole Vorst, St. Louis, Missouri.

Fig. 92, above, right Joseph Paul Vorst, *Mississippi Fisherman*, ca. 1936, oil, whereabouts unknown, reprroduced in *St. Louis Post-Dispatch*, 1936, photograph, Carl and Carole Vorst, St. Louis, Missouri.

been cut down to their trunks. The mules stand amid deep furrows that are barren. Withered branches are scattered on the ground around the animals. The small house and barn perched on top of the hill appear empty. In fact, there is little life in the image aside from the mules.

Vorst made a colored pencil drawing of *Missouri Mules* (Fig. 102) as well. The composition is nearly identical, but the drawing is noteworthy because Vorst rarely worked in the medium.

In July and August, Vorst returned to the Ste. Genevieve Colony for its summer session, which consisted of 21 students. This was an especially important period for the colony. After a dispute between the founding artists Jessie Rickly and Aimee Schweig in 1935, Schweig was left to run the affairs of the school. She outdid herself and brought Benton to Ste. Genevieve for the first time, along with Joe Jones who was listed along with Oscar Thalinger as co-director. The school added a class for mural painting as a nod to the interest in Federal Works Projects, and it featured visiting faculty Lawrence Adams from Yale and five other regional figures affiliated with university art programs. Vorst was present at

the colony during the summer, as indicated by his photograph with Benton teaching a group of students, but Vorst entered into a career of teaching elsewhere that continued past a summer session.

A newspaper reported in 1936 that he conducted the Academy of Fine Arts, and it listed the address as 5599a Page Avenue. This was Vorst's home address. Seemingly, he set up an arts institution, at least in name, from his residence.

On August 9, 1936, Jefferson College in St. Louis announced that Vorst had accepted a teaching position with its institution. The College was part of the St. Louis Y.M.C.A., and it occupied all of one floor and parts of two additional floors. The *St. Louis Globe-Democrat,* ran an article about the appointment and provided the first interview with Vorst in print. The article was accompanied by a photograph of the artist and was titled, "Joseph Vorst Named Art Supervisor at Jefferson College" and ran under this subheading, "Artist Who Painted Hitler Chosen for New Course at 'Y' Institution."[15]

This article, while brief, sets the pattern for public expecta-

Fig. 93 Joseph Paul Vorst, *Trailer Camp,* ca. 1937, oil, whereabouts unknown, reproduced in *St. Louis Globe-Democrat,* 1937, photograph, Carl and Carole Vorst, St. Louis, Missouri.

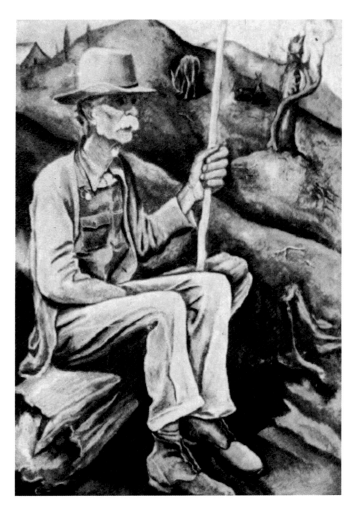

Fig. 94 Joseph Paul Vorst, *Prophet of the Ozark*s, ca. 1936, oil, whereabouts unknown, reproduced in *Joseph Paul Vorst Missouri Artist*, ca. 1938, Carl and Carole Vorst, St. Louis, Missouri.

tion of him and his work that would continue for over a decade. It is something of a template that appears again and again when speaking of Vorst, in the press. Almost without deviation, the first thing that local articles noted about Vorst was his German background. Then, he was linked to political figures in Germany. In response, Vorst next distanced himself from that past, and finally, the story shifted to his accomplishments in America, particularly those that could sway the public to a sense of local pride, artistic accomplishment, and American patriotism. It is logical to imagine that the first article about a recent immigrant should recount this history, but with Vorst, every article connected him anew to Germany.

The article of August 9, 1936 began with this sentence, "Joseph Vorst, the 40-year-old German-born St. Louis artist, who, on a visit to Germany in 1932 painting campaign portraits of Adolph Hitler and other Nazi leaders, has been selected to supervise a new course in applied arts…."[16] It continued and rehearsed the story of Vorst's 1932 trip to Germany and his commission to paint Nazi portraits. Next, Vorst went out of his way to describe the experience as an "unhappy one" and cites "his antipathy for the Nazis dates back to 1924…." Vorst told the story of landing the commission to paint the portrait of August A. Busch, noted other "major commissions," and pointed out that Vorst had been working "for three months as a WPA painter, drawing a top wage under WPA schedules," and said "'Missouri Mules' now hangs in the White House."[17]

The unspoken message here was that Vorst's German identity was inextricably tied to his art. This was not Vorst's message; rather, it was the insinuation of the press. Whether this response by the public spoke to their general fears of outsiders or to the specific and unfolding history of European war, the fact is that Vorst wished to be free of it and be all-in as an American artist.

In truth, his art after 1932 was not German stylistically, and the constant refrain of his German-born status did not align itself with his visual output. Vorst produced no images, after emigrating to the U.S., of German landscapes and subjects—other than the portraits he made on a brief return visit in 1932. He discarded the style of German Expressionism that he developed as a printmaker and even the German Impressionism of his education in Berlin. Nostalgia for the old country and a longing to recreate it in visual art, although

commonplace with artists who move from one country to another, are altogether missing with Vorst. The associations with Regionalists and Social Realists influenced his work, but philosophically, he had already made the leap to American ideals by the time he met Benton and Jones. His painted subjects—all of them—were local and highly identifiable as Midwestern American. He was not painting any generic horses, to give but one example, they were Missouri Mules. He was not painting any farm workers, they were Ozark sharecroppers and tenant farmers. He was specific: he was grounded in the landscape adjacent to the Mississippi River.

Paul E. Williams, the director of Jefferson College, had approached the City Editor of the *St. Louis Globe Democrat*, Francis Douglas, at the end of July about a potential article on Vorst. Correspondence indicates that Williams sought to place an article about its new Applied Arts Division and specifically about Vorst. Douglas made a strong case about the artist as an important figure worthy of an article. Still, the letter contained inaccuracies. He wrote, "A colorful personality, [Vorst] was forced to leave Germany because of trouble with the Nazi officials involving Hitler and Goering."[18] It is logical to picture the American public suspicious of Germans as Europe descended into war, but this unabating pattern slid toward stereotype and prejudice; Vorst left Germany, but he never truly escaped it.

In November of 1936, Vorst participated in a large survey, the first annual Missouri Exhibition, held at the City Art Museum. He was awarded an honorable mention for a lithograph described in the press as a "harvest scene with mules." But from November 15-30, 1936, Vorst experienced something more momentous: he had his first one-man exhibition of paintings in America. This took place at the Vanguard Gallery at 3520 Franklin Avenue in St. Louis.

The gallery produced a small brochure and checklist of the exhibition. The show consisted of 26 paintings. Some of the works have been lost, but a number of them remain and/or were documented by photographs. These titles hint at a Regionalist mode of presenting local scenes. It is as if Vorst were chronicling the activities of the area as seen in works such as *Strawberry Pickers* (Fig. 90), *Spring in Arkansas, Church Picnic, Wheat Harvest, Threshing Wheat, Blacksmith, A Young Cornfield, Boiling Sorghum, Riding to Town,* and *Apple Butter.*

Some of the paintings hinted at larger ideas, however. *Strawberry Pickers*, for example, quoted Millet's work, *The Gleaners* (1857). Vorst knew his art history, and it was common for him to refer to classical paintings. Several of these works spoke to a more politicized message than a mere chronicling of local events. These included *Limekiln Work* and *Hooverville Hills*.

Ste. Genevieve was known, among other things, for its limestone quarry. Throughout the summer of 1936, efforts were made to organize the laborers of the company into a union. Joe Jones was sometimes accused of inciting the action, but this is a questionable statement given the artist's limited time in the area. Still, this caused considerable difficulties for relationships between the locals and the artists in Ste. Genevieve, and it eventually contributed to the colony's decline.

Vorst was willing to engage in the imagery of labor, particularly the sharecroppers, beasts of burden, and manual laborers of the quarry. Even the images of wheat harvest held a certain social meaning at the time because Joe Jones' series on the subject drew considerable attention in New York, and for him, works of labor always equated to a Marxist message on the beleaguered proletariat. Furthermore, African Americans appeared frequently in these early Vorst works. According to local historians at the time in Ste. Genevieve, African Americans were "not generally welcome" in the historic community.[19] The art colony had an agenda of inclusion, however, and Vorst's paintings in particular were indicative of a broader attitude of acceptance and a personal commitment to social causes.

THE FLOOD

In the final week of December 1936, the rains began in the Ohio Valley. Warm, tropical air from the south collided with polar air masses from the north in irregular patterns and with an abnormally high barometric pressure. Over a period of roughly one month, the storms continued, and rivers rose to historic levels throughout Ohio, Tennessee, and Arkansas. Flooding is nothing new to the area of the United States where the Mississippi River joins with tributaries like the Ohio River. The worst flood in American history occurred in the spring of 1927 in the same area. To prevent a recurrence of its devastation, many levees and floodways were

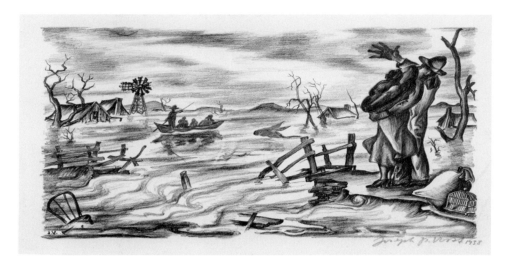

Fig. 95 Joseph Paul Vorst, *Drifters*, 1938, lithograph, 10.5
x 15 in., Carl and Carole Vorst, St. Louis, Missouri.

constructed by the Federal government, which altered the river's flow and brought unintended consequences of increased flooding in succeeding years. Nevertheless, annual floods were the norm, and cities in the 1930s had high city walls and levees intended to protect them.

The United States Weather Bureau estimated at the time that the 1937 storms brought 165 billion tons of water into the region, enough to submerge 200,000 square miles to a depth of 11 inches. St. Louis is 150 miles northwest of Cairo, Illinois, where the Mississippi and Ohio Rivers meet. St. Louis saw eight inches of rain during the storms, but Cairo received 22 inches.[20] The devastation was immediate and overwhelming. By January 18, 1937, the Ohio River began to overflow its banks. Martial law was declared on January 23 in Evansville, Indiana. By the 26th, river levels in Cincinnati reached 80 feet. Louisville, Kentucky received 15 inches of rain in 12 days, and 70% of the city was under water. 90% of Jefferson, Indiana, just across the river, was submerged.[21]

Entire cities were evacuated. These were winter storms, and they were accompanied by temperatures that dropped into the teens. The rain turned to sleet. Melting snowfall exacerbated the challenges, and rescue crews of several thousand WPA workers dispatched from Washington, as well as

Coast Guard and other responders, battled large chunks of ice that capsized their boats. Gas supplies were flooded and leaked into the rivers, which caught fire. The result was a horrifying scene: burning buildings recently capped in snow, sleet, and ice were now surrounded by a smoldering lake of contaminated water.

Hard choices had to be made. As the rivers continued to rise, cities realized that their walls 60 feet high and higher were insufficient. Levees were under strain as well, and officials decided to breach the levees. The U.S. Army Corps of Engineers demolished the Cairo levee. Although the action was aimed at saving the city, it came at a direct sacrifice of Missouri farmland. The immediate loss of crops was minimal, being in a fallow period before planting season, still, it was highly destructive to the land. As a countermeasure, the Federal Resettlement Administration initiated a program to help suffering farmers. Loans of assistance granted farmers and their families $18 a month until the next harvest. This money was paid to landowners, not to sharecroppers or tenant farmers. The result was that the workers of the land, who were already living on the edge of solvency, became impoverished. In all, 385 people died during the Great Flood of 1937. It is estimated that the damage was $500 million dollars (its inflation-adjusted amount today is about $8 bil-

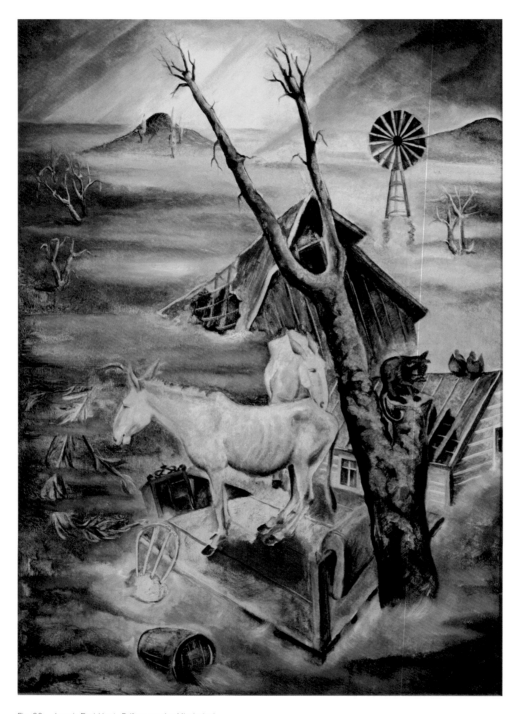

Fig. 96 Joseph Paul Vorst, *Drifters on the Mississippi*, 1937, oil on maonite, 36.5 x 27 in., Carl and Carole Vorst, St. Louis, Missouri.

lion). The flood made one million people homeless.

Vorst captured this calamity in his artwork. In 1937, he created a series of flood paintings and related prints that further solidified his reputation as an important artist of the region. Heretofore, the work of Social Realists had drawn upon injustice as their overriding theme—man was pitted against man, often informed by political systems that exaggerated the differences between classes and races and compensated them quite distinctly and unequally. In some ways, artwork based on the '37 Flood echoed those divides. Painters documented and highlighted the imbalanced ways that the disaster affected its citizens, particularly regarding remuneration. In Flood paintings, they were depicting parallel tragedies: the natural devastation of a flood and the social ruin of inequality.

It was an entirely logical theme progression for Vorst's body of work. Already attuned to the plight of the downtrodden, the agrarian Missouri landscape, and its inhabitants—including its animals—the artist was able to combine them into dramatic narratives that informed, illuminated, and documented recent tragedies.

A number of regional artists illustrated the flood as it was happening. Margaret Bourke-White's dramatic photographs captured residents of Louisville, Kentucky in January. In *The Louisville Flood* (1937), besieged residents line up seeking relief, in front of a billboard that ironically proclaims, "World's highest standard of living" and "There's no way like the American Way." And *Flood Victim, Louisville, Kentucky* (1937) shows men in makeshift boats rowing to safety, including one man who has created a boat out of three small metal washtubs.

Thomas Hart Benton was dispatched by the Kansas City Star to document the flood. The newspaper published numerous Benton sketches. These "notes," as he called them, were later developed further. In *Study for Spring on the Missouri* (1937), a family loads its belongings hurriedly into a mule-drawn wagon, its wheels mired in mud at the edge of a swollen river. In his autobiography published the year of the flood, Benton wrote, "Descriptions can give no sense of the dread realities of flood misery—the cold mud, the lost goods, the homeless animals, the dreary standing around of destitute people."[22]

Other notable 1937 Flood works include Jon Corbino's paintings, *Flood, 1937* (1937) and *Flood Refugees* (1938); Clarence Holbrook Carter's *Down River* (1937); and John Steuart Curry's tempera drawing, *Flood Victims, 1937* (1937). There are also sculptures, including Christian Petersen's *Flood* (1938) made of painted plaster and Seymour Lipton's *Flood, 1937* (1937), carved of oak. It appears that the impact of the Flood remained longer with Vorst than with these artists, however. It became a theme to which he returned for years.

The ACA Galleries exhibition of 1936 proved successful enough that it brought together another exhibition the following year. It opened in New York in early June, 1937. The galleries listed it as the second annual "Midwestern Artists Show." Vorst contributed two paintings for it, both of them flood pictures: *Flood Tragedy* [Fig. 97] and *Drifters on the Mississippi* [Fig. 96]. *The New York Times* remarked on them and contrasted Vorst's tone with that of other Regionalists, "Joseph Vorst of Missouri has depicted incidents of the floods. His refugees and fleeing animals are not seen romantically as were those in Curry's somewhat similar painting, but, rather, presented grimly as a raw event. Such works as these give the show rugged strength."[23] Other critics also responded to the show warmly. Some thought it was stronger than the 1936 exhibition, "with scarcely a mediocre canvas in the lot." Another paper noted, "…one of the most gratifying presentations of the whole season."

Critics were surprised and pleased by the artists' lack of sentimentality. An article in *The World Telegram* that reproduced *Drifters on the Mississippi* on its pages said, "But the work of the others [besides Joe Jones] is even more exciting because they come unheralded. There is, among them, Joseph P. Vorst whose "Drifters on the Mississippi" and "Flood Tragedy" are masterly in the amount of movement achieved in the composition, the utilization of every inch of canvas surface to plastic purposes, the high pitch of excitement sustained in the whole arrangement, the sure, deft draughtsmanship, and the shafts of clear, brilliant color illuminating the whole."[24]

Both of these works brought the artist cash prizes and recognition during the coming year. *Flood Tragedy* is Vorst's depiction of an African American family in a small wooden boat. They have survived the Great Flood of 1937. The majority of the surface of the painting shows a river with waves

that lap at the boat. The man looks anxiously toward the mooring of a dock while a woman is nursing a tiny infant behind him. The only possession aboard is a large chest. Seagulls swoop overhead, and the turbulent sky—a Vorst hallmark—appears to be easing with patches of sunshine. For such a dark topic, the image is remarkably light-filled. The tragedy is coming to an end, perhaps. But the emotional effects remain as seen on the faces in the picture. One imagines their ordeal. There are no oars or motor visible. Perhaps they have been at the mercy of the storm, and now they reach solid ground as expressed by a trinity of wooden pillars lashed together with rope alongside the boat, which has its own loose rope on its prow.

Victims of an entirely different sort are the subjects of *Drifters on the Mississippi*. In this painting, the artist shows the ravages of the disaster on farm animals. It is an interesting approach, and in the body of Regionalists' works, somewhat singular. The landscape is flooded. Only two small hills far in the distance escape the inundation. Visible are barren trees, a windmill, pieces of furniture, a wooden barrel, and a dilapidated red barn. A small house with part of its roof torn off and a wooden platform have become rafts for animals. Two white mules and a pair of roosting chickens look somewhat placid, balancing on them. A black cat licks its paw on the stump of a large tree.

Like *Flood Tragedy*, Vorst is showing the ending of the storm. He seems to be asking about the future. What will happen with these damaged structures? Who owns these animals? Who will take care of them now? The animals are safe, but there is no food in sight. Vorst's affection for animals is one of his defining personality traits. Mules are in nearly every picture during his early years in America, but there is almost always a black cat in the paintings, too—Vorst had a black cat as a pet named Schatze—and he seems concerned about animals in the face of economic upheaval.

Drifters on the Mississippi is disarming because it is slightly comic at first glance. It is, essentially, a painting of mules surfing. The work is divided by sharp, intersecting diagonals, and the only things that stand strictly upright are the animals, the windmill, and the hills; all else is askew. Is he presenting the animals as indomitable creatures or abandoned ones? As other of the human possessions have been destroyed, it is the livestock and pets that have outlasted the storm, seemingly, without help. It is also entirely possi-

ble, given Vorst's penchant for symbol and allegory, that this flood picture connects to the biblical storm of Noah's ark and the animals will be the first to repopulate a soggy world.

Both of these pictures were exhibited in New York in June, 1937 and then returned to St. Louis, where they were shown at the St. Louis City Art Museum from November 3-30, 1937. St. Louis tastes differed from those of New York. The critic Reed Hynds of the *St. Louis Star-Times* focused his comments about the exhibition with notes that it was free of the influences like Abstractionism and Marxism. The director of the Museum, Meyric R. Rogers, wishfully pronounced, "Abstractionism and the various other 'isms' have just about spent themselves."[25] Hynds found *Flood Tragedy* "somewhat less convincing" but wrote, "Vorst has made 'Missouri Mules' at once descriptive and beautifully composed."[26] The paper noted that in February, another exhibition, "American Show" would include Vorst's "Missouri Mules."

Vorst entered *Drifters on the Mississippi* in the "Forty-Eighth Annual Exhibition of American Painting and Sculpture" at the Art Institute of Chicago, and he received notice from Robert B. Harshe, director of the Institute on November 17 , 1937 that it had won first prize and an accompanying award of $250.[27] His reputation continued to grow. Harshe wrote to Vorst and requested *Drifters on the Mississippi* for a traveling show of forty-five paintings from January 27 to June 5, 1938 to museums in Flint, Michigan, Grand Rapids, Michigan, and Dayton, Ohio.

Flood Tragedy was also a prizewinner. The painting appeared at the Kansas City Art Institute, *Midwestern Artists Exhibition,* in February 1938, and it won first prize with an accompanying $100. The director of the Kansas City Art Institute, Rossiter Howard wrote to Vorst, "Your painting has power and evoked a great deal of praise at the opening of the exhibition yesterday."[28] Vorst loaned *Missouri Mules* to the Toledo Museum of Art for a summer exhibition in August 1937. As these paintings gained recognition, Vorst networked with the directors of regional museums. To them, he sent copies of his exhibition catalogs, and Vorst received correspondence acknowledging them and offering congratulations.

As the paintings traveled, Vorst stayed close to home. In the summer of 1937, Vorst taught during the session of the Ste. Genevieve Summer Art School. Although he had been affili-

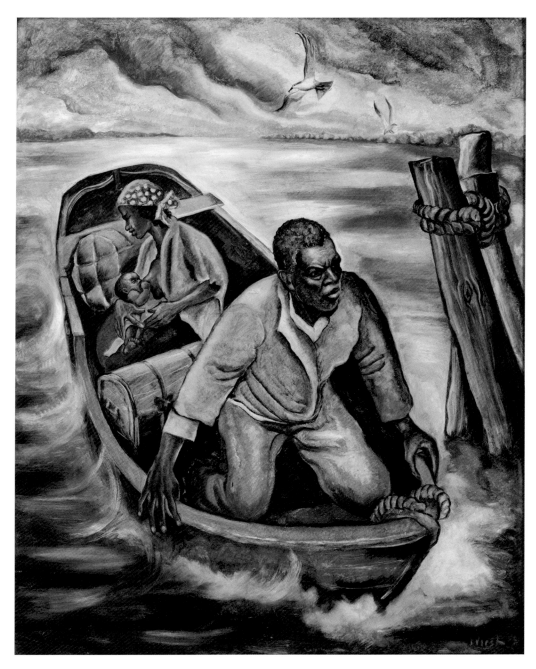

Fig. 97 Joseph Paul Vorst, *Flood Tragedy*, ca. 1937, oil, 56
x 50 in., private collection, Illinois.

ated with the Colony from the beginning, this is the first time that he was listed as an instructor.

Joseph Paul Vorst was a prolific artist. Not all of his work has survived, but the documentation of his gallery exhibitions, the artworks remaining in his estate, and works collected and published in the press indicate he worked steadily. Anecdotal information suggests that he was always laboring on new work. He and Lina stayed up late into the night. That was their common practice. She sat in a chair knitting as her husband painted.

The American Artists' Congress sponsored an exhibition in February, 1938 at St. Louis Art Center. It had been two years since the organization issued its "Call" in New York. Chapters of the Congress had sprouted up in cities around the country. For the St. Louis show, Vorst exhibited *Ironing* sometimes known as *Proud* (Fig. 99). In February, the Kansas City Art Institute awarded *Flood Tragedy* first prize.

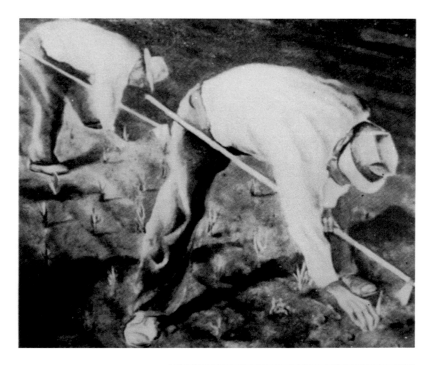

Fig. 98, left Joseph Paul Vorst, A *Young Cornfield*, ca. 1936, oil, whereabouts unknown, photograph, Carl and Carole Vorst, St. Louis, Missouri.

Fig. 99, bottom, left Joseph Paul Vorst, *Proud*, 1938, lithograph, 20.5 x 17.5 in., Carl and Carole Vorst, St. Louis, Missouri.

Fig. 100, bottom, right Joseph Paul Vorst, *Going to Town*, ca. 1936, oil, whereabouts unknown, reproduced in *Joseph Paul Vorst Missouri Artist*, ca. 1938, Carl and Carole Vorst, St. Louis, Missouri.

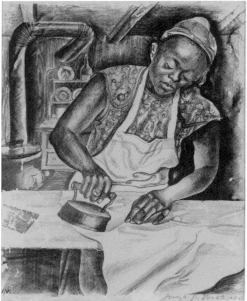

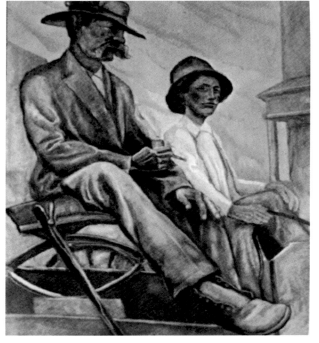

ENDNOTES

1. "Lynching in America: Confronting the Legacy of Racial Terror," report conducted and published by Equal Justice Initiative, Montgomery, Alabama, 2015.

2. See: Marlene Park, "Lynching and Anti-Lynching: Art and Politics in the 1930s," *The Social and the Real: Political Art of the 1930s in the Western Hemisphere*, Pennsylvania State University Press, 2006. Also, specifically about the NAACP exhibition: Margaret Rose Vendryes, "Hanging on Their Walls: An Art Commentary on Lynching, the Forgotten 1935 Art Exhibition," *Race Consciousness: African-American Studies for the New Century*, edited by Judith Jackson Fossett and Jeffrey A. Tucker, New York University Press, 1997. Also: Bryna R. Campbell, "Radical Regionalism in American Art: The Case of Joe Jones," *Regionalists on the Left: Radical Voices from the American West*, edited by Michael C. Steiner, University of Oklahoma Press, 2013.

3. See Matthew Baigell and Julia Williams, *Artists Against War and Fascism: Papers of the First American Artists' Congress*, Rutgers University Press, 1986.

4. *The Call for the American Artists' Congress, Town Hall, New York City, February 14, 1936, 8 p.m.*

5. Andrew Hemingway, op. cit., 124.

6. *Illustrated in Allied Arts in Greater St. Louis*, June, 1936; the brief article notes that the lithograph was "furnished through the courtesy of Barnes-Crosby Engraving Company, St. Louis."

7. Membership record 202, June 15, 1935.

8. Deedee Wigmore, op. cit., 37.

9. Correspondence from Jones to Green, January 1936, Green papers, cited in *Joe Jones, Radical Painter of the American Scene*, 2010, St. Louis Museum of Art, 87.

10. Grant Kniffen, "Joseph Paul Vorst," 10; citation of original flyer seeking artists for the ACA Galleries exhibition of Midwestern art, 1936.

11. Thelma Wiles, "Regional Art: Middle Western Paintings by Midwestern Artists, New York: ACA Galleries, 1936, 1.

12. Ibid.

13. Jerome Klein, "3 Group Shows of American Art Provide Variety," *New York Post*, May 9, 1936.

14. "Joseph Vorst Named Art Supervisor at Jefferson College," *St. Louis Post-Dispatch*, August 9, 1936.

15. *St. Louis Globe Democrat*, August 9, 1936 .

16. Ibid.

17. Ibid.

18. Paul E. Williams letter to Francis Douglas, City editor of the *St. Louis Globe Democrat*, July 28, 1936.

19. James G. Rogers, Jr., op. cit., 65.

20. Bennett Swenson, "Rivers and Floods," *Monthly Weather Review,* River and Flood Division, February 1937.

21. Christopher Havern, "The Great Ohio, Mississippi River Valley Flood of 1937," *Coast Guard Compass*, official blog of the U.S. Coast Guard, originally posted June 4, 2011; accessed August 26, 2015.

22. Thomas Hart Benton, *An Artist in America,* New York: Robert M. McBride & Company, 1937, 146-147.

23. Howard Devree, "A Reviewer's Notebook, Comment on Some of the Newly Opened Group Exhibitions and One-Man Shows," *The New York Times*, Sunday June 6, 1937.

24. *The World Telegram*, "Sudden Deluge of New Art… Critics by Surprise" 13, undated, c. June 6, 1937.

25. Reed Hynds, "City Art Museum to Show Work of St. Louis Artists," *St. Louis Star-Times*, November 2, 1937.

26. Ibid.

27. M. V. Kohnstamm Prize.

28. Correspondence from Rossiter Howard to Vorst, February 7, 1938.

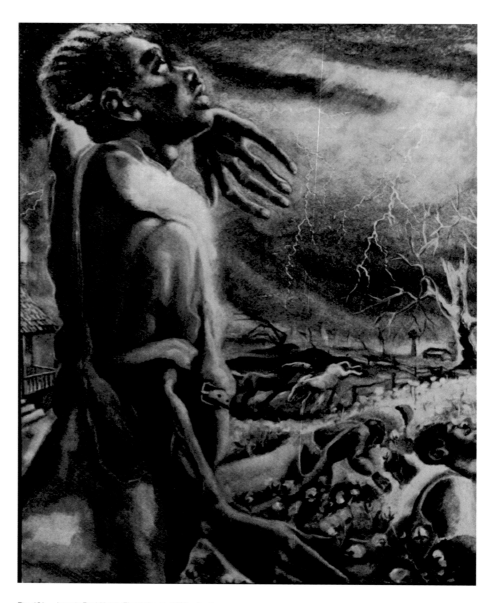

Fig. 101 Joseph Paul Vorst, *Elements*, ca. 1938, oil, where-abouts unknown, reproduced on the cover of *Joseph Paul Vorst Missouri Artist*, 1938, Carl and Carole Vorst, St. Louis, Missouri.

CHAPTER 6
MISSOURI ARTIST

A FORMAL INTRODUCTION

Shortly after he began winning important prizes, Vorst self-published a 20-page monograph of his work titled *Joseph Paul Vorst Missouri Artist.* It was comprised of an extended article by William Edward Hoffman. There is some evidence that the name is a pseudonym for the artist.[1] The booklet reproduced 10 black and white illustrations of recent paintings, several of which have citations as prize winners.

Joseph Paul Vorst Missouri Artist was designed to be a formal introduction to the artist. If the artist was not the author, it almost certainly was created under Vorst's direction and close supervision. At the very least, the author knew Vorst and his work intimately. In the book, the artist's history is recounted in personal ways that exist in no other published account, and it is a candid look into the artist's family, financial struggles, idealism, and artistic goals. The book is also an important document because it is the only text that describes how Vorst painted.

Hoffmann compares Vorst's process of laying paint on canvas to that of Renoir, noting that the French artist "prepares hardly any mixtures on his palette." He continues, "These statements rather closely approximate a description of Joseph Vorst's technique."[2] He contrasts the two sensibilities "as opposed to Vorst who paints, with inborn Teutonic solidity and strength, subjects heavy in social content, tragedy, and 'heroics.'"[3]

A feature of Vorst's work that went unremarked upon at the time but seems obvious is his paintings' opacity. Viewers reacted to the works as heavy, muscular, unsentimental, and tragic, but they were responding, in part, to the artist's method of building up the painted surface. His Regionalist contemporaries drew solid figures, too—Benton's murals are full of figures and structures that appear almost like sculptural friezes—but at the same time, other planes of their pictures were dappled, thinly painted, even transparent.

Hoffmann hints at a proprietary painting method that Vorst developed to combine opacity with transparency in a single step,

> Rubens, Titian, Watteau, Rembrandt—all famous for their so-called "glaze-technique"—were forced to use the tedious system of laying mass over mass, allowing time for drying between each layer and then glazing the whole after it had been set aside for a period of time. Vorst, on the other hand, is able to complete a large canvas or press-board in a day, arriving at the desired glassy effect without the fear of sinking in and cracking which harassed his celebrated predecessors.[4]

The booklet calls Vorst's technique a "progress in science," but Hoffman stops short of divulging precisely how it was accomplished. Still, he notes that

> Vorst uses no palette at all and always applies only pure color to canvas. Thus, seldom appears the chalkiness so apparent in most of our present-day paintings…. Yet tones and harmonies are not absent, for one thin layer of spectrum-clear pigment is brushed over another to obtain a desired hue for a highly saturated color—and the final tone shows doubly luminous because of the shining foundation used. There is never any retouching or overpainting, for a predetermined design composition does not allow changes in color composition.[5]

Joseph Paul Vorst Missouri Artist was not published in conjunction with any exhibition. There is no publisher listed. Presumably, it was accomplished at the artist's expense. He used the book promotionally. Multiple museums received copies. Vorst presented one of the books to the Metropolitan Museum of Art. It was cataloged on August 23, 1938 as a gift from the artist.

With his reputation growing, Vorst likely wanted to codify his own story. More than with any interview in Missouri newspapers, the catalog gives details of his gradual decision in Germany to be a fine artist (despite odds that often seemed insurmountable), his military record, and his reaction to the Great Depression upon his arrival to the U.S., "At about the time when despondency reached its darkest depths, Vorst's commercial art training came to his rescue and he 'landed' several sizable accounts which enabled him to live more comfortably, raising him from the slough of despair and restoring his tottering confidence."

The book finishes an overview of his biographical information with the following: "Only recently married, Instructor Vorst lives not unhappily on his limited income, but he still labors unceasingly, feeling that life provides too little time in which to crowd the work he *must* accomplish."[6]

EXHIBITIONS

Vorst had planned to have an exhibition of recent paintings in New York in the Spring of 1938. It took place, rather, on November 22 through December 10, at the Charles L. Morgan Galleries on West 57th Street. This was the third consecutive year that Vorst showed work in New York, but it was his first one-man exhibition in the city. The gallery produced an exhibition catalog. Its cover included *Drifters on the Mississippi* and noted its prize-winning citation from the Chicago Art Institute.

Thomas Hart Benton wrote the essay for the catalog. In it, Benton recalled meeting the artist for the first time and described why he was fond of the man and his art. The combative Benton likely enjoyed noting the irony of a German painter making works so thoroughly American in theme and spirit. Himself having abandoned the New York scene and its tilting tastes for abstraction, Benton praised Vorst for steering clear, incongruently, of European influences to be-

come an American artist:

Art is not made by having ideas which are purely verbal tricks in ninety-nine cases out of a hundred, may be obtained in quantity in any library, borrowed outright or made to appear new by phrase recombinations. Art is made by allowing the actualities of sense experience, to affect and modify learned craft procedures. Other things enter in and condition the business because artists are human beings and subject to emotional "build ups" of all sorts but the effect of things with their individual peculiarities on craft procedure is fundamental. When and if we have what

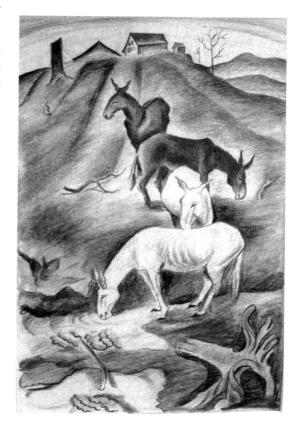

Fig. 102 Joseph Paul Vorst, *Missouri Mules*, ca. 1936, color pencil, 19 x 15.25 in., Collections of the St. Louis Mercantile Library at the University of Missouri–St. Louis.

can be called an American Art it will be because the inclusion of American experiences in our expression have formed marked modifications and reorganizations of the procedure we have inherited from Europe.[7]

The exhibition consisted of twenty-nine paintings, completed between 1936 and 1938. Although a few of the works had been exhibited in museums outside of St. Louis, only *Flood Tragedy, Missouri Mules,* and *Drifters on the Mississippi* had been shown before in New York. Of the works, seven were from 1936, thirteen from 1937, and nine from 1938. A photograph of Vorst posing in the midst of the exhibition shows him approaching middle age. He stands with a dark overcoat, white shirt and tie, streaks of gray in his hair, and his omnipresent mustache. He is alone in the room with mid-sized to large paintings, but he is surrounded by characters of Missouri as depicted on his canvases. They all speak of life near St. Louis, *Returning from Church, Heat Wave, St. Louis, Forgotten Man*, and particularly of agricultural labor, *Cabbage Planters, Pecan Pickers, Potato Croppers, Gleaners, Final Harvest, Apple Butter, Cotton Queen, Haying, Young Corn, Wheat Harvest,* and *Kansas Dairy.*

Many of Vorst's images were anchored to water in some way, but after the Flood of 1937, the rivers of the area increased in their symbolic potency for the artist: *Drifters on the Mississippi, Flood Tragedy, Show Boat, Along the Creek, Mississippi Fisherman* (Fig. 92)*, and *Deep Sea Fishing.* None of the images is a simple landscape; rather, each carries a message. The land or the water holds power—sometimes ominous, sometimes life-giving, and often beyond the control of humankind.

Show Boat (Fig. 103)*, in the hands of another painter, might be a subject of recreation and glamour. Vorst depicted the two-tiered boat as a backdrop for another kind of action altogether: the workers who toil along the riverbank and the African Americans who lounge, not in the comforts of the vessel, but fanning each other on the grassy, shaded riverbanks.

The painting is related to another work, *Showboat, St. Louis* (Fig. 104)* painted circa 1939, that is more about the tensions of classes on these boats. In the latter picture, Vorst divided the image into three mural-like sections. The far left contains workers and sailors on board an old ship. The center

panel depicts a performance before a crowd in opera boxes. Onstage, a cast dances and acts. They appear to be caricatures of Southern stereotypes—with grotesquely large hands and bare feet—and a man holds what appears to be a butcher knife behind his back. The far right panel of the painting shows the backstage of the performance, with chorus girls napping, applying makeup before a mirror, and flirting with two black men, who ignore what is going on around them, and play a game of checkers—on a black and white board. It's a rare scene for Vorst, one which shines a Social Realist's light on the world of entertainment.

In some of the 1938 pictures, Vorst's style made a subtle shift in artistic approach. Largely gone were the expansive, moody skies, and the symbolic landscapes of lush or withering vegetation that had previously been hallmarks of his style. The artist experimented by zooming in to concentrate on central images of homes, animals, and people. In multiple examples, Vorst cropped the paintings very tightly. The frames sat nearly on top of the artist's main subjects, and in some cases, the frames strangely obscured details of the paintings. This had the effect of telescoping the action on the canvas and forcing the viewer to confront his subject matter without the more felicitous trappings and distance of traditional landscape painting.

The press commented on Vorst's emerging American point of view. *Art News* wrote the following regarding a perceived transition:

> In the eight years since his arrival from Germany, Joseph Vorst has completely shed the teachings of the Impressionists, Slevogt and Liebermann whose pupil he had once been in Berlin. Instead under the influence of Benton, has become a full-fledged Bentonian depicter of midwestern Americana. He sees America largely as a land of floods, disasters and tornados, and his pictures are restless and stormy but never quite in full realization of the fury of the elements or the tragedies of the victims. Despite the turbulent distortion of perspective and the vigorous, rippling of forms, the spectacles narrated by this artist generally evoke little of the sense of immediate danger or disaster. An exception, an electric storm over a cotton field "Elements," which portrays the primitive terror of the cotton pickers and the fright of the mules as branches of lightning rend the sky.[8]

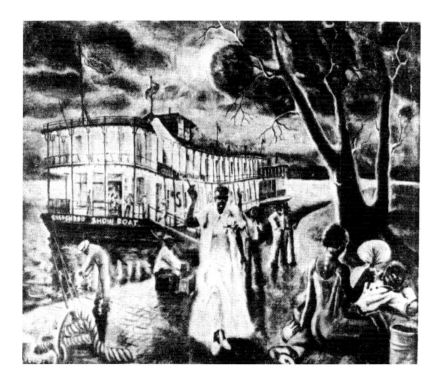

Fig. 103, top Joseph Paul Vorst, *Showboat*, ca. 1938 oil, whereabouts unknown, reproduced in unidentified newspaper, 1938, Carl and Carole Vorst, St. Louis, Missouri

Fig. 104, bottom Joseph Paul Vorst, *Showboat, St. Louis*, n.d., oil on board, 33.3 x 43 in., private collection.

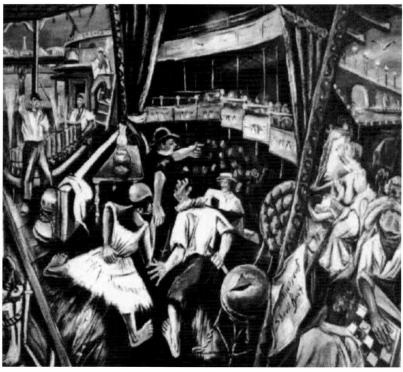

Vorst likely read every review and reacted to each with some level of anxiety. Never one to respond publicly to critics, he let his work speak for him. His voice, so to speak, was shared by the galleries and museums that exhibited his work.

A week after the opening of the exhibition at the Charles Morgan Gallery, Morgan wrote to the artist and provided follow-up information regarding critics and publications. It is rare correspondence, and it provides insight into the commitment that the gallerist had for shaping Vorst's career and his ability to connect to the tastemakers in the art world. Morgan wrote:

Dear Friend:—

I hope you had a pleasant trip home, and that all is well with you.

All the publicity over the week-end has brought in quite a few visitors. Personally I am satisfied with the reaction. I much prefer a controversial press than a faint hearted one. You have created a definite impression, and although the critics show confusion, you have registered on their minds; and I can assure you they will not forget you.

Just as an example of an after thought, Mrs. Davidson of the ART NEWS, just called an[d] requested a photograph of your "Elements." It would seem that she is going to use it in the next number. So you see, second thoughts are often better than first ones.

Then, Mr. Robert Coats of the NEW YORKER, came in and made copious notes. From what he said, very little, I am sure that he thought your work was strong and showed great talent.

So, since the hour is almost at closing, I wish to thank you for the honor I have in showing your fine and important paintings, and that I am proud to have shown them in your first one-man exhibit.

Wishing you the best of luck, and kindest personal regards to you, and Mrs. Vorst, I remain,

Sincerely,
[signed] Charles Morgan[9]

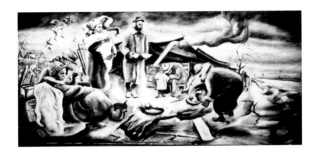

Fig. 105 Joseph Paul Vorst, unidentified painting, ca. 1939, whereabouts unknown, color transparency, Carl and Carole Vorst, St. Louis, Missouri.

At the time of the exhibition, a small notice in an unidentified St. Louis newspaper remarked on the occasion. It provided a paragraph of biographical details on the artist, including recent prizes won by the artist. Regarding identity, it was typical of the kind of press Vorst received in America, even after nearly a decade as a citizen:

> Vorst, a native of Essen, Germany, was wounded by shrapnel in the war and left his native land only after several meetings with the rising Hitler. He realized that Hitler was coming into power and that there would be no freedom under the new Government, he explained later.[10]

1939 was a year of global tumult. Germany invaded Poland on September 1, 1939 setting in motion the alliances and aggressions that led to World War II. But it was also a year of international cooperation and celebration in the arts and sciences. To celebrate the completion of the San Francisco-Oakland Bay Bridge and the Golden Gate Bridge, San Francisco hosted the Golden Gate International Exposition. Treasure Island, an artificial island in the bay, was constructed by the U.S. Government to house the exposition. Its theme was "Pageant of the Pacific," and although the region was in turmoil as the war begun in 1937 between Japan and China grew in potency, the goals of the international show were to showcase the goods produced by Pacific nations and to encourage unity and peace.

Fig. 106 Joseph Paul Vorst, *Fear*, ca. 1938, oil, private collection, Illinois.

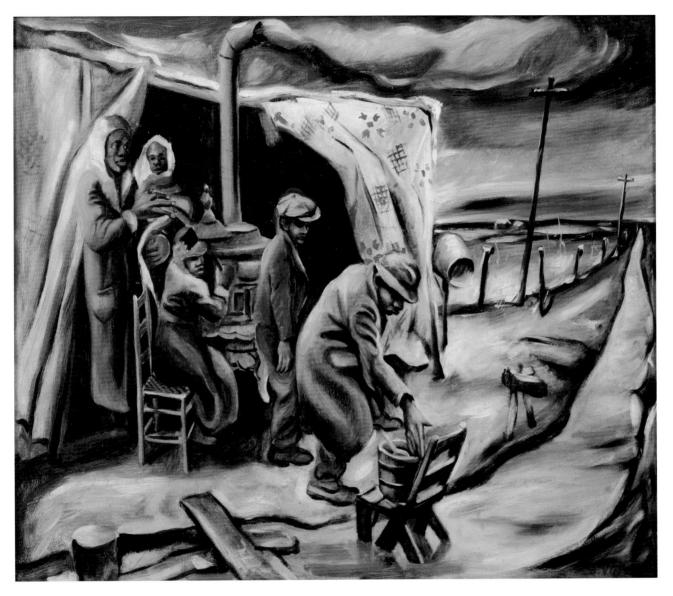

Fig. 107 Joseph Paul Vorst, *Sharecroppers' Revolt,* 1939, oil on panel, 24 x 31 in., Dan Shogren, North Oaks, Minnesota.

Joseph Paul Vorst contributed a painting to the exposition, which ran from February 18, 1939 to December 2, 1939. The painting that he loaned was *Fear* (Fig. 106), a curious, if prescient choice by the artist. In the image, an African American family prepares to enter an underground shelter as a storm approaches the farm. A woman cries out, possibly calling unseen children to safety while a young man kneels beside a pig. The central figure, meanwhile, a man with his arm raised over his head, with his palm turned to shield him, stares into the distance in a nearly-paralyzed state.

The artist, having lived through World War I, clearly sensed the approaching dangers around the world. Like many of his pictures that can be described as farm scenes at their simplest level, *Fear* foreshadows something more devastating than an event of severe weather.

On January 10, 1939, approximately 1,500 people in southeastern Missouri began a protest of the eviction of sharecroppers and renters from their farmland. For more than 100 miles, they set up makeshift shanties along U.S. Highways 60 and 61 and huddled around campfires and wooden stoves. In freezing temperatures and snowstorms, they silently and peacefully protested for five days. The federal government had decided that landowners would be required to share with workers some of the subsidy that was being paid to cotton producers. Instead, to keep all of the subsidy for themselves (approximately $1,500 for a 200-acre enterprise), owners evicted the sharecroppers and renters and hired them back as day laborers, thereby skirting the new government program. Newly-homeless workers were forced to subsist on 75 cents a day, paid less than six months of the year.

Sharecroppers' Revolt (Fig. 107) was one of at least two of Vorst's responses to the protest. This painting captures a family of five in the freezing weather during the protest encampment. Wearing long winter coats and hats, they emerge from a crude dwelling with cloth walls, a small stove billowing smoke.

It is the kind of painting that the artist returned to again and again throughout his career. Essentially, it is a documentary picture. Uncoupled from the historical event, political images likes this one have a dreary, heavy air to them, and contemporary eyes can wonder why they were painted in the first place. The answer is that they came from Vorst's continu-

ing interest in the dispossessed. Like the quiet dignity of the protesters of 1939 themselves, the paintings recorded these acts of heroism and defiance that took place far from the view of the nation's capital and media.

It is easy to mistake some of Vorst's farm paintings for quaint rural depictions of agricultural life, when they were intended to be instruments of agitation. A man plowing his field, in a painting by Vorst, can give the impression of a bucolic farming event. But there are clues to larger meanings. For example, in 1934, President Roosevelt passed the Agricultural Adjustment Act (it was reenacted in 1938). Its aim was to raise the price of commodities during the Depression by reducing the amount of crops and livestock on the market. Landowners received subsidies; they were paid not to plant. In some cases, farmers were informed of the law after they had already planted their crops for the season. This forced owners to plow under their crops, even shortly before harvest. Although this benefited exporters and owners, workers on the farms received diminished wages because their pay was tied to crop production. Furthermore, the landowners reduced their acreage, which in turn made sharecroppers poorer. During the Depression, black farmers lost their land in disproportionately large numbers. Scholars have estimated that African American farmers lost, on average, 350,000 acres each year during the Depression.

Harvest scenes represent a considerable portion of Vorst's images in this period. In order to recapture the power they had when they were created, they need to be viewed in context with events of the times. This expansive approach includes politics, but it is greater than that. In many of the artist's works, Vorst seems to be asking the viewer to consider what will happen next. In the farm pictures specifically, who is doing the work? Where is the profit from the labor going? How is the land used? In what ways is a farm a symbol for mankind and its treatment, one with another? This context often includes political commentary, protest, allegory, and documentary.

Nearly a decade after arriving in St. Louis, the artist still had much to say, and increasingly, critics and patrons began to understand Vorst's interpretation of the land that they knew well. And yet, many critics continued to see Vorst as an immigrant fascinated with American life rather than an artist commenting on it. Harry R. Burke, an art critic for the *Daily Globe-Democrat*, reviewed Vorst's one-man show at the Art

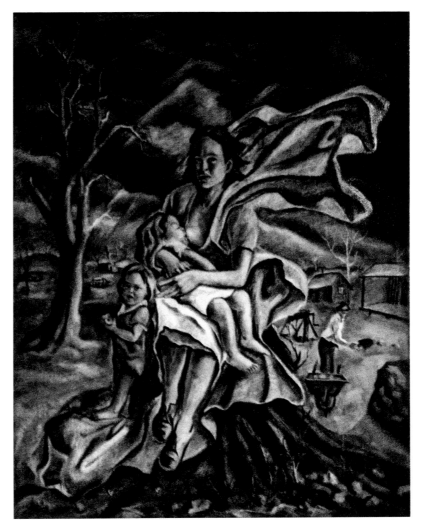

Fig. 108 Joseph Paul Vorst, *Madonna of the Tiff Miners,* 1939,
oil, private collection, Illinois.

Center in St. Louis, October 31, 1939:

> After nine years these Middle West storms astonish him still not less than they did the first middle-European artist to search out a homeland at St. Louis in Missouri…. The life of the Negroes interests Vorst; the toil of the Ozark mountaineers; the harvesting of cotton and other farmland crops; and the manifestations of nature, whether in "Drouth" or in flood, whether in a Mississippi's raging, or the quiet of a trickle of a brooklet. Elemental power, elemental emotion, elemental life, so different from that which regimented, controlled, and civilized, became his birthright in Essen, Germany, 32 years ago, and regained his heritage in Germany until 1930, when he came to this country.[11]

STILL LIFES

The Art Center exhibition included a few works that showed Vorst's expanding visual vocabulary: still life paintings. The genre, a common one for many of the artist's peers, had not been of much interest to him, heretofore. Instead, his works focused on the storytelling possibilities of larger scenes. These new paintings were more tightly composed, although they gave the impression that the artist merely happened across them in nature. Burke describes his reaction to them:

> But there are two examples particularly interesting to at least one observer, because they are so different. They disclose Vorst's affection for nature's intimacies. In "End of the Trail" an old shoe, a Jack-in-the-pulpit, some vines, some fungi are woven into the vibrant pattern. In "Tales of the Missouri Woods" a pool, a frog, some lichens, a mantis, a snail.
>
> They emphasize the depth of the affection of one who, while an adopted son of Missouri, is becoming one of her truly distinguished painters.[12]

On April 30, 1939, the 1939 New York World's Fair opened. It covered an immense 1,200 acres in Flushing, Queens and ran for two seasons—from April to October—until October 31, 1940. The New York fair was organized earlier, in the nadir of the Depression; officials saw the international event as an opportunity to rebuild the national economy. Up until the 1939 fair, world expositions focused on science and technology. Any number of inventions, such as the telephone, were unveiled at world's fairs. The New York fair shifted its emphasis away from technology and toward themes of developing society. Countries from around the world created pavilions to showcase their cultures. The title for the fair was *Building the World of Tomorrow*. It was designed to be a blockbuster, and indeed it was. By its end, over 44 million people had attended.

The fair featured separate, themed zones—transportation, communications, business, food, government, amusements, etc. A special, elevated line of the subway system was constructed to take visitors to the site. The fair held an invitational art competition and selected 1,200 works for exhibition. One of Vorst's contributions to the New York World's Fair was *Blacksmith*. It was another curious submission choice. The painting shows a blacksmith sitting next to an anvil, a hammer in his hand. Bare-chested, with suspenders, the powerful man with an enormous blonde mustache looks away from the viewer. There is no other work in Vorst's oeuvre quite like it (although he later created a lithograph that retains the figure and the foreground). There was also a drawing that Vorst chose to be included in *Der Vulkan* with

Fig. 109 Joseph Paul Vorst, untitled, n.d., oil, whereabouts unknown, photograph.

Fig. 110 Joseph Paul Vorst, *Driftwood*, n.d., oil on masonite, 20 x
24 in., Carl and Carole Vorst, St. Louis, Missouri.

a worker sitting in a similar posture. In *Blacksmith*, however, Vorst smears the background into an abstracted blur of saturated color.

Two other Vorst paintings were exhibited at the Fair, as revealed later by exhibition labels on the works. They include a still life painting, *Mexican Still Life*, and a portrait of mother and child, *Madonna of the Tiff Miners* (Fig. 108), in which a mother nurses an infant while another child stands at her side, as the wind sweeps her cape dramatically behind her. The landscape is barren. A man digs in the dusty soil behind her.

He received a letter dated June 1, 1939 from Charles Morgan, the gallery owner who exhibited his work the year before. He reported to Vorst his trip to the fair in New York,

Had an opportunity to see your painting at the Fair on Memorial Day. I think you have a painting there you can well be proud of. It is well above average, and holds its own easily with all the so-called "first painters." I congratulate you. I only wish they had given it a better position, but probably the hanging problem with 1200 hundred [sic] entries is not an easy one, and not all could have the center of the main wall!

After the 10th I am hanging a group show for the summer and will include one of yours along with all the other men who have had one-man shows with me in the past two years.

Fig. 111, above, left Joseph Paul Vorst, untitled, n.d., oil, 23.5 x 18.5 in., Pat Morrissey, Alton, Illinois.

Fig. 112, above, top Joseph Paul Vorst, *Tahiti*, photograph, Carl and Carole Vorst, St. Louis, Missouri.

Fig. 113, above, bottom Joseph Paul Vorst, *Wildflowers*, 1940, oil on masonite, courtesy Treadway Gallery, Cincinnati, Ohio.

I haven't noticed that the fair has brought in any out-of-town visitors, but of course the season is yet young. Business has been very slack all year. In fact most of the gallery men I have spoken to say it has been one of the worst since the Anno Roosevelt.[13]

On a undated scrap of paper, Vorst wrote:

I arrived in America as an [illegible] German artist however I ran away from all publicity and went to the middel [sic] west to be born over again as wholly American.[14]

This became a public refrain for Vorst, one of many comments the artist seems to have been compelled to make, particularly as American tensions with Europe escalated, to justify being a German-born immigrant in the U.S. He consciously remade himself—Westphalia traded in for the American Midwest—a sentiment he repeated over the years, and this played out in his art as well.

In coming to America, specifically to Missouri, Vorst had conflicting aims of hiding, escaping, reinventing, and as he put it, being all-American. After the initial introduction to the art world, whereby he proved his claims as an artist of talent based on his history and accomplishments, he appears to have stowed his German-ness in the sense he no longer exhibited works made in Germany and altered his visual style to fit his new surroundings. The artworks made in Europe were packed away, but more than that, the attitudes, techniques, and subjects in his former art were also supplanted by Missouri and a new way of seeing.

Regarding subject matter, in Germany he had shown little interest in depicting laborers, for example, while in America, they became a primary source of imagery. The German works were nearly devoid of animals, which populate the American works heavily. Although he lived in St. Louis, a large city, he avoided urban imagery almost entirely and instead trained his sights on the farmer, the miner, the riverboat entertainer, the field hand.

Vorst put away beauty to some extent as well. His impulse to create lyrical landscapes in Germany, with their saturated colors, glowing skies, and stately town squares simply ceased after 1930. He certainly could have made his im-

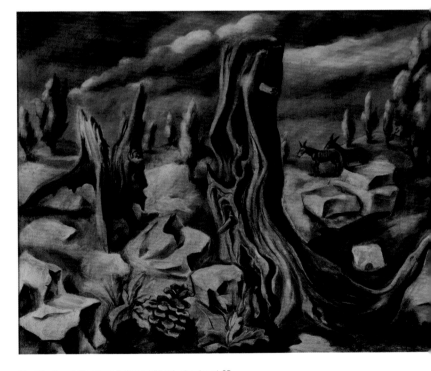

Fig. 114 Joseph Paul Vorst, *Driftwood #2*, n.d., oil on board, 25 x 30 in., Carl and Carole Vorst, St. Louis, Missouri..

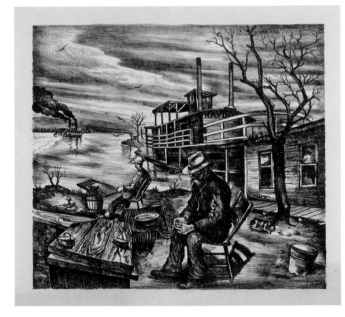

Fig. 115, top unidentified photographer, Vorst in Germany with photos of American relatives, courtesy of Louise Wade, Reston, Virginia.

Fig. 116, bottom Joseph Paul Vorst, *Fisherman on the Mississippi*, n.d., lithograph, 11.5 x 12.75 in., Carl and Carole Vorst, St. Louis, Missouri.

ages of the Depression more colorful and prettier had he wanted. Benton was a prime example of that duality of the gritty and the candy-colored picturesque. But Vorst was after something different.

Although it is tempting to equate the moodiness of his 1930s paintings with a psychological and biographical reading of the artist himself, personal photos in the 1930s reveal the same, fun-loving Vorst that was a fixture of his German photo album. Certainly, the artist struggled, but the reimagining of what his art should be appears to have been a carefully determined philosophical construct.

Comparing German and American Vorst paintings, the most obvious shift beside the geographical change is the latter embrace of African American subjects. One could argue that the predominance of black Americans in his art, in particular, could have been an initial response to their exoticism by a European with little previous exposure to people of African heritage. Some of Vorst's images veer toward stereotype, with accentuated features of eyes, hair, and lips, in particular. In fairness, however, this kind of depiction is common throughout American art of the period. Vorst quickly proved his sensitivity to African Americans in his repeated advocacy of racial issues, which his paintings equate with moral imperatives. Vorst seized on the inequalities of American races to such an extent that he seems to have identified with their outsider status.

After nearly a decade as an American, however, he began a reappraisal. Concepts he developed in his earliest watercolors, prints, and paintings made around 1920 began to resurface, now with an American slant to the story. An example of this is Vorst's new interest in the still life. In the mid-20s, the artist gravitated to some floral subjects. It is likely that the impulse connected back to his studies with Johan Thorn Prikker and the floral decoration of the Jugendstil movement. In photographs of Vorst's studio, large and elaborate paintings of flowers can be seen.

The American still lifes are entirely different—they have little inclination toward being decorative for their own sake, for example—but the decision to merge the Midwestern landscape with its flowers, animals, and geology into a single, formal composition springs from earlier interests. In the intervening decade, Vorst had found that his strength lay in storytelling. He might be documenting an event, but by us-

ing components that were identifiable and specific, such as a Missouri mule, or a broadbrimmed farmer's hat, the artist rooted the stories to his own observed experience.

Beginning in his early school studies, Vorst realized the power of nature as a symbol. Once acclimated to America, and with a widening circle of admirers, his exhibitions began to include still life paintings. Gradually, still life paintings joined Vorst's more famous images of mules and workers in gallery exhibitions.

Vorst had momentum. He had recently experienced success in competitions with large groups of artists at the Chicago Art Institute and Kansas City Art Institute, in which he bested his peers. His paintings were being seen by much larger audiences than ever before. With his successful inclusion in very prominent fairs concurrently in San Francisco and New York, Vorst entered a new period that altered his life and reputation.

In a decade, Vorst had seen a wholesale change in his life. He had left his homeland and arrived in the United States at the precise moment the American economy collapsed and on the eve of profound devastation of German cultural life. He developed a supportive and nurturing new home amid family and artists in St. Louis and at the Ste. Genevieve Art Colony. He returned to Germany just long enough to be associated with the most despised figure of the century. He endured the abject poverty of peddling artworks on street corners by building commercial art relationships, creating portraits for members of Missouri high society, and gaining teaching positions—all the while painting tirelessly. His personal friendships with artists of distinction such as Thomas Hart Benton and Joe Jones opened doors of opportunity and shifted his ideological approach toward making a truly American art, bringing him into the circle of the two leading painting movements of the era, Regionalism and Social Realism. He married Lina and set up a home together, and gradually, painstakingly, he built an artistic résumé of important exhibitions, prizes, and press that led to museum shows, one-man exhibitions, and even a painting in the White House. Despite all of that, his most enduring accomplishments lay before him.

ENDNOTES

1. Although the author is printed as "Willam Edward Hoffmann," it is most likely a typographical error; a manuscript copy of the essay in the Vorst estate lists the author as "William Edward Hoffman." The Vorst family thinks Hoffman was a member of his Mormon congregation, but no one by either of those names is known to have lived in the area to date.

2. William Edward Hoffmann, *Joseph Paul Vorst Missouri Artist*, 1938, unpaginated.

3. Ibid.

4. Ibid.

5. Ibid.

6. Ibid.

7. Thomas Hart Benton, "A Missouri Artist," catalog for *Joseph Paul Vorst,* Charles L. Morgan Galleries, New York, Nov. 22-Dec. 10, 1938.

8. *Art News,* Dec. 3, 1938.

9. Correspondence from Charles Morgan to Vorst, November 29, 1938.

10 "Joseph Paul Vorst Paintings to Be Shown in New York," unidentified St. Louis newspaper article, December 1938.

11. Harry R. Burke, "Oils by J. P. Vorst on Exhibition: Missouri Scene Admirably Painted by European Artist, *Daily Globe-Democrat*, October 31, 1939.

12. Ibid.

13. Correspondence to Vorst from Charles Morgan, June 1, 1939.

14. Joseph Paul Vorst, undated note in the artist's hand.

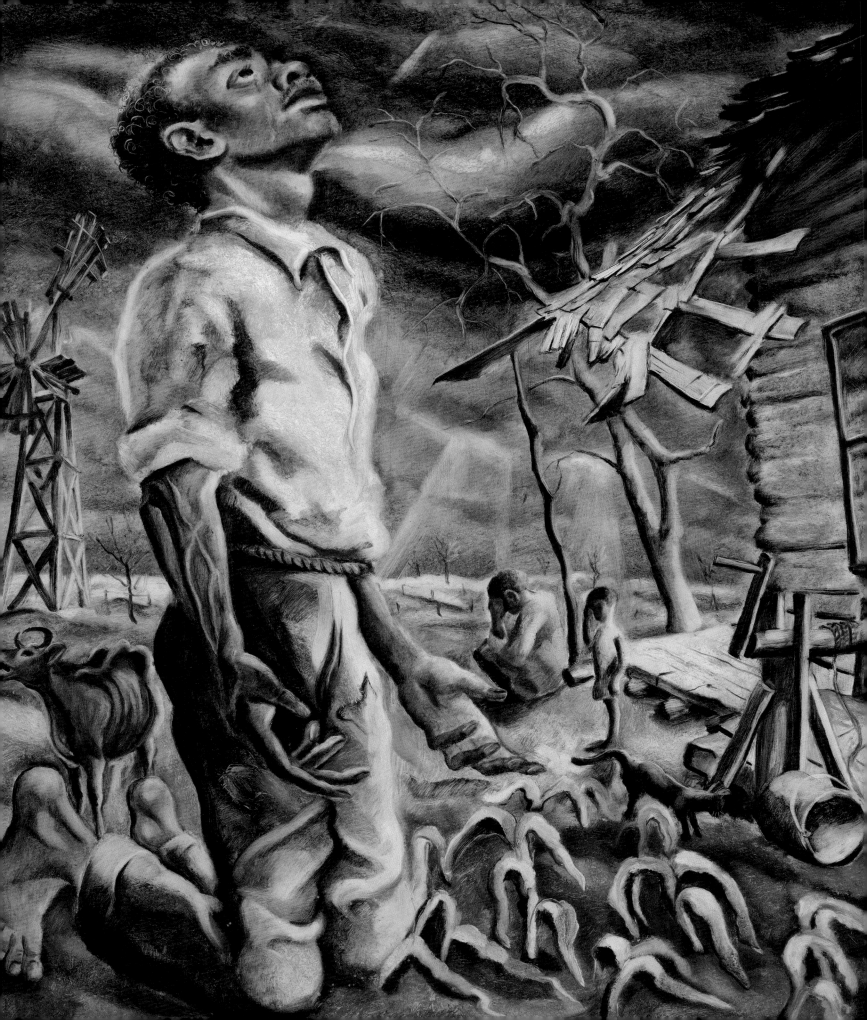

PART 3: 1939-1947
WAR, DEATH, BIRTH, AND REBIRTH

"This picture taken by the RAF shows a fraction of what Sir Archibald Sinclair then described as probably the heaviest blow in German war industry in the whole of our bomber offense.

"This was Essen on the night of March the fifth. Thousands of incendiaries doing their work. Great fires burning. And in between all of those fires, buildings rocked and shattered and blasted as the RAF's big blockbusters explode.

". . . Finally more damage from the first of the two blitzes, where scarcely a roof remains. Essen may be the heart of the largest gun-defended area in Europe, but they can't stop the RAF."

Movietone News, "The Blitzing of Essen," March 18, 1943

Fig. 117 Joseph Paul Vorst, *Drought,* 1938, oil on masonite, 39.5 x 35 in., private collection, Illinois.

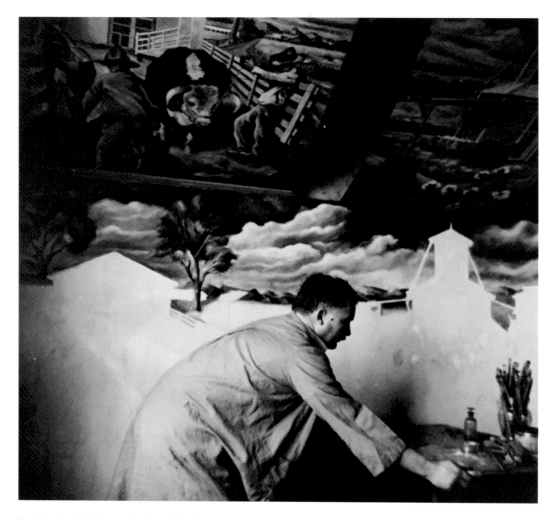

Fig. 118 unidentified photographer, Vorst painting the revised
Paris, Arkansas mural, *Rural Arkansas*, 1940, Carl and Carole
Vorst, St. Louis, Missouri.

CHAPTER 7
PUBLIC MURALS

MURALS

In the June 1939 bulletin of the Section of Fine Arts, Public Buildings Administration, the U.S. Government announced an enormous competition for American artists. A nationwide contest would be conducted to produce murals in each of the 48 states. These murals would be placed in public post offices and their imagery would draw from local sources: farms and livestock, folk legends, history, industry, people, and landscapes. The deadline was set for October 2, 1939.[1]

Vorst had some experience applying for public murals. In 1937, he had applied for a local post office mural at the Wellston Station in St. Louis (later renamed the Gwen B. Giles Station). His bid was unsuccessful, and the commission went to Lumen Martin Winter. Around 1939, he created a mural study, likely for a post office in Hutchinson, Kansas. The surviving study is oil on canvas. In the large image, the right side is populated by bison and Native Americans on the plains. The left side shows a long line of pioneers in covered wagons pulled by teams of oxen. The two are bisected by a steam locomotive and a Pony Express rider. On the front of the train, a pair of long horns from a steer has been mounted to the iron—a black, mechanical animal. The work is titled *Hutchingson's Progress in 1876* [Fig. 119]. Undated photographs shows other studies with similar dimensions, *Agricultural Center* and *Hutchingson Westbelt*, likely created for the same location.

The Treasury Department also announced a mural competition for a new $4.5 million post office in St. Louis in 1939. It was the largest federal mural project to date, offering the winning artist some $29,000, a very large sum.[2] Ultimately, the artists selected were Edward Millman and Mitchell Siporin from Chicago. Vorst apparently created eight studies for the project (the surviving works are titled but undated).

His studies are worth exploring in some detail, however, because they are unique in his visual output. Their subject matter shows the artist's expanding interests. To this point in America, Vorst had been preoccupied with regional narratives. These mural studies include Missouri, but like *Hutchingson's Progress in 1876*, they turn west to the open prairie. Here are 19th century pioneers, Native Americans, the Pony Express, and early settlers.

In *Flood on the Mississippi* [Fig. 122], a barge-like wooden platform floats in a flooded area. Houses are almost entirely submerged, dead trees and debris are scattered in the foreground, while a paddleboat sails in the distance. Three men are visible guiding the makeshift vessel that also holds a small house and two mules. A different kind of barge can be seen in *Ea[r]ly Boat Travelers* [Fig. 127]. White men pull a flat boat with a large sail to shore near log cabins while Native Americans paddle in canoes alongside.

Vorst had visited the Rocky Mountain West multiple times, but his images of Western frontier life are rare. *Pony Express* [Fig. 121] hearkens back to Cowboys-and-Indians Americana. A rider on a mountain trail races away from trouble. He shoots his revolver while facing backward at full gallop. On the ground to his left is a skeleton of a steer. Many European artists viewed America as a land of rustic cowboys, and it is to his credit that Vorst almost entirely avoided these clichés and instead chose to paint more accurate scenes.

Early Overland Mail [Fig. 124] is Vorst's version of a more tranquil scene. Homesteaders near their log cabin wave at an approaching wagon bringing mail. Another farmer plows a field, and an old, bearded man holds his fiddle on his lap. *Horse Breaking Farm* [Fig. 123] is the title for another of the watercolor sketches. This is the closest Vorst gets to pictures of cowboys at work. Men lean against a fence that

Fig. 119, left, top Joseph Paul Vorst, *Hutchingson's Progress in 1876*, ca. 1939, oil on canvas, St. Louis Post-Dispatch, St. Louis, Missouri.

Fig. 120, left, bottom unknown photographer, unidentified Vorst mural study, ca. 1939, photograph, Carl and Carole Vorst, St. Louis, Missouri.

Fig. 121, opposite page, top Joseph Paul Vorst (unsigned), *Pony Express*, ca. 1939, watercolor, 6 x 16 in., St. Louis Post-Dispatch, St. Louis, Missouri.

Fig. 122, opposite page, second from top Joseph Paul Vorst (unsigned), *Flood on the Mississippi*, ca. 1939, watercolor, 6 x 16 in., St. Louis Post-Dispatch, St. Louis, Missouri.

Fig. 123, opposite page, third from top Joseph Paul Vorst (unsigned), *Horse Breaking Farm*, ca. 1939, watercolor, 6 x 16 in., St. Louis Post-Dispatch, St. Louis, Missouri.

Fig. 124, opposite page, bottom Joseph Paul Vorst (unsigned), *Early Overland Mail*, ca. 1939, watercolor, 6 x 16 in., St. Louis Post-Dispatch, St. Louis, Missouri.

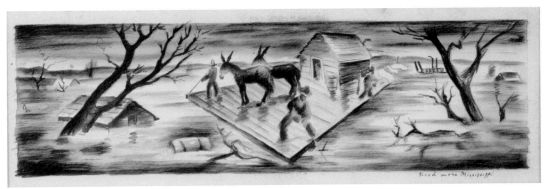

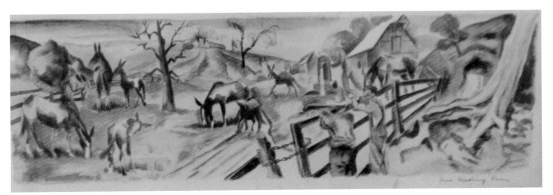

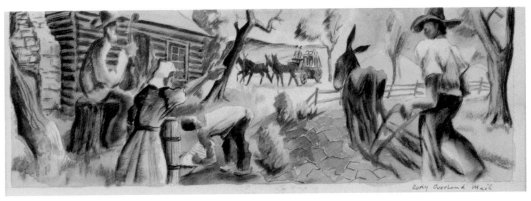

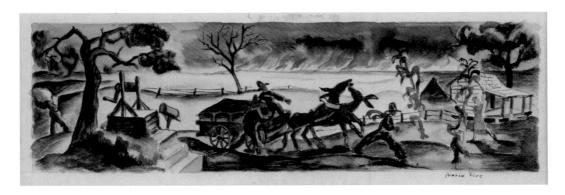

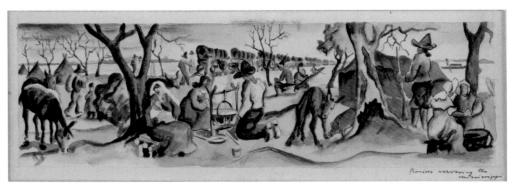

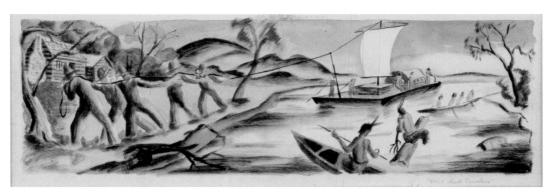

Fig. 125, top Joseph Paul Vorst (unsigned), *Prairie Fire*, ca. 1939, watercolor, 6 x 16 in., St. Louis Post-Dispatch, St. Louis, Missouri.

Fig. 126, middle Joseph Paul Vorst (unsigned), *Pioneers Crossing the Mississippi*, ca. 1939, watercolor, 6 x 16 in., St. Louis Post-Dispatch, St. Louis, Missouri.

Fig. 127, bottom Joseph Paul Vorst (unsigned), *Ea[r]ly Boat Travelers*, ca. 1939, watercolor, 6 x 16 in., St. Louis Post-Dispatch, St. Louis, Missouri.

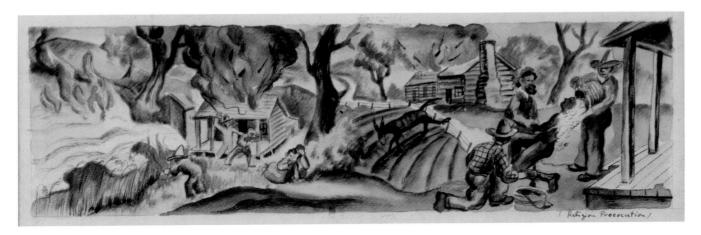

Fig. 128 Joseph Paul Vorst (unsigned), *Religious P[ers]ecu-tion*, ca. 1939, watercolor, 6 x 16 in., St. Louis Post-Dispatch, St. Louis, Missouri.

holds pinto horses and colts. A man pumps water from a well, and a bright red barn sits in the distance.

The three remaining studies of the group are more dramatic. In *Prairie Fire* (Fig. 125), a team of animals rear up as their owners prepare a wagon to escape from (or perhaps battle) a raging fire that engulfs the entire horizon in flame. *Pioneers Crossing the Mississippi* (Fig. 126) is possibly a religious scene of Mormons crossing the Mississippi into Iowa.

A Mormon connection is unambiguous in *Religious P[ers] ecution* (Fig. 128). This is the only known work in which Vorst combines his Mormon beliefs overtly with his philosophical Social Realism. It is an image of brutality, a retelling of the 1838 tragedy of Haun's Mill painted near the centennial of the attack. A man is bound and tarred by two men while a third assailant pours a basket of white feathers on him. Two homes have been set on fire, and another member of the mob lights a field aflame. Before a burning home, a Missouri Mormon is attacked by a man wielding a bullwhip. A woman has collapsed at his feet, shielding a child, and even a horse or mule in the field kicks against a fence in protest.

Thomas Hart Benton had illustrated the scene of Mormons

attacked at Haun's Mill, too. In his mural that encircles an entire room, *A Social History of the State of Missouri*, and installed in House Lounge in the Missouri State Capitol building, a small panel is devoted to the event. Benton's work was completed in 1936. It is not at all unlikely that Vorst knew of the mural, and perhaps contributed his feelings about the events before the mural was created. The Benton image consists of a single line of characters: a naked man with tar gathering in a pool on the ground at his feet, his attackers holding him tightly. A house is on fire in the center of the image, watched by a Mormon couple in horror. At the far left, a woman wearing a bonnet and a bearded man in a hat speak to a shirtless African American man. The smoke from the fire is jet black, and it billows into a dark cloud over their heads. Benton did not shy away from images of slavery, violence, and abuse in the state's history—even for a mural in the capitol.

After a few misfires, Vorst landed two post office commissions in 1939, in Vandalia, Missouri and Paris, Arkansas. *Corn Harvest* is the title of the large mural that Vorst painted for Vandalia, Missouri, a small town approximately 100 miles northwest of St. Louis. The post office was constructed with New Deal funds for the town of about 2,500 residents. In

the mural, figures of different generations gather corn into shocks and stack them into a wagon pulled by a pair of mules. The mural is also known by an alternate title, *Harvest Festival.* The artist received $550 from the Treasury Department for the commission (a considerable amount given that the average U.S. annual income was $1,368, according to the 1940 Census). The work was installed in October 1939. During the same period, he created *Threshing*, a harvest scene intended for the Jackson, Missouri post office. He was unsuccessful in the competition; the prize went to James Barre Turnbull.

Generally, the post office murals filled the wall above the postmaster's doorway. The payments were calculated, for the most part, based on the size of the wall to be filled, 5 feet by 12 feet, on average, for approximately $650-750. The state of Missouri came late to WPA/FAP projects (Works Projects Administration and Federal Art Project). Until the mid-1930s, it did not have the prerequisite WPA art program up and running in order to qualify for federal funds. Only seven artists in Missouri were authorized, as late as 1935, to create public WPA art.[3] But it was the Treasury's Section of Fine Arts that was charged with decorating post offices. Once the WPA was in place, however, Missouri created numerous public works in addition to post office murals. Many of the artists involved were associated with the Ste. Genevieve Colony.

From nearly 1,500 entries, Vorst was selected one of the winners in the "48 States Competition," and he was given a project in Paris, Arkansas. Other artists selected in the nation-wide competition included Joe Jones, Fletcher Martin, and Adolph Gottlieb.[4] He was notified by the assistant chief of Section of Fine Arts, Edward B. Rowan, on October 16, 1939 that the jury had selected his design. He was asked to keep the news confidential until local papers could announce it.

Much has been written about the importance of these commissions for artists suffering in the Great Depression—the income and public exposure certainly benefited Vorst, as well—but the murals were significant for residents, too. For many people living in rural America, the post office murals may have been the first original paintings they had ever seen. This fact created certain problems, however. As scholars have pointed out, the subject matter might seem tame today, but at the time they were created, they had the power

to shock. Artists frequently depicted acts of protest in the murals—farmers dumping milk to raise prices or workers of industry fighting to establish unions—and this caused heated controversy.[5] Another source of tension arose from the fact that artists who painted the murals were often outsiders, albeit residents of the same region and even the same state, and their choice of subject matter could be contentious if for no other reason than the image didn't match the locals' views of themselves.

Unwittingly, Vorst stepped into this latter type of controversy in late 1939. He discovered firsthand how a post office can be come a political battlefield as he executed the commission for a mural in Paris, Arkansas.

THE PARIS CONTROVERSY

Vorst's design for Paris was illustrated in *Life* magazine, December 4, 1939.[6] The *Life* magazine article, "Speaking of Pictures, This Is Mural America for Rural Americans," had shown Vorst's Paris, Arkansas mural study [Fig. 129]. Its caption read, "Tenant farmer at work in his field was subject chosen by German-born Joseph Vorst of St. Louis."[7] By the time the article appeared, some residents of Paris, Arkansas were already furious.

The first to sound the alarm of scandal was the editor of the *Paris Express* newspaper, John Guion. In a sarcastic op-ed piece titled, "That's Right, We Don't Like the Mural," Guion decried Vorst's design as an ugly stereotype, and mocked the Missouri artist, Vorst.

> If this is Artist Vorst's conception of Arkansas, we suggest that he stay in Missouri where mules have mule colts, as he shows in his sketch. Farming just isn't being done in Arkansas in the manner he shows. This may [be] Missouri farming but we do not care for it.[8]

Two weeks later, Vorst wrote a response that the *Paris Express* published with the title, "Letter from the Artist Vorst," in part:

> I wish to state that of the eight sketches I submitted to the committee the one chosen, I believed was the least appropriate.[9]

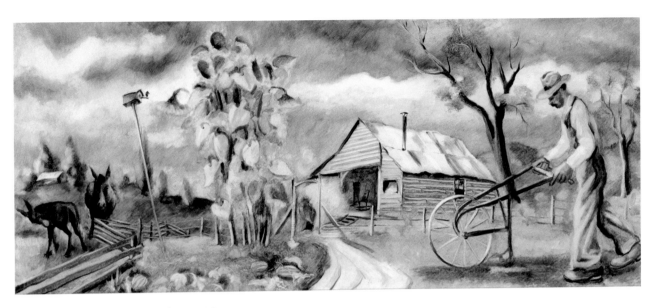

Fig. 129 Joseph Paul Vorst, *Rural Arkansas (mural study Paris, Arkansas Post Office)*, 1939, oil on fiberboard, 26 x 44 in., Smithsonian American Art Museum, Transfer from the U.S. Department of the Interior, National Park Service.

The artist was eager to placate their concerns. Still, residents of Arkansas rightly recognized a pattern of depictions of rural and poor residents in widely-known works such as plays like *God's Little Acre* and *Tobacco Road*, lampoons by novelists Sherwood Anderson and Sinclair Lewis, and countless stories and folk songs about hillbilly ways and corn liquor-drinking, barefooted, illiterate hillfolk. That all of the state citizens should be seen as primitive, uneducated, and impoverished was offensive to them. In particular, residents felt, Arkansas was derided more often than its neighboring states.

The editor had also written a complaint to the government, even before the first editorial was published:

> I believe you will agree that this picture is not appropriate for our state. Arkansas has been the butt of jokes for many years, I do not believe in perpetuating this attitude by placing a painting of this type upon the walls of our most prized building, the post office.

Every citizen contacted has expressed an opinion conforming with my own. We appreciate the honor of having our post office selected among the 48 to receive murals, but believe we prefer doing without than to have the selected subject.[10]

Guion continued that he believed the prize awarded to Vorst should be set aside and the submission process be conducted again.

He wrote to Arkansas Congressman Fadjo Cravens and the letter was forwarded to the Section of Fine Arts, Public Buildings Administration (commonly known as the Section), the government agency responsible for mural selection and production. What followed was a story that splits in two: a public relations narrative in which Vorst confronted the criticisms, explained himself, and created a replacement work; and a series of private exchanges with Section official, Edward B. Rowan that revealed what Vorst thought about creating public art, his desire to please the common man,

and his sense of American camaraderie with his subjects. He was simultaneously attempting to please two stakeholders—the town and the government.

Rowan enclosed the letter of Congressman Cravens when he wrote to Vorst on November 6. He said, "Letters of protest are arriving relative to the inapprorpirate subject matter."[11] He calmly reassured Vorst that the artist had been selected for the project because of his "artistic achievement" and therefore urged him to "reconsider subject matter appropriate to the locale." He suggested that Vorst write directly to the Postmaster.

Two days later, Roman responded to Cravens, acknowledged the problem, and said, "The selection made by the jury in the Forty-Eight State Mural Competition was primarily based on the selection of the best artist available in the competition for this work. Mr. Vorst, the artist, would be the first to understand the logic of the protests and he will be instructed to confer with the Postmaster relative to subject matter and redesign in order to meet local requirements.[12]

Vorst might have argued that he had drawn the image from direct observation. Scholar Karal Ann Marling has noted that Vorst was the one of the few artists of the 48 murals to go to the intended site for field research and to draw from first-hand experience.[13]

Vorst's response to Rowan on November 11 began with an appeal for a "much-needed check" as payment for an earlier mural in Vandalia, Missouri. He then turned to the controversy:

> Referring to your letter of November 6th, I wish to say that I was not disappointed at the evident reception given your committee's choice of subject matter for the Paris, Arkansas Mural, for frankly, I was a bit surprised myself. Although, truthfully, whether the Arkansas Parisiens wish to admit it or not, I made that sketch from life during my recent visit to Paris and it *is* authentic.

He conceded, "No doubt the reason behind it all is that the selected sketch is not too flattering.[14]

Vorst reported to Rowan that he intended to handle the controversy himself. This all unfolded quickly. Less than

two weeks had passed between the letter to Cravens and Vorst's response to the Section. He asked Rowan that reassurances be forwarded to Congressman Cravens "that steps are being taken to please the Paris citizens, but not, I may add at the sacrifice of genuine Art." He also said, "Naturally, if restrictions are too great, or unreasonable demands too insistent I will not be able to do the work. After all, I came to this country partly to attain artistic freedom."[15]

Again, Rowan was supportive of both the artist and the community,

> I wish to state my gratitude at your kind attitude relative to your design selected by the jury for the Paris, Arkansas Post Office.
>
> My personal feeling relative to the numerous sketches submitted to this office was that there are others more appealing to me than the one which was actually chosen.
>
> Your courtesy in getting in touch with the Postmaster of Paris and creating a design which will be regarded by the citizens of Paris as appropriate to and reflective of the locale is greatly appreciated. Such procedure actually strengthens the program and you know I am with you in objecting to unreasonable demands. This office, under no circumstances, wishes an artist to undertake work which is not consistent with his aesthetic convictions.[16]

Vorst traveled the nearly 400 miles to the town of Paris to discuss the matter in early December—not to try to sway the public to his point of view but to determine what they wanted him to do in order to find satisfaction with their mural. By then, the *Life* magazine article had appeared on newsstands.

Privately, he noted in correspondence to Rowan that Guion's defense of the state was ironic, given that he was only "a native Arkansan of 6 months standing" and he joked about the dubious sophistication of Arkansas Parisians. Publicly, however, he was entirely submissive. He reported to Rowan afterward:

> As you will recall, quite a commotion was stirred-up over the subject which was selected for the Post Of-

fice Mural down there, but I am happy to report that everything's lovely now.

Their contention was that Arkansas had been the butt of "backward" quips long enough and that now, the "truth" should out—that Arkansas is a modern and progressive state.

It is amusing to note that the voice raised most vehemently in caustic criticism came from the larynx of the newspaper editor who is a "native" Arkansan of 6 months standing, hailing from "home state" Oklahoma.

However, I was pleased to meet with a committee of leading citizens, including the Postmaster, Editor and Banker.... Everyone was very kind in going out of his way to explain that their criticism was directed only at the subject and not at the art. Suffice it to say that they were all very happy over the results of the gathering and we parted very good friends.

Experiences like these make me love this country of ours more and more. Where else in the World could one find the earnestness, the serious interest shown by one and all in every move of the government, local, state and Federal, even to the choice of a subject for the village Post Office. Everyone has a voice and uses it. May we never lose our Democracy![17]

Vorst's meeting with the locals prompted a completely new mural study, rather than a reworking of the previously selected sketch. As he described it to Washington,

> At the left is an up-to-the-minute stock farm, in the center a cotton gin, at the right the process of weighing cotton, at central left background a mine.[18]

Rowan's response was immediate and positive. He wrote, "The sketch is entirely satisfactory and is regarded as a thrilling improvement over the first sketch. I want to tell you how pleased all of us are with this new design which reflects the thought and industry that you have brought to bear on this project."[19]

Vorst's revised mural study was approved almost immediately. By the end of December 1939, and on February 5,

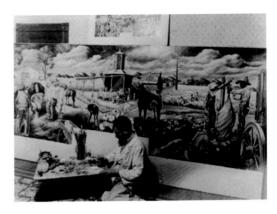

Fig. 130 unidentified photographer, Vorst working on the revised Paris, Arkansas Post Office Mural, *Rural Arkansas,* 1940, Carl and Carole Vorst, St. Louis, Missouri.

1940 paperwork was initiated to authorize the first installment to pay Vorst for the mural. Vorst's contract stated that he was to be paid after he could document progress of specific benchmarks. The first installment made after a preliminary design was approved. The second after a photograph of the "cartoon" of the mural was submitted and verified. These, Vorst completed by the end of February. At this point, the Postmaster was notified of the request to permit installation of the mural. At each step, letters from the Section communicated between all parties.

On March 29, Vorst wrote to Rowan, "It gave me a very great pleasure to paint the Mural for the Post Office in Paris Arkansas. I just finnished [sic] it and made as good as I could do a photograph of it." He also noted that he was preparing a one-man exhibition in New York in October and added "I... hope to see you again."[20]

The artist likely imagined that the project was all but completed, but in a letter to him dated April 3, Roman asked for alterations:

> The diagonal road leading into the composition from the man mounting the horse does not seem to take its place convincingly. In other words it does not lie

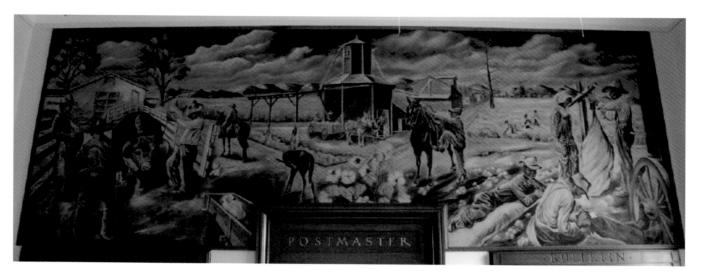

Fig. 131 unidentified photographer, *Rural Arkansas* by Joseph
Paul Vorst, n.d., photograph, Carl and Carole Vorst, St. Louis,
Missouri.

down as much as it might. The mountains seem to come over the meet the shed and the roof of the porch attached to the octagonal building. Possibly you could send the mountains a little further into the background.[21]

He also requested that the artist paint a band between the mural and the architectural elements of the post office to harmonize them. He suggested a color tone from the mural be selected and he requested a "simple drawing in 1/2" scale incorporating your color proposals."

On April 12, Vorst responded with an acknowledgement of Rowan's criticisms but he wrote "...the points you bring out are much less noticeable in the full-sized painting." Still, he promised to "remedy them together with one or two other minor things which I have noticed that do not just satisfy me."[22] Finally, Vorst said that he planned to return to Paris "in order to refresh my memory and to eliminate the chance of making a suggestion which would not look well if put into being."

At each juncture, the artist tried to appease everyone. He was thorough and responded to each comment quickly. On May 17, he wrote again to Rowan and enclosed both a color photo of the mural installed in Paris and a note from the Postmaster, W. F. Elsken, "I wanted to hand you this card while you were here but forgot. The mural is going over big. Have lots of compliments."[23] Vorst demurred on the painted border, however, and told Rowan he thought it unnecessary. Still, he added, "if you feel a painted border on the wall will aid in tying the whole together, I will be glad to submit a color sketch."

Rowan's letter of May 22 was one of congratulations. He noted to the artist that the color photograph, architectural rendering, note from the Postmaster, a specially-installed lighting fixture, and photographs documenting the installation of the mural had been received, and that he was preparing the final settlement. He wrote, "The photographs indicate that the work looks very handsome in place and I want to congratulate you on your very fine achievement." He also agreed with the artist that a band of color around the mural would not be required. He added, "I was very happy to learn that the mural is going over so well."[24]

With the mural installed (see Fig. 131), the final hurdle was doc-umentation by the Postmaster that all was completed. After some prodding by Rowan—Vorst could not be paid until the Postmaster's letter had been received—, Elsken wrote a lavish letter of praise,

> ...this is to advise that the mural by Mr. Joseph P. Vorst has gloriously met with the approval of all the citizens of this city.
>
> I am sorry that I am unable to favor you with copies of the many compliments given by our local papers and other state papers. I wish to express for all the people of Paris whom I have heard openly commending this wonderful painting, and giving it their sincere praise and appreciation, a complete approval of the mural.[25]

Vorst received a letter dated July 9, 1940 from the Commissioner of Public Buildings, W. E. Reynolds, and a check for the balance of the commission, $350, for a total of $740.

The Section published a description of each community mural. Its official description of the Vorst painting was the following:

> At the left of the mural is depicted a modern stock-breeding farm with foreman, hired men and a prize bull. In the far distance is a coal mine. In the middle center is a cotton gin with a wagon load at the suction pipe. In the right foreground two weight recorders are reclining and a sack of cotton is being weighed. In the background are pickers working in the cotton fields.[26]

The episode of the Paris controversy was relatively brief, but its backstory became clearer over time. Guion had masterminded the entire affair. He had stirred up the business community with an ad hoc committee to force the artist to remove the tenant farmer image by lobbying the banker, postmaster, then the congressman. There had been no attempt to reach a local consensus, presumably with people like those whom Vorst had depicted originally. It was a marketing play to make the area appeal to outsiders for business development purposes.

For his part, Vorst also proved himself to be a flexible artist, willing to leave his studio and rub shoulders with the people of his paintings. The reaction in Paris proves as much. His

eagerness to please commissioning agents was certainly a welcome and ingratiating gesture. The opposite would have been foolish, to irritate a source of funding at a time when other opportunities were few and far between.

Regarding the correspondence itself, Vorst's reassuring letters to the Section are, at once, patriotic, collegial and deferential. Given his English language skills, it is likely that he had help drafting the letters, all of which are erudite and free of the ungrammaticalities that plagued his direct quotations and publications when he acted as the sole author. This suggests that he took the scandal seriously. Arkansas wanted to protect and create its brand; Vorst wanted to protect and create his.

Mural commissions opened an unintended creative avenue for Vorst: the murals themselves became fodder for additional works. It became his practice first to create a mural study, which sometimes included multiple panels, in watercolor or oil on panel, next to paint and install the mural, and then to take the finished composition as source material and translate it into additional paintings and lithographs. Possibly, he developed these works simultaneously.

The Paris mural is an example of this process. In addition to the finished, final version of the mural, Vorst divided the image into three segments as subject matter for lithographs: scenes of cattle raising, a grain elevator, and cotton picking. Placed side by side, they compose a panorama that is very similar to the mura, but not identicall. The corresponding lithographs are *Cattle Buying, Paris Arkansas Grain Elevator* [(Fig. 133)], and *Picking Cotton*. Each of the prints takes the mural imagery and tweaks it subtly. *Cattle Buying* is the least manipulated of the three, but here, Vorst added a few elements to tighten the composition at its edges. *Paris Arkansas Grain Elevator* is also slightly altered from its source imagery. The changes are largely shifts of proportions. *Picking Cotton* is alternately referred to as *Picking Crops*, and its imagery is very close to the mural. But a separate lithograph, *White Gold* (sometimes listed as *White Gold—Last Cotton*) provides additional insight into the mural's creation. It is similar to *Picking Cotton*, but the four characters picking cotton in the mural are changed to three in the lithograph—one of them a woman in a bonnet working next to a man lying on a long bale of cotton on his stomach. Some copies of the lithograph are dated 1939, and it is possible that it predates the mural altogether—that is, that Vorst took

the print's imagery and incorporated it into the redesigned mural in Arkansas. He also created at least one painting based on the mural, using the left side of the work that showed cattlemen. Again, some differences are evident in a comparison of mural and painting.

LITHOGRAPHS

Among the glories of WPA art are its printmaking and photography. Logically, this was by necessity. The market for paintings had essentially vanished. With lithography, for $5 or so, a patron could purchase an original print, signed and numbered by the artist, that provided a similar kind of artistic experience and integrity to works displayed in museums or commissioned as murals by the Federal government. There was nothing new about the technology of making prints, but artists of the Depression embraced printmaking in ways and on a scale that earlier American artists had never done. It addressed multiple needs of the artist that ranged from an intent to spread a message—political and revolutionary ideas, protest art, and later, World War II propaganda and poster art—to an ability to create powerful works that could stand up on their own alongside the artist's best paintings. It was democratic, too, in the sense that practically anyone who could draw could make a simple print. The breadth of printmaking artists of the era is quite astonishing. It includes artists with extensive technical training and those with almost none. For an artist who understood the basic principles of working with a lithographic stone or a metal etching plate, materials were less expensive to purchase than painting or sculpture, sales were not dependent on elite galleries, and the ability to create multiples from a single source was additionally attractive.

The Depression opened a floodgate of printmaking activity, and in some regards it was a golden age that had lasting effects on artists, collectors, museums, and art education programs in the United States. Furthermore, artists with a Social Realist bent discovered that fine art prints had the potential to be just as provocative and more easily disseminated than a high-profile public mural. In an era before color printing was common for magazines and books, the black and white power of WPA prints had all the immediacy of drawing with the benefits of added ease and affordability.

Some of Vorst's most effective works are lithographs. This

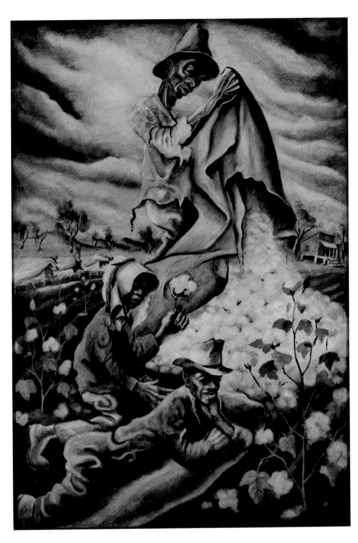

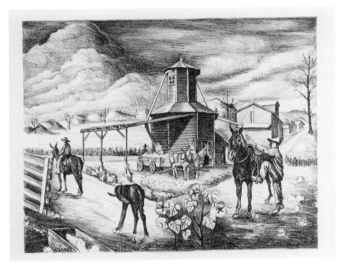

Fig. 133, bottom Joseph Paul Vorst, *Paris Arkansas Grain Elevator*, 1940, lithograph, 8 x 10 in., Carl and Carole Vorst, St. Louis, Missouri.

Fig. 132 Joseph Paul Vorst, *White Gold*, n.d., oil on masonite, 37 x 24.5 in., courtesy McCormick Gallery, Chicago, Illinois and Vallarino Fine Art, New York, New York.

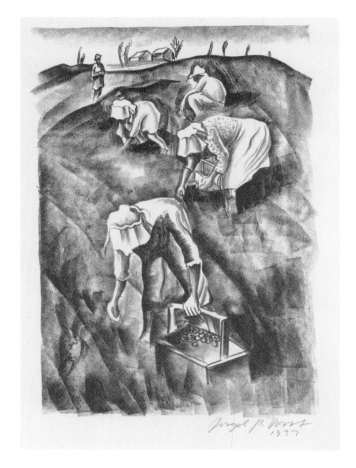

Fig. 134, right, top Joseph Paul Vorst, *Strawberry Pickers,*
1937, lithograph, 14 x 10 in., Carl and Carole Vorst, St. Louis,
Missouri.

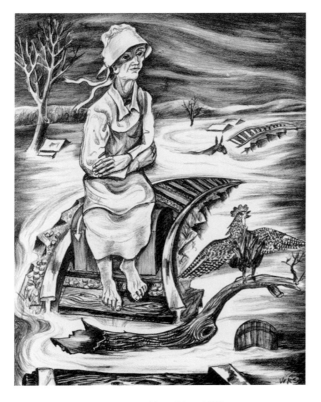

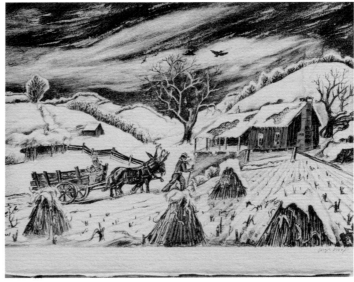

Fig. 135, above, left Joseph Paul Vorst, *Missouri Annual*, 1940, lithograph, 13 x 10.75 in., Carl and Carole Vorst, St. Louis, Missouri.

Fig. 136, above, right Joseph Paul Vorst, untitled card, color lithograph, American Cards, Carl and Carole Vorst, St. Louis, Missouri.

should come as no surprise—his early training was as a printmaker. He created lithographs in Germany for newspapers, and his German linoleum cuts were especially arresting. It is interesting to note, nevertheless, that once firmly established in America, his only known linoleum cuts were a poster in 1930 and his wedding announcement in 1935; all the rest are lithographs. He took to printmaking with passion and dedication. He exhibited prints regularly. While some of them derived from mural imagery, many are original compositions. *Harvest* was exhibited from November 10, 1939 to January 15, 1940 at the Chicago Art Institute's *Seventh International Exhibition of Lithography and Printmaking*. He also participated in The Print Club exhibition in Philadelphia, Pennsylvania, January 15 through February 3, 1940. He exhibited the lithograph *White Gold* at the San Francisco Museum of Art in 1940 and at The Print Club in Philadelphia, Pennsylvania. Gradually, he began to exhibit prints with his paintings in galleries.

In 1937, Vorst printed *Tobacco Planters* (Fig. 92), a scene of workers in the field. He inscribed one of the prints, "To my best friend, Tom H. Benton." His work, *Drifters* (Fig. 95), is a lithograph based on his experiences with the Flood of 1937. In the print, a man and woman with an infant stand on a tiny outcropping of land, the edges eroded by storms. At their feet rest a small sack and what appears to be a birdcage or closed basket. The man—with enormous hands splayed wide—tries to hail a small rescue boat already filled to capacity. His other arm wraps around his wife tightly. They stand with their backs to the viewer. The landscape is completely destroyed by the flood. The water has risen to the eaves of roofs, and a lone donkey swims past dead trees and broken wooden fences. Other lithographs of the late 1930s are *Strawberry Pickers* (Fig. 134), *Dry Riverbed* (Fig. 155), *Missouri Annual* (Fig. 135), *Missouri Mules, Drifters on the Mississippi*, and the Benton family portrait. Most of the prints were published in small editions of approximately 30 copies.

Definitive dating and titling of Vorst's lithographs can be problematic. Typically, his prints were signed in pencil, but they are not always numbered nor dated. He would occasionally write a title on the works, but that is an exception. Not infrequently, the prints have been given multiple titles after the fact, and in cases when the title is unknown or in dispute, galleries, auction houses, the artist's estate and museums seem to have created their own titles for them. But all of that is beside the point of their creation. Vorst was

a natural printmaker. His paintings are highly tonal, and they translated well to the gradient mark-making of lithographic pencil and crayon. In general, Vorst was very interested in light and shadow, even in his paintings, and the one-color process of his lithography, which allows for gradation of shading, was an instinctive fit.

Annually, the Vorsts created lithograph Christmas cards and sent them to friends. These were printed on single, colored sheets and folded horizontally and then vertically into cards with a greeting from Joseph and Lina inside and an image on the front. Amusingly, the Christmas images took prints that he had been creating and gently altered them, repurposed them, as holiday images (compare Figs. 176, 200). The scale of the cards is entirely different from the original prints—to say nothing of the changed imagery. They are not reprints; they are original prints. In effect, these Christmas cards can be seen as original, unnumbered lithograph works.

Commercially, Vorst also created imagery for American Artists Group, N.Y., an operation that commissioned a small number of notable American painters each year to offer limited editions of holiday cards. Vorst's contribution was a farming scene in winter (Fig. 136). A family in a wagon pulled by mules is led by the father across a fallow field dotted with harvested crops toward a red house with smoke rising from a chimney.

Although he received press about his artwork with regularity, personal profiles of Vorst were considerably rarer. Jefferson College and its student newspaper covered the artist in broader and more personal terms than St. Louis and New York newspapers. Still, anyone wishing to know about the artist's home life or more intimate issues was left wanting. For that reason, then, the profile of Vorst in a religious magazine in 1940 is significiant.

Vorst identified as a member of and believer in Mormonism, and he participated in local religious activities with other Mormons in St. Louis. There is no proof, however, that the broader Church itself, headquartered in Salt Lake City, Utah, was aware of him and his work after his initial introduction in Utah at two small exhibitions in 1934 at the Deseret Gymnasium and the Springville Museum of Art. The Springville Museum maintained no records of early exhibitions and the Deseret Gymnasium was demolished in 1997. Vorst's status as a figure within Mormonism changed slightly in 1940

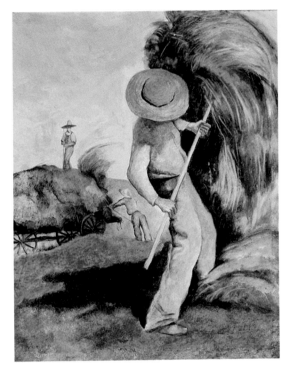

Fig. 137, above, left Joseph Paul Vorst, *Harvest Time*, ca. 1936., oil on panel, 28 x 22 in., courtesy Weschler's Auctioneers & Appraisers, Rockville, Maryland.

Fig. 138, above, right Joseph Paul Vorst, *Southern Mississippi*, 1941, oil on canvas, 30.25 x 25.25 in., courtesy Link Auction Galleries, St. Louis, Missouri.

when the Church's general interest magazine, *The Improvement Era* [Fig. 139], published a profile about him.

The article was titled, *Missouri Artist: Introducing Joseph Paul Vorst*, and it was written by William Mulder. At the time, Mulder was a 25-year old recent graduate from the University of Utah. He was born in Holland and served as a missionary to his native country from 1935-1937. It is unknown why Mulder received the assignment to write the article or whether he discovered the earlier booklet on Vorst and pitched the idea to the magazine publication. It is entirely possible that Vorst sent a copy of his self-published catalog to Salt Lake City, which precipitated the article. Still, the two men did share some interests and general European backgrounds. Mulder later became an important scholar of Mormonism.

A sidebar to the article was written by Virginia Freebairn, a Mormon missionary serving in Missouri at the time,

> Not enough could be said of Brother Vorst's loyalty, his enthusiasm, his desire to help the St. Louis Branch, his genuine sincerity…. He treats the missionaries royally, and his wife is a marvelous hostess…. He leads the singing in Sacrament meeting and also does missionary work among his business associates. I love to hear him tell why he came to St. Louis to take up his work—about this being the chosen spot of the world…. This summer he is coming to Utah. One of the main reasons is to find some of the missionaries he met in the old country, particularly the one who baptized him.[27]

These small glimpses into his personal life are seemingly insubstantial when talking about Vorst's art as a whole, and yet, they provide firsthand insight about his life that is unavailable elsewhere. At the time, no public critic made any connections between Vorst's subject matter—which is nothing if not a litany of concern for the disadvantaged along the lines of Christian charity—and its basis in Vorst's religious thought. His morality was implied and vaguely invoked as a sensitivity to humanist values of compassion, but a Christian source for it went unrecognized.

Mulder's profile, then, is a departure. He begins by rehearsing facts about Vorst, that he is "one of the finest of all Midwestern portrayers of the American scene," that he con-

verted to the Church in Germany and came to American "to obtain unreserved liberty for himself and his talents," and he adds that Vorst chose Missouri because of its "association in Latter-day Saint belief with the original site of the Garden of Eden." This is similar to Vorst's rationale that he wanted to be "wholly American," but it differs in purpose. Here, he justifies immigration as a religious act.[28]

The article also told a bit about his position as an arts educator, and

> As a member of the St. Louis Branch of the Church finds time to lecture before M.I.A. [Mutual Improvement Association classes for teenagers] groups and conduct them on enlightening art tours. A constant missionary himself among his friends, his introductions assist the full-time missionaries in their activities.[29]

It is entirely possible that Mulder and Vorst never spoke. The majority of the information in the article is cribbed from the Hoffmann catalog about Vorst published in 1938. After reviewing Vorst's most recent prizes and accomplishments—the painting *Drifters on the Mississippi* is reproduced in the article along with a photograph of Vorst in a painter's smock, suit and tie—Mulder ends with these thoughts, lifted from the catalog *Joseph Paul Vorst Missouri Artist*:

> Vorst paints, with inborn Teutonic solidity and strength, subjects heavy in social content, tragedy, and "heroics."
>
> He decries "propaganda" painting. He admires fearless honesty and absolute sincerity…. He labors unceasingly, feeling that life provides too little time in which to crowd the work he *must* accomplish.[30]

A logical question would be whether this article in 1940 had any lasting effect on Vorst's reputation within or outside Mormonism—either in St. Louis or in the Church more broadly. It appears that it did not. Regarding his status in Utah, there is no other reference to the artist in the Church's extensive archives, museum collection, or library. The Church purchased none of his work in his lifetime nor had any copies of his publications or press. Although it commissioned numerous member-artists routinely and subsidized their work in various ways throughout the Depression, there is no evidence

THE IMPROVEMENT ERA, JUNE, 1940

MISSOURI ARTIST

Introducing

JOSEPH PAUL VORST

By WILLIAM MULDER

Concerning the subject of this sketch, Virginia Freebairn, missionary serving in the Central States Mission, writes from Columbia, Missouri, as follows:

"Not enough could be said of Brother Vorst's loyalty, his enthusiasm, his desire to help the St. Louis Branch, his genuine sincerity. . . He treats the missionaries royally, and his wife is a marvelous hostess. . . . He leads the singing at Sacrament meeting and also does missionary work among his business associates. I love to hear him tell why he came to St. Louis to take up his work —about this being the chosen spot of the world. . . This summer he is coming to Utah. One of the main reasons is to find some of the missionaries he met in the old country, particularly the one who baptized him."

JOSEPH PAUL VORST

Recognized as "one of the finest of all Midwestern portrayers of the American scene" is Joseph Paul Vorst, German convert to the Church, who came to America in 1930, at thirty-three years of age, "to obtain unreserved liberty for himself and his talents," and who chose to live in Missouri because of its association in Latter-day Saint belief with the original site of the Garden of Eden. Joseph Paul Vorst is Art Director at Jefferson College in St. Louis, and as a member of the St. Louis Branch of the Church finds time to lecture before M. I. A. groups and conduct them on enlightening art tours. A constant missionary himself among his friends, his introductions assist the full-time missionaries in their activities.

An illustrated monograph has been prepared by William Edward Hoffmann presenting a brief sketch of Vorst's life and an evaluation of his work as contemporary artist. Before the fearful ordeal of the World War, which left him permanently lame in one leg, Vorst had been engaged in the field of commercial art and printing at Essen, Germany. The period of readjustment after the war turned him to lithography. Finally, as student at the German National Academy in Berlin, where he studied under the famous impressionist, Max Slevogt, and the renowned Max Liebermann, his paintings began to receive notable recognition—until new desires sent him to America.

In America the early years brought hardship, but in spite of poverty, lack of influence and influential friends, and a limited knowledge of the English tongue, he persisted doggedly, and in the field of commercial art finally earned enough to restore his confidence. His work began to receive notice. He

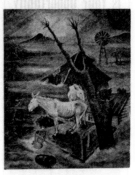

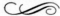
"DRIFTERS ON THE MISSISSIPPI"—PRIZE-WINNING PAINTING BY JOSEPH PAUL VORST.

executed a number of portrait commissions, and, along with his commercial work, found time to create many excellent paintings, several of which have won prizes at exhibitions in the larger cities. Among recent prize works are his "Drifters on the Mississippi," awarded the M. V. Kohnstamm prize at the Chicago Art Institute in 1937; his "Flood Tragedy," awarded first prize at the Kansas City Art Institute in 1938. National honors were accorded his mural for the postoffice at Vandalia, Missouri, and for the mural for Paris, Arkansas, entered in the Forty-eight State Competition.

Joseph Paul Vorst's newly discovered transparent-appearing foundation —a new way of combining opacity with transparency in one operation— is considered a step toward the ultimate in the proper use of color. He uses no palette and applies pure color to canvas. "Vorst paints, with inborn Teutonic solidity and strength, subjects heavy in social content, tragedy, and 'heroics.' . . . He decries 'propaganda' painting. He admires fearless honesty and absolute sincerity. . . . He labors unceasingly, feeling that life provides too little time in which to crowd the work he *must* accomplish."

Fig. 139 "Missouri Artist: Introducing Joseph Paul Vorst," 1940, *The Improvement Era* magazine, Salt Lake City, Utah.

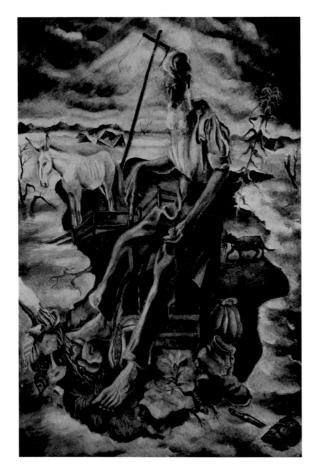

Fig. 140, left Joseph Paul Vorst, *Refugees*, 1940, oil, where-
abouts unknown, reproduced on Vorst's ACA exhibition catalog,
1941, Carl and Carole Vorst, St. Louis, Missouri.

Fig. 141, above Joseph Paul Vorst, *Ferry*, ca. 1940, oil, where-
abouts unknown, photograph, Carl and Carole Vorst, St. Louis,
Missouri.

that Vorst was a beneficiary of it in any way. Likewise, there is no indication that Vorst viewed this as a slight.

GROUP EXHIBITIONS

A reputation in art is a curious thing. Often it is correlated to the company one keeps. Vorst had exhibited with fine artists for a number of years, but the Whitney Museum of American Art's 1940-41 Annual Exhibition of Contemporary American Painting (November 27, 1940 through January 8, 1941) was a milestone for the artist in that it placed him in the tighter circle of American masters. 164 artists were represented with paintings at the museum's home on 10 West Eighth Street in New York. The catalog reads as a checklist of pre-war American artistic prominence, including: Thomas Hart Benton, Isabel Bishop, Charles Burchfield, Paul Cadmus, Ralston Crawford, John Steuart Curry, Stuart Davis, Wenrer Drewes, Guy Pène du Bois, Lyonel Feininger, Arshile Gorky, Adolph Gottlieb, George Grosz, Marsden Hartley, Edward Hopper, Joe Jones, Rockwell Kent, Walt Kuhn, Yasuo Kuniyoshi, Jack Levine, Reginald Marsh, Jan Matulka, Saul Schary, Ben Shahn, Charles Sheeler, John Sloan, Raphael Soyer, Bradley Walker Tomlin, and Max Weber.[31]

The director of the Whitney, Juliana Force, had written to Vorst June 7, 1940 to invite him to contribute a painting to the 1940-41 Annual. Unlike many large group exhibitions at the time that followed a structure of open competitions, this exhibition was an invitational affair. The letter read, "only works of invited artists will be shown."[32] It was also the largest in the history of the museum. Costs of transportation and insurance were borne by the Museum. Vorst accepted the invitation and sent a painting to New York.

Vorst's contribution to the Whitney exhibition was *Refugees* [Fig. 140]. A reproduction of the work appeared along with six other paintings from the show in *The New York Times*, November 24, 1940 and misspelled his name "Joseph P. Vorset."[33] In the painting, an old man with a long beard sits on an island with encroaching water all around it. He sits on a wooden chair surrounded by various objects: a black cat with a mouse in its mouth, an old, laceless boot, a pumpkin, a tall stalk of corn, a lily pad with a frog jumping into the water, a log with moss and vines growing around it, and a cob of corn. Behind him are a mule, a fence dividing the foreshortened space, and a leaning telephone pole. The proportions

of the man are unusual. He looms like a heroic figure with enormous hands and feet. He is far bigger than anything around him. In the distance, like many of Vorst's flood images, a house is submerged nearly to the roof and the sun is breaking through an ominous sky.

In April, Vorst heard that he had won his third commission to paint a post office mural, this time in Bethany, Missouri, 285 miles northwest of St. Louis. Opportunities to exhibit his paintings came more frequently now. The same month, Vorst contributed four paintings to *Art and Artists Along the Mississippi*, a second annual show at the Davenport Municipal Art Gallery in Davenport, Iowa. The press in Chicago and Davenport noted his participation: "Three Mississippi artists who have arisen to national prominence, William Bunn of Muscatine, Joseph Vorst of St. Louis and Adolf Dehn…."[34] *The Davenport Democrat and Leader* published a photograph of Vorst standing in front of *Ferry* [see Fig. 141]. The caption noted the artist's increasing notoriety. Another photograph showed Joseph and Lina standing in front of a Benton painting. Its caption read:

> Thomas Benton's oil painting, "Missouri Musicians," was being viewed by two of the reknown artist's personal friends, Mr. and Mrs. Joseph Vorst of St. Louis, Mo., the former of whom is also a distinguished artist and exhibitor in the current show at the Art gallery, when the above photograph was taken during Thursday night's formal opening…. Mr. Vorst is head of the art department of Jefferson college in St. Louis. His oil painting, "Drifters on the Mississippi," a flood scene, occupies a position of prominence in the river show. The painting was awarded the Kohnstamm prize during the recent 48th annual show of the Chicago Art Institute."[35]

Although public documents and press indicate that Vorst's paintings traveled with some frequency, less is known about the artist's own movement. Did he attend openings of exhibitions in Chicago, New York, San Francisco, and elsewhere? Did he ever return to Germany or communicate with his family there? There is little proof one way or the other. Occasionally, a photograph appeared in a local newspaper that placed him in front of a painting at a gallery or museum opening. Extrapolating a bit, one assumes that he did see some of his works on display. During the Depression, this travel must have been a sacrifice of the Vorsts' resources.

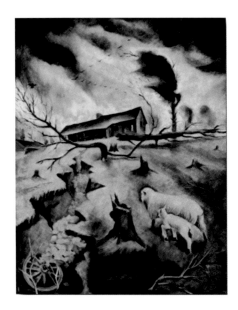

Fig. 142 Joseph Paul Vorst, untitled, n.d., oil, whereabouts unknown, photograph, Carl and Carole Vorst, St. Louis, Missouri.

Gradually, in the 1940s, financial pressures eased.

A discussion of travel leads to conjecture about his sales history. Although he exhibited somewhat widely, did his works sell? No ledger has been found to document the business side of his studio during his lifetime. Certainly, mural commissions and museum prizes were cash-positive events. Another clue to his success placing artworks with collectors is the fact that from the mid-1930s to 1941, when Vorst had a solo exhibition in a gallery, all or nearly all of the works were new and had never been shown before.

Having lived on Page Avenue for a number of years, the Vorsts wanted dedicated space in which he could paint. He needed a studio. In July 1941, Joseph and Lina purchased an empty lot for an art studio on 11146 Morrow Drive, in Overland—later incorporated as St. Ann—in northwestern St. Louis. At the time, it was an undeveloped part of the city that slowly grew as workers in the defense industry moved in. Originally, the Vorsts built their lot as a garage studio.

At the time, restrictions existed on building materials, and Vorst negotiated exceptions in order to add a kitchen and sleeping quarters. He told officials that the studio would be used to paint government murals, and as such he needed an exemption in order to make the studio habitable with essential additions. He had no money for materials, and so he bartered artworks for construction goods. "In the process of building his 'essential' additions, a living room and fireplace 'happened to appear.' These joined the kitchen and sleeping quarters to the studio, creating a home."[36] Wooden beams in the ceiling were taken from the 200-year old home of Vorst's forefathers in Ste. Genevieve, he later explained.[37]

He was ready for a change, and the impulse extended to his paintings' subject matter. Perhaps it is coincidental, but he wrote a letter to Edward B. Rowan of the U.S. Treasury in April and told him he was tiring of painting mules all the time.[38]

Vorst participated in a local exhibition at the City Art Museum in St. Louis in November. The critic for the *St. Louis Star-Times*, Reed Hynds, had previously been supportive of Vorst. But in a gloomy review that took all of the artists to task for being insufficiently contemporary, he wrote, "Joseph P. Vorst's 'White Gold,' with the cotton pickers that are becoming an old refrain...."

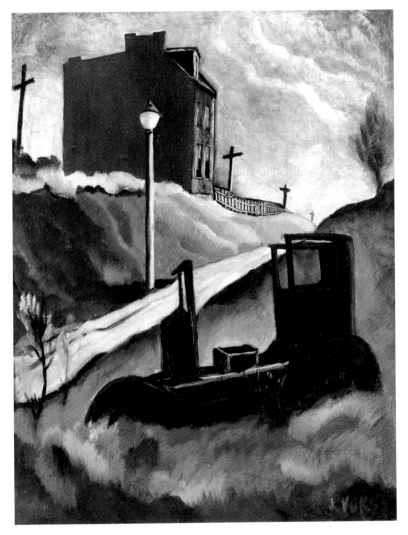

Fig. 143 Joseph Paul Vorst, untitled, n.d., oil on canvas, 24 x 20
in., Carl and Carole Vorst, St. Louis, Missouri.

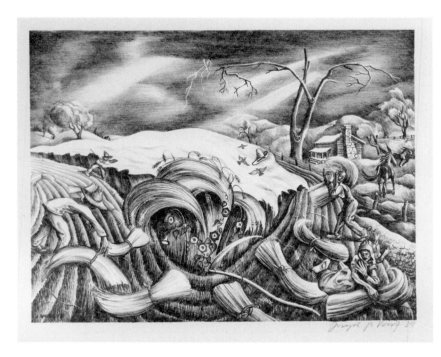

Fig 144 Joseph Paul Vorst, *Early Morning Storm*, 1939, litho-
graph, 16.75 x 15 in., Carl and Carole Vorst, St. Louis, Missouri.

The criticism is not unjustified. Vorst had a proclivity to cre-
ate an image that was personally meaningful (and success-
ful)—mules, floods, sharecroppers, harvest scenes—and
duplicate the image (at least in tone and general subject
matter) again and again in his works. This replication of his
primary imagery went beyond the process of taking a draw-
ing and developing it into a painting or conversely, making a
print out of a painting; he was simply comfortable repeating
himself.

Over time, this became somewhat detrimental to his career
for two reasons: first, the 1940s became a transitional time
in American art in which traditional styles were soon to be
upended beyond recognition with an impulse to create a
passion for "the new"; and second, Vorst rarely explained his
paintings and creative process, and he lacked an articulate
advocate who would write in any extended way about the
meanings to be found in his work and why certain subjects
and symbols deserved to be explored in multiple paintings.

Critics began to comment that he was reworking familiar
territory.

Perhaps this began from the way he developed murals in
the late 1930s. In addition to completed murals and mural
studies for known competitions for post offices and other
government buildings, Vorst made designs for other murals
over a period of several years, beginning in 1938 and con-
tinuing through World War II. He developed the imagery in
various ways. Occasionally, the studies contained images
that appear nowhere else in his career—western themes
such as the Pony Express are examples—and elsewhere he
drew works that connect to his signature issues and style
but are singular in composition. Unlike his practice of tak-
ing completed murals and mining them for ideas for prints
and smaller-scaled paintings, he occasionally worked in an
additional and opposite way: taking finished paintings and
reimagining them as pieces of a mural. Perhaps the most in-
terest of these is a reworking of *Drought* for an unidentified

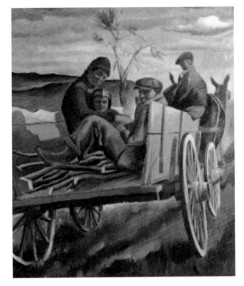

Fig. 145, left, top Joseph Paul Vorst, unidentified painting, photograph, Carl and Carole Vorst, St. Louis, Missouri.

Fig. 146, left, bottom Joseph Paul Vorst, *Barn Fire*, ca. 1941, oil, whereabouts unknown, photograph, Carl and Carole Vorst, St. Louis, Missouri.

Fig. 147, above Joseph Paul Vorst, *That This Land*, n.d., oil on canvas wrapped on panel, 26.5 x 32 in., Carl and Carole Vorst, St. Louis, Missouri.

mural study $^{(Fig. 154)}$, likely around 1939.

At the end of 1941, Vorst had a flurry of exhibitions. His work was shown at the Carnegie Institute in Pittsburgh, Pennsylvania from October 23 to November 14. The Corcoran Gallery of Art in Washington, DC held a biennial exhibition of contemporary paintings every other year. 1941 marked the 17th biennial, and it ran from March 23 to May 4. Vorst showed a painting in the exhibit. It was *Southern Mississippi* $^{(Fig. 138)}$, a flood image with a muscular black man wading through floodwaters while a submerged house floats in the background. Spanish moss hangs from withering branches, and in the far distance a steamship billows smoke. Here, the artist combines documentary paintings with allegorical ones. The bare-chested man holds a lamb over his shoulder. His left hand holds a net full of buoyant, jumping fish, while another net hangs empty and abandoned on a broken tree stump.

Then he had two nearly overlapping one-man exhibitions. He had exhibited in group shows, but he had not had a solo show in New York since 1938. He returned to the ACA Galleries in New York for a show of 23 paintings and 12 lithographs, exhibited from November 30 to December 13, 1941. All the works had been completed (with the exception of one lithograph, *Loading Hay*) in 1938 and after. The work was unusually diverse in subject matter, possibly indicating an artist in transition. Some of the paintings were new works on familiar subjects, *Strawberry Pickers, Fear, After the Flood, Drought* (illustrated in the catalog and captioned incorrectly, as "Drough"), *Hill Farmer, Ferry Boat, Evening* $^{(Fig. 153)}$, and *Too Much Rain*. In dramatic fashion, they told the stories of crisis, peril, and anguish.

Other paintings showed a new vein for Vorst. He had always employed symbols in his works, but the ACA Galleries show debuted paintings that were purer allegory. These included *Deep River, War Council,* and *Oyster Fishing* (sometimes known as *Oyster Fisherman*). Additionally, there are works on the exhibition catalog checklist that are unknown and may have fit into this latter category, including *That This Nation* and *Human Cargo*.[39]

AN AMERICAN ARTIST

Joseph Paul Vorst kept no diary or journal—at least none has been found—and his surviving correspondence is spotty and generally limited to letters to and from museums and government agencies. For the sole reason that it is his only autobiographical text, the catalog for the 1941 ACA exhibition is especially enlightening. On the cover is *Refugees*. Vorst wrote an essay himself for the catalog, which he called a "Foreword." In it, he explained himself. He described what being an artist meant to him and how one becomes an artist. He provided a colorful history of his childhood. He took one of the new paintings and explained it. He spoke of nations and patriotism. He referenced art history and his own genealogy. That is a lot of ground to cover in a five-page essay, and unsurprisingly, it is a bit of a jumble.

He admitted as much in the first paragraph of the essay,

> In presenting my convictions and ideas on art outlined in the following pages, I must beg that you bear with me, as having been born in old Germany and in America for a relatively few number of years, I consequently, do not have as yet a full command of the language.[40]

Vorst wrote of America and its art with pride. He noted that "Art in America has finally found its place in the sun…. Art in America is a 'free art' and will remain as such, unrestrained and unhampered by narrow prejudice as long as there is an America."[41] At the same time, he condemned artists who only give the public what it wants, "'fad' painting which sells." For him, "true art" is a vocation attacked with scientific devotion to its methodology and history. Only then, he argued, can someone become an artist.

> Before reaching this state of complete emotional freedom of expression, the artist is quite often influenced by the work, or works of a particular master or school of art and thereby passes through, and sometimes remains indefinitely in, the intermediate stage of conscious or sub-conscious imitation.[42]

This is a curious statement for Vorst to make. Despite his connection with Thomas Hart Benton, Joe Jones, and others in their circles—and Jones, in particular is an undeniable influence in numerous paintings before 1940—Vorst never nods in his career toward any indebtedness to them artistically or to an acknowledgment of their influence. Critics, on the other hand, consistently referred to Vorst as an acolyte

Fig. 148 Joseph Paul Vorst, *After the Flood,* ca. 1940, oil on board, 28 x 36 in., Crystal Bridges Museum of American Art, Bentonville, Arkansas, 2007.220.

of other painters. Perhaps, he was affirming his independence. Vorst wrote extensively in the catalog text about the history of great art and the common goals of artists such as Rembrandt, Hals, and Cézanne, specifically that they transcended mere technique—the implication being that he saw himself in those terms, as well. Any number of his paintings that appeared to be regional imagery are in fact references to classical European paintings.

> Any born artist is a born virtuoso. And as such, may work all his life to perfect a certain technique, but fundamentally it is a technique of realism, not the bare technique of mechanics. Cézanne called it the imagination—his feeling.[43]

Vorst was also a musician. For a time, he considered his career choices to be between art and music. The essay provided some insight into how music affected his thinking as a painter. He described in some detail the painting *Deep River* which is a female nude standing in a river holding a large fish in a net. Vorst described the symbolism of the painting and discussed its connection to music:

> The real artist designs his masterpiece in the simplest and truest form. To illustrate this statement I take as an example one of my later paintings which I have called "Deep River." This painting symbolizes the great Mississippi river as I imagine it in the strongest sense of emotion. The painting further portrays a negro Venus born out of the muddy water, catfishing. I have tried to transfer to canvas the great music of the river and river life as strong and moving as Dvorak's masterful New World Symphony—all of the color and tradition of the negro slaves, their spirituals, the great south, the tugboats and traders, all combine to add harmonious tones to the whole.

> All these traditions, the sweep and majesty of the great river, awake in me such strong emotions that the "Deep River" can only be painted symbolically, or in expressionistic character.

> Whenever I listen to the musical composition, "Deep River," I feel that it is the essence of harmony with powerful, sweeping emotional current.[44]

It is assumed that Vorst was drawn to subject matter—indeed he based his American career on it—of the local landscape and inhabitants of Missouri because that was where he lived. Vorst wrote that he painted the "Missouri Scene," rather, because it is "unspoiled and untainted by ruthless modernization." He wrote that he painted workers of the Ozarks and Missouri mules because he was compelled to do it.

"Perhaps one of the basic reasons for my desire to paint the 'Missouri Scene' is because I understand the rugged life it characterizes and the philosophy of the people."[45] He described his childhood, training, and deep admiration for the great masters, Michelangelo, Titian, and Rembrandt. And then he added,

> I do not want to be as good as Rembrandt or any other artist living or dead. What I want to portray on canvas for the public and the way in which I paint it will be as good as its own conception and execution as any work accomplished by any other artist.

> May I say frankly, that the only school of art which ever influenced me in the least is the Renaissance Dutch School, especially such artists of that school as Peter Bruegel and Rembrandt. Some case for my trend of interest toward this era in art may be found in the fact that among my ancestors were famous Dutch statesmen.[46]

He dedicated the exhibition to the memory of his parents, to his immigrant forefathers, to his teachers in Germany, "and last but not least to my wife as she faithfully faces with me all of life's ups and downs."

The essay was part autobiography, part thesis, and part love letter to art history. Perhaps above all, it was a declaration of his thinking as an American artist. He ended the essay with this statement, published a week before the surprise Japanese attack on Pearl Harbor,

> As a token of my appreciation for privilege of living as an American citizen in this great country of freedom of expression, and for the honor of being commissioned to paint three murals for United States Post Offices, I donate all proceeds over and above expenses to National Defense Organizations.[47]

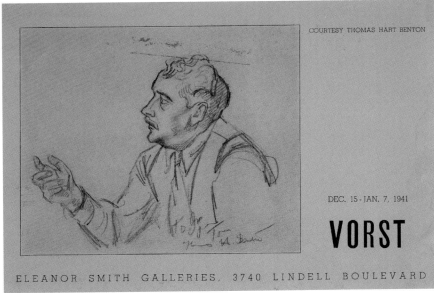

Fig. 149, left, top original frame for the painting, *Drought*, detail, private collection, Illinois.

Fig. 150, left, bottom exhibition catalog at ACA Galleries, NY, 1938, with drawing of Vorst by Thomas Hart Benton, print media, 6.75 x 9.75 in., Carl and Carole Vorst, St. Louis, Missouri.

Fig. 151, above Joseph Paul Vorst, *Oyster Fishing*, ca. 1941, oil on masonite, 52.5 x 41.5 in., Carl and Carole Vorst, St. Louis, Missouri.

New York newspapers covered the exhibition with reviews and reproductions of paintings. It was the most extensive response to an exhibition that the artist had ever received. The painting *Time Out* was printed in *The Villager, Greenwich Village*, and *Barn Fire* (Fig. 146) appeared in *The New York Sun*. The latter published an extended critique of the exhibition, which began with a response to Vorst's offer to donate money to the military,

> We hear a great deal about national defense in these days and the necessity of supporting it. Yet it has remained for Joseph Paul Vorst to be the first artist to announce that the entire proceeds of his exhibition, beyond expenses, would be devoted to that end. This, with the picture market as it is today, may prove little more than a well-meant gesture.[48]

The paper's critic noted Vorst's reputation as a follower of Benton and Jones, then clarified the statement by putting the artist's work in context of global conflict,

> The mention of Joe Jones may indicate to some that Mr. Vorst is engaged in social front or political propaganda. Nothing could be farther from the truth except that he sometimes seems to see the outer world much as Joe Jones sees it. Mr. Vorst, one is inclined to think, goes deeper. For virtually his entire series of canvases seems like an arrangement of elements. Flood and disaster and drought are everywhere. A woman and a cow float down stream on a raft, a Negro on his knees in his parched field prays for rain under troubled but rainless skies. Even fire adds to the tale of disaster. But one suspects that the actors in this saga of rural catastrophes are really symbols that represent a sensitive artist's reactions to the current worldwide upheaval and desolation wrought by the return of human savagery of the present world war.[49]

The *St. Louis Post-Dispatch* published a short notice about the exhibition. It also mentioned the subject matter of the paintings as well as Vorst's offer to donate its proceeds to national defense. And like *The New York Sun*, it noted the paradox that he was born in Germany.

The New York Times, on the morning of December 7, 1941, published its own review of Vorst's show written by Howard DeVree. Like other critics, the writer attempted to contextualize Vorst's style within the visual vocabulary of other Regionalists and found that the artist was becoming his own man,

> Joseph Vorst, who has not shown in New York for several years, is the current exhibitor at the A.C.A. Gallery. These large temperas reveal a decided advance over his previous work, although Benton, Curry and perhaps Joe Jones still seem to be strong influences—more noticeable now in details than in the whole picture. He has abandoned what some one once described as the "Toonerville Trolley effects in Benton" for solid painting and the work is sincere and earnest albeit at times strangely lacking in taste.[50]

Issues of taste and influence grew to be problematic for the artist. He had always had a fondness for heavy, gaudy picture frames, for example (see. Fig. 149). These were weathered and ornate frames or frames that he distressed to appear old. All of his paintings were displayed in this way, and the effect was an extra layer of heaviness added to a painting style that had become increasingly dark and moody. This, at the same time that many artists were trying to navigate their way to new, brash, and revolutionary styles.

In the mid-40s, some of Vorst's paintings seemed to grow increasingly more connected to El Greco. Any number of comparison paintings between Vorst and El Greco reveal tight correlation: the moodiness, the streaky skies, the saturation of greens and blues, the distortions of portraiture, the distancing of the landscape, and so forth. As Vorst aged, he seemed to reach back farther and farther to classical modes. He evoked them and quoted from them. In subject matter he was decidedly American and more specifically Missourian, but his engagement as an artist stretched more broadly, however unfashionably.

Just as the paintings are a mixed bag in some respects, the reviews vacillated in their opinions of the works. *The New York Herald Tribune* focused on Vorst's interest in drama, for better or worse,

> Joseph Paul Vorst, Missouri artist, is a stimulating painter, even though his dramatic talent rather runs away with him. At the A.C.A. Gallery, easily the best of his Middle-West subjects is "After the Flood," a simple, serene and richly painted picture of two Negroes,

man and wife, standing alone in their storm-devastated fields. Most of his works, which show strong Benton influence, are keyed up to excessively violent moods of drama; dramatically, at least, they are way ahead of the artist's capacity fully to control and harmonize them. With vigor and imagination in his favor Mr. Vorst could easily afford to tone down and consolidate his gains instead of pushing on at full force.[51]

It had been seven years since *Time* magazine launched Benton, Wood, and Curry in the minds of Americans as the principal voices for Regionalism. In some ways, the public was still trying to sort out the key players. Vorst had arrived in New York galleries on the coattails of Regionalists and Social Realists, and he was not entirely successful freeing himself from those connections. The issue of influence was a recurring question for those writing about his work. Some noted differences between Vorst and Benton, for example, and their reactions to Vorst were often litmus tests to their attitudes toward Benton—it should be remembered that Benton was a highly divisive figure in New York art circles. In their remarks, however, one catches glimpses of Vorst as an independent voice.

Vorst kept a newspaper clipping of the following review—unfortunately, it is without a citation of its origin—from a New York critic, who signed his column, E.G.,

At the A.C.A. Gallery Joseph Vorst is showing new pictures. It's a pity Joe Jones and Thomas Benton keep getting in the way of real appreciation of Vorst. There is unquestionably a strong likeness between himself and both of these better-known men. Perhaps the similarity derives in some extent from similarity of subject. All three artists paint the Missouri countryside, especially the Ozark region. Vorst paints it with sinuous, slightly hard but highly animated linear patterning which recalls much of Benton's work, and with that explosive textural quality (especially in the handling of wheat fields) plus a type of characterization (particularly of Negroes) which suggest Jones.

Because really, when you get close up to these things and give yourself over to them for a while, you realize that Vorst has qualities quite his own. There is a freshness and subtlety of tone (as in Strawberry Pickers) which is personal. There is a compactness of design (as in Refugees) which is Vorst alone. There is a porcelain-like surface quality you don't get in either of the two other men.

Vorst really is himself—and at his best—however, when he does something like War Council, a broadly brushed, inventively designed study of a group of turkeys."[52]

It is mere conjecture to suggest whether Vorst was uncomfortable with the idea of influence from his contemporaries. There is no additional published document written by Vorst to clarify his thinking on the topic. It was undisputed, however, that he and Benton were friends. The ACA exhibition closed on Saturday, and two days later Vorst had another one-man show, this one in St. Louis at the Eleanor Smith Galleries on 3740 Lindell Boulevard. Here, the Benton connection was unassailable. For the cover of the exhibition catalog, Benton contributed a drawing he had made of Vorst inscribed, "To Joe, Yours, Tom H. Benton." And in bold type across the cover: "Courtesy Thomas Hart Benton" (Fig. 150). The Kansas City artist had written an essay for Vorst's 1938 New York exhibition, and a paragraph from it was excerpted for the 1941 show's catalog in St. Louis.

After more than a decade in America, galleries, even local ones in St. Louis, led off their texts about Vorst with disclaimers about his German birth, "Joseph Paul Vorst, a native of Essen, Germany, came to America in 1930, where he immediately took out his naturalization papers," Eleanor Smith Galleries wrote.[53] In the context of 1941 America, however, one can readily imagine prejudice aimed at German Americans. Since World War I, there had been a consistent distrust of any hyphenated citizens, as it were. In Vorst's case, the emphasis on his background was not isolated to the 1940s; it started when he stepped off the boat from Europe.

Had critics taken the time to look at Vorst's work through German Art historical lenses—rather than merely marginalizing him as German—they might have better understood his exaggerations and distortions in painting figures, for example, and the "taste" issues that rankled their sensibilities might have been given a proper context within German art movements that influenced him, particularly New Objectivity. Without that key deciphering data, his work appeared to them as brutish rather than stylized.

Fig. 152 Joseph Paul Vorst, *War Council*, ca. 1941, oil on canvas, 20 x 24 in., Carl and Carole Vorst, St. Louis, Missouri.

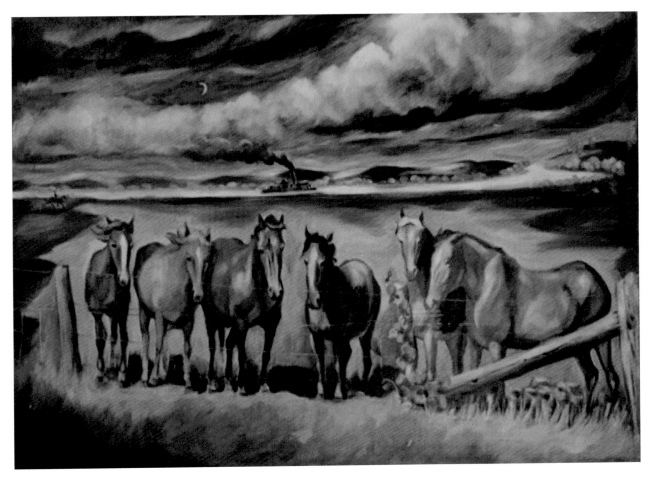

Fig. 153 Joseph Paul Vorst, *Evening*, ca. 1941, oil on masonite,
30 x 50 in., Carl and Carole Vorst, St. Louis, Missouri.

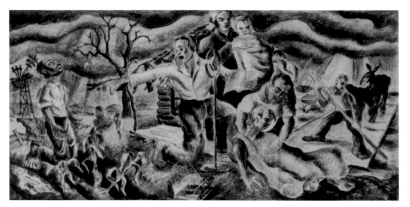 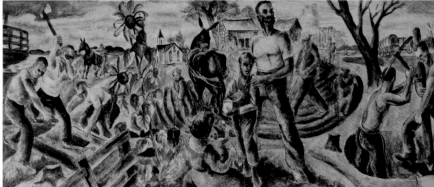

Fig. 154 Joseph Paul Vorst, untitled mural study, ca. 1938, watercolor, private collection, Illinois.

The works on view at Eleanor Smith Galleries were some of the same paintings and lithographs shown in New York. It must have been a hastily-hung exhibition if the paintings had to travel from New York to St. Louis in a single weekend. The St. Louis show featured 19 paintings and 7 lithographs. Reading only a checklist of the exhibitions, it is impossible to know exactly which paintings were in both places because the titles have slight discrepancies, and Vorst did tend to create multiple works on similar subjects. Furthermore, variations of this sort are consistent with the practices of Vorst and his gallerists, who seemed to take license with titles and allowed errors to creep into their publications with regularity. One assumes that *Self-Portrait* is the same as *Self Portrait*, that *Ferry Boat* is the same as *Ferryboat*, and that *To Much Rain* is the same as *Too Much Rain*. But is *War Council* the same painting as *The Council,* for example? Likely it is, given that press accounts refer to it as a painting of turkeys, an unusual symbol—Vorst told friends these turkeys represented specific European despots plotting war—and are other paintings that share themes actually the same works?

The press in St. Louis responded to the art as "full of movement, bold in pattern."[54] The critic Reed Hynds, who had recently chided Vorst, now turned to the paintings with admiring eyes and wrote about them descriptively and almost rhapsodically,

…Vorst achieves a dynamic effect by vigorous line and broad surfaces of raw color.

Waves lash in white fury at the edge of a raft, in his picture of a woman and cow floating on a storm-swept river. Yellow wheat is bent and broken viciously in "Too Much Rain."

Tragedy looks from the eyes of a Negro woman and baby. There are happier paintings, of quiet landscapes and bright still lifes, but the dominant quality is of ceaseless and somber activity, whether of storm or human work.[55]

To the public, reading about Vorst in a newspaper was the primary source of their information about him. Unlike Benton, who published not one but two autobiographies (and he was working on a third at the time of his death, in 1975) and had multiple volumes of published letters, collected essays, and scores of interviews, Vorst's career never attracted that degree of attention. Even if someone had wanted to do an in-depth profile on Vorst at the time, there were very few source documents to use as base materials. Regarding the general public, a relative few had access to the gallery catalogs that attempted to give additional insight into the man and his thinking. For that reason, then, it is significant

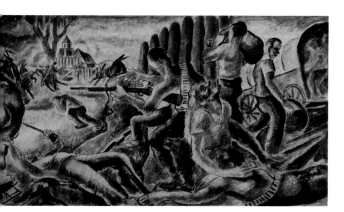

to parse the comments of critics, and local critics in particular, when attempting to determine how Vorst was viewed by others.

Harry R. Burke began his review of the St. Louis exhibit with a new slant of a backhanded reference to his German roots, "Joseph Vorst loves his adopted America in a curious way." He then described his reaction to the artworks, which he called "quaint."

> "Quaint" is used deliberately. His is a fairy-tale sense of humor which compromises itself with the angular forms of Missouri mules and Missouri rail fences in order to effect a rhythmic composition. But that formalization flings back to the Brothers Grimm the minute there is an opportunity to depict a racing rabbit, a stealthy fox, a ruminative sheep, a placid but masterly mule."[56]

This is the first time that Vorst's work was linked in the press to literary fables. In a sense, it was inevitable, and not only for the German connection. Vorst found storytelling to be a powerful tool, and because his medium forced him to depict a single event rather than an extended timeline of narratives, he packed the pictures with allegorical clues to larger meanings. Many of Vorst's stories connect to specific and

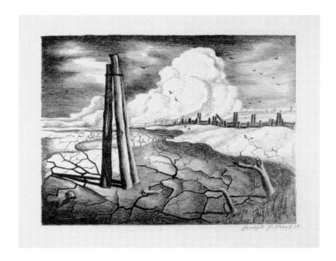

Fig. 155 Joseph Paul Vorst, *Dry Riverbed*, 1939, lithograph, 12 x 9 in., Carl and Carole Vorst, St. Louis, Missouri.

historical events, but without further commentary to explain them, viewers can be forgiven for overlooking the artist's larger intent and instead seeing, merely, a group of turkeys or a line of mules leaning against a fence. One assumes that Vorst might have winced at the word "quaint," but in some regards he had been constructing a vocabulary of tales in the Ozark woods not entirely unlike the Brothers Grimm.

Burke continued his review and emphasized humor, a quality that had been unremarked upon until now,

> Fundamentally, as one has said, Vorst is a rhythmic constructivist. In addition there is that whimsical, fairy-tale humor. Both of these one may attribute to the German birth and training which he has abjured. But the important thing is his perception of beauty in the most squalid and desolate of Missouri hillside aspects.[57]

It is debatable whether Vorst ever abjured his birth and training, but perhaps more interesting was the backhanded compliment of a local critic who sought to claim Vorst and wrote that Vorst loved America. The fact is that any connection to Germany in 1941 was hazardous.

ENDNOTES

1. The National Archives Catalog, Federal Works Agency: Public Buildings Administration 7/1/1939-12/11/1949. National Archives identifier: 532306, accessed October 8, 2015.

2. Tim O'Neil, "A Look Back: Chicago Artists Tell Story of Early St. Louis in Fresco in 1942," *St. Louis Post-Dispatch,* April 13, 2013.

3. See "Speaking of Pictures…This Is Mural America for Rural Americans," *Life* magazine, December 4, 1939, 12-15.

4. Ibid, 12.

5. See Marlene Park and Gerald E. Markowitz, *Democratic Vistas: Post Offices and Public Art in the New Deal* (Philadelphia: Temple University Press, 1984), xvii.

6. United States Department of the Interior, National Park Service, "National Register of Historic Places," OMB No. 10024-0018, section 7, 8.

7. "Speaking of Pictures, This Is Mural America for Rural Americans," *Life* magazine, December, 1939, 12.

8. John Guion, "That's Right, We Don't Like the Mural," *Paris Express*, November 2, 1939, 1.

9. Joseph Paul Vorst, "Letter from the Artist Vorst," *Paris Express*, November 16, 1939, 1

10. Correspondence between John Guion and Fadjo Cravens, October 28, 1939.

11. Correspondence between Joseph Paul Vorst and E. B. Rowan, November 6, 1939, see National Archives Record Group 121, P.B.S. #133, boxes 4 and 59.

12. Correspondence between E. B. Rowan and Fadjo Cravens, November 8, 1939, see National Archives Record Group 121, P.B.S. #133, boxes 4 and 59.

13. See Karal Ann Marling, *Wall-to-wall America: Post Office Murals in the Great Depression*, University of Minnesota Press, 1982.

14. Correspondence between Joseph Paul Vorst and Edward. B. Rowan, November 11, 1939.

15. Ibid.

16. Correspondence between E. B. Rowan and Joseph Paul Vorst, November 16, 1939, see National Archives Record Group 121, P.B.S. #133, boxes 4 and 59.

17. Correspondence between Joseph Paul Vorst and E. B. Rowan, December 15, 1939, see National Archives Record Group 121, P.B.S. #133, boxes 4 and 59.

18. Correspondence between Joseph Paul Vorst and E. B. Rowan, December 28, 1939.

19. Correspondence between E. B. Rowan and Joseph Paul Vorst, December 29, 1939, see National Archives Record Group 121, P.B.S. #133, boxes 4 and 59.

20. Correspondence between Joseph Paul Vorst and E. B. Rowan, March 29, 1940, see National Archives Record Group 121, P.B.S. #133, boxes 4 and 59.

21. Correspondence between E. B. Rowan and Joseph Paul Vorst, April 3, 1940, see National Archives Record Group 121, P.B.S. #133, boxes 4 and 59.

22. Correspondence between Joseph Paul Vorst and E. B. Rowan, April 12, 1940, see National Archives Record Group 121, P.B.S. #133, boxes 4 and 59.

23. Handwritten note from W. F. Elsken to Joseph Paul Vorst, undated, see National Archives Record Group 121, P.B.S. #133, boxes 4 and 59.

24. Correspondence between E. B. Rowan and Joseph Paul Vorst, May 22, 1940, see National Archives Record Group 121, P.B.S. #133, boxes 4 and 59.

25. Correspondence between W. F. Elsken and E. B. Rowan, June 27, 1940, see National Archives Record Group 121, P.B.S. #133, boxes 4 and 59.

26. "One-Page Summary Sheets on Murals and Artists," 135 (Box 203), Vorst, Joseph, "Rural Arkansas," Paris, Arkansas, cited in Karal Ann Marling, *Wall-to-wall America: Post Office Murals in the Great Depression*, 113.

27. William Mulder, "Missouri Artist: Introducing Joseph Paul Vorst," *The Improvement Era*, June 1940, 326-327.

28. Ibid.

29. Ibid.

30. Ibid.

31. See *1940-41 Annual Exhibition of Contemporary American Painting, Whitney Museum of American Art*, New York: 1940, catalog.

32. Correspondence between Vorst and Juliana Force, June 7, 1940.

33. "American Art," *The New York Times*, November 24, 1940, 4.

34. "Open 'Art Along the Mississippi' Show on April 3," *Chicago Tribune*, March 13, 1941.

35. Unidentified newspaper clipping in possession of the artist, presumably circa April 4, 1941.

36. Phone conversation between Grant Kniffen and Carl Vorst, August 17, 1989, as cited in "Joseph Paul Vorst" by Grant Kniffen, 1989.

37. Howard Derrickson, "Indignation Over Wrongs in Oils by Joseph Vorst at Noonan-Kocian," *St. Louis Post-Dispatch*, April 20, 1947.

38. Correspondence between Vorst and Edward B. Rowan, April 27, 1941.

39. See "Vorst," ACA Galleries, exhibition catalog, November 30-December 13, 1941, New York, unpaginated, checklist laid in.

40. Ibid.

41. Ibid..

42. Ibid.

43. Ibid.

44. Ibid.

45. Ibid.

46. Ibid.

47. Ibid.

48. *The Villager, Greenwich Village*, December 4, 1941.

49. Ibid.

50. Howard DeVree, "A Reviewer's Notebook," *The New York Times*, December 7, 1941.

51. "Drama in Missouri," *The New York Herald Tribune*, December 7, 1941.

52. "Gallery Exhibitions Continue Full Blast," by "E.G.," unknown newspaper, presumably in New York, circa December 7, 1941, 9.

53. *Vorst*, Eleanor Smith Galleries exhibition catalog, December 15 through January 7, 1942. [Note: the catalog reads "Dec. 15-Jan. 7, 1941, but newspapers are clear that the exhibition ran through January, 1942.]

54. Reed Hynds, "Exhibition of Art by Joseph Vorst Depicts Vitality," *St. Louis Star-Times*, December 16, 1941, 6.

55. Ibid.

56. Harry R. Burke, "Vorst Exhibit Puts Quaint Humor in Desolate Ozarks," unidentified newspaper in Vorst's collection of press, presumably St. Louis, circa December 1941.

56. Ibid.

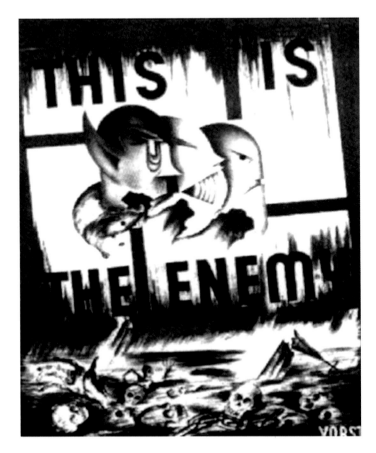

Fig. 156 Joseph Paul Vorst, *This Is the Enemy*, c. 1942, tempera, 32 x 24.75 in., private collection.

CHAPTER 8
AGAIN AT WAR

WORLD WAR II

By the time Vorst's exhibitions at the end of 1941 were over, America was at war. The attack on Pearl Harbor shook the public and the government awake and into action, and Congress enacted a declaration of war immediately, with only a single congressman in opposition. Three days later, Germany declared war on the U.S. in solidarity with its Axis partners, Japan and Italy. Suddenly the country was fighting battles on two fronts.

It had much catching up to do. Even as the inevitable conflict had escalated in Europe and in the Pacific—U.S. forces had served as naval escorts for its allies across the Atlantic, and Roosevelt felt increasing pressure from Winston Churchill and others for more committed assistance and an end to the country's protracted isolationism—its armed forces were wanting. In 1939, the U.S. military ranked 18th in the world in size. Italy's army, for example, was three times that of the U.S. But by the end of 1941, American troops numbered nearly 2.2 million. All men aged 18 to 64 registered for the draft, although realistically, soldiers were 38 and under. (Vorst was 44 years old.) Over time, 36 million men were registered for the U.S. draft and processed at 6,000 local draft boards.

The war was a catalyst for economic growth as well. In the U.S., unemployment, a vestige of the Great Depression, practically vanished with the onset of global conflict. Women and minorities entered the workforce in historic numbers. Entire industries of defense manufacturing sprang up, including significant entities in St. Louis. Hardship abounded too, with forced rationing, recycling, shortages, and income tax withholdings—to say nothing of the horrible loss of soldiers' lives—but America's retooled economy skyrocketed. Consider this statistic: the Gross National Product of the U.S. was $99.7 billion in 1940 and $212 billion by 1945. Of course, it came at an unfathomable cost. The largest military conflict in history ultimately involved six continents, all of the world's oceans, and was the direct cause of an estimated 50 million military and civilian deaths.[1]

Certainly, it is beyond the scope of Vorst's story to chronicle each event of World War II, and yet one can imagine how complex and difficult an era it must have been for him, and how he likely followed each headline of breaking news with resignation and dread—an injured veteran of World War I (for Germany), someone who had met and drawn portraits of political candidates who would become Nazi leaders, his family still in Germany, and now with American ideals and citizenship, painting works about American landscape, people, and principles, but who was frequently tied back to the place he had left behind by implication, innuendo, and prejudice.

Vorst's agitated paintings of the 1930s, full of natural disasters and inhuman treatment of the poor, suddenly looked symbolically prescient. There is indication that the artist was foretelling global conflict all along. He had gradually introduced political allegory into his work after having warned the public of the spread of fascism as early as 1936. What had been misread (and dismissed) in his paintings as fable, dark humor, and barnyard illustration looked prophetic in the light of war.

The press had been reluctant to view Vorst as an expert or someone with insight on current affairs outside of Missouri. Perhaps the public was simply unable to see Vorst's art as foreshadowing current events. They were too immersed in the shadows, that is, the baggage of his history in Germany, and the brooding nature of the paintings themselves.

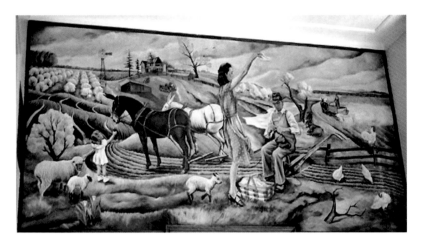

Fig. 157, top Joseph Paul Vorst, *Time Out*, Bethany, Missouri, 1942, oil., 6 x 12 ft..

Fig. 158, bottom Joseph Paul Vorst, *Time Out*, 1942, drawing, whereabouts unknown, reproduction, Carl and Carole Vorst, St. Louis, Missouri.

The art movements with which he was associated focused so closely on documenting the land and its people that those analyzing art, even those in a position to sound alarms, could not see the connection between Vorst's war experience, his history with fascism, even his own dealings with Nazis as anything more than images capturing natural catastrophes of droughts, fires, and floods. The artist's own voice was muted, too, by his inability to articulate to his audience the complexities of metaphor.

Some of the paintings were directly connected to European events. Titles hinted at deeper meanings, but it appears that no one delved into what they might be. To give one example, his painting and lithograph of a group of turkeys, *War Council* (Fig. 152), was intended as an Orwellian parable. He gave it a subtitle, "Hitler and His Lieutenants." Critics admired it, for example, but they stopped short of looking for any deeper meaning or political connection.

Nor was this symbolic way of working new to Vorst's process. As early as 1936, in the painting, *Missouri Mules*, Vorst was asking the viewer to examine his choices closely and to extrapolate political significance in agrarian scenes. Why were there four mules? Why did the artist select mules and not horses? Why were the animals facing in opposite directions? What did their various colors signify? What did the barren landscape suggest about their story? Looking at Vorst's paintings in this probing way is an interesting exercise that invites, in many ways, a reappraisal of his artistic goals entirely. Suddenly, symbols appear everywhere in the paintings, and they make sense as weighty global markers.

Beyond a yearning to communicate and warn, artists still needed to make a living, and during wartime, art required repurposing. From a commercial standpoint, there were many unanswered questions. Would people subsisting on food rations purchase art at any price? Would they retain an interest for serious art in the midst of an avalanche of bleak news headlines and its accompanying fear? Artists questioned their own relevance, too. Could (or should) the imagery of American paintings change to reflect the mood of the country?

People in the visual arts pondered these questions but also new possibilities. Could art alter and uplift the nation? Could art be used by the government as a means to buoy up the morale of its people, engage them patriotically, and even

raise badly-needed funds for manufacturing and for the troops?

These were new issues for contemporary artists, many of whom had no personal history involving war. Vorst seems to have taken these challenges to heart. Social Realism leaned on criticism of American political structures. In the years directly before the war, this potent avenue of artistic expression faded from prominence as ideological philosophies clashed with the realities of the consequences of those ideologies. The American intelligentsia's fascination with Communism in the 1920s is an apt example. The Soviet Union was admired from afar as a utopia of togetherness and equality. Its 1940s realities, therefore, came as a shock.

Vorst's subject matter, tone, and approach to artmaking shifted, too. As a philosopher, Vorst surely debated these issues internally as another war began. Still, there were practical matters to address. First, he needed to complete the mural for the Bethany, Missouri post office.

In January of 1942, Vorst installed *Time Out* (Fig. 157), a large mural scene of a family during planting season, for which he received $750. The work is nearly 6 x 12 feet.

In the mural, a worker in pristinely clean denim overalls sits on a plow, a picnic basket at his feet, while his wife in a stylish, patterned green dress and pink apron—she looks like she just stepped out of a *Life* magazine advertisement—waves a white handkerchief to other workers in the field. Their daughter reaches up to feed one of the mule team in a spotless white dress. Her other hand pets a fluffy ewe, whose two lambs scamper about playfully near a clump of daffodils. It is springtime, and fruit trees are saturated with pink flowers (an orchard in the distance is a checkerboard of white puffs) and a farmhouse and barn sit on a hilltop surrounded by colorful trees. Chickens frolic in the foreground on a sunny day. The colors could hardly be any cheerier: pale pinks, lime greens, bright blues, and warm browns. Even the freshly-tilled soil is shiny and chocolatey.

Although the mural is nearly identical to its preliminary sketch (Fig. 158) made the year before, every artistic modification represents an undeniable softening of symbolism, brightening of color, clarity, and an urge to appear hopeful. Typically, Vorst used bare branches to great moody effect, for instance, and the original sketch had several examples

Fig. 159 Joseph Paul Vorst, *Time Out,* 1941, whereabouts un-known, photograph, Carl and Carole Vorst, St. Louis, Missouri.

of them. In the mural, however, they are all gone but one. They are blossoming trees now. The single bare branch that remains has been shrunken by half. The entire foreground, which had been dark in the sketch, is fresh and bright in the finished painting. An addition of a rooster stands on a fence post crowing.

Vorst had painted another work exhibited in 1941 with the same title and theme, and it is instructive to compare them. In the earlier *Time Out* (Fig. 159), an exhausted farmer sits, slumped down, at the foot of a decaying and lifeless tree. A team of mules hitched to a plow stand idly before him. Everything in the picture is heavy, symbol-laden, dramatic. Elements that would become part of the Bethany, Missouri mural are evident in it: the team of horses (one white, one black) pulling a plow, the winding road, the farmer, and some trees shown in decay. Yet the tone is dramatically different.

In the earlier painting, the laborer is taking a rest, a time out, and his energy is clearly spent. The same could be said of the land, which shows few signs of life although it is being plowed for future bounty. The Bethany painting, on the other hand, is hopeful and candy-bright.

The evolution of these three images, all with the same title, suggests the artist coming to terms with a changing po-

litical landscape. It is emblematic of the way Vorst's work was shifting as well. It was not as though the world situation was suddenly cheerier in 1942 than it had been in 1941, but Vorst altered the message of the works as if a light had been turned on in his artistic disposition. While it is accurate that the mood of the audiences for the *Time Out* of 1941 and the mural of 1942 had changed, the latter requiring a more populist and upbeat message, Vorst began to meld his need to be a voice shouting and warning from the rooftops with a desire to be a hopeful source of uplift and support for America.

The artist started to work on new images as well. As Vorst created new work in 1942, some of his older pictures circulated. In March, Vorst participated in a show of works by St. Louis artists exhibited at the Kansas City Art Institute/Nelson-Atkins Museum in Kansas City, Missouri. On November 24, the annual exhibition of Contemporary American Art opened at the Whitney Museum, and Vorst again was invited to send a work. This time, he sent a lithograph, *Ozark Spiritual.*

The American Red Cross held an annual competition during the war. The contest had multiple layers of purpose. Artists submitted paintings, watercolors, or prints to a jury. Artists were told that winning works might be displayed in exhibitions, reproduced in the press, and used in Red Cross publications. The relief organization requested the images be "ordinary people in everyday life." This competition also had a fund-raising component. Exhibited works would be for sale, and artists would receive a portion of their proceeds: paintings and watercolors $40, engravings $20, and prints $10. Vorst received a letter and a check for $40 from Pauline Ehrlich on July 3, 1942, in charge of the exhibition as a subsidiary of the FWA federal agency, Section of Fine Arts, noting that his gouache, *Missouri Flood*, had sold. The purchaser's name and city were given to Vorst.[2]

PROPAGANDA

Found in Vorst's archive after his death is *United We March, The American Red Cross* (Fig. 160). It is an unsigned and undated poster, presumably aimed at the war effort and the American Red Cross, specifically. It can be attributed to Vorst with some confidence because of stylistic similarities with other posters that Vorst created during the war. The

Fig. 160 Joseph Paul Vorst, *United We March: The American Red Cross*, ca. 1942, poster, 20 x 14 in., Carl and Carole Vorst, St. Louis, Missouri.

esses of "Cross," in particular, are a design that the artist had worked on in his sketchbook.

It is almost without precedent that the U.S. Government was able to mobilize its artists so quickly in the 1940s war machine. The Federal apparatus was already in place to leverage American artists for help in the war effort. Having provided funds for artworks during the Depression, government agencies had listings of thousands of qualified artists. They knew where to reach them and how to engage them. Managers of arts-related agencies in Washington, D.C. had established personal relationships with the artists through stacks of friendly and supportive correspondence. It is an exaggeration, but still somewhat accurate, to say that U.S. arts administrators had the tools at their disposal to turn the nation's artists into propagandists.

In addition to working directly with artists as they had done on murals and other public projects, American museums were encouraged to present large-scale exhibitions that fit the government's agenda during wartime. The Metropolitan Museum of Art in New York turned over its galleries for *Artists for Victory*, an exhibition of 1,418 contemporary American paintings, sculpture, and graphic artists. To mark the anniversary of the bombing of Pearl Harbor, it opened December 7, 1942 and was organized by Artists for Victory, Inc. The Museum awarded forty-one purchase prizes for a total of $51,000. Nearly 15,000 works were submitted for the exhibition. Vorst displayed two works in the Metropolitan Museum show. One of them was *Corn Harvest*, a painting that had won honorable mention at an exhibition in Missouri the previous year, and the other, a painting that Vorst had exhibited at his one-man show the year before and at the Pennsylvania Academy of Fine Arts.[3]

The National War Poster Competition was announced in mid-1942. The effort to create posters to encourage citizens to support the war was organized by Artists for Victory, Inc. (the same entity that produced the Metropolitan Museum exhibition) with the collaboration of the Council for Democracy and the Museum of Modern Art in New York. The Modern had produced war-themed exhibitions from 1938 onward. Staff members acted as liaisons between the government and artists in order to rally support. Like many museums, it saw its role with the public as an important intermediary with society regarding the spread of democracy and freedom. James Thrall Soby was named director of the

Museum's Armed Services Program in 1942 with the mandate to facilitate war-themed exhibitions, to entertain servicemen and women at the Museum, and even to decorate mess halls on military bases.[4]

Applications for the poster competition flooded in, beginning August 15, and the deadline was extended to allow late entries until October 22. In all, 2,224 designs were submitted by artists in 43 states directly to Artists for Victory, Inc. headquarters on Park Avenue. Prizes were nine $300 war bonds. These were gifts of individual donors (who collectively called themselves Council for Democracy) and a corporation, R. Hoe and Company, Inc., a producer of rotary printing presses that also had a long history of U.S. military manufacturing. Winning posters would be exhibited at the Modern, at the Carnegie Institute of Art in Pittsburgh, and then tour nationally. Of those winners, artists' designs were selected to be printed as posters, sold, and distributed. Judges were: curators from the Museum, James T. Soby and Monroe Wheeler; artists, John Taylor Arms and Stuart Davis; government officials Francis H. Brennan, Charles T. Coiner, and Walter Baermann; and Council for Democracy board member Rex Stout. During the exhibition, visitors would receive ballots asking which posters they liked best, which poster made them "want to do more to help win the war," and also whether there was an important idea for future posters that they wanted to see.

Eight topics were chosen for the competition. These themes were drawn from President Roosevelt's first war message to Congress on January 6, 1942: Production; War Bonds; The Nature of the Enemy; Loose Talk; Slave World or Free World?; The People Are on the March; Deliver Us From Evil; and Sacrifice. Artists—the competition was open to photographers as well—received 20 slogans to choose from. These were to appear on the posters. Loose Talk's slogan, for example, was "Loose Talk Sinks Ships."

In his 1938 book, *Joseph Paul Vorst Missouri Artist*, the artist had used the word "propaganda" disparagingly. He was quoted as believing, "Vorst decries 'propaganda' painting. His subjects are chosen to fit his own varying whims, and if they do chance to fall most often into one certain category, it is not because of any 'political' pressure. Above all else he admires fearless honesty and absolute sincerity...."[5] At the time, he used the term propaganda synonymously with coercion. He refused to be bullied and pressured as an

artist and insisted on independence. In wartime, however, he gave over to the needs of society as he saw them. That is not to say that he would have viewed the governmental works as capitulation, or for that matter, even referred to them as propaganda at all. There is no evidence that he looked down upon his 1940s paintings or was ashamed of them. His commercial art training laid the foundation for him to approach with respect the needs of the customer. In this case, his personal feelings aligned with those of the U.S. Government.

Vorst threw himself into the poster competition with gusto. He had not created work of this sort since his early days in St. Louis as a freelance commercial artist. A surviving oversized sketchbook shows that he explored many possibilities for the war posters. These reflected his draftsmanship and graphic arts training. The sketchbook is full of panels, some of them lightly worked cartoons and others semi-polished prototypes. His antipathy for Hitler is readily apparent. The Nazi dictator is shown in multiple panels: with a rat circling about him; superimposed on a swastika; and alongside garishly cartoonish portraits that satirize him, Hirohito, and Mussolini. Vorst is sensitive to graphic design in ways that would have been a surprise to anyone familiar with his American paintings alone. He explored setting the words "sink" and "ships," at a right angle, each initial ess overlapping and forming a red and black swastika. These are not subtle works, obviously—they are packed with racial stereotypes, for one thing—but they are passionate, informed, and energetic.

Ultimately he settled on two themes for submission to the exhibition, The Nature of the Enemy and Loose Talk. *This Is the Enemy* (Fig. 156) is one of Vorst's finished designs. The foreground is a wasteland, not unlike Vorst's flood scenes. Skulls are strewn at the base of the image with an animal carcass. A steeple has been broken, the cross on the top of it dashed to the ground. The main image is a large, tilted billboard with the cartoon busts of Hitler, Hirohito, and Mussolini in profile. Their features are exaggerations: Hitler has pointy ears, Hirohito bares enormous teeth, and Mussolini has a bald head and slanting, menacing eyes. The slogan "This Is the Enemy" in full caps frames the billboard. Behind the enemy leaders, attenuated lines of a swastika are glimpsed, but the heads obscure its convergence point. The result, then, is an off-center grid. Vorst's name appears in the bottom corner.

Fig. 161 Joseph Paul Vorst, untitled mural study (detail), ca. 1942, mixed media, overall dimensions 12 x 67 in., Church History Museum, Salt Lake City, Utah.

Fig. 162, above and opposite page Joseph Paul Vorst, untitled drawings from a bound sketchbook, color pencil, pencil, ink, overall dimensions 23.5 x 18 in., Church History Museum, Salt Lake City, Utah.

Fig. 163 Joseph Paul Vorst, untitled mural studies:

above, ca. 1942, mixed media, overall dimensions 12 x 67 in., Church History Museum, Salt Lake City, Utah.

opposite page, top, n.d., pencil, Carl and Carole Vorst, St. Louis, Missouri.

opposite page, middle, n.d., mixed media, 15.75 x 54 in., Carl and Carole Vorst, St. Louis, Missouri.

opposite page, bottom, n.d., mixed media, 11.5 x 49 in., Carl and Carole Vorst, St. Louis, Missouri.

On November 16, 1942, President Roosevelt wrote a letter to the president of the poster competition, Hobart Nichols,

Dear Mr. Nichols:

I have seen the report by Artists for Victory on its National War Poster Competition. It is proof of what can be done by groups whose ordinary occupations might seem far removed from war. More than two thousand war posters were produced by the artists of the country, not as a chore that they were asked to do but as a voluntary, spontaneous contribution to the war. The very name of your organization is symbolic of the determination of every man and woman in every activity of life throughout the nation to enlist in the cause to which our country is dedicated.

Very sincerely, yours
[signed] Franklin D. Roosevelt[6]

According to a St. Louis newspaper, Vorst was notified that one of his entries, *Loose Talk Sinks Ships* had been accepted for the Museum of Modern Art exhibition.[7] There is some discrepancy here, however. The Museum's checklist of the exhibition and its participants does not include Vorst's name.

Perhaps the Museum's list is incomplete—although that is doubtful—or perhaps Vorst's designs entered the exhibition after it finished on January 5, 1943 and began to tour. It is also possible that the newspaper simply got the information wrong. The timing of the short article is a red flag, as well. If the date stamped on the newspaper clipping—it is in the possession of the Metropolitan Museum of Art—is correct, December 16, 1942, the dates do not align. The poster show opened at the Modern on November 11, 1942; it was already underway.

On December 4, 1942, President Roosevelt wrote a letter to Major General Philip B. Fleming, the acting Commissioner of the WPA to liquidate the department and close all its operations by February 1, 1943. By June of 1943, the public programs ended. Vorst's participation in federal projects had resulted in three post office mural commissions and submissions for several more, it had supplemented his income as a working artist and art instructor even before the post office murals initiative began, and it had rewarded him with

press coverage and ongoing interest in his work. In literal ways, the war supplanted the WPA for some artists, but additional mural competitions continued.

Vorst created a mural study for a government building in Washington, D.C. The specifics of the competition and its date have not come to light, and the study is undated. Still, based on the finished study, it is clear that it was intended for a very large room; the drawing indicates cut out spaces for three doorways and was likely finished in the early days of the war (see Fig. 163).

The untitled study consists of a series of tableaux about life in America during wartime. These scenes are divided with wide, curving gray strips that are very similar in design and color to painted molding in Benton's monumental, *America Today*, of 1931. In Vorst's earlier murals, it was common for him to combine multiple narratives into a single work—characters sharing the landscape of a farm during harvest, for example. Primarily, they were linked by their proximity to each other. In the large Washington study, Vorst expands his storytelling to include scenes of America much more broadly than he had ever attempted previously: science, religion, academia, agriculture, manufacturing, education, medicine, etc.

Overall, it is a sophisticated image. There is a lot going on. Although the scenes are divided, they have a progression of links between them thematically. In the first panel, for example, an American fighter pilot flies over an armada of warships with its wing breaking through the gray division of the mural and overlaping the panel of scientists in the lab next to it. The effect is the heightening of three-dimensional space; the plane is flying right out of the picture. This first panel is the most complex of the mural. The Statue of Liberty stands with a soldier holding an enormous U.S. flag at its base. Other soldiers, tanks, a parachutist, pilots, and mounted cannons point to an unseen enemy. A squadron of planes flies in formation overhead. These are layers of images, a collage of united military action. The Capitol building in Washington is presented on one side behind Lady Liberty. Vorst has reversed the orientation of the Statue. In his version, she holds the torch with her left hand and the tablet with the date of the Declaration of Independence in her right. This alteration opens up space behind her for the golden spires of the Salt Lake temple, the most recognizable Mormon building in the country.

Fig. 164 Joseph Paul Vorst, *Family on Horse Drawn Cart*, n.d., oil on board, 32.25 x 32.25 in., courtesy Treadway Gallery, Cincinnati, Ohio.

Although he had interactions with Washington for a number of years, Vorst began, around 1943, to exhibit in the nation's capital more frequently. In May and June, 1943, he exhibited a print, *Haying*, at the Library of Congress's *First National Exhibition of Prints Made During the Current Year.* He was also selected to participate in the Corcoran Gallery's (Washington, D.C.) *Eighteenth Biennial Exhibition.* The *Biennial* selected a painting titled *Good Lord Give's Peace.* In the large painting, an aging man kneels to pray in a field. He is shoeless and wears tattered slacks and a white shirt. A black cat at his side stares at the viewer. The man with gray hair and beard looks upwards, his fingers gently interlaced in prayer. The *Washington Star* wrote about the exhibition and Vorst's painting, briefly,

> …The most emotional works are two Negro subjects, Joseph P. Vorst's figure of an aged man praying "Good Lord Give's Peace" and Dan Lutz's vibrant evocation of a Negro spiritual, "Climbing Jacob's Ladder."[8]

The artist received a letter from the American Federation of Arts on March 25, 1943 requesting the painting for a traveling exhibition of twenty paintings, *Art from the Wartime Capital* at the conclusion of the Corcoran show. Vorst agreed, and *Good Lord Give's Peace* toured for a more than a year at various arts institutions. (The exhibition was alternately titled *People Posed and Unposed.*) The painting left the exhibition briefly to be shown at the Chicago Art Institute and then rejoined the tour.

FAMILY PORTRAITS

Christine Wißkirchen Vorst, the artist's mother, died at the age of 78, in Berlin on August 5, 1943. This must have been a blow to Vorst. Two years earlier, he had dedicated his New York exhibition to the important people in his life, including his "good parents." Vorst painted a portrait of her in old age [Fig. 167]. She sits on a wooden bench in front of a field of sunflowers. There are no other paintings like it in his oeuvre. Her black, white, and red plaid blouse is loosely worked, as are the flowers that almost overwhelm her. But her face is detailed in a way that moves beyond Vorst's usual depictions of people. These can sometimes seem almost cartoonish, but his mother's face is constructed lyrically and warmly— one wants to say, affectionately. She looks directly at the viewer. Her gray hair is pulled back behind her head, and her

Fig. 165, opposite page, top unidentified photographer, Vorst and his mother, n.d., Carl and Carole Vorst, St. Louis, Missouri.

Fig.l 166, opposite page, bottom unidentified photographer, Vorst (far left) and family at Christmas, n.d., Carl and Carole Vorst, St. Louis, Missouri.

Fig. 167, above Joseph Paul Vorst, *Mother with Sunflowers*, 1931 (poss. 1937)., oil on canvas, 27.5 x 23.5 in., Carl and Carole Vorst, St. Louis, Missouri.

hands rest quietly in her lap. In the photo, Vorst sits with his arm around her, the subjects are identified in pencil underneath, "Joseph" and "Mother."

Questions worth asking but probably unanswerable are whether Vorst saw his mother again after he left Germany in 1934, how she survived in Essen during the war, and how she ended up in Berlin. Shortly after Vorst returned to the United States in 1934 after a visit, she was pleased to report to him that she won the legal claim against Hitler regarding non-payment, but no other correspondence has surfaced.

As for the sunflower portrait, she looks elderly, but in the photographs of Vorst as a young man, before immigration, she already looks to be aged. It is noticeable particularly in the condition of the skin of her wrinkled face. But it is good to remember that the family life and work were outdoors, and it was not an easy life, at that.

Vorst's paintings are not particularly autobiographical. They represent first-hand experience in the sense that they reflect where he lived and what he was thinking, but one would be hard pressed to line up his paintings before 1943 and find Vorst's family in them aside from occasional self-portraits. All of that changed in 1943 and 1944.

Similarly, Vorst had not created fine art images overtly about war. Aside from war-era murals and propaganda and his allegorical images with interpretations connected to world events, the artist's images on display in galleries and museums did not include soldiers at battle, citizens in factories working in the war effort, and so forth. Likewise, his paintings had not focused on domestic life, particularly life in his own household. The war brought those two divergent subjects together.

Although correspondence between Vorst and his German relatives has not been uncovered, he was certainly aware of his family abroad. The war caused rifts in the Vorst family. Of his three younger brothers, Friedrich Paul, Peter Paul Karl, and August Ludwig, one of them joined the Nazi party and became an officer in it. During or after the war, Vorst painted at least two images of this brother, and his contempt for him is palpable. The first painting is an untitled portrait of the brother as a soldier (Fig. 168). He is older, with gray at his temples, still in uniform. He is disheveled and tired, his eyes are glassy. The style of the image is quite distinct from other

Vorst works of the period. For this painting, Vorst returned to a long-discarded German Expressionism as a style. The coloration is harsh and disquieting.

The choice to revisit this older style of portraiture is telling. The unrealistic coloration of the skin, particularly the use of green, can be seen to some degree in the portrait of the artist's mother, as well. It is also noticeable in a self portrait that Vorst painted at least ten years earlier. It is as if the artist recalled his German artistic roots as he painted the three members of his immediate German family.

The portrait of the brother is personal. Curiously, at the right of the image, just to the brother's left eye, in the direction his head is turned, an apparitional face is seen in taupe, outlined in light brown. The technique of embedding images in this way is an odd departure for Vorst, yet the outlined face is clearly there. Whose face is it? One possibility is their deceased father, Paul Johan Josef Vorst, whose strong profile and closely-cropped haircut can be seen in Vorst's German photo album.

Throughout his career, opportunities to depict soldiers were frequent, but Vorst hesitated to engage in them. In *Der Vulkan*, the artist showed police or military officers abusing their power as they ignore or harm citizens in a town square in the linoleum cut, *Der Tragödie aus der Strasse* (The Tragedy on the Street). And an untitled and undated portrait of a helmeted soldier is another rare example of a Vorst artwork with such officials in it. For the most part, however, outside of the murals and war posters, Vorst was reluctant to focus on warfare didactically.

Is it possible that the threat of censorship and the memory of his colleagues' "degenerate" designations in the 1920s haunted him still? Did the echoing sentiments in the American press about his German background reignite previous fears of danger and retribution each time Vorst read them? Were his leanings to political subject matter via Social Realism in America and his allegorical paintings before the war proxies for the artist's deeply-held ideas on how to deal with war as an artist?

There is scant evidence in the record to address inferences like these—certainly insufficient to answer them with a strong degree of confidence. When the artist spoke about his art, he was circumspect and brief. Further, there were

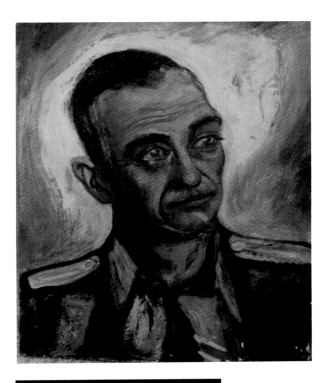

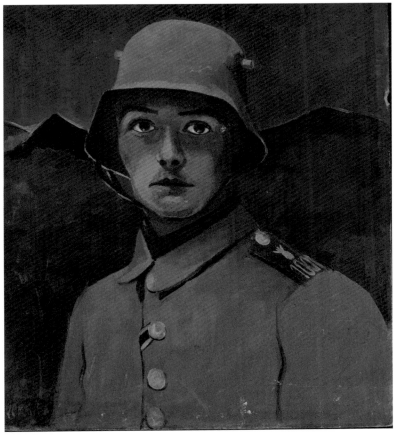

Fig. 168, above, left Joseph Paul Vorst, untitled portrait of the artist's brother, n.d., oil on masonite, Carl and Carole Vorst, St. Louis, Missouri.

Fig. 169, above, right Joseph Paul Vorst, untitled, n.d., oil on masonite, 24 x 20 in., Carl and Carole Vorst, St. Louis, Missouri.

Fig. 170, left Joseph Paul Vorst, *Self Portrait*, ca. 1930, oil on canvas, 30 x 21 in., Carl and Carole Vorst, St. Louis, Missouri.

Fig. 171 Joseph Paul Vorst, *Defect*, ca. 1944, oil, whereabouts
unknown, photograph, Carl and Carole Vorst, St. Louis, Missouri.

no probing interviews to discuss such things. For better or worse, Vorst exhibited his work and left a discussion of its meaning (including what the work meant to him) to others.

And yet, looking at the body of his work before 1944 through the prism of war and the artist's immediate knowledge of it, the paintings begin to take on an added layer of purpose and autobiographical credo. Consider that the artist lived with the wounds of war. He wore an elevator shoe throughout his life, after his World War I injury, in an attempt to walk without a limp. It is unknown whether he was in chronic physical pain as a result of the wound, but he spoke of himself as being permanently lame. Yet, this was not a morose man prone to depression and darkness. On the contrary, his innate personality was lighthearted and fun-loving. But after a life of turmoil, the cracks had begun to show. His shoe was a symbol: on some level, he recalled war, fear, and personal loss with every footstep.

As tense as the brother's portrait is, another painting of him by Vorst crosses the line from disapproval to disgust. *Defect* (Fig. 171) is the title of the painting of Vorst's Nazi brother marching to a prison camp after the war. He is defeated. The city is aflame, and the exhausted, captured soldiers move past the Brandenburg Gate under a blackened sky. Only one soldier looks up defiantly. This is Vorst's brother.

Years later, a scholar interviewed Lina and inquired about the painting. He wrote of their conversation, regarding *Defect*:

> One of Vorst's younger brothers who had remained in Germany had joined the Nazi party and had been captured during the war. The painter's hatred for the party was certainly greater than his love for his brother, as his almost vicious depiction of the captured man indicates. Before a stylized Brandenburg Gate and a burning Berlin, the remnants of a defeated army pass. The men are utterly destroyed, physically, emotionally, psychologically. The sole person, his brother, who tangentially regards the viewer does so with the vacant, unknowing look of despair. There is no feeling whatever in that passive face. This is not the depiction of those countless Missouri farmers who were confronted with a disaster totally out of their control, but nevertheless accepted that disaster with nobility and strength. This is the face of confu-

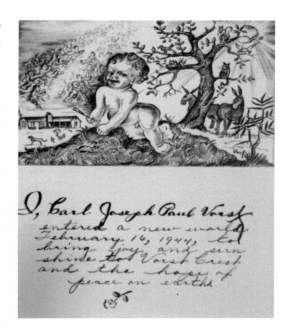

Fig. 172 Joseph Paul Vorst, untitled birthday announcement, 1944, lithograph, 12 x 10 in., Carl and Carole Vorst, St. Louis, Missouri.

sion and hopelessness and this is a painting where evil is identified and realized. That the evil is so great that it is hopeless evil. This painting is the emotional antithesis of all his other work, for it contains none of the usual Vorst attributes of sympathetic understanding of and identification with the subject. It displays a shattering contempt for that man and those men in their total defeat.[9]

CARL

Nine months after the death of Christine Wißkirchen Vorst, the artist's life and art changed radically with the birth of a child. As momentous as the previous two years had been, 1944 became unforgettable for the Vorst family for a happier reason: Joseph and Lina had a son. The couple had been married nearly nine years. Lina was 43 years old and Joseph was 46. On February 16, 1944, a baby boy was born, and they named him Carl Joseph Paul Vorst. The new father

marked the occasion by creating a lithograph ^(Fig. 172), a birth announcement, with this grammatically idiomatic text:

> I, Carl Joseph Paul Vorst
> entered a new world
> February 16, 1944, to
> bring joy and sun
> shine to Vorst Crest
> and the hope of
> peace on earth.

The main feature of the lithograph of course is Carl, a large, cherubic, naked infant with curly hair, who holds an artist's paintbrush in his right hand. He rests on a mound of grass through which a little turtle crawls. Animals are everywhere in the image. In the large tree behind the baby, there is a squirrel, a cat, a nest of birds, other birds, and at its base, two Missouri mules stand side by side under a gleaming sun. In the distance is the Vorst's home on Morrow Drive—its walls of paned windows light the artist's studio. In the front yard stand a dog and a chicken. In the image, half of the sky is given to a concourse of angels receding to infinity, looking toward Carl, front and center.

The artist chronicled the development of his son, beginning with a drawing of Carl sleeping, made in March 1944 ^(Fig. 173). It so closely mirrors his 1925 etching, *Schlafendes Kind* ^(Fig. 174), that it gives the impression that the birth of his son fulfilled a dream that artist had for decades.

Vorst created a painting and lithograph of Carl asleep in a cradle. (The painting was titled *The Crib*, and the lithograph, *Lullaby* ^(Fig. 176).) When Vorst exhibited the painting in 1947, he described what the painting meant to him. It remains one of the rare occasions of the artist explaining his work to the public. At the opening, Vorst talked about some of the paintings. Howard Derrickson, captured some of these comments about the artist's intent and incorporated them into his review, published in the *St. Louis Post-Dispatch* on April 20, 1947. Referring to *The Crib,* the painting of the artist's son in his bed, Vorst explained that he painted the image to "represent the manger in which Christ was born."

> I wanted to stress the tenderness of a baby born in a cruel, rough world, Vorst said. Therefore I was interested in make the coarse textures of the grain of the wood as real as possible, and the same modeling of

Fig. 173, top Joseph Paul Vorst, untitled drawing, 1944, pencil, Carl and Carole Vorst, St. Louis, Missouri.

Fig 174, bottom Joseph Paul Vorst, *Schlafendes Kind*, 1925, etching, sheet side: 10.43 x 14.96 in., private collection, Germany.

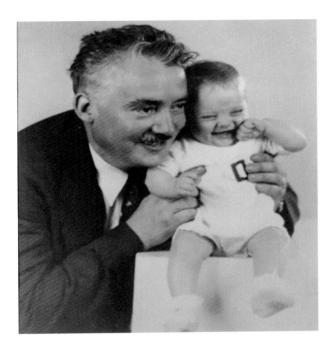

Fig. 175, left unidentified photographer, Vorst and Carl, 1944, Carl and Carole Vorst, St. Louis, Missouri.

Fig. 176, below Joseph Paul Vorst, *Lullaby*, ca. 1944, lithograph, 9.5 x 13 in., Carl and Carole Vorst, St. Louis, Missouri.

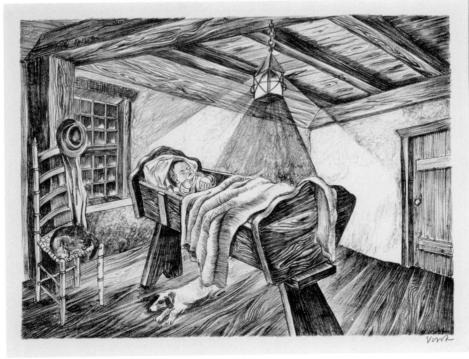

Fig. 177, top Joseph Paul Vorst, untitled, ca. 1945, oil, 16.5 x 22.5 in., Carl and Carole Vorst, St. Louis, Missouri.

Fig. 178, bottom Joseph Paul Vorst, *Wild Gooseberries*, n.d., lithograph, 11.5 x 8.5 in., Carl and Carole Vorst, St. Louis, Missouri.

paint is used for emphasis in my other pictures.[10]

Vorst created a tender image of a baby, dog, and cat asleep, the artist's hat and coat hanging from the chair at the end of the day. To some extent, it is a literal depiction of the artist's household. The room shown is the artist's studio, its beams harvested from the homes of Vorst's ancestors.

The visual element that expands the reading of the image beyond a family scene is the light above the cradle. Hardly a child's night light, the lamp is almost beacon-bright. It turns the image into a symbol. Like many of Vorst's work, texture is a key element. Here, rough wood surrounds the scene—hand-hewn lumber fashioned into beams, flooring, and cradle. He had built that room and the cradle. The artist wanted the public to make a connection with Jesus, Christmas, the politics of the day, and perhaps give a nod to the fact that Vorst had made—with the exception of the animals—everything on view.

Domesticity became a major theme of Vorst's work after the birth of his son. The artist had long been interested in maternity just as he had been in genealogy and his own family tree. Any number of paintings depicted women breast-feeding, for example. These images showed motherhood in times of crisis, such as *Flood Tragedy,* in which a family is trapped in a small boat. The nursing mother both calms the child and nourishes him or her. In *After the Flood* [(Fig. 148)], *Drifters* [(Fig. 95)], and *Mother and Child*, women hold bundled infants in their arms. In *Madonna of the Tiff Miners* [(Fig. 108)], exhibited at the New York Worlds Fair, a women is shown nursing in front of an open mining vista.

These images, and many other similar works, find women at work as mothers of infants. In these paintings, the mothers are shown serenely, even as their landscapes are filled with peril.

Women, it should be noted, are an important source of Vorst's artistic influence. Although none of his known professors in Germany were women, his mother as the worker and provider for the family after the death of her husband certainly served as a foundation for his approach to gender in his art.

It does not appear that he had extended associations with women artists in Germany, but the opposite was true in the

Fig. 179, above, left Joseph Paul Vorst, *Spare Ribs*, n.d., watercolor, 19 x 17 in., Carl and Carole Vorst, St. Louis, Missouri.

Fig. 180, above, right Joseph Paul Vorst, *Representatives of the Town Gossip*, n.d., watercolor, 19 x 17 in., Carl and Carole Vorst, St. Louis, Missouri.

United States. In America, Vorst immediately began creating artwork in the midst of female artists. The Ste. Genevieve Art Colony was founded by women, and the unusual opportunities for women to exhibit there and later to win commissions for mural competitions provided a sensibility of inclusion and support for women and a lesson for Vorst on parity and equality.

Vorst's American paintings are about workers, and he was as inclined to show women at work as he was men. Occasionally, these works express humor in ways that other images of men do not. An example is *Representatives of the Town Gossip* (Fig. 180), a watercolor.

Domestic life aside, the war raged on. The birth of Carl did not alter the facts that the world's very fate seemed uncertain. If anything, the contrast of happiness at home and terror outside manifested itself in imagery that pleaded for peace, as if for the Vorst family, there was suddenly even more at stake. These works differ in tone from earlier paintings that sounded a warning. A new urgency appeared in Vorst's work, reflecting the unsettled global landscape.

By the time Carl was born in February much of Western Europe was occupied by the German army and its allies. Soviet soldiers had prevailed against Germany, forcing a retreat from Moscow in 1941 and surrender at Stalingrad, February 2, 1943. On June 6, 1944, General Dwight D. Eisenhower of the U.S. ordered Allied soldiers to the beaches of Normandy with the goal to liberate the country (D-Day). They arrived in Paris, August 24, 1944.

The tide of the war was turning, but uncertainty remained. As the Soviet forces pressed into Germany in April 1945, German citizens rightly feared for their future. Meanwhile, Japanese forces were defeated in a series of Allied offensives. The Japanese Prime Minister resigned in June 1944, and some of the largest naval battles in military history were won by Allied forces near the Philippines. Manila was recaptured in January, 1945. British, Chinese, and American forces retook Japanese conquests in the Southeast Asia and began attacks on Japan directly. The Reichstag was captured on April 30, 1945, thereby ending the war with Germany, and Japan surrendered on August 15, 1945 after the United States Air Force dropped atomic bombs on Nagasaki and Hiroshima.[11]

At the same time Vorst's son was born, in 1944, he created a painting that showed a father in prayer, *For Thine Is the Kingdom* (Fig. 181). It is impossible to envision that Vorst conceived the image and completed it without imagining himself as a father in a dangerous world.

The painting is an interior scene of a man in prayer at his bedside. He is nude—a white cloth or towel drapes his upper thigh—but he is nearly without possessions. It is a dilapidated room. Wallpaper is peeling close to the ceiling. The paint on the old metal frame of the small bed is cracking. The perspective is exaggerated to suggest a claustrophobic space. The only visible decorations are a small table, a tiny frame hanging on the window with small Blue Star Banner that designated the household of a soldier in the war, and a black cat that is perched on the sill and looks outside. The tiny room has a weathered wood floor. It is bare except for the open newspaper, upside down, at the man's feet. It is the clue to the meaning of the painting. The headline announces that the Yanks—and presumably, the man's son—have landed in Germany.

Vorst created a lithograph based on the painting, also with the title, *For Thine Is the Kingdom*. The two are almost identical. The main difference is that the painting shows the newspaper upside down, and in the lithograph, it is turned directly to the viewer and is therefore easier to read. The lithograph was exhibited at the Library of Congress, "Third National Exhibition of Prints Made During the Current Year," from May to August, 1945.[12]

PHOTOGRAPHS

Vorst had taken preparatory photographs, as was his practice, to assist in the composition of paintings. Vorst built up his paintings through photographs as well as sketches. This had been his process for years. That is not to say they are painted versions of photographs; the snapshots are mostly his source material. Although he sought to depict real events and real people around him whom he knew intimately, the creation of at least some of the works started with Vorst and his camera. For years, he was in the habit of photographing people, animals, farm equipment, and landscape that he intended to use eventually to populate his pictures. He did not treat the camera as a journalist would going into a disaster scene, composing the photograph, taking the image, and

Fig 181 Joseph Paul Vorst, *For Thine Is the Kingdom*, n.d.,
oil on canvas on panel, 51.125 x 41.875 inches; Saint Louis Art
Museum, Eliza McMillan Trust 204:1944.

then painting it, nor did he ever approach photography in America as a fine artist.

Rather, Vorst's images were constructed more systematically, if fragmentally. A trove of his surviving photographs, hundreds of them, show that he worked from these black and white pictures as source material. These are not carefully composed photographs. Some are candid images of people whom he met. Others are more obviously models that are costumed and posed in positions that could easily be translated to specific paintings. The man hanging onto a tree in *Hope Alone Remains* (Fig. 183), for example, is photographed by Vorst in the same clothing as he wears in the painting, holding onto a considerably less dangerous pillar on a suburban front porch. In the photograph, however, the little girl is grabbing his waist and looking up to his face. In the eventual painting, the little girl is moved, depicted with the same gestures, holding onto an elderly man. These staged photographs are the exception to his common practice.

The photographs, which are roughly 4" x 5", include a number of men that might have been subjects for the eventual painting of *For Thine Is the Kingdom*. Using the photograph as a base for the composition, Vorst finished the painting and entered it into the fourth annual Missouri Exhibition at the St. Louis City Art Museum. It won the purchase prize of $200.

SYMBOLS

The act of prayer reentered Vorst's paintings as recurring subject matter. In earlier works, people pushed to their limits by natural disasters and oppression often stood frozen; facing calamity, figures in Vorst's 1930s artworks seemed immobilized by shock. In the few years preceding and during the war, however, his subjects took on a new pathos. Entirely overwhelmed by nature—particularly crop failures as a result of drought or storm—Vorst's subjects fell to their knees. In *Hope Alone Remains*, residents during a flood climb into trees to seek safety. An elderly man, with a girl clutching tightly to his waist, raises his arms in supplication. *Drought* shows a man amid withering crops. He is on his knees, his eyes looking into the skies. *The Saint* (Fig. 184) is a similar image. A man on his knees holds a pole in front of him. Dead stalks of corn are on his left and right. Indeed, one of Vorst's ongoing interests is the depiction of drought calamities.

The Dust Bowl—the one-two punch of severe drought and poor land management during the Great Depression—affected millions of residents from Texas to Missouri. Its most potent and deadly years coincided with Vorst's arrival in America. From 1930 to 1936, approximately 100 million acres were affected. This phenomenon caused the largest migration in U.S. history. 2.5 million people were forced to abandon homes and farms in the decade leading to 1940.

As is common in Vorst's paintings, images of drought depict the land and its inhabitants, but the shadow over these events is often politics, policies, social unfairness, and their consequences for the average citizen. Weather is a metaphor. Like the opposite extremes of his flood pictures, Vorst paints parched landscapes that overwhelm animals and people, and force farmers into submission.

In some regards, Vorst broke little new ground regarding subject matter during the war. He found continued resonance in images that he had developed in the 1930s with the addition of domestic pictures.

The Missouri mule had long been a familiar figure in his work. He had complained to friends—just as critics had complained—that he was tiring of doing paintings in which the mule was featured. Nevertheless, it appears that critics and the public failed to make the political connection between the animal and its symbol as a beast of the military. The official state animals of Missouri, mules were prized for their strength and stamina in labor. It would not have escaped Vorst's knowledge that Missouri also became the leading breeder of mules, and that in World War I, Missouri shipped hundreds of thousands of mules to England to be used in battle. A single Missouri dealer, Guyton and Harrington at Lathrop, sold $37 million worth of the animals to England for the war effort. In his paintings of flood and drought, Vorst used the physical condition of Missouri mules as a proxy for the condition of its entire population. Flood mules were often depicted as survivors, while the emaciated mules of drought raise questions of abuse of government policy on local residents. It is also likely that Vorst identified the mule as a specifically local animal in his quest to depict the regional landscape.

Throughout his career, back to his student days in Essen, Vorst made striking use of light in the sky. Most commonly, the artist's skies showed fractured planes like bolts of light.

Fig. 182 unidentified photographer, Vorst, wagon, and mules,
n.d., Carl and Carole Vorst, St. Louis, Missouri.

Fig. 183 Joseph Paul Vorst, *Hope Alone Remains*, n.d., oil on masonite, 57 x 30.5 in., Carl and Carole Vorst, St. Louis, Missouri.

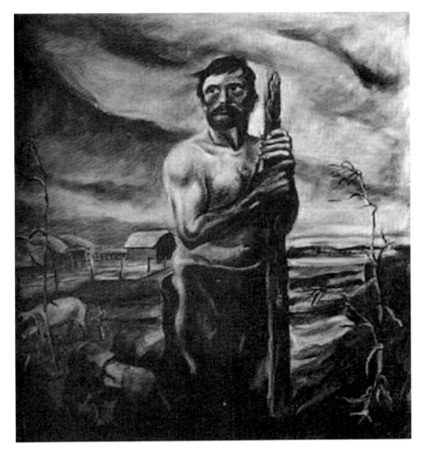

Fig. 184 Joseph Paul Vorst, *The Saint*, c. 1935, oil on masonite,
38.5 x 33.5 in., courtesy Treadway Gallery, Cincinnati, Ohio.

These appear in nearly every landscape. Even in his flood pictures, otherwise so full of stormy devastation, the artist provided an emotional escape hatch by parting the clouds and letting rays of light penetrate the scene of tragedy. Light was Vorst's symbol of hope. The pictures of prayer are slightly different. Some of them feature light breaking through the clouds—*Good Lord Give's Peace* is unique in that the background is a mottled swirl of abstraction—but given the religious posture of the subjects, the light becomes a symbol of a force more powerful and unknowable, even, than nature.

With the war over, Vorst finally was able to look around himself and see that his long-held hope for peace, stability, recognition, and family had suddenly materialized.

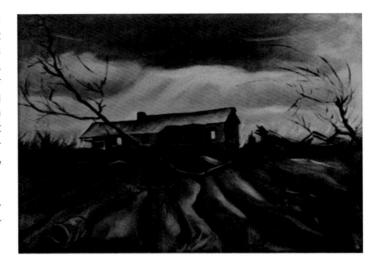

Fig. 185 Joseph Paul Vorst, *Sharecroppers' Cabin*, n.d., oil on canvas laid on panel, 21 x 18 in., private collection, New York, New York.

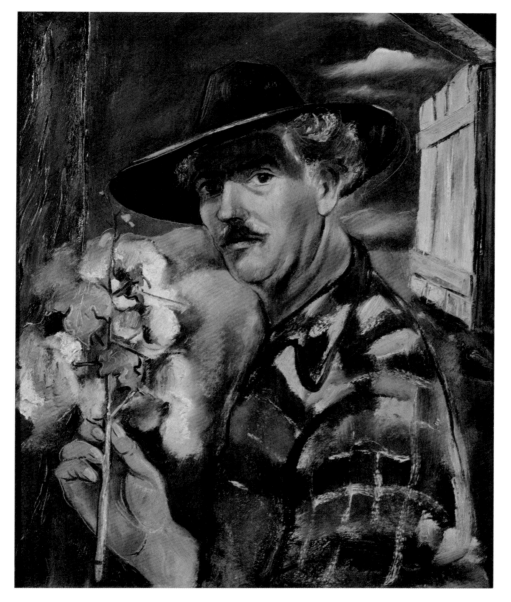

Fig. 186 Joseph Paul Vorst, *Self Portrait with Cotton*, ca. 1945,
oil on canvas wrapped on panel, 26 x 22 in., Carl and Carole
Vorst, St. Louis, Missouri.

Fig. 187 unidentified photographer, Vorst sitting for *Self Portrait*
(compare Fig. 1) and with other Vorst works in the background,
n.d., Carl and Carole Vorst, St. Louis, Missouri.

ENDNOTES

1. This statistic and the general data about the war, cited in the overview above, come from The National World War II Museum, national-ww2museum.org.

2. Personal correspondence from Pauline Ehrlich to Vorst, July 3, 1942.

3. "Two Vorst Paintings Displayed in New York," *St. Louis Star-Times,* December 16, 1942.

4. See the exhibition, *The Museum and the War Effort: Artistic Freedom and Reporting for "The Cause,"* Museum of Modern Art, New York, 2008, moma.org.

5. William Edward Hoffman, op. cit, 17.

6. See Museum of Modern Art press release, 4 1121-76, "President Roosevelt Congratulates 2,200 Artists of the Country on Response to National War Poster Competition," moma.org.

7. "Two Vorst Paintings Displayed in New York," *St. Louis Star-Times,* stamped date on the newspaper clipping: December 16, 1942.

8. Florence S. Berryman, *Washington Star,* May 2, 1943.

9. Thomas E. Morrissey, "Joseph P. Vorst, An American Scene Painter," unpublished article, 12.

10. Howard Derrickson, "Indignation Over Wrongs in Oils by Joseph Vorst at Noonan-Kocian," *St. Louis Post-Dispatch,* April 20, 1947.

11. See the United States Holocaust Memorial Museum, ushmm.org, accessed, July 24, 2017.

12. It should be noted that the print is sometimes mislabeled as "The Good Lord Give's Peace" or "Lord Give Us Peace." These errors, however persistent, crept in posthumously. Works with the original titles above were photographed and published in newspapers and catalogs at the time they were first exhibited. The confusion, perhaps springs from the subject matter: in both *For Thine Is the Kingdom* and *The Good Lord Give's Peace*, an elderly African American man is depicted in prayer.

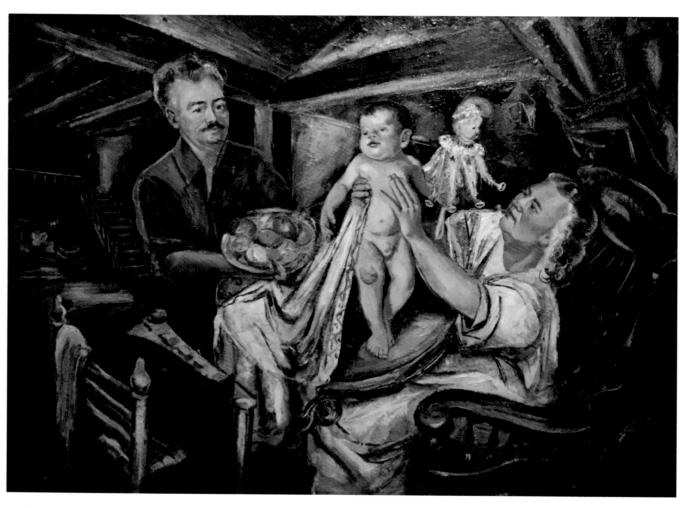

Fig. 188 Joseph Paul Vorst, *Family Festival*, 1945, oil on panel,
31 x 45 in., Carl and Carole Vorst, St. Louis, Missouri.

CHAPTER 9
TOWARD PEACE

AFTER THE WAR

Four and a half years after the U.S. forces joined the global conflict, Germany and Japan surrendered separately. As the Soviet military neared Berlin, Hitler committed suicide in his bunker on April 30, 1945, and on May 8, Victory in Europe (VE) Day was declared. Japan ceded power on August 15 and officially signed an unconditional surrender on September 2, 1945.

Vorst's entire adulthood had been lived under the haze of war: first as an injured young soldier; then as a student in devastated post-World War I Germany; next in America throughout the Great Depression; and finally, during the harrowing destruction of World War II. He had never known extended periods of peace and stability.

Now, nearly fifty years old, he could look around him and see a brighter future. He was not wealthy, but he was comfortable. He had a teaching position, and he added a guest lecturer post at Drury college during the summer. He had a lovely home, a loving and devoted wife, and a growing son.

Vorst continued to show his work regularly at important national venues in group exhibitions. November 27, 1945 marked the opening of the Whitney Museum's *Annual Exhibition of Contemporary American Painting*. The exhibition ran until January 10, 1946. For the show, Vorst's contribution was the painting *Family Festival* [Fig. 188].

It is misleading to say that Vorst's imagery abruptly changed with the end of World War II. For one thing, it is difficult to date all of the paintings given that he was inconsistent in the way he signed works, which he rarely dated, and there are no records to rely on for clarification other than exhibition checklists. Further, it appears that many, even a majority, of the paintings of the period were never exhibited at all.

Still, the late paintings, when seen as a group, take a decided shift away from earlier themes. The most significant departure was Vorst's new interest in home life. After a career of painting scenes out of doors, Vorst moved inside. Numerous paintings depicted his small family and documented little Carl's growth—groupings of all three of them, of Lina and Carl (*Late Motherhood* [Fig. 207]), mother and son peeling fruit, and of Carl alone. In separate works, the boy is shown playing the piano (*The Talented Son* [Fig. 208]), holding a pet cat, crawling on the floor with a rattle, feeding chickens, and selling newspapers on a street corner.

Many of Vorst's pictures in America centered on regional events. He was comfortable saying that he was part of the American Scene painters movement. In the mid-1940s, broader American history began to interest him as well, and Vorst made his first paintings about important moments in history: *Washington Crossing the Delaware, Byrd at the South Pole,* and *Lincoln and Douglas* [Figs. 189-191]. Marginally, these paintings are consistent with his earlier output—there are some hallmarks of technique in the ways he incorporated raging weather into his storytelling, for example—but they are odd pictures, too, almost cartoonishly grotesque. In fact, they are so far out of the norm for him stylistically that one imagines they might have been created for a specific commercial client.

Overt patriotism in paintings—as opposed to images painted by the artist who thought of himself as patriotic but whose subject matter does not immediately read as primarily aimed to encourage such fervor—manifested itself in Vorst paintings gradually. Other than the World War II propaganda sketches and mural studies that drew upon scenes of America preparing for, supporting, and fighting the war, the artist

connected more directly with individuals than ideologies.

Perhaps the most resonant story that combined the two interests of history and the military was the story of Captain Eddie Rickenbacker, a World War I flying ace and decorated hero. In the painting *Pacific Miracle* (Fig. 192), Vorst depicted the pilot years after the war, in 1942, in a story that became a famous tale of endurance and hope. Rickenbacker, a civilian in 1942, toured the Pacific on a mission from U.S. President Franklin D. Roosevelt. Flying an old B-17 bomber, the crew strayed off course hundreds of miles. Finally, the plane was forced into the Central Pacific Ocean.

Rickenbacker and the surviving crew ran out of food after three days. Without rations, they grew despondent. The story goes that they prayed to God for help, and a seagull landed on Rickenbacker's head which was captured and used for bait to catch fish, and which saved the men. For 24 days they drifted in a raft in the open sea. At the time, the newspapers and radio programs reported the loss of the plane and announced Rickenbacker's death. U.S. Army and Navy patrols were ready to abandon the search, but Rickenbacker's wife cajoled them into giving the hunt one more week. On November 13, 1942, a patrol plane spotted the raft and rescued the men—all but one of whom had survived the ordeal.

In *Pacific Miracle*, Vorst shows Rickenbacker reaching up to capture a descending seagull. An open book of scripture rests on the floor of the raft, and the dark sky parts to reveal shafts of light in the distance.

Fig. 189, left, top Joseph Paul Vorst, *Washington Crossing the Delaware*, n.d., oil on gessoed panel, 11.5 x 11.5 in., Carl and Carole Vorst, St. Louis, Missouri.

Fig. 190, left, middle Joseph Paul Vorst, *Lincoln and Douglas*, n.d., oil on gessoed panel, 11.5 x 11.5 in., Carl and Carole Vorst, St. Louis, Missouri.

Fig. 191, left, bottom Joseph Paul Vorst, *Bryd at the South Pole*, n.d., oil on gessoed panel, 11.5 x 11.5 in., Carl and Carole Vorst, St. Louis, Missouri.

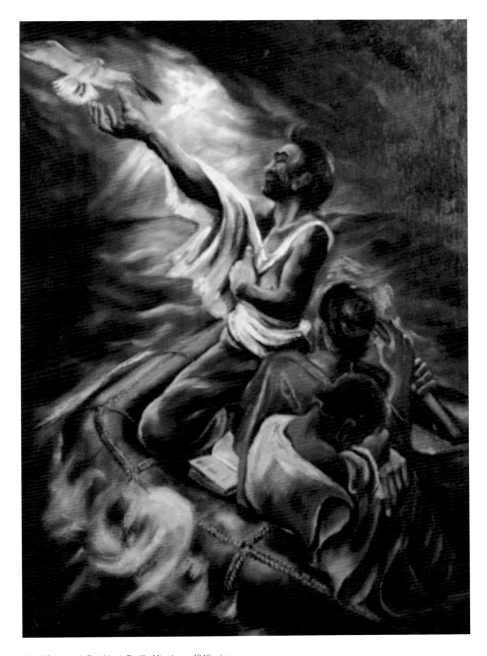

Fig. 192 Joseph Paul Vorst, *Pacific Miracle*, ca. 1942, oil on canvas, 48 x 36 in., Church History Museum, Salt Lake City, Utah.

He became fascinated with exotic locations. He painted a number of imagined scenes of bare breasted women, tropical fruit and baskets, and plants from the Pacific islands, for example—some of them oddly juxtaposed with urban cityscapes in the background. All were places he never visited.

Vorst also executed a number of domestic scenes that are less dramatic, in watercolor and lithography. These include people cooking dinner, making music, gossiping, picking fruit, children riding horses, and farmers working with their livestock. A number of these themes had been a focus of Vorst's early introduction into American life, but now, he returned to the subjects—one wants to say, no longer as an outsider. Additionally, he began to create works that appear to be liberated from the weight of symbolism altogether: simple arrangements of flowers in a vase and still life compositions. Generally, however, his issue-laden subjects continued. He lost none of his Social Realist fire. He found new topics of social ills to rail against.

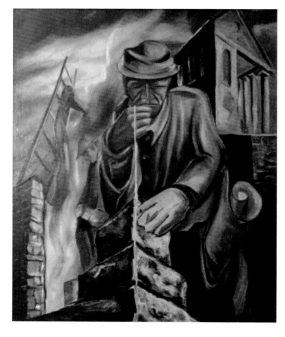

One interest was the global effort to rebuild after the destruction of war. Given his personal experience of Germany in the 20s, this must have been an instance of déjà vu. Vorst created a painting titled *Reconstruction* (Fig. 194) (sometimes also referred to as *Stone Mason*) with a figure in the center in the act of repairing a structure in a landscape strewn with bombed out buildings. In his satchel is a rolled up set of blueprints.

Other paintings, such as *Woman Picking Up Sticks* (Fig. 197), *Urban Scene* (Fig. 196), and *The Latest News* (Fig. 195) feature men, women, and children reacting to bleak aftermaths of harrowing events with stoic determination. Children had not previously been part of Vorst's work in this way, or at least, they had not been a common metaphorical device in Vorst's work. Although they were occasionally featured in his paintings and prints—and the baby paintings of Carl exemplify the impulse to capture the wonder of childhood and new fatherhood— they had rarely been used to stir up the emotions of the viewer to political ends. Certainly the birth of his son influenced this newfound messaging for the plight of children. *Newspaper Boy* is especially interesting in the way it merges scenes of adults huddled together to read the latest news, presumably regarding the war, while a boy with one arm raised cries out to spread the word, standing on discarded newspapers, all in front of a church.

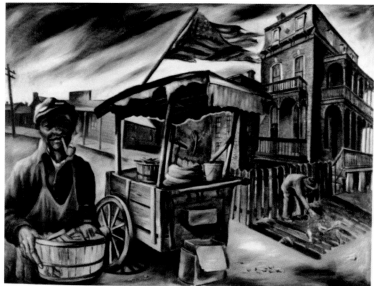

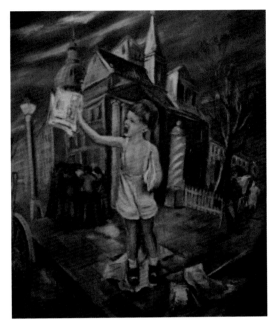

Fig. 193, opposite page, bottom Joseph Paul Vorst, *The American Scene*, n.d., oil on canvas, 24 x 30 in., private collection.

Fig. 194, opposite page, top Joseph Paul Vorst, *Reconstruction (Stone Mason)*, n.d., oil, 28.5 x 23.5 in., Carl and Carole Vorst, St. Louis, Missouri.

Fig. 195, above, left Joseph Paul Vorst, *The Latest News*, ca. 1947, oil, 31 x 26 in., Carl and Carole Vorst, St. Louis, Missouri.

Fig. 196, above right Joseph Paul Vorst, *Urban Scene*, n.d., oil on board, 27.5 x 18 in., courtesy Treadway Gallery, Cincinnati.

Fig. 197, right Joseph Paul Vorst, *Woman Picking Up Sticks*, n.d., oil on panel, Carl and Carole Vorst, St. Louis, Missouri.

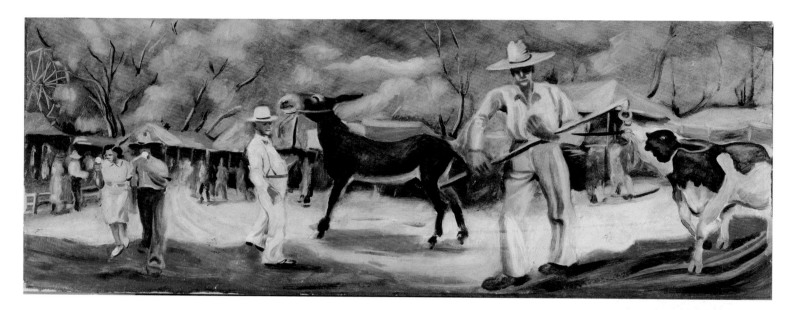

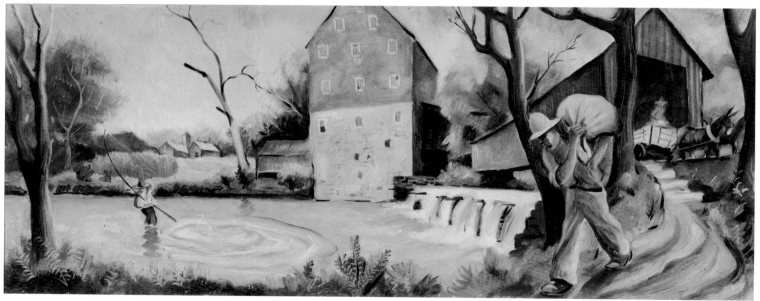

Fig. 198, top Joseph Paul Vorst, *Blue Ribbons*, n.d., oil on masonite, 15 x 36 in., Carl and Carole Vorst, St. Louis, Missouri.

Fig. 199, top Joseph Paul Vorst, *Jackson County Bridge*, n.d., oil on masonite, 26 x 44 in., Carl and Carole Vorst, St. Louis, Missouri.

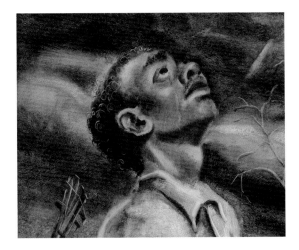

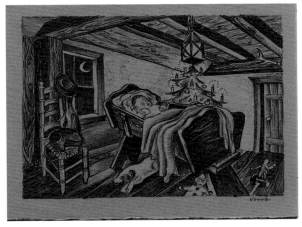

Fig. 117, top Joseph Paul Vorst, *Drought* (detail), 1938, oil on canvas, private collection, Illinois.

Fig. 200, bottom Joseph Paul Vorst, untitlted exhibition announcement, 1947, lithograph, 5.25 x 6.5 in., Carl and Carole Vorst, St. Louis, Missouri.

From November 17 to December 17, 1945, Vorst exhibited three paintings at the *Fifth Annual Missouri Exhibition*. The paintings included a still life, *Driftwood*, *The Talented Son*, and a work titled *"Musikhall" Debut*. The paintings then traveled to Kansas City and the Nelson-Atkins Museum.

The Pennsylvania Academy of Fine Arts included his work in 1946. He sent a painting, *Prayin' for Rain*, to the Virginia Museum of Fine Arts for their *Fifth Biennial Exhibition of Contemporary American Painting*, (March 30-April 25, 1946). It was later acquired for the permanent collection of the City Art Museum in St. Louis. Vorst's painting *The Keeper* was part of the Whitney Museum's *Annual Exhibition of Contemporary American Painting*, in December of 1946. Group exhibitions were one of the ways American artists were codified as important. Vorst had now been in four Whitney surveys.

In large part because of the war, he had not had a one-person exhibition since the back-to-back shows in New York and St. Louis of 1941. There is much to indicate, however, that Vorst had been painting continuously or nearly so throughout the war.

Vorst continued to experiment with the techniques of painting. In the late 1930s and especially in the mid-1940s, as he used gesso techniques more often, his markmaking expanded to included an etched or incised detailing. These were made with his fingernails, the ends of paintbrushes, and other tools, and they were not exclusively a technique of gessoed panels. Rope, curly hair, outlines of dark forms, and beards were delineated and accented by these scratched marks in this way, and this process appears in paintings on various surfaces. It is less apparent looking at the paintings as reproductions, in which the marks seem to be highlighted lines in contrasting colors, but it is actually a trick of the light; they are etched lines that sometimes reveal underpainting but more often are not additions of color at all. (The hair of the figure in *Drought*, above left, is just one example of this technique.) Observing the paintings in person, these marks strike the viewer as inventive and almost a focal point. Vorst is, essentially, taking a flat plane and giving it shape and motion by etching into the paint. The proximity of one etched line to another also became a way that Vorst shaded the images. By adding density to paintings in this fashion, he developed a process that took a simple surface and made it complex in unexpected ways.

A RETURN TO EXHIBITIONS

In April of 1947, Vorst mounted a one-man show at the Noonan-Kocian Galleries at 1000 Locust Street in St. Louis. It included 22 paintings and six lithographs all made in the previous three years; there are discrepancies between various news reports of the number of works in the exhibition. None of the works had been shown in St. Louis before.

The public invitation for the show included a variation of the lithograph *Lullaby*. The family had used this reworked image as its annual Christmas card, adapted by the insertion of a candle-lit tree in the background and scattered children's toys on the floor. The original multi-paned window was replaced with a more storybook-like window that framed a crescent moon (see Fig. 200).

For the catalog's cover, the artist chose a self-portrait (Fig. 186). In the work, he turns to face the viewer. Unlike other images of Vorst in which he is typically in formal clothing, here he wears a brightly patterned shirt, open at the collar. His curly hair is graying, shown under a broad-brimmed hat. Instead of the paintbrush that he held in his hand in earlier self-portraits, now he holds a stalk of cotton. The catalog itself was not a fully-illustrated booklet; rather, it was a single sheet, with the portrait on one side and an essay on the other. There appears not to have been a checklist of works, which adds to the confusion about the exhibition's contents.

To some extent, the exhibition works can be pieced together through a compilation of newspaper critics' remarks. It remains incomplete, and it is at the mercy of writers who referred to paintings descriptively at times rather than with the artist's proper titles. Still, the exhibition included the following: *Of One World, Spring, Miracle, Along the Bluffs, Actress, Reconstruction, Spiritual, Self Portrait, A Showboat Calliope, St. Louis Riverfront, Historical Church, Missouri Annual,* and *The Crib.*

The catalog of the exhibition featured an essay about the artist written by John Hersey. At the time, Hersey was riding a wave of critical recognition. His World War II novel, *A Bell for Adano*, won the Pulitzer Prize of 1945, and in August, 1946, *The New Yorker* published his article "Hiroshima," the nonfiction account of survivors of the Japanese bombings, which received widespread attention. Hersey had covered the war in Asia and Europe as a correspondent for *Time*

and *Life* magazines, and he was sympathetic to many of the issues that Vorst put into his paintings. The young author began acquiring Vorst paintings five years earlier. Nearly twenty years separated the age of the men, but philosophically they were peers.

Hersey began his writing about Vorst by referring to the artist's apprenticeship in Germany decades earlier, specifically, his being forced to break stained glass panels in order to deceitfully drum up sales for his boss. Then, Hersey employed the tale as a metaphor for Vorst's work:

> In our society, a painter—even a painter of genius—has to throw some kinds of stones in order to get attention and employment. For many artists, the choice is easy: they throw artistic stones; they use self-consciously eccentric and outlandish forms, not merely for the sake of experiment, which is often necessary and laudable, but simply for the sake of notoriety and its companion, prosperity. Joseph Vorst has never succumbed to this temptation. He has experimented, constantly, for his is a restless and inquiring mind; his style has changed and developed through the years, keeping always a stamp of his own personality. But he has never compromised with his art, as he understands it, merely for the sake of drawing attention. Since that first experience, he has never thrown stones just to get business.[1]

Hersey admitted that he was no art critic, but cited the insight of having lived with Vorst's artworks as a qualification to write about them and the artist's character.

> The quality of excellence that I see in Vorst's work… is the quality of the man. He has the breadth of spirit, the love of humanity, the sympathy for small people, the understanding of nature, that are the essentials of any superior artist's work.[2]

The essay concluded with the author detailing why Vorst left Germany in 1930, but unlike so many other journalists for whom such references were coded prejudice, Hersey connected the immigration to a catalyst for insight:

> He left Germany in 1930, three years before Hitler came to power, because he felt uneasy at the stirrings in that country. In America, he was tremendously ex-

cited, not only by the visual panorama of the country, but by the freedoms he found; and where he found the freedoms abused, it worried him.[3]

Hersey wrote a fan letter, essentially. He liked the paintings—although he interjected, "Not every one of his paintings is successful, for no man can be at his best always."[4] But it is clear that Hersey admired the man equally as much.

During Vorst's career, very little was written about his home life. It is apparent that Hersey knew Vorst in a more thorough way and was willing to describe it differently than other journalists. He wrote:

> He loves his family; he has integrity about his work… But when Joseph Vorst is at his best, he catches, I think, a glimpse of humanity—of suffering and happiness at once, of all those things in men, and around them, that make them what they are. That is why I like Vorst's work.[5]

Not everybody agreed. Critics took Vorst to task. To some, the exhibition was unfocused. It represented an artist in transition rather than a tightly-curated show thematically. He exhibited domestic portraits of his son and his wife, a protest picture of the Klu Klux Klan, and a patriotic episode of the rescue story of Eddie Rickenbacker. There was a prayer picture, laborers who symbolically reconstruct the nation after the war, a jaunty self-portrait, a local scene of the St. Louis riverfront, a lyrical composition of flowers, and a showboat on the Mississippi. Thematically, the paintings were all over the place.

In the *St. Louis Star-Times*, Reed Hynds wrote of his conflicted reaction to the pictures,

> Placed close together, they assault the spectator with a kind of brute force; they have such vigor in dynamic line, boldness of color and vividness of composition through rawly opposed masses, as to cause one to blink on a first look at the lot of them. There's no sophistication in them, and very little subtlety.

> But they have power. It is the power of a prolific but uncontrolled talent, not yet channeled into a completely developed style….[6]

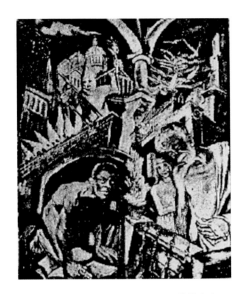

Fig. 201 Joseph Paul Vorst, *Of One World*, ca. 1947, oil, whereabouts unknown, reproduced in *St. Louis Star-Times*, 1947, photograph, Carl and Carole Vorst, St. Louis, Missouri.

Fig. 202 Joseph Paul Vorst, untitled sculpture, n.d., unsigned, plaster, 17.25 x 5.75 x 3.5 in., Carl and Carole Vorst, St. Louis, Missouri.

Fig. 203, above, right Joseph Paul Vorst, Christmas card, n.d., lithograph, (note: the above sculpture can be seen at the far right, in a recessed niche), 5.25 x 6.5 in., Carl and Carole Vorst, St. Louis, Missouri.

Vorst had created several of the works on gesso panels, a laborious process that the artist explained took four weeks' of special preparation. When pressed for specifics, Vorst did not disclose his methods. He acknowledged that some of the paintings' imagery was made with a palette knife, the sharp end of his brush, his fingers, and even his fingernails. It appears that Vorst was continuing to challenge himself regarding subjects and techniques. He had not landed on a single path of expression; rather, he continued in some familiar veins of thought, explored new approaches to painting, and looked for new stories to tell.

As early as 1938, the press noticed his techniques in the medium of gesso. *Art News* reported, "Vorst has been experimenting with his medium and most of the pictures are painted with quick-drying translucent glazes on gesso prepared boards."[7] Gesso and frescos were a fascination of the German art movement, New Objectivity. It appears that nearing 20 years after his immigration, Vorst was still drawing on influences in his native country.

In the exhibition, one large painting received special attention and represented the fearless tone of some of the works: a moral indignation to oppression. It was titled *Of One World* [Fig. 201]. In post-War America, Vorst still found ideals and liberties that he wanted to protect and wrongs that he wanted to protest. Tyranny and subjugation were the themes of *Of One World*.

The whereabouts of the painting are unknown, but it was photographed and reproduced in St. Louis newspapers at the time of the exhibition. It shows an influence of his mural-making in the sense that the painting brings together multiple scenes that coalesce, thematically. Images are layered atop each other in dynamic ways, similar to his untitled mural study for a Washington building years earlier.

Derrickson described the work:

> Most elaborate in message is "Of One World," a large oil. It shows part of a bombed building, symbolizing war, and is peopled by hooded figures of the Ku Klux Klan, a cowering Negro in a narrow subterranean corridor and other abused persons, including the mentally ill in state institutions.

> Every detail has significance. The klansman's torch

comes close to the dome of a government building to suggest rumors of federal officials as klan members; old French grill work and architecture convey the impression of the Deep South, and spikes on a fence are intended, the artist said, to remind the viewer of both the crucifixion of Christ and the restrictive injustices of the world.[8]

The newspaper critics of the exhibition, like Hersey in his essay, noted that Vorst's works were imperfect, that he could be brutish and unsubtle. And yet, they found in his paintings things to admire and champion. Even the negative review of Reed Hynds ends with this conflicted exhortation, "Those who are interested in art will want to see the show, though I'm afraid they'll be as much annoyed and baffled by it as they are impressed."[9]

But it was Harry R. Burke in the *St. Louis Globe-Democrat* who wrote a much more substantial and less reactionary review. While acknowledging problems, he also attempted to link themes of Vorst's work over time, which was a new and elevated approach to looking at his work. This was facilitated by the fact that the range of the exhibition's subject matter was broad itself. It is an insightful review that moves closer to an understanding of the totality of Vorst's output than the artist had never enjoyed before. Burke began his review invoking German immigration, but this time, the critic attempted to describe how his origins may have affected his current work:

> It is impressive. Stridently dramatic, if you please. You are very likely to intensely like it or dislike it. That Vorst's is a personal idiom is certain. He paints in a low key, but often with high color. When he left a depressed Germany in 1930 he landed plump in the middle of the depression here. That experience has left its mark—in Chinese white and in ashen green-grays.

> Actually, one suspects Joe Vorst is a lyricist in search of an excuse for lyricism. German expressionism left its mark upon him. Sharecropper art did also. He has felt the impact of synthetic primitivism. He even flirts with marginal surrealism. These left traces, one suspects, in a dynamic and reforming spirit perplexed and puzzled by the world's plight.[10]

Fig. 204, above unidentified photographer, St. Louis LDS Branch outside the Maple Avenue Chapel, 1933 (Vorst is on the back row, third from the left), courtesy Tom Farmer, St. Louis, Missouri.

Fig. 205, left unidentified photographer, Vorst (far left) and the St. Louis LDS Branch choir inside the Maple Avenue Chapel, 1946, courtesy Tom Farmer, St. Louis, Missouri.

All of those observations represent a breakthrough regarding appreciation of Vorst as an artist worth exploring in depth. Burke notes disappointments and misgivings, too, but even those comments are fresh critical approaches to the artist:

> Thus his show betrays a bundle of contradictions, for through it all runs like a thread of gold as joys. He is never happier than in brooding over a cradle, or dreaming of a lullaby, or smiling at the antics of a boy with a cat. Yet he will not permit himself to approach these simple things simply. The low key, the spotted high color, the swirling rhythms tend to make them dramatic. It is as though an intellectual were ashamed of being human.[11]

For some fifteen years, Vorst's work had wrestled with social issues, and although his paintings and prints garnered attention, prizes, and exhibitions, what they did not generate was public discussion, at least, not dialogue in print. Here, at last, was an acknowledgment that the artist had larger goals, or as Burke wrote, "There is social commentary in this brush."[12]

Whether or not Vorst agreed with these three critics is almost beside the point; after a hiatus from gallery exhibitions because of the war, he was on the verge of being part of the larger conversation of Art in America. Further, it appeared that critics were willing to discuss his works in ways that Vorst surely craved. For one thing, there were no references in the reviews to the influence of Thomas Hart Benton or Joe Jones. Vorst's work was standing on its own and receiving attention.

Burke's review ended by noting which paintings in the exhibition attempted social discourse. Personally, however, he preferred Vorst's other, more personal scenes:

> Yet one likes better his recreation of the old St. Louis Waterfront, the "Still Life," and those pictures which center about a home life which he seems to share, or those notes of the Missouri scene in "Showboat Calliope" and "Along the Bluffs." One may or may not have a taste for Vorst, but these pictures, such as "Spiritual" are something to think about. They have something to say.[13]

In two notices for the *St. Louis Post-Dispatch*, Derrickson wrote that the exhibition was scheduled to be shown in New York. This never happened.

HIS DEATH

On Wednesday, October 15, 1947, Joseph Paul Vorst was conducting a choir rehearsal for his Mormon congregation. He collapsed, stricken by an aneurysm, as his wife and three-year old son sat outside waiting for him in their car. He was taken to Lutheran Hospital, where he died of a cerebral hemorrhage. Vorst had been under a doctor's care for two years because of hypertension. An autopsy was performed on October 17 that confirmed the hospital's initial explanation: a hemorrhage in his right frontal lobe.[14]

At the time of his death, Vorst was 50 years old, three years younger than his father and grandfather had been when they died. Newspapers ran an obituary on Friday and announced funeral services for the following day. He was buried at the Lake Charles Cemetery.

Lina was devastated, of course. Furthermore, they had no significant savings to fall back on. Financial stability was another casualty of war for the family, and Vorst had not exhibited regularly in commercial spaces for years. She wrote to friends about their limited options. Arvid Langnickel of Little Falls, New Jersey penned this response on November 2, 1947:

> Dear Lina,
>
> The day your letter reached here is the same day that I returned from a short trip as far west as Detroit. On finding the letter I thought it would contain word about Joe's intended trip to New York. You can imagine that it was quite a shock when I read of Joseph's passing. He was one of my best friend's [sic], I only have about two others that share the same place in my esteem as Joseph dose [sic]. We all realize the extreme loss you have suffered and offer you our heartfelt sympathy.
>
> I believe your intentions of keeping the home and taking in a couple of roomers and boarders is worth a try. However with the high cost of food, you will have

to be sure and ask enough for board or you will be working for nothing. Am wondering how you are fixed for ready cash, did Joe have any insurance? If you need money at any time let me know, I believe that I told you this the last time I was in St. Louis.

As to Joseph's artist and photographic equipment, I would suggest the following. That you try to return any unused materials for refund or credit and try to sell the credit to some other artist. There are certain things that I would buy for my own use, such as photographic equipment, the typewriter and any office supplies. Any used items I would sell for you at what ever I can get for them. I also take it that there are certain things that you want to keep, in hopes that Carl may want to paint when he gets older. So if you will list what you want to sell and how much you want for it, I will send you a check and pick up the items on my next trip to St. Louis, which should be in the Spring.

In regards to the unused brushes that I sent Joseph, if you have no use for them I will take them back, but if you can sell them or want some for Joseph's artist friend in Germany, it will be alright with me.

If you want to sell the painting of Chri[s]t that Joseph wanted me to take to New York once, I will buy it as well. So if you don't want to keep it add it to the list.

If anything ever happens to you and Carl is still small he can always have a home with me, I know that there are relations of Joseph's in Missouri, but don't know if they would take care of him or not. It is hardly likely that you won't be able to raise and see him well on the road of life, but merely mention it so you won't worry about anything of this nature. Mention this mainly as I know you are inclined to worry about things.

Write me from time to time how things are going and you can depend on it that I will stop with you when I am in St. Louis. With best wishes from us all and Hell'o to automobile Carl.

As ever,

Arvid[15]

Fig. 206 Joseph Paul Vorst, untitled, n.d., oil on canvas, 29.5 x 23.5 in., private collection, New York, New York.

Fig. 207, top Joseph Paul Vorst, *Late Motherhood*, ca. 1944, oil, 31 x 36 in., Carl and Carole Vorst, St. Louis, Missouri.

Fig. 208, bottom Joseph Paul Vorst, *The Talented Son*, ca. 1945, oil on canvas wrapped on panel, 36.5 x 44.5 in., Carl and Carole Vorst, St. Louis, Missouri.

Lina had worked as domestic help when she first met Vorst, and with few options after his death, she returned to this line of work taking in laundry and cleaning houses. She also sold artworks as the opportunity arose, but these sales would have been minimal help and appear to have been limited. The earliest, though undated, inventory of the estate lists 23 paintings, including some of his most well-known works, offered for $25-50. The two largest works were listed at $60 each.[16]

To give an idea of her financial condition after her husband's passing, Lina wrote this letter—on "Vorst Studios" stationery that advertised "Distinctive Artwork, Creative Product Design, Accurate Retouching"—on January 21, 1949:

> Dear sir: I cannot begin to tell you how much the check of $7.50 I received today meant to me. The enclosed clipping will tell you better than I can. I am very sorry that I neglected to inform you of my husband[']s passing, but there was so much to be taken care of and I had to do it all myself. Would there be any chance, that you could use some of my husband[']s work[?] I would be only to[o] glad to send you photographs and all the information you would require.
>
> Thanking you kindly
>
> I am respectfully yours
>
> Mrs. Joseph P. Vorst[17]

Two years after Vorst's death, the following notice was sent to his friends:

> You and your friends are cordially invited to the Memorial Exhibition of paintings and lithographs by the late Joseph P. Vorst
> Saturday November 19 through Thursday November 24, 1949
> Open daily except Monday from four to eight o'clock
> Sunday from two to six o'clock
> The Church of Jesus Christ of Latter-day Saints
> 4720 Jamieson Boulevard
> Saint Louis 9, Missouri[18]

A short notice in the newspaper announced the memorial show. It included the largest group of works that had ever been exhibited by the artist: 56 oil paintings and 15 lithographs. *The Globe-Democrat* reported that the exhibition was mounted by members of the LDS congregation. They erected screen panels for the display, and they transported the art from the Vorst home to the church building. They hung the works as "an effort to help Mrs. Vorst present a memorial exhibit of his work in New York."[19] But a New York show did not materialize. The same newspaper article wistfully noted,

> Vorst came from Germany in 1930—an unknown, and entered into the heart of the depression. Some bits of Missouri flora his brush had caught made a first impression on art lovers. He had a dramatic spirit, a sense of comedy in the juxtaposition of things. But these were interpreted with a rhythmic dash, which made effective his later genre work. Slowly he made his way to national recognition and to New York shows. And on the verge of success he died.[20]

In the decades that followed, Lina and Carl continued to reside at the Morrow Drive home in Overland, Missouri. She worked as domestic help until she grew too old to manage such labor. Sales of Vorst's paintings provided the family occasional added income. In a letter dated December 21, 1975, Lina wrote to an art collector whom she had not met about her struggles as a single mother:

> My husband passed away suddenly October 19th, 1947. He had a Cerebral Hemorrhage.
>
> He left behind his widow and a little 3½ year old son.
>
> Everybody that knew him was stunned. I had a hard time to raise and educate our son by myself. We had no savings, because everything went into his work. He was a wonderful person and Artist, and I was very proud he chose me for his life companion….
>
> He worked so hard, as he had a feeling that his life might be shortened. He was just 50 years old.
>
> I hope this helps you understand why he was such a fine Artist and man.[21]

Lina's comment about Vorst's premonition that he would die young—just as his father and grandfather had before

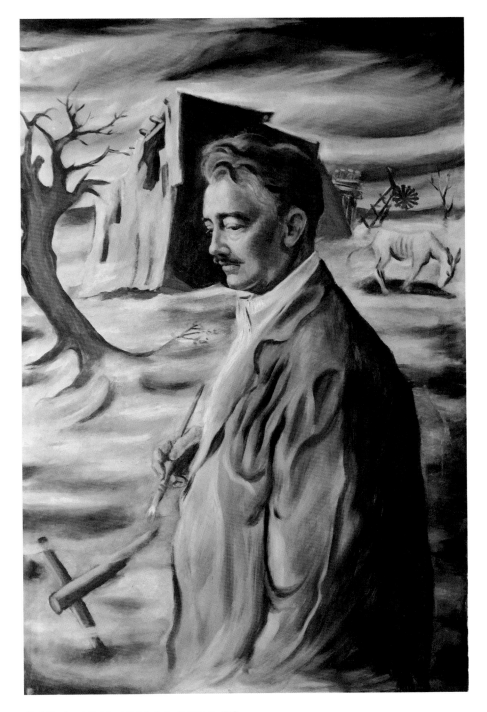

Fig. 209 Joseph Paul Vorst, *Self Portrait with Mule*, ca. 1947,
oil on masonite, 37 x 25.5 in., Carl and Carole Vorst, St. Louis,
Missouri.

him—seems to align with his frenetic, visual output in his last years. It is as if he imposed on himself a practice to capture ideas as they came to him, rather than working in thematic series as he had often done previously. Vorst displayed an urgency that baffled his admirers and critics.

John Hersey, who had written the catalog essay for Vorst's final exhibition in 1947, penned a letter to a scholar who wrote about the artist in 1990, in which Hersey commented on Vorst's state of mind late in life:

> …I thought you caught him very well, and I only wished he could have had a tribute like this paid to him during his lifetime. I thought that toward the end he was discouraged by his being overshadowed by Benton, and that he thought he was a failure—which, of course, taking the body of his work, he was not. He had a more generous spirit, both in his person and in his work, than Benton, who ended up a bad-tempered reactionary.[22]

Over time after his death, Vorst's paintings were infrequently exhibited. When they were shown, one or two of them at a time, mostly, they were part of surveys by Depression-era regionalists. Artworks that had sold to collectors changed hands. American tastes in painting were shifting, dramatically, in ways Vorst probably never foresaw. Abstract Expressionist works by Jackson Pollock, Mark Rothko, Barnett Newman, and the New York School of artists trumped representational imagery as the most important new art in America. Indeed, because of these abstract works and the movements that followed them, New York became the center of the art world. Even had he lived, Vorst's work would likely have been seen as antiquated by those most responsive to shifts toward modernity. There is nothing in his last works to suggest that he might have changed his approach to painting—as a number of the young painters who would become Abstract Expressionists did—in order to be part of the emerging movements, but that is conjecture.

After the end of the war, the art market boomed. Painters began to receive recognition and financial success beyond what they could have imagined. They became stars and celebrities. American Scene painting did not fall out of style overnight, but the political impulse behind it did, nevertheless. In fact, the social commentary that had long been implicit in Regionalist painting—certainly in Social Realism—

became suspect in the era of Soviet-American tension. McCarthyism was just around the corner, and its impact on the art market was tangible. Museums and collectors did not want to display works that could be traced ideologically to Communism, even by a vague insinuation. Some scholars have argued that the rise in abstract paintings was a calculated attempt to circumvent this exact brand of criticism.

The Vorst estate slowly fell into disrepair—the surviving paintings, prints, books, and works on paper owned by Lina were stored away and scattered to some degree between the home and art galleries. Some of these works sank into troubling conditions of decay. Many of the works were painted on masonite, a notoriously difficult material for conservation that is prone to being brittle. Masonite is a pressure-molded board of wood fibers. It was patented in 1924 and began to be mass produced in 1929, just as Vorst arrived in the United States.

One painting, *Dance Marathon* [Fig. 57]—a dynamic and colorful work that dramatically shows a grueling competition through overtones of German Expressionism—was found decades after Vorst's death, rolled up and wedged in a hole of the Vorsts' attic to keep the rain from coming in; it is as apt a metaphor as one is likely to find for the artist's broader reputation.

Carl, being only three years old when Vorst died, has limited memory of his father, although he does have vague recollections posing as a child model. Lina died on January 20, 1992 at the age of 92. In adulthood, Carl became a scientist and engineer for Boeing in St. Louis. As Carl neared retirement, however, he and his family began to rediscover their legacy of art. They collected 100 Vorst paintings and slowly began to restore them.[23] They found a local gallery willing to champion Vorst, show works from the estate, and include him in a survey of Missouri artists in a self-published, richly illustrated book, *An American Art Colony: The Art and Artists of Ste. Genevieve, Missouri, 1930-1940.* Meanwhile, galleries that had been at the forefront of exhibiting Regionalism continued, and they mounted shows and published books that kept the period in the public's view, especially after 1970. Local museums, university collections, and private collectors acquired some significant Vorst paintings and prints as well.

At the time of this writing, Carl and his wife Carole, having

raised three adult children, still live in the home that Joseph and Lina Vorst built. It is lined with Vorst's paintings, particularly those completed toward the end of his life, a number of which show Carl as a child.

IN SUMMARY

Looking at Vorst's paintings now with a large range of artists of his period in mind, one sees numerous connections: the storytelling of Archibald J. Motley, Jr.; the humor and dignity of Midwestern life of John Steuart Curry and Grant Wood; the search of beauty in urban industry of Charles Sheeler, the chronicling of despair of Isaac Soyer; the urgency of the worker of Kyra Markham; the moodiness of Edward Hopper; the concern for African Americans of Jacob Lawrence, Richard Correll, and Hale Aspacio Woodruff; the documentation of St. Louis life of James Turnbull; the attention paid to the immigrant of Rafael Soyer; the cinematic style of Thomas Hart Benton; the conviction in local protest of Joe Jones; and the regional interests of many, many others—including the artists of the Ste. Genevieve Art Colony in particular.

The fact is that during the 1930s and 40s, as the commercial opportunities for fine art in America diminished to a point of disappearance, the familiar instruments for calibrating quality in art—gallery exhibitions, critical appraisal, publicity, sales, auction results, and the marketplace in general—and the accompanying sifting of the best artists in ways that codified their accomplishments, was similarly undermined. From this vacuum, a few artists stood out, and it is somewhat logical to imagine that they represent the breadth of the artists of the day, with the remainder mere acolytes. What emerges over time, however, is a realization that, if anything, more artists of significance were at work than anyone could have imagined. Their similarities of style, once easy to oversimplify and dismiss as derivative or highly influenced by others, show unique and individual voices today, if one is willing to look closely.

In the absense of a market for their work throughout the Depression and World War II, accomplished artists by the dozens and hundreds worked privately, but constantly. Like Vorst, many never showed to the public a fraction of their total output. There was simply no venue for it to happen. Still, they were artists compelled to communicate, and in their isolation, the resulting works were often personal and

fearless. This is the case for Joseph Paul Vorst.

Rather than highlighting Vorst in relation to other American artists of his era in terms of influence, it is worthwhile to note the impulses of the day and how individual artists approached these stimuli similarly and differently. A number of Vorst's subjects, including the Flood of 1937, the sharecroppers' protest of 1939, lynching, and the effects of war and the Great Depression generally, were treated by numerous artists working in similar styles and at the same time. Yet each put a distinct spin on their subjects. When viewed now in a more comprehensive fashion, the works have fascinating and dissimilar points of view that may have been discounted previously because of an urge to generalize.

A distinguishing characteristic of Vorst's work was his German background, which he certainly downplayed in America. But as a way to look at his American art, it is an essential component because it places impetus in the social awareness he discovered before he emigrated. He had not fully incorporated New Objectivity in his painting practice while still in Germany, but any number of his American works draw upon it directly as a style and a philosophy.

It is no coincidence that Grant Wood and John Steuart Curry were both students of New Objectivity before they came to prominence in the mid-1930s. Wood studied the movement in Germany, and Curry became a student of it after his European studies were completed. To suggest that Vorst was taking his cue in art from other American Regionalists ignores his own history and the fact that a number of his recurring images of decaying nature, unvarnished views of the suffering, and humor in the face of depression owe directly to his art training and personal experience in Germany. He was painting this way before 1930 and before he met any of these Americans. Certainly, he was influenced by American painters and America itself, but any push to dismiss his work as wholly derivative seems misplaced when looking at the totality of art from the period.

During his lifetime, disassociating those elements from his American exhibition history told only part of the story and likely contributed to the public's limited response to his work, which only began to broaden in the year leading up to his early death. Whether these identity-related shortcomings, which became a tacit censorship, were the fault of the

artist, critics, or the art establishment matters less now than a reappraisal with the extended lens of history.

The artist never lived to see a retrospective exhibition of his work. He exhibited in America frequently, widely, and well, but the occasion to bring a large number of his paintings, drawings, watercolors, murals and mural studies, artists books, linoleum cuts, sketchbooks, photographs, etchings, sculpture, and lithograph prints under one roof escaped him. Likewise, no extended interview or article about him and his art was ever published in his lifetime.

Although every journalist's notice of his work mentioned, reflexively, his German birth, it appears that the artworks he created in Germany were never exhibited in America other than a few prints and a small number of landscape paintings that were shown in Utah, even though he kept a number of them, particularly works on paper, in his studio.

All of his exhibitions had compressed periods of execution, that is, the paintings and prints on display were made relatively shortly before they were hung. Each of the one-man shows could have been subtitled "recent works." But many works—more than half of his output—were never exhibited publicly. It is also likely that a substantial number of his paintings that are in private hands have not been part of his exhibition history and critical appraisal, at all. Further, Germany is the big question mark. How many pre-1930 works by Vorst survived and may come to light over time is anybody's guess.

No exhibition showed how his paintings changed over time. No attempts were made to connect Vorst's early graphic work in Germany, the influence of his teachers, his religious art, and ways that his moral values in particular infused his art. Nothing showed the development of works from the early 1930s in America, through the Great Depression, the WPA, into World War II, and its aftermath. No attempt was made to depict his evolving identity, which was surely complex and is something of a symbol for the 20th century itself. He died without summation.

ENDNOTES

1. John Hersey, "Joseph Vorst," exhibition catalog, Noonan-Kocian Galleries, St. Louis, April, 1947, unpaginated.

2. Ibid.

3. Ibid.

4. Ibid.

5. Ibid.

6. Reed Hynds, "Vorst Pictures in Show Here Termed Dynamic, Vivid, Bold," *St. Louis Star-Times,* April 1947.

7. *Art News*, Dec. 3, 1938.

8. Howard Derrickson, "Indignation Over Wrongs in Oils by Joseph Vorst at Noonan-Kocian," *St. Louis Post-Dispatch*, April 20, 1947.

9. Reed Hynds, op. cit.

10. Harry R. Burke, "Vorst Oils and Lithographs Make Impressive Exhibit," *St. Louis Globe-Democrat,* April 17, 1947, 2B.

11. Ibid.

12. Ibid.

13. Ibid.

14. The State Board of Health of Missouri Standard Certificate of Death, state file no. 36362, registrar's no. 9666, registration district no. 318, primary registration district no. 1003, filed November 3, 1947.

15. Letter to Lina Vorst from Arvid Langnickel, November 2, 1947.

16. Undated financial documents in the Vorst estate.

17. Letter between Lina Vorst and unidentified recipient, Vorst estate.

18. Invitation, The Church of Jesus Christ of Latter-day Saints, November, 1949.

19. The *Globe Democrat,* Nov. 20, 1949.

20. Ibid.

21. Letter from Lina Vorst to Mr. Hewitt, December 21, 1975, unpublished.

22. Letter from John Hersey to Dr. Thomas E. Morrissey, March 11, 1990, unpublished.

23. See Loretta Shea Kline, "Portrait of a Father: Son Reconstructs Artist's Career," *County Star-Journal*, January 11, 1989; also in the same issue, "Painter Made Mark in American Regionalist Movement."

PERMISSIONS AND PHOTO CREDITS

PERMISSIONS AND PHOTO CREDITS

All works by Joseph Paul Vorst © the heirs of Joseph Paul Vorst and are used with permission.

Every effort has been made to contact the owners of copyright for permission to reproduce the images of the artworks in this book. They are gratefully acknowledged below. In many cases, the only known photographs of Vorst's works come from newspapers, auction houses, and other secondary sources, a number of which are no longer solvent. Additionally, the Vorst estate's slides and photographs of dispersed works are without credits and sometimes have been taken years ago with aging or unstable processes, making it nearly impossible to properly identify every photograph. Likewise it has not been possible to locate photos that would show every artwork ideally.

Photo credits by: Charles Baird (Figs. 15, 16, 18, 19, 25, 26, 27, 28, 36, 42, 43, 44, 45, 46, 47, 48, 57, 89, 90, 96, 97, 107, 110, 117, 121, 122, 123, 124, 125, 127, 127, 128, 143 (also front cover), 147, 151, 152, 161, 162, 163, 167, 169, 183, 186, 189, 190, 191, 192, 197, 198, 199, 209); Church History Library Preservation Staff (Figs. 2, 3, 4, 5, 6, 7, 8, 9, 10, 11, 12, 13, 14, 15, 20, 21, 22, 23, 24, 29, 30, 31, 32, 33, 34, 35, 38, 39, 40, 41, 49, 50, 51, 52, 53, 54, 55, 56, 58, 63, 64, 65, 66, 67, 77, 81, 82, 88, 94, 95, 99, 100, 101, 116, 133, 134, 135, 136, 139, 140, 150, 154, 165, 166, 176, 182, 200, 202, 203); Crystal Bridges Museum of American Art, photograph by Dwight Primiano (Fig. 148); Esquire magazine (Figs. 71, 72, 73, 75); Tom Farmer (Figs. 204, 205); Hanzel Auction Galleries (Fig. 104); Illustration House (Fig. 156); Kaminski Auctions (Fig. 83); Link Auction Galleries (Fig. 138); McCormick Gallery (Figs. 59, 132); Pat Morrissey (Fig. 111); Mercantile Library at the University of Missouri-St. Louis (Figs. 60, 102); Glen Nelson (Figs. 1, 17, 37, 61, 69, 70, 74, 76, 79, 84, 87, 91, 92, 98, 103, 118, 119, 120, 130, 141, 142, 144, 149, 153, 157, 158, 158, 160, 168, 170, 171, 172, 173, 175, 177, 178, 179, 180, 185, 187, 188, 194, 195, 206, 207, 208, 209 (also back cover); Salt Lake Tribune (Fig. 78); Daniel Schutz (Figs. 69, 174); Smithsonian American Art Museum (Fig. 129); Saint Louis Art Museum (Figs. 85, 181); St. Louis Globe-Democrat (Fig. 93); St. Louis Star-Times (Fig. 201); Treadway Gallery (Figs. 62, 86, 113, 164, 184, 196); Tyler Fine Art (Figs. 106, 108, 155); Carl Vorst (Figs. 80, 105, 112, 114, 131, 145, 146, 193); Louise Wade (Fig. 115); and Weschler's Auctioneers and Appraisers (Fig. 137).

MORMON ARTISTS GROUP

PUBLISHER

Mormon Artists Group, founded in 1999, is a collective of creative artists. We publish and sell original artworks (books, music, prints, and collaborative projects), organize exhibitions, readings, concerts, and charitable events, and conduct research on topics related to Mormon Art.

We are unaffiliated with The Church of Jesus Christ of Latter-day Saints except for the fact that our participants are past or present members of the Church.

To date, we have created projects with 83 artists:

1999 - LDS Photographers in New York City Exhibition
2000 - Exquisite Corpse Exhibition and Charity Auction
2000 - Virtual Discussion Group
2001 - Handcart Ensemble Benefit
2001 - Lending Library established
2002 - Silent Notes Taken (Stephen Moore; essayists)
2002 - Musical Compositions by LDS Composers
2003 - Mona Lisas and Mad Hatters (Lane Twitchell)
2004 - Mormoniana (Valerie Atkisson; composers)
2005 - Manhattan New York Temple Portfolio (photographers)
2005 - The Book of Visions (Annie Poon)
2005 - The Articles of Faith (David Fletcher)
2006 - Curses for Your Sake (Javen Tanner)
2006 - Salt Water Jetty (Kent Christensen)
2006 - On the Road with Joseph Smith (Richard Bushman)
2007 - The Book of Gold (Murray Boren/Glen Nelson)
2008 - I Visit the Spirit World with My Mother (Brent Wilson)
2008 - Church Drawings (Casey Jex Smith)
2008 - Atonement (Walter Rane)
2009 - On Sunday (essayists)
2010 - The Island of Bali Is Littered With Prayers (Jeremy Grimshaw)
2010 - Song/Cycles (composers/poets)

2010 - The Book of Moses (Linda Etherington)
2011 - Handprints (David Chapman Lindsay)
2012 - Mormons at the Met (Glen Nelson/Annie Poon)
2013 - Palimpsests (Jared Lindsay Clark)
2014 - Field Notes on Language and Kinship (Tyler Chadwick/ Susan Krueger-Barber)
2014 - Medallions (Kent Christensen)
2014 - Isaiah (Stephen Anderson)
2015 - Me and Thad (Tim Sutton)
2016 - Paco (Nathan Thatcher)
2017 - Prayers in Bath (Luisa Perkins/Jacqui Larsen)

Joseph Paul Vorst is our 31st project.

In addition to the above, Mormon Artists Group has been instrumental in the discovery and research of artists in a wide array of disciplines: music, literature, visual arts, dance, film, architecture, and design.

This book began with a 2014 project that included finding works by Vorst in Germany that, as it turns out, were rare and historically important, and conducting preliminary research and analysis.

Scholarship and the advocacy of artists are the main goals of the organization. For additional information about us, see our website:

www.mormonartistsgroup.com